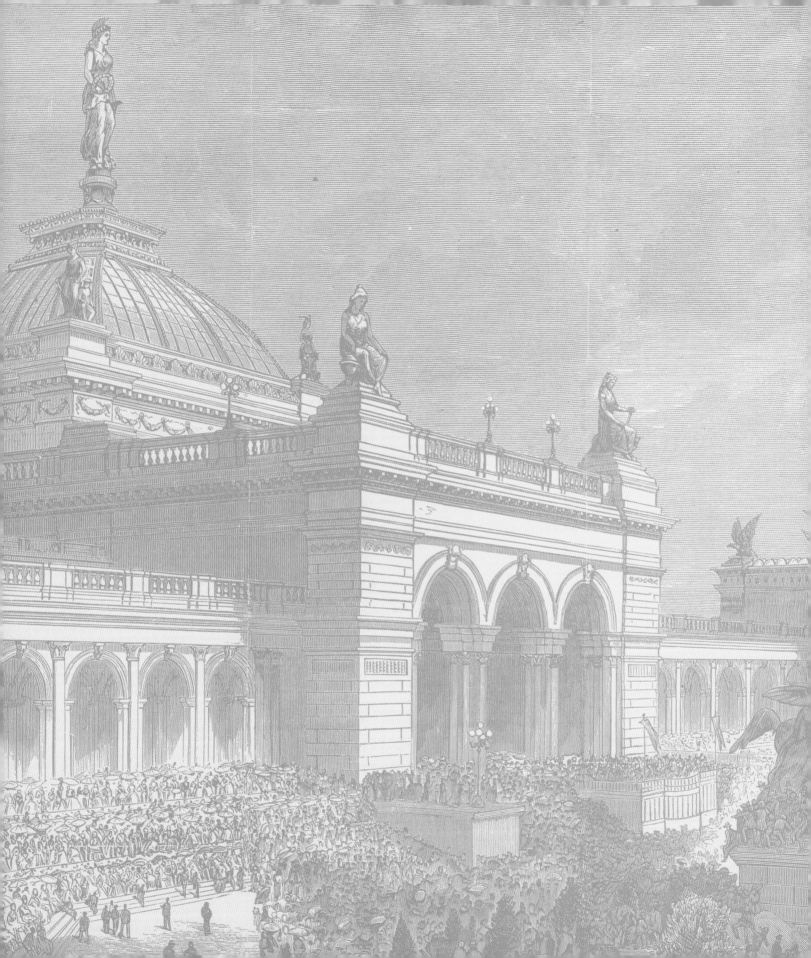

POWER & POSTERITY

American Art at Philadelphia's 1876 Centennial Exhibition

Kimberly Orcutt

The Pennsylvania State University Press, University Park, Pennsylvania

Library of Congress Cataloging-in-Publication Data

Names: Orcutt, Kimberly, author.
Title: Power and posterity : American art at Philadelphia's 1876
Centennial Exhibition / Kimberly Orcutt.
Description: University Park, Pennsylvania : The Pennsylvania State
University Press, [2017] | Includes bibliographical references and
index.
Summary: "Explores the art exhibits at the 1876 Centennial Exhibition
in Philadelphia, along with the circumstances of their creation, the
ideological positions expressed through their installation, and the
responses of viewers, including critics, collectors, and the general
public"—Provided by publisher.
Identifiers: LCCN 2017009259 | ISBN 9780271078366 (cloth : alk.
paper)
Subjects: LCSH: Art, American—19th century—Exhibitions. |
Centennial Exhibition (1876 : Philadelphia, Pa.)
Classification: LCC N6510 .O73 2017 | DDC 709.73/09034—dc23
LC record available at https://lccn.loc.gov/2017009259

for Brian

There are two classes of people

in the United States, those who

did go to the Centennial and

those who did not.

—PROFESSOR D. S. WRIGHT

CONTENTS

ILLUSTRATIONS

ACKNOWLEDGMENTS

A satirical book about the Centennial Exhibition (discussed in the text) begins with its fictional narrator, Samantha Allen, spending several pages explaining "my reasons to the kind and almost gentle reader why I don't have no preface to this book"—and then, of course, her account of the debate with her husband over the matter becomes her preface. She explains that though she has done her very best, she feels a duty to tell her readers of the volume's flaws up front. Her husband, Josiah, assures her, "Anybody that reads *your* book will find out the faults in it for themselves" since "such things can't be hid." In the case of this book, I agree with Josiah that its shortcomings will be found out soon enough, and they are entirely my own; however, many of its strengths are due to the generous assistance of others.

Katherine Manthorne and Kevin Murphy of the Graduate Center, City University of New York, provided thoughtful comments early on, as did Theodore E. Stebbins Jr., Harvard Art Museums. Linda S. Ferber, New-York Historical Society, was unfailingly kind and generous. William H. Gerdts, Graduate Center, City University of New York, was wonderfully supportive, and I have been privileged to draw from both his accumulated wisdom and his incomparable library. I received valuable advice from two centennial experts of long standing: Susan A. Hobbs, director of the Thomas Wilmer Dewing and Maria Oakey Dewing Catalogues Raisonné; and the late Dr. David Sellin. I benefited from the outstanding research assistance of Bree Larson, Catherine Mackay, and Hadrien Viraben. The manuscript was immeasurably improved by the advice of Sarah Burns, Indiana University; Margi Conrads, Crystal Bridges Museum of American Art; and John Davis, Smith College, who read draft chapters and made helpful and perceptive comments. An anonymous reader of an early draft and two anonymous readers for the Pennsylvania State University Press gave freely of their time and expertise to offer much-appreciated suggestions. Most of all, Sally Webster's steadfast support and enthusiasm for the project helped propel it over many years.

Other scholars generously shared their own research and insights: Ross Barrett, Boston University; Anne Bentley, Maryland Historical Society; M. Elizabeth Boone, University of Alberta; Katherine Bourguignon, Terra Foundation for American Art; Teresa A. Carbone, Henry Luce Foundation; Melissa Dabakis, Kenyon College; Gina M. D'Angelo; David B. Dearinger, Boston Athenaeum; Jennifer Dismukes, Archives of American Art; Kathleen A. Foster, Philadelphia Museum of Art; Melissa Geisler, Cape Ann Museum; Abigail Booth Gerdts, Lloyd Goodrich and Edith Havens Goodrich, Whitney Museum of American Art, Record of Works by Winslow Homer; Susanna Gold; Karen Lemmey, Smithsonian American Art Museum; Mary Lublin, Mary Lublin

Fine Arts; Patricia Mainardi, Graduate Center, City University of New York; Katharine Martinez, Harvard University; Leo Mazow, Virginia Museum of Fine Arts; Virginia Mecklenburg, Smithsonian American Art Museum; the late Cynthia Mills, Smithsonian Institution; Kevin Moore; Charles Pearo; Akela Reason, University of Georgia; Letha Clair Robertson, Collin College; Jessica Todd Smith, Philadelphia Museum of Art; Carol Soltis, Philadelphia Museum of Art; Darcy Tell, Archives of American Art; Thayer Tolles, Metropolitan Museum of Art; Evelyn Trebilcock, Olana State Historic Site; Carol Troyen, Museum of Fine Arts, Boston; Phil Valenti, Please Touch Museum; Bruce Weber, Museum of the City of New York; and H. Barbara Weinberg, Metropolitan Museum of Art.

The staffs of several libraries and archives were very helpful, including those of the Free Library of Philadelphia; the Historical Society of Pennsylvania; the Houghton and Widener libraries, Harvard University; the Library Company of Philadelphia; the Library of Congress; the New York Public Library; the Philadelphia City Archives; and the Thomas J. Watson Library, Metropolitan Museum of Art. I would also like to acknowledge the help of Susan K. Anderson, Philadelphia Museum of Art Archives; Alina Josan and Theresa Stuhlman, City of Philadelphia, Parks and Recreation Historic Archives; Cheryl Leibold, Pennsylvania Academy of the Fine Arts Archives; James Moske, Metropolitan Museum of Art Archives; and Diana Thompson, National Academy of Design Archives. At the Smithsonian American Art Museum Library, I benefited from the kind assistance of Cecilia Chin and Alice Clarke and from the remarkable body of research assembled by Colonel Merl M. Moore Jr.

A number of people assisted with the monumental task of gathering the images that so beautifully illustrate this book. I am especially grateful to Julia M. Baker; Dayna Bealy, New-York Historical Society; Melissa Goldstein, Bridgeman Art Library; Takako Hara, Hudson River Museum; Daniel Lipcan, Metropolitan Museum of Art; Jackie Maman, Art Institute of Chicago; Daniel Starr, Metropolitan Museum of Art; and Laura Stroffolino, Free Library of Philadelphia.

The staff at the Pennsylvania State University Press brought this project to fruition with outstanding expertise and collegiality. Eleanor Goodman's wisdom and support guided this book throughout its development. Laura Reed-Morrisson and Hannah Hebert skillfully managed numerous logistical matters, and Patricia A. Mitchell expertly guided production. Merryl A. Sloane's masterful editing prevented many errors and inconsistencies. The book was beautifully designed by Regina Starace.

Finally, I wish to thank my husband, Brian, whose steadfast support has made this journey not only possible, but a great joy.

POWER AND POSTERITY

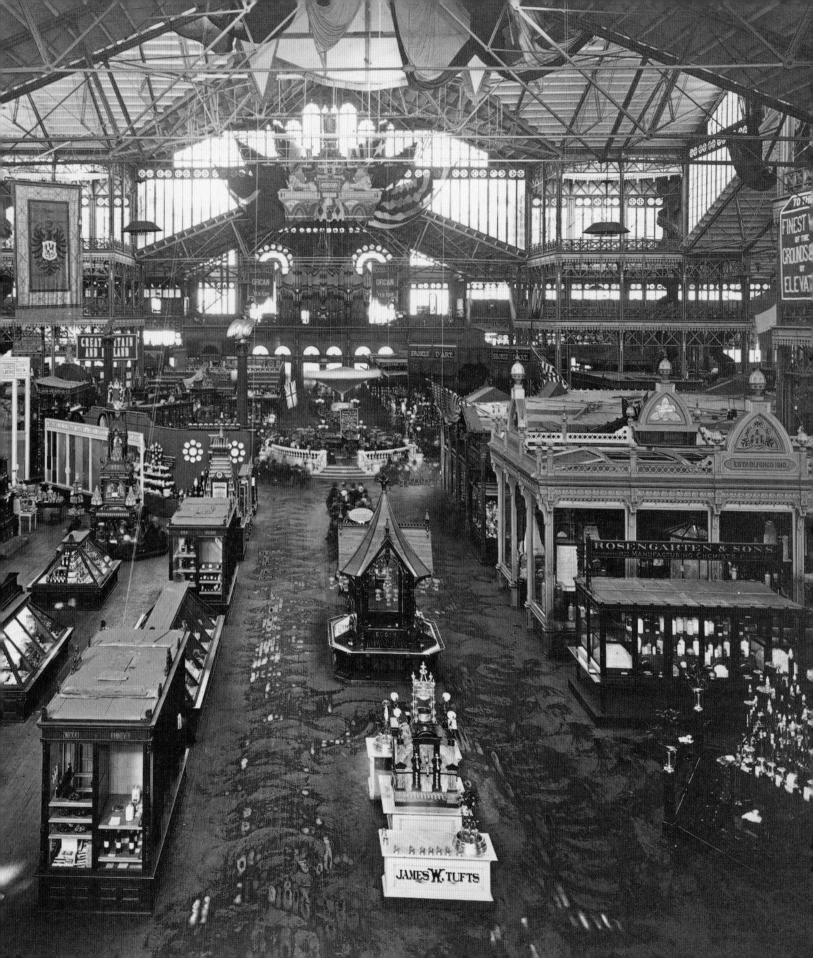

INTRODUCTION

Writing History

A National Reckoning in Fairmount Park

The International Exhibition of Arts, Manufactures, and Products of the Soil and Mine, better known as the Centennial Exhibition, celebrated the hundredth anniversary of the signing of the Declaration of Independence. It was the first world's fair on American soil to reach a genuinely national and international audience, and thirty-six countries were represented. Over six months, almost ten million people attended the exhibition in Philadelphia's Fairmount Park, a number equaling nearly one-fourth of the U.S. population. The fairgrounds covered 236 acres and contained hundreds of exhibits dedicated to American social, industrial, and cultural progress. D. S. Wright's remark quoted at the beginning of this book affirms the fair as the signal cultural event of the author's generation, one that required every American's attention.

On the morning of May 10, 1876, the nation's eyes were on Fairmount Park for the opening of the fair. The official report of the U.S. Centennial Commission describes the stately progress of the opening ceremonies and the dignitaries who graced them. The gates opened at 9:00 A.M., and more than 110,000 people soon thronged the plaza between the Main Building and Memorial Hall, the site of the fine arts display (fig. 1). An orchestra led by famed conductor Theodore Thomas performed the anthems of participating nations. President Ulysses S. Grant, escorted by Pennsylvania governor John F. Hartranft and troops from New York and New Jersey, arrived to the strains of the "American Centennial March," composed for the occasion by Richard Wagner. (Though he was German, his music was very popular in the United States.) Grant was accompanied by the

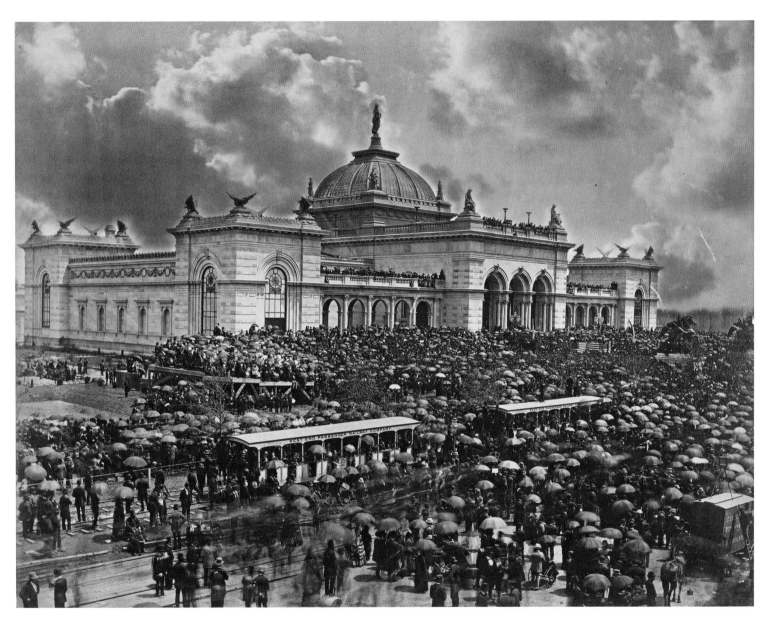

FIGURE I
Centennial Photographic Company (American photographer, nineteenth century), *Opening Day, "The Orators," Centennial International Exhibition of 1876, Philadelphia*, 1876. Silver albumen print. Free Library of Philadelphia.

dashing and ebullient Dom Pedro II, the emperor of Brazil and the first major foreign ruler ever to visit the United States. After a series of grave and fervent speeches, punctuated by American poet John Greenleaf Whittier's "Centennial Hymn," President Grant declared the exhibition open. In a burst of pageantry worthy of the anniversary moment, flags were unfurled, chimes rang, a hundred-gun salute was staged on nearby George's Hill, and a thousand-voice choir broke into Handel's "Hallelujah" chorus. The president and his party progressed to Machinery Hall, where Grant and Dom Pedro started the mammoth Corliss engine (fig. 2) that powered the exhibits in that building and served as the fair's symbol of American industrial progress. Finally, Grant and his guests were escorted to the Judge's Pavilion, where he held a brief public reception.[1]

The foregoing official account reports for posterity the smooth and dignified march of this most auspicious event. However, it is belied by other reports and recollections, which suggest a messier, more complicated morning. The *Philadelphia Evening Bulletin* described how the rain of the previous few days had left the streets and the fairgrounds "in wretched condition"; the mud was ankle-deep in places.[2] The *New-York Times* reported that as soon as the gates opened at 9:00 A.M., crowds thousands strong rushed the reserved seating area on the stage. They overwhelmed the mere ten policemen stationed there, and reinforcements had to be sent in. Only a fraction of the required seats were provided for ticketed guests; the *Times* writer, left without a seat, finagled his way to the top of the Main Building, where he observed the ceremonies from on high. He described the barely manageable crowd and the

FIGURE 2 Centennial Photographic Company (American photographer, nineteenth century), *Corliss Engine, Centennial International Exhibition, Philadelphia, 1876*, 1876. Silver albumen print. Free Library of Philadelphia.

unceremonious arrival of President and Mrs. Grant, who were not initially recognized in the noise and confusion. Despite his vantage point, the reporter missed some other incidents; for example, orator and statesman Frederick Douglass, who was formerly enslaved, was denied his place on the platform by a policeman and was only admitted through the intervention of Senator Roscoe Conkling.[3]

Some of the music and many of the illustrious guests' remarks were lost on the crowd because of the open-air setting. Though some speakers could be heard clearly, others were entirely inaudible, notably the president himself.[4] Had the crowd been able to

hear Grant's speech, they might have been a bit disappointed. His brief address ended on an apologetic note, as he explained that over the previous century, the necessity of subduing the wilderness and building roads, canals, factories, schools, and churches had left the nation little time to develop in areas such as law, medicine, theology, science, literature, philosophy, and the fine arts. He summarized Americans' worries about how their nation's cultural life would measure up in the coming fair when he remarked, "While [we are] proud of what we have done, we regret that we have not done more."[5] Another newspaper article reported on the president's group's transit to the Main Building afterward: "It may be imagined that a procession such as this would be such a brilliant display as is not likely to be seen twice in a life time. But, unfortunately, the most imposing spectacle it presented was upon the printed programme, for directly the eminent ladies and gentlemen composing it descended from their position on the stage they became part of the crowd below and almost disappeared from sight." Further, the president "seemed to think he had enough of public receptions in that short march across the grounds," and Grant declined to attend the gathering afterward.[6]

Other newspaper accounts related moments of earnest patriotism and enthusiasm that were not noted in the official report but create a vivid picture of the day. The vast audience's response to the Right Reverend Matthew Simpson's benediction for the fair and for the nation was called the most devout and attentive since Lincoln's Gettysburg address, with most of the men touching their hats in reverence. When the fair was declared open and the choir sang the "Hallelujah" chorus, the "united multitude" of more than one hundred thousand shouted along with the singers, which must have been a moving spectacle.[7] The varied accounts of the opening ceremonies attest to the broad and spirited interest in the event. Because it was a truly national celebration, the great fair spoke with many voices on the exhibition as a whole and on its art exhibition in particular. These voices sometimes spoke with gravity, and sometimes with levity, but always with passion for the country and for this important anniversary.

This book focuses on just one aspect of a sprawling and complex event. The fairgrounds were composed of five main exhibition buildings and several smaller ones, seventeen state buildings, nine foreign government buildings, and numerous restaurants and refreshment stands.[8] The fine arts exhibit represented a fraction of the total displays and square footage. Yet its location in the fairgrounds and its prominence in written accounts acknowledge the key role it played in the fair's assessment of humanity's handiwork. Nineteenth-century world's fairs were structured as summaries of all the products of the earth and the works of humankind, both physical and cultural. The spectrum ranged from the elemental, such as animal and vegetable products, to the manufactured, such as machinery and furniture, and to the abstract, including systems of education and nonprofit organizations. Conceptually, the fine arts display stood at the point where the physical met the cerebral, and where the real met the ideal. It represented the pinnacle of civilization, making it one of the most closely watched aspects of the show. At the Centennial Exhibition, the fine arts exhibit's advantageous physical placement directly behind the Main Building made it many visitors' natural second

destination.[9] Newspaper accounts acknowledge that it was one of the most-visited displays on the grounds, and the works there were carefully documented and widely discussed.

The fine arts display in Fairmount Park was recognized in its time as the most important exhibition in the United States up to that point. It remains the nation's first blockbuster show and was one of the largest, best-attended, and most hotly contested of the nineteenth century. As the nation's first truly international exhibition of art, it attracted an audience of unprecedented size and diversity. It took place at a pivotal cultural moment, when concerns about American identity and international influences were reaching a critical point, and museums were being built to enshrine artworks, most of them foreign.

The Centennial Exhibition represented a call not merely to bear witness to history, but to interpret it, to recapitulate it, and to write it, raising the question of who would write that history and what verdict would be pronounced upon a nation still nursing the wounds of a devastating Civil War and rocked by the scandals of the previous decade. The world's fair also demanded an accounting of the nation's cultural history. The American art displayed in Fairmount Park was the country's first official, government-sanctioned reckoning of American art. The U.S. art exhibition provided not just an opportunity but a mandate to create a canon of the country's art from the previous century, along with a historical narrative that would join the past to the present and enshrine a national "American School." The exhibition came at a time of unrest in the art world as well, as the nativists of the Hudson River School of landscape painting were challenged by expatriates who studied abroad and

favored figural subjects.[10] The value of the centennial exercise was in the way that it set up a series of high-stakes encounters with art and its constituencies on an unprecedented scale. The exhibition brought to a public forum questions that had been ripening in private circles for some time about nationalism versus internationalism, American connoisseurship, and how to create a past with which Americans could arm themselves for the challenges ahead. The national and global scale of the fair made every exchange an important one, freighted with the weight of a hundred years and the understanding that its impact would resonate across the country and the world. At Memorial Hall, the forces of history and power collided, transforming each facet of the art world and setting the stage for the burgeoning realms of art, museums, and collecting that would mark the decades to come.

The Call to Write History in Fairmount Park

The centennial mandate to create a reckoning of American art defined the exhibition at Fairmount Park, which offered a microcosm of the art world in 1876. Investigating it lays bare the power structures of the postbellum art world and opens up inquiry about the nature of cultural power and authority in late nineteenth-century America. A great deal of power is invested in who writes history and whose narrative endures. Exhibitions, particularly those in sanctioned venues like art museums, are exercises in writing history. If they are successful, visitors leave with a new narrative that changes their understanding of the works on view. The American art display at the

Centennial Exhibition was widely understood to be such an opportunity writ large.

The hundredth anniversary of the nation's birth called for a moment of reckoning in the realms of history, commercial progress, and culture, and it inspired a national self-consciousness about American history. For example, U.S. senator Carl Schurz was asked to write a political history for the celebration, and University of Michigan professor Moses Coit Tyler was annoyed that his history of American literature would not be ready in time for the centennial year. General interest publications formed their own assessments of American progress: *North American Review* presented a series of six articles in its January 1876 issue on the development of fields such as law, economics, science, education, and religion; *Harper's* issued a similar series of eighteen articles from November 1874 through May 1876 that were published in book form as *The First Century of the Republic*; and *Lippincott's* series on the wonders of the Centennial Exhibition, including a keynote article titled "American Progress," became the book *The Century: Its Fruits and Its Festival.* Most significant, each local community was asked to prepare an address tracing its history. These were delivered as part of local July Fourth celebrations and compiled in one volume.[11] The resulting publication, *Our National Centennial Jubilee*, was "a commemorative record of the most brilliant bursts of oratory, inspired by the enthusiasm of the occasion, and . . . a permanent treasure of historic data and valuable statistical information."[12] It included historical addresses from cities across Connecticut, Florida, Kentucky, Massachusetts, New Hampshire, New York, North Carolina, Ohio, Rhode Island, Tennessee and Vermont. As rank-and-file citizens

contemplated their past, a growing cadre of professional historians also honed their craft; for instance, George Bancroft finished writing his monumental *History of the United States* in 1876.

The centennial year was widely considered a turning point in the country's development. Fred Lewis Pattee, known as the first professor of American literature, would later call it the "Second Discovery of America," and Rev. Henry W. Bellows considered it "the close of the first volume of our history" and "the opening of another volume."[13] However, the centennial represented a break with the past based on far more than simply being an anniversary. The hundred-year reckoning was shaped by the transformative impact of the previous years. Writing history was complicated by the need to link the nation's noble and illustrious beginnings, sanctified by time and glorious memories, to the less distinguished deeds of the current generation. Accounts of the great exhibition glowed with the fervor of celebration and commemoration, but the shine was somewhat tarnished by recent events. Industrialization, urbanization, and incorporation had wrought cataclysmic changes in the decade after the Civil War. The integrity of the country's leaders was called into question, along with the religious values that were credited as America's foundation. Ironically, it was an Englishman, scientist Thomas Henry Huxley, who posed the question often quoted to sum up the uncertainties of that year: "I cannot say that I am in the slightest degree impressed by your bigness, or your material resources, as such. Size is not grandeur, and territory does not make a nation. The great issue, about which hangs a true sublimity, and the terror of overhanging fate, is what are you going to do with all

these things? What is to be the end to which these are to be the means?"[14] Huxley's question embodied the country's almost horrifying awareness of its barely governable power, combined with the uncertainty of its future in the face of great changes.

The impact of the Civil War was still being keenly felt, and the Centennial Exhibition was intended as an occasion to heal the breach between the North and South and present a united nation to the world. The war was referenced constantly in the planning stages and in the ceremonies surrounding the exhibition. The *New York Herald* quoted President Ulysses S. Grant's hopeful remark to General Robert E. Lee that "the animosities which attended the war" were "dying out," and "we shall soon celebrate their funeral in the centenary."[15] A writer for the *Atlantic Monthly* observed the flags lining the streets of Philadelphia during the fair and rejoiced that although "the last time the waving of those colors brightened the air, it meant war and woe; now it means peace and exultation," but he added somberly, "how much lies in between!"[16]

Reconstruction had almost run its course, but in 1876 Florida, Louisiana, and South Carolina were still under federal military control.[17] The South had been left behind economically, as large farms in the Midwest and manufacturing concerns in the East eclipsed its small-scale agrarian economy. In the late 1870s, per capita wealth in the South was half the national average.[18] Though the reunion of the North and South was a major focus of the centennial, the Southern states had little voice or participation in the proceedings.

The centennial summer saw wave after wave of political scandals and setbacks. News trickled in of Lieutenant Colonel George Armstrong Custer's loss on June 25 against the Sioux and other native tribes at Little Bighorn; on July 4, nine days after the battle, word had still not reached Philadelphia. Secretary of War William W. Belknap was impeached under suspicion of accepting bribes and soon resigned, though his trial ended in July with an acquittal.[19] The budding labor movement became a serious concern in 1876 with the suppression of striking coal miners known as the Molly Maguires.[20] The tensions that simmered throughout the centennial year exploded soon after with the Great Railway Strike of 1877, the first nationwide clash between labor and management.[21]

Despite the genuine patriotism and joy that the Centennial Exhibition inspired, the triumphal march of the past was difficult to reconcile with the stumbles of recent years. The great world's fair opened against a background of cynicism and disillusionment, embodied in *The Gilded Age*, Mark Twain and Charles Dudley Warner's scathing 1873 critique of endemic greed and political corruption. It told a tale of land speculators attempting to manipulate governmental systems in the hopes of "making a killing." The authors explained in the foreword to the London edition, "In America nearly every man has his dream, his pet scheme, whereby he is to advance himself socially or pecuniarily. It is this all-pervading speculativeness which we have tried to illustrate in *The Gilded Age*, particularly the shameful corruption which lately crept into our politics."[22] At one point in the story, the savvy president of the Columbus River Slack-Water Navigation Company has to explain to the naïve would-be entrepreneur Henry Brierly that the $200,000 congressional appropriation that he thought would assure their project's success had to

be spent on lobbyists and bribes to congressmen so that they could secure an even larger appropriation.[23] Twain and Warner included elements of recent scandals that they knew their readers would recognize: the trial of William M. "Boss" Tweed in New York for graft, the Credit Mobilier fraud (which contributed to the Panic of 1873 and the ensuing economic depression), and Kansas senator Samuel Pomeroy's efforts to buy his reelection.[24]

Twain and Warner's literary indictment was echoed even in the literature around the Centennial Exhibition, hinting at the disturbing realities beneath the veneer of celebration. The book *Young America at the Centennial* described a family exploring the fair and learning about the nation's history and about its imperfections. In spite of the patriotic feelings that the great exhibition inspired, one of the sons asked:

> "But I heard some men talking out there as if we had something to be ashamed of; what is it, papa?"
>
> "I suppose they were talking about our great American fault—our love of money; for that has brought trouble and disgrace upon our country; and all good people have felt like hanging their heads in shame at the terrible doings of men in power."[25]

The hundred-year-anniversary call to examine the nation's history raised questions about how history is written and why. In the eighteenth and early nineteenth centuries, patrician men of wealth and leisure wrote American histories following what has been termed the "great man" model, glorifying the virtues and ambitions of the illustrious figures who propelled wars and governments.[26] The eminent Boston historian Francis Parkman took this approach in his works beginning in the mid-nineteenth century and continuing to his 1865 book, *France and England in North America.* His chapters were organized around the lives and deeds of key figures, and his introduction spoke of how some "men, lost elsewhere in the crowd, stand forth as agents of Destiny. In their toils, their sufferings, their conflicts, momentous questions were at stake, and issues vital to the future world."[27] Charles Francis Adams had criticized the tendency in 1831: "We are fond of celebrating the virtues of our forefathers. . . . Yet it is much to be feared, that this is not the right way to come at that real history, and those cool and rational conclusions which can alone be supposed likely to confer permanent benefit."[28]

Around the mid-nineteenth century, accounts of U.S. history began to move away from the lives of "great men" and toward coherent, integrated narratives that framed history as an ascent to ever-higher levels of achievement.[29] Many historians of the United States during the antebellum period are characterized as "romantic" in their uncritically patriotic and celebratory narratives of the country's growth. George Bancroft's sweeping *History of the United States* is a classic example; it filled ten volumes and was published over the course of thirty years. Bancroft's career spanned more than a half century, and he was warmly embraced as a long-awaited national historian who, according to modern scholars, "told the American people what they wished to hear about their past."[30]

The mythos of American advancement reached its zenith at the Centennial Exhibition, which one modern scholar characterized as an "affirmation of the nineteenth century's boundless faith in

progress."[31] An act of Congress required the managers of the Centennial Exhibition to present full reports of their results, and the *New-York Tribune* suggested several topics to make the lessons of the exhibition available to current and future generations, including the "advancement of artistic culture and . . . the appreciation of art products."[32] It was hoped that gathering accounts of all the centennial exhibits, and the art display in particular, would produce a synthesis that would improve the general understanding of the country's development.

The glorification of American advancement is also evidenced by the privately produced histories and guides sold at the exhibition. In keeping with the mercantile nature of world's fairs, many authors surveyed the past by means of commercial statistics and concluded their accounts with a guide to the Centennial Exhibition as a visual embodiment of American progress. Benson John Lossing's *The American Centenary* claimed to tell "a history of the progress of the republic of the United States during the first 100 years of its existence." He traced the development of commercial products and industries in chapters such as "The Uses Made of Swine," "Pins and Hooks and Eyes," and "Fire Insurance."[33] In like manner, Sylvester W. Burley's *American Enterprise: Burley's United States Centennial Gazetteer and Guide, 1876* bears the subtitle "Sketches of Progress During the Past Century in Arts, Manufactures, Literature, Education, Inventions, Railroad Facilities and Steam Navigation, etc. and Articles on the Press, Government and Laws, and Other Matters of Interest to Both Citizens and Visitors from Foreign Countries."[34]

This apotheosis of American progress was also affirmed by the lampoons that it inspired. In *One Hundred Years a Republic: Our Show*, David Solis Cohen gave his own account of American history, skewering civic pride, divine sanction, and Yankee thrift. He began with Columbus: Queen Isabella gave him "command of the steamer 'Mayflower,' with permission to row out and see what he could find. He landed at Plymouth Rock [and] discovered the city of Boston, first, by special request." Cohen continued by mixing biblical stories with prerevolutionary tensions: "George III of England commanded that all the male children born in the Colonies should be cast into the Atlantic ocean." Even the Liberty Bell was not exempt from his wit: "They practiced economy in those brave days, and bought a cracked one, because they got it at half price."[35]

The need for a narrative affirming American progress was a collective manifestation of the basic human drive to make meaning of one's life experience; this spurs individuals to remember some events and forget others. Historian David Lowenthal has pointed out that people sometimes recall things differently from the way that they actually happened, and they continually reorganize memories to conform to the ideas of the moment.[36] The strong pull toward a coherent personal narrative is writ large in the selection and shaping of events, which characterizes the writing of history. Since it is impossible to include every occurrence in a historical account, some things are not included, and therefore forgotten, while others are highlighted and take on great significance. Even in the present day, when the canon has steadily expanded to include heretofore neglected people and stories, and new recording capabilities offer the possibility of continuously capturing events in more and more places, the incorporation of the accumulated

data is limited by the human ability to analyze and process the information. Modern philosopher Paul Ricoeur concludes that "an exhaustive narrative is a performatively impossible idea."[37] Along with the outpouring of local histories, statistical analyses, and personal reflections in the centennial year came the need for selection—and the inherent biases that accompany it.[38]

The changing relationship between memory and history was entangled in the centennial exercise. Accounts of people and events progressed from eyewitness reports and archival materials, to attempts at analysis and explanation, to the professional historian's representation of the past.[39] Americans had begun collecting documents and materials from the country's early period just a few years after its formation. However, collective memory was a stronger force in citizens' popular understanding of their heritage.[40] Ricoeur pithily points out, "one does not remember alone," and he recognizes average citizens as an important party in the creation of historical narrative, bringing their store of experiences to bear on assessing whether received histories resonate with their personal knowledge.[41] From the nation's early days through the antebellum period, most Americans learned their country's history from the recollections of their forebears, and some legends and traditions of long standing took on the venerable aura of history by virtue of their endurance.[42] A portion of mainstream collective consciousness was often formed by lesser and sometimes even spurious intellectuals who transmitted history through artworks, the classroom, and the pulpit.[43] The Centennial Exhibition marked the apex of Americans' collective memory.[44] It was the largest shared event in the nation's history to

date, and it held out the hope of creating a communal experience that would heal America's wounds.

Creating a coherent understanding of recent U.S. history was perhaps the most difficult task of all, and the selection of past events was guided by the needs of the present. In his study of American historiography, Michael Kammen called on Bronislaw Malinowski's famous definition of myth "a story about the past which has the function of justifying the present and thereby contributing to social stability."[45] Earlier events had receded from the realm of personal experience and taken on the benevolent glow of legend, but for Americans in 1876, the call to write history was also the call to face painful shared memories of the nation's recent past. Americans sorely needed reassurance that treasured national values remained intact and that a reunified nation could move confidently into a larger, more complicated modern world. The Centennial Exhibition was presented as a break between the past and the future, a moment to put the lingering effects of a divisive war to rest and embrace the country's new role in the international community. To attend was to participate in that exercise and (at least outwardly) agree to relegate the recent past to history.

The Power to Write History in Memorial Hall

The centennial moment also resonated with the mandate to write a history of U.S. art and to create a cultural narrative that would enshrine the chosen artists of 1876. But who would, or could, write that history? The call to form and display an American art narrative and a canon of its current efforts raised a

number of crucial questions: Who had the authority to choose and assemble a summary of the country's cultural life? How might they address the issues that defined its history—for example, the delicate balance between national identity and the influence of acclaimed international styles? How would the resulting exhibition be understood by visitors, not only the critics and intellectuals who usually attended art exhibitions, but the millions coming from all over the country, many of whom would see fine art for the first time? And how would the display be impacted by the forces of the burgeoning international art market?

Just as important as the message the U.S. fine arts exhibition conveyed was how it would be assembled. Who would conceive and organize the exhibition? Which artists' work would be included? And in an era when great metropolitan museums were only in their infancy, where would the artworks be found? The ambitious plan for an unprecedented survey of the nation's artistic heritage required the involvement of all art-world constituencies. Each brought its own interests and internal conflicts, and each played its role in shaping the exhibition and the reception of American art in Fairmount Park. Artists, critics, visitors, dealers, and collectors vied for the power to define American art and write its history in the centennial year. The story of creating and analyzing the exhibition is the story of the art world in 1876 and its power structures.

In the months before the fair's opening, publications across the nation closely tracked the preparations in Fairmount Park. Even the decorous *Art Journal* joined the centennial boosterism, describing the rise of "a new city on the banks of the Schuylkill" (fig. 3).[46] Readers were bombarded with

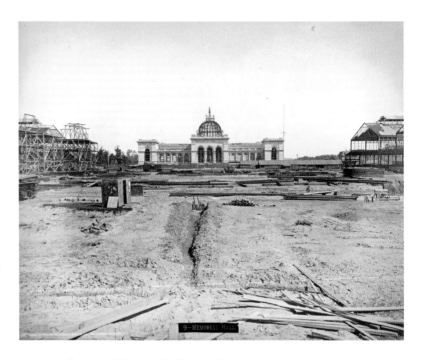

FIGURE 3 Centennial Photographic Company (American photographer, nineteenth century), *Memorial Hall Building Site, Centennial International Exhibition of 1876, Philadelphia*, 1876. Silver albumen print. Free Library of Philadelphia.

statistics on the astonishing size and scope of the preparations: more than 200,000 cubic yards of earth were moved to grade the land; 300,000 cubic yards were excavated to create a chain of ornamental lakes; and twenty miles of streets, sidewalks, and railroads were installed.[47] There were 190 buildings dotting 236 acres of land, of which 75 acres were "under roof."[48] The *Art Journal* boasted that the Centennial Exhibition would be the largest world's fair ever, far exceeding its most recent rival, the 1873 Vienna Universal Exposition, which only covered 50 acres.[49] One of the most-discussed buildings erected in Fairmount Park was Memorial Hall, which would

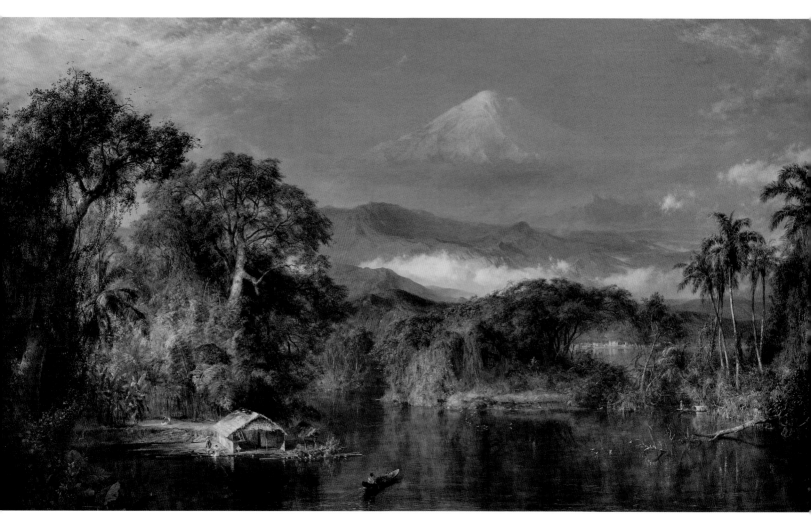

FIGURE 4 Frederic E. Church (American, 1826–1900), *Chimborazo*,
1864. Oil on canvas, 48 × 84 in. (121.9 × 213.4 cm). © Courtesy of the
Huntington Art Collections.

house the art exhibition. Americans recognized the Centennial Exhibition as a signal moment in the country's cultural history. In 1876, art critic Philip Quilibet called it "the first general muster for inspection ever attempted by American art."[50] Like the nation as a whole, the art world was at a crossroads, as artists, patrons, galleries, museums, critics, and the viewing public faced challenges from within and without. In the post–Civil War period, the nation was flexing its muscles politically, commercially, and culturally, and the art world too stood on the cusp of maturity. For the first time, all the players that form the basis of today's art power structure had taken the stage. The task of organizing the American art exhibition set off a struggle to define the nature of American art and to present its history that reverberated throughout the late nineteenth-century art world.

The great task of discerning and displaying a contemporary American School came at a time that the critic Clarence Cook called "an era of revolution."[51] The mid-1870s were marked by heated debates between two groups of artists and their advocates: the New York–based nativists of the Hudson River School of landscape painting, represented by artists such as Albert Bierstadt, Frederic Church (fig. 4), Asher B. Durand, Sanford Gifford, John F. Kensett, and Worthington Whittredge; and the cosmopolitan expatriates advocated by younger New York artists and those from other cities, such as John Sartain and Thomas Eakins in Philadelphia and the Barbizon-influenced painter William Morris Hunt and his circle in Boston. The latter group supported artists who studied and worked abroad, most often in Munich and Paris, and who took the human figure

as their principal subject, including the orientalist Charles Sprague Pearce (fig. 5).[52]

Early in the nineteenth century, artists in New York and Philadelphia had banded together to form their own academies to create opportunities for education and exhibition. By 1876, both institutions, the National Academy of Design in New York and the Pennsylvania Academy of the Fine Arts in Philadelphia, had matured into powerful organizations: the National Academy of Design had inaugurated its new building in 1865, and the Pennsylvania Academy of the Fine Arts would open its new home during the centennial summer. However, both faced tensions that would erupt most intensely and most publicly at the U.S. exhibition in Fairmount Park. The National Academy of Design had been challenged in 1875 when it had temporarily closed its school under financial duress; in response, a group of disgruntled young aspirants formed the Art Students League to organize their own classes.[53] Tension boiled over again the following year, when younger foreign-trained artists seceded from the National Academy of Design to form the Society of American Artists in response to the academy's perceived bias against artists studying and working abroad. These two camps competed fiercely for the opportunity to determine who would represent the American School at the Centennial Exhibition and, in so doing, inherit the mantle of history. Their conflict was focused in Philadelphia's Fairmount Park, but the Centennial Exhibition's national scope and the breadth of media coverage gave their dispute a significance that reached far beyond Philadelphia to the nation's principal cities and subsequently the entire country.

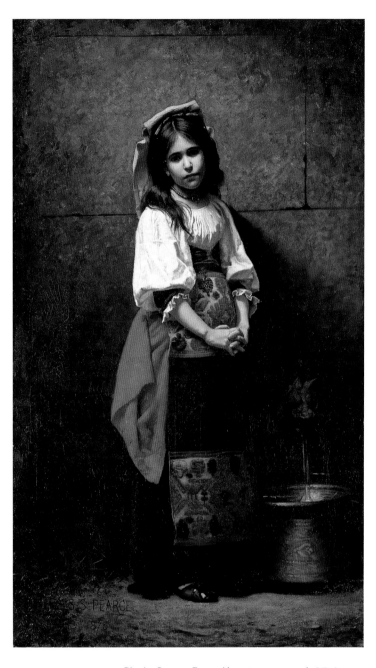

FIGURE 5 Charles Sprague Pearce (American, 1851–1914), *L'Italienne (At the Fountain)*, 1875. Oil on canvas. Private collection.

In addition to the growing antagonism between nativist and expatriate artists, the exhibition organizers faced the task of melding their disparate civic identities into a comprehensive vision of American art. Their work was complicated by the United States' character as a nation of proudly distinct cities. Up to this point, the country was a society of "island communities," isolated localities with little communication among them. However, the post–Civil War period was, in historian Alan Trachtenberg's words, "dominated by an increasingly standardized national way of life," as an "official breed of culture" was disseminated throughout the country from the eastern seaboard.[54] The quest to enshrine an American School of art for the entire country evidenced this nationalizing impulse.

At the same time, the leaders of the Centennial Exhibition's Fine Arts Department were well aware that the patronage of civic and business leaders was crucial to the country's cultural advancement. Newly wealthy Americans had been acquiring art on an unprecedented scale in the years following the Civil War.[55] In New York, August Belmont and John Taylor Johnston purchased works by both American and European artists. The *Atlantic Monthly* observed that even in conservative Philadelphia, art collecting had picked up after the war, and well-to-do citizens began building houses with picture galleries.[56] William Morris Hunt introduced Boston elites to Jean-François Millet and the French Barbizon style, and they enthusiastically purchased such works from both French and American artists.[57] Farther afield, great collections were being formed by T. O. Walker of Minneapolis and E. B. Crocker of Sacramento.[58]

The Centennial Exhibition also presented another challenge. The art exhibition in Memorial Hall and the nearby Art Annex would include fine arts displays from the United States, Great Britain, France, Spain, Italy, Germany, Japan, Mexico, Australia, Brazil, and Russia, among others, that would be seen and compared side by side. Travel to Europe had skyrocketed after the Civil War, and as the journey became more comfortable and less expensive, the travelers developed a greater familiarity with European culture from their "grand tours," which usually included England, France, Italy, and sometimes Switzerland, Germany, and the Low Countries. The exhibition would be the first time that a large number of American works were displayed in the United States in a truly international context. The U.S. Art Department would showcase the country's artistic taste to both American and European audiences and would face either their approbation or their scorn during a period when artists and collectors turned increasingly to French and German ideals.

Americans were anxious to show their good taste at the centennial, and questions of taste were discussed with great seriousness. As New York's Metropolitan Museum of Art, the Museum of Fine Arts in Boston, and the Corcoran Gallery in Washington, D.C. opened their doors with an exclusive dedication to the highest forms of art, intellectuals were just as concerned about how American visitors to Memorial Hall would demonstrate their sophistication as they were about its artists. As *Scribner's Monthly* pointed out, "All the West is coming East" for the fair, and "the nation is to be brought together as it has never been brought before."[59] Writers expressed their worries about the public's behavior in the galleries, since so many Americans had little knowledge of art and none about how to comport themselves upon encountering it.

Changes to the American art world were accompanied by changes to the dynamics among its constituencies—plainly put, to their power. The term "power" can be understood in a number of ways, most of them with sinister connotations. At first glance, the term suggests crass and grasping ambition, marked by dirty dealings between warring factions. Undeniably, the pursuit and exercise of power can bring out the worst in people, hence the quote sometimes attributed to Abraham Lincoln: "Nearly all men can stand adversity. If you want to test a man's character, give him power." However, the pursuit of power is not exclusively about the urge to dominate; it can also be understood as the natural inclination of people and organizations. In the case of the art world, committed artists passionately desire to have their works seen and understood; critics strive to have their voices heard and their points of view widely read; devoted collectors spend fortunes and travel to the ends of the earth to secure the works that they love; and exhibiting institutions are formed to make some of humanity's greatest achievements available to everyone.

Numerous essays and books have been written on the nature of power. Proposed definitions include the ability of agents to change or to control specified objects.[60] All refer to the capacity for creating change, but for many scholars, it is the capacity to impose sanctions that characterizes power.[61] Some focus on domination of the other, that is, "power over," while others see it as the ability to affect

behavior more generally, that is, "power to." Some prominent scholars concentrate on power in its extremes, when it is punitive in nature and concentrated in one person or institution against the relatively helpless, for example, a warden in a prison or a tyrant over his people in an oppressive regime.[62] Such constructs might apply to the European art world of previous eras; for hundreds of years Europe was dominated by a few major patrons who could decide an artist's fate, such as the church, the king, or an excessively wealthy individual. However, theories that concentrate on such lopsided dynamics do not apply to most nineteenth-century Americans. Then as now, most art dealings were among parties that held varying degrees of ability, influence, and agency, which amounted to more of an ongoing negotiation than simple domination. By the late nineteenth century, the East Coast art community in the United States had grown in size, specialization, professionalization, and sophistication. It had become a complex interactive community of agents poised at the edge of the modern world. This type of power was defined by interdependent relationships that held a mix of punishments and rewards—and a large measure of persuasion.[63]

Similar questions of power and narrative dominate discussions about art today. Unlike other art forms, such as music or literature, visual artworks can be privately owned, and their access can be restricted, whether by the nature of their current home (be it museum or private collector) or by sales that move them from one owner to another. Art world observers question the impact of collectors' purchases at fashionable, high-impact, gallery-dominated art fairs, where sales for staggering sums can make an artist's

reputation. Yet we are just as skeptical about the choices and the resulting narratives formed at noncommercial biennials, because we are acutely aware of the curatorial efforts that shape what we see. We decry museums deaccessioning key works of art, and passionate discussion rings out from online forums. The outrage expressed in those conversations is fueled in part by a sense of impotence, because we understand that usually only the owner can legally guide the artwork's fate, and the other concerned parties can only express their disapproval and wait on the sidelines.

These questions about power are rarely raised in relation to art or exhibitions of the past. Yet they were just as important to shaping works of art and exhibitions then as they are now—and possibly even more so in 1876, when fewer venues for display and sales concentrated greater authority in fewer hands. When examining the nation's cultural history, perhaps the most important question after the seminal query "What's American about American art?" should be "Who's in charge here?" The study of the nation's artistic development has flowered since the mid-twentieth century, but there is still a need for close readings of exhibitions as well as in-depth studies of the power dynamics behind them and the influence exercised by various players in the art world.[64] Individual studies have examined the basic facts about specific collectors, critics, artist organizations, and museums. However, scholars have yet to delve deeply into these stakeholders' pursuit of influence and their efforts to shape events and, more important, to shape *accounts* of events in order to align official histories with their particular visions of the art world.

To trace the development of power among different art world groups, we must define the terms of the discussion. How do we talk about power? How do we describe and measure it? Even if some theories about the nature of power do not resonate with the situation under discussion, surveying them yields a number of questions that can help define the conversation and shape the inquiry. As we approach each group and its involvement in the fine arts displays at the Centennial Exhibition, we might ask: Where does power lie? What is its source? How is it sanctioned? What is its scope? What resources are at its disposal? How is it distributed—is it exercised directly, via an organization, or is there influence behind the scenes? Further, we should ask, the power to do what? Who can affect or control whom, and how—by punishment, reward, persuasion? Finally, what are the desired goals? What are the effects of the exercise of power?[65]

While some theories of power cannot be applied to the complexities of the art world, a few specialized studies provide useful models for tracing its dynamics, and they inform my approach to each group under consideration. Sociologist Pierre Bourdieu has offered a nuanced understanding of the nature of power in his studies of the art world. Bourdieu's theory posited a "field of cultural production," a structured space with its own laws of functioning and its own relations of force. Each element can be understood in terms of its relationship to other elements, and all compete to control the field's particular interests and resources. Bourdieu considered not only the artworks but their producers and their position in relation to others who legitimize and respond to works of art, such as critics, galleries, and the public. He also incorporated what

he called the "habitus": the set of dispositions and assumptions that generates common practices in the art world.[66]

The call for a canon of American art of the past and present at the Centennial Exhibition initiated a struggle among and within art world constituencies. As Bourdieu pointed out, the canon becomes a site of struggle that creates changes in the field, as different groups argue for shaping it along lines that favor their interests.[67] This type of change usually comes about gradually, but the occasion of the Centennial Exhibition and the urgent, nationwide expectation of an American art display forced an accelerated conversation among art-world groups that resulted in a more sophisticated, professionalized, and international community.

Sociologist Howard Becker's landmark study *Art Worlds* delineated the various agents that constitute an art community and studied their relationships to one another. He called an art world "the network of people whose cooperative activity, organized via their joint knowledge of conventional means of doing things, produces the kind of artworks that art world is noted for." He examined not merely artworks but their systems of production and circulation as well. He also considered them "joint products of all the people who cooperate via an art world's characteristic conventions to bring works . . . into existence." Of course he recognized that this shared activity is not always harmonious. As art world functions become more specialized and as professional groups such as critics, collectors, and dealers take on more specific tasks, their interests can diverge significantly from each other's and from the artist's.[68] His model not only includes different types of agents relating to one

another but also implies a narrative, a hypothetical journey that worthy artworks make through that world: the artist produces a work and exhibits it, the public views it, critics assess it, a dealer offers it for sale, a collector buys it, and eventually it is given to or purchased by a museum, enshrining it in the canon.

In the early nineteenth century, the art world was united by an understanding that the nation's art was still in its rough beginnings and needed the full and unqualified support of critics, collectors, dealers, and the U.S. government. Critics generally responded with praise for any American effort, and collectors patriotically purchased American creations to encourage native artists. Dealers, however few, who offered American works for sale were singled out for praise, while orators fulminated against the government for its lack of support for the nation's cultural progress. At the Centennial Exhibition, this tacit agreement was tested by a call for a reckoning of American progress and by an accompanying comparison with the art of Europe, through productions by both Europeans and Americans abroad. Even more challenging, the task required collaboration not only among different agents but also among different cities in an unprecedented effort that was expected to involve and embrace the entire nation.

Revisiting Fairmount Park

The Centennial Exhibition is one of the most thoroughly documented events of the nineteenth century in the United States, and as a national event, reports and commentary were widely disseminated. The story of the fine arts exhibition is told in this book through a variety of contemporary sources that encompass the range of the constituencies involved. These diverse voices articulate the concerns, attitudes, and goals of various art-world groups as they prepared, experienced, and tried to understand the fine arts display, sometimes in the context of the American art world, sometimes in the context of the entire fair. As might be expected, this book draws largely from the records of the works of art that were on view in the fine arts displays at Fairmount Park and from the bounty of published criticism in newspapers and art journals. I also take a page from the New Historicist school of literary criticism in highlighting the importance of contemporary accounts from many points of view. New Historicism acknowledges the value of both literary and nonliterary texts, and the Centennial Exhibition is a particularly rich vein to mine, with a wonderfully varied and intriguing range of texts. The Centennial Exhibition's wide audience called for an investigation of general interest periodicals and the many guidebooks and commentaries that touched on all aspects of the exhibition. The centennial moment was embedded in American life and popular culture, so perceptions of the event were also shaped by cartoons, songs, and poems. Letters, personal reminiscences, photographs, and even contemporary appropriations of records and recollections have provided important clues.

World's fairs attempt to create meaning on a massive scale, largely through the mediums of raw materials and manufactured products. Similarly, art exhibitions use paintings and sculpture as building blocks that add layers of meaning and (hopefully) enrich each artist's original intent. Writing about an exhibition involves analyzing groups of works, their

cumulative significance, and the new meanings that are created by their coming together; a close reading of an exhibition requires a consideration of the whole without neglecting individual works. Most important, it must move beyond the two dimensions of the image on the page and even the three dimensions of the art object's physical reality to the experience of an exhibition, which incorporates not just space but also time and the senses. This discussion studies the forces of history and power through the lens of my experiences as a curator, and it emphasizes the realities of the museum experience and the art market that have shaped our understanding of historical art, whether we realize it or not.

Many twentieth- and twenty-first-century studies of world's fairs, following the example of Robert Rydell's foundational text, *All the World's a Fair*, approach them as exercises in legitimation, with the organizing governments purposefully shaping their structure to affirm national values and ideals, which have included white supremacy and "scientific racism."[69] That approach is less applicable to the fine arts display at the Centennial Exhibition, which was strikingly *not* shaped by government organizers. In fact, the events surrounding its formation were spurred by the vacuum of leadership that government neglect created.

My inquiry is limited to the paintings and sculptures in Memorial Hall and the Art Annex, buildings dedicated exclusively to fine art. I bow not only to limitations of space but, more important, to the sharp lines that the organizers drew between various media in 1876. Painting and sculpture were firmly placed at the pinnacle of the art hierarchy. They were segregated from engraving, lithography, and photography both in the galleries and in critical accounts.[70] Although the medium of watercolor was growing in importance, I do not address it in this book. There were two galleries of watercolors in Memorial Hall, and they received their share of critical acclaim. However, the selection was not representative of American art at the time. Most of the artworks were from a mass submission by New York's American Society of Painters in Water Colors, and the only prize for American watercolorists was a collective award for that organization.[71]

Though furniture and decorative objects are now the subject of scholarly study and rightly merit consideration as works of art, they were not classified among the fine arts at the Centennial Exhibition. The Main Building, considered the preserve of commercial objects, included vast displays of silver, furniture, textiles, cabinetry, glass, and terra-cotta wares (fig. 6). Those commercial exhibitors, including familiar names such as Tiffany, Gorham, Reed and Barton, and Doulton and Company, had no interest in displaying examples of decorative arts from the past.[72] In keeping with the fair's overriding goal to affirm American progress, and the exhibitors' natural wish to show their prowess and boost their sales, they brought their latest, most modern products.[73]

Each of the chapters in this book focuses on the role played by a particular constituency and its pursuit of power in the exercise of creating, visiting, interpreting, and even rivaling a history of American art in Memorial Hall and the Art Annex. The chapters are arranged in pairs that investigate the parallel issues and dualisms that these groups encountered. Each chapter includes texts that represent the group in focus, including, letters from artists, reviews from

FIGURE 6 Centennial Photographic Company (American photographer, nineteenth century), *Main Building, Centennial International Exhibition of 1876, Philadelphia*, 1876. Silver albumen print. Free Library of Philadelphia.

critics, and recollections of the fine arts display from members of the general public. Some accounts are marked by personal bias, some are interpretations of official material, and some are presented as if they were firsthand records when they were in fact based on information provided by others. Some are based on nothing at all. Others employ literary forms, such as plays and historical fiction, which indicate the great fair's hold on the national imagination. These writings show the range of voices clamoring

POWER AND POSTERITY

to tell the story of American art at the Centennial Exhibition, and they underscore the profound interest in the fine arts exhibits that gripped not only art-world elites but all Americans.

Chapters 1 and 2 concentrate on the artists who organized and participated in the exhibition and their bitter disputes, intensified by civic rivalries, over questions of nationalism and internationalism. Chapters 3 and 4 address the responses of the general public and of highly informed professional commentators, as the millions seeing fine art for the first time were countered by art critics just entering a period of increased cultural authority. Chapters 5 and 6 examine the dialogue between buyers and sellers, as American collectors confronted the European art establishment in an East Coast showdown that confirmed their growing influence on nascent American museums. The conclusion recounts the organizers' attempt to revise the fair's legacy and traces the Centennial Exhibition's impact on the American art world.

My own first experience of Memorial Hall took place 128 years after the centennial. I visited the building in 2004, when it served as offices for the Fairmount Park Commission. It had been put to many uses since the centennial. It had been the home of the Pennsylvania Museum, which evolved into the Philadelphia Museum of Art and moved to its current location in 1928. Since 1954, Memorial Hall had been under the aegis of the Fairmount Park Commission, and some areas had undergone renovations as its function evolved, including the installation of a pool and basketball courts when it served as a community center and of holding cells when it was a police station.[74] It had suffered some structural damage and loss of

architectural detail from leakage, but the entrance and rotunda retained their magnificent architectural detail, and the marble mosaics in the floor remained, even if their splendor was dimmed by dust and grime. The galleries that had echoed with the voices of millions who planned, saw, and commented on the exhibition were all but silent, in keeping with the neglect the 1876 exhibition had suffered among scholars.

On the lower level was an astonishing monument to the fair that affirmed its enduring importance. A basement room was dominated by a thirty-foot-diameter model of the Centennial Exhibition constructed at a scale of 1:192 (fig. 7). It was created and funded by John Baird, a member of the Centennial Board of Finance. The model was designed by a team of several draftsmen and constructed by skilled craftspeople over more than a year. Made from wood, marble, metal, and ivory, it is topographically accurate and populated by replicas of the buildings that are exact in scale and color. Baird presented it as a gift to the city of Philadelphia in 1890, and it was transferred to Memorial Hall eleven years later. Visitors then and now marvel at the detail in the trees, the color and ornament of the buildings, and the mind-boggling sense of scale that they hint at. In three dimensions, it is clear that Memorial Hall was not the largest building by any means, but it stands out in its stately grandeur and sense of permanence, which speaks to the planners' intentions for the building to be a long-term monument and future museum. Commenting on his work more than a decade after the exhibition closed, Baird maintained, "It would hardly be worth while to go to so much expense as was involved in the construction

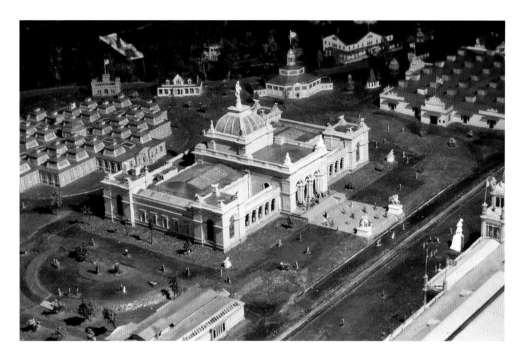

FIGURE 7 *Model of the Centennial Exhibition of 1876*, 1889.

of this model . . . if [it] did not stand for something more than a mere exhibition or World's Fair. The Centennial marked the entrance of a great free nation on a second century of beneficent life; it gave a mighty impulse to its arts and industries, and it is partly to keep fresh in memory this important agency in the nation's advancement that this model has been prepared."[75]

Memorial Hall's state in 2004 testified to the changing fortunes of the fair's reputation over the twentieth century. The representation of American art at other late nineteenth- and early twentieth-century world's fairs, such as the 1867, 1889, and 1900 Expositions universelles in Paris, the 1893 World's Columbian Exposition in Chicago, and the 1915 Panama-Pacific International Exposition in San Francisco, have been the subject of thorough scholarly study.[76] In comparison, the American art display at the 1876 Centennial Exhibition has been neglected.[77] But despite the minor depredations of time and neglect, Memorial Hall's core remains intact and retains hints of its former luster. Similarly, many of the reminiscences and commentaries on the exhibition, one of the broadest and most thoroughly documented events in American cultural history, remain. In a time when the power relations of the art world are on daily display, lively reflections from 1876 beckon us to consider the tales they have to tell about how and by whom the Centennial Exhibition's accounting of American art was written.

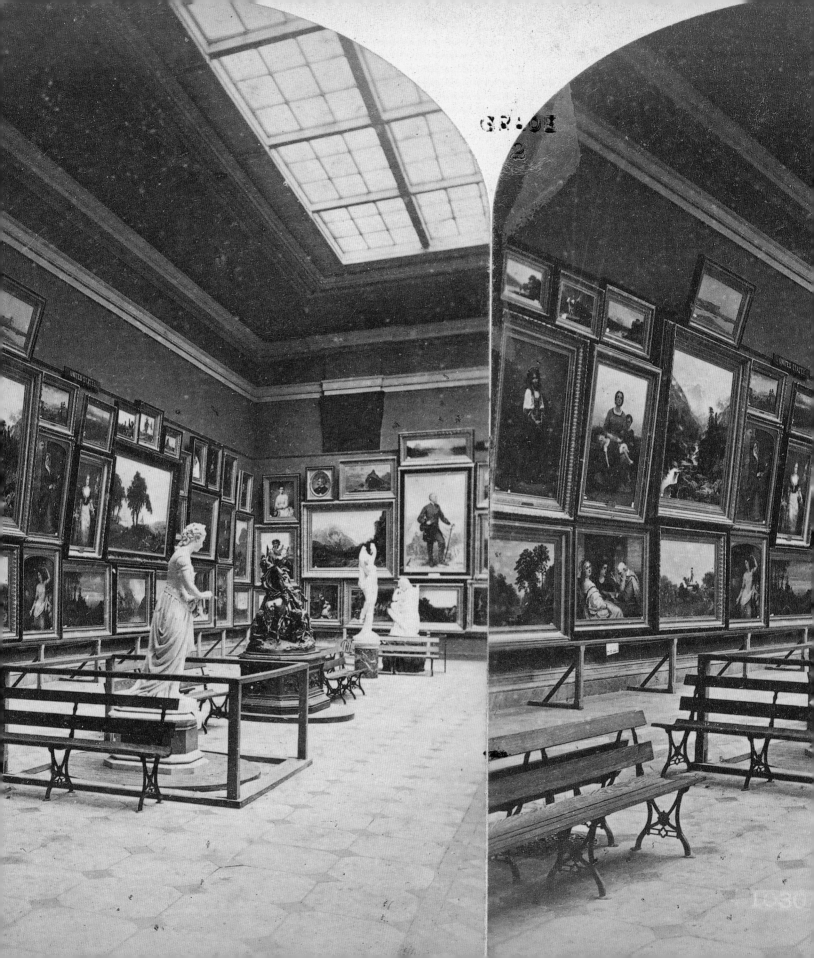

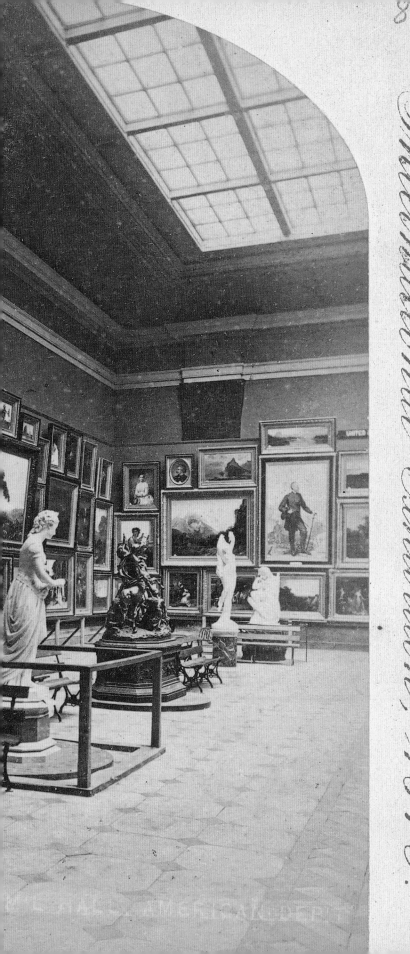

International Exhibition, 1876.

PART I

ARTISTS

Shaping the Exhibition

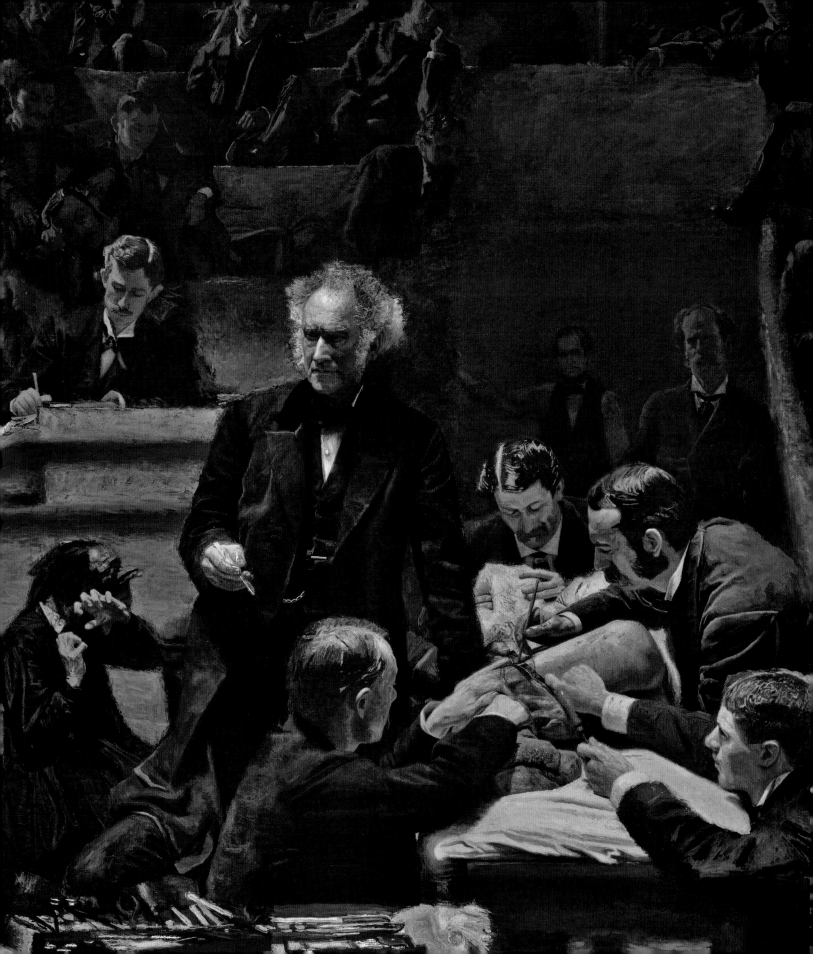

CHAPTER I

CONFRONTATION IN PHILADELPHIA

Artists Create a Canon of American Art

Worthington Whittredge, a leading landscape painter and president of New York's august National Academy of Design, arrived at the Centennial Exhibition fairgrounds in Philadelphia's Fairmount Park on April 24, 1876. He was accompanied by the New York painter and engraver James Smillie. These two respected artists had come to help hang the U.S. fine arts display in Memorial Hall. The exhibition would open in two short weeks, on May 10, and it would be viewed by a national and international audience numbering in the millions. The very next day, Smillie noted in his diary the antagonism between Whittredge and the exhibition's Art Bureau chief, John Sartain, an engraver and a prominent figure in Philadelphia art circles who supported progressive European-trained figure painters such as the young Thomas Eakins. On May 2, another artist recorded that "Whittredge and Sartain are by the ears and quarrel all the time." Their antagonism came to a head

on May 5, just five days before the opening; Smillie wrote that Sartain had "put [Whittredge] out of Mem. Hall (practically) and things had reached such a crisis that something had to be done."[1]

Art world leaders in 1876 considered the exhibition to be so important that its installation merited an altercation worthy of a Victorian melodrama. The project of organizing the American art contribution was left to a group of artists divided by city and ideology. The disputes between Whittredge and Sartain marked the climax of the long and contentious process of organizing the exhibition of American paintings and sculptures. The incident in the final days before the opening vividly illustrates how preparations for the event raised questions of national identity and cultural authority. Competing attempts to construct history, fired by civic rivalries and organizational politics, exposed the gritty, sometimes ugly business of using art and power in the service

of writing history. Artists worked against time—and each other—to organize the American painting and sculpture display, keenly aware of their mixed record of success with art exhibitions at foreign and domestic fairs throughout the nineteenth century.

Exhibitions are always implicitly interpretive; meaning is created not only through the works themselves, but also through which objects are chosen and how they are displayed. My analysis of the centennial American art exhibition begins with how, why, and by whom it was organized. The job and the authority vested in it passed from hand to hand and finally fell to a small group of polemically opposed artists. They realized the importance of the fine arts display as a nationally recognized history of American art. The artists represented there would be imprinted on the memories of millions of fairgoers and would enter a canon of the nation's cultural history. Those who were not chosen risked being neglected, or even forgotten, by posterity. As the exhibition's significance became clear, two factions struggled to form an American School of art that would legitimize their work and determine whether the nation's cultural future would be shaped by national or international interests. The curatorial task became a public referendum on whether nationalistic ideals should guide American artists or whether new European styles would prevail.

Sociologist Howard Becker's well-known model of the art world and its power relations begins with artists, and it is only fitting that the story of the fine arts exhibition begins in the same way. Artists are the focal point of the art world, and their ability to create works of lasting significance is the result of technical skill combined with a mysterious and ineffable quality of vision, one that is not easy to identify or evaluate.

Despite their essential role, artists are acutely dependent on other agents. Their work is sanctioned by others, particularly authorities such as critics for approval and collectors for sales. In the long term, artists are legitimized by having their works in museums, a complicated proposition in the United States of 1876, when art museums were in their infancy and not as yet inclined to seek out the work of Americans. In the centennial year, the world's fair was artists' best hope for the kind of long-term legitimacy that a museum could provide. The Centennial Exhibition offered a chance to multiply the size of their audience, broaden their scope from regional to national, and leap from the brief, temporary acclaim of a local exhibition to a legacy involving an audience of unheard-of size, notice in national publications, and the imprimatur of a monumentally significant event.

From their central position, artists are potentially in direct contact with critics, collectors, dealers, and the public, but most cannot exercise much influence as individuals. In the absence of a government-run system of training, certifying, and promoting artists, or many other exhibiting options or ways to connect with potential purchasers, American artists quickly learned that they could work more effectively by forming artist institutions that advanced their interests. In the early nineteenth century, the art world was so limited that these organizations performed a crucial function in connecting artists to the few other existing constituencies. By 1876, the National Academy of Design (founded in 1825) and the Pennsylvania Academy of the Fine Arts (founded in 1805) were already powerful organizations; they had created a means to legitimize artists through membership in their group and through exhibiting opportunities that

provided visibility and connections to critics and collectors. Their power was not just in securing benefits for their members and those they chose to include in their exhibitions but also in their ability to exclude artists whose work did not meet with their approval.

In the early 1870s, as other groups withdrew from the daunting task of shaping the American art contribution at the Centennial Exhibition, artists were given an unprecedented role in creating the exhibition and the canon that it implied. The artists involved were the acknowledged leaders of their communities and key members of the New York and Philadelphia academies. Americans often looked to Britain, Germany, or France for models of art institutions, but unlike those countries, the United States did not have the government apparatus to administer a large cultural undertaking like a world's fair. The Centennial Exhibition was a federally sanctioned project, and in allowing artists to organize the American exhibition, the government conferred its power on them, giving their exhibition a tremendous weight of authority that extended far beyond their status as individual artists or as members of their respective organizations. Their task was to select works to represent the United States, past and present, and by implication to decline those that did not meet their standards. The size of the exhibition, the government sanction, the epoch-making importance of the event, and the huge expected attendance exponentially magnified these artists' power to shape a lasting vision of American art.

Artists in the United States were growing in stature after the Civil War, but they were divided by fundamental questions about national identity, which would shape the country's cultural future. This chapter traces how the exhibition developed, using the letters and diaries of the artists involved and press accounts that show how much public attention was focused on the preparations for the American art display.

American Art at Previous Fairs: A Checkered History

Artists and elites in the United States had been cultivating a national identity at fairs both at home and abroad for decades. Early exhibitions at world's fairs put Americans' indifference and lack of experience on display. However, the country's artistic contributions to fairs received increasing attention as the nineteenth century progressed. Americans' ambitions for their art displays escalated, but the fair organizers did not always achieve them. At the fairs leading up to the Centennial Exhibition, different models of cultural authority were played out, with varied results Some exhibitions were organized by collectors, others by artists, still others by civic leaders. Those involved came to realize that the art exhibitions were a closely watched barometer of the country's national development and cultural progress, and sentiment evolved from indifference to an urgent understanding of the high stakes involved. As the displays became a matter of national pride, the question of who would create them was hotly contested. Inevitably, tensions grew into outright antagonism in an art world that was as unformed and fragmented as the rest of the nation.

London's Great Exhibition of 1851 (displayed at the Crystal Palace) was the first exposition of international scope, but American artists and collectors had been participating in similar exhibitions at

home for decades. Those fairs were often presented by mechanics' institutes, organizations dedicated to educating working people and improving the quality of American manufactures. One of the longest-running presenters was the American Institute, whose annual fairs in New York dated from 1828. The exhibitions were highly successful—more than a half million people attended the 1852 fair—and even the well-to-do considered it an important social event, with attractions such as music, fireworks, orations, and odes.[2] Art galleries were included at an early stage.

The Exhibition of the Industry of All Nations at New York's Crystal Palace in 1853 (fig. 8) was the first attempt at an international fair in the United States, organized by a private group of investors hoping to duplicate the financial success of the London Crystal Palace exhibition.[3] The New York Crystal Palace fair, located at what is now Manhattan's Bryant Park, boasted the first separate picture gallery in such an exposition; it was housed in a two-story annex to the main building.[4] However, New York artists objected that the 1853 exhibition, like its London counterpart, had no special classification for fine art, and members of the city's Sketch Club refused en masse to send works because the arrangement degraded art.[5] Some people associated with the National Academy of Design boycotted the Crystal Palace fair because the idea of an art exhibition connected with "grosser material—*manufactures*—has always been repugnant to the American artist."[6] As a result, only 33 of 685 paintings were by Americans, and some of those were copies of European works. One New York diarist called the paintings exhibition "rather a failure."[7] The New York Crystal Palace exhibition was plagued with other problems, too. The project was not endorsed by the

U.S. government, so few foreign countries participated, and attendance was disappointing. Organizers of the Centennial Exhibition would ensure that the 1876 fair had government sanction, along with the authority lent by broad national and international involvement.

Most influential for the Centennial Exhibition were the sanitary fairs that sprang up in the Northern states during the Civil War. Beginning in 1863, the U.S. Sanitary Commission organized fundraising fairs to benefit Union soldiers at the front. Approximately thirty-five took place in cities, including Brooklyn, Chicago, and Cincinnati.[8] Larger fairs included art galleries organized by local artists and collectors. They set important precedents for the structure that would be followed in 1876, as well as for the conflicts that would play out in organizing the American art exhibition. The largest and most important of these were the Metropolitan Fair in New York and the Great Central Fair in Philadelphia.

New York's Metropolitan Fair of April 4–23, 1864, included a remarkably elaborate art exhibition that apotheosized the Hudson River School (fig. 9). The fine arts gallery housed the largest display of paintings to that point in New York, including such monuments of American landscape painting as Frederic E. Church's *Niagara* (fig. 72); the famed triumvirate of Church's *Heart of the Andes*, Albert Bierstadt's *The Rocky Mountains, Lander's Peak*, and Emanuel Leutze's *Washington Crossing the Delaware* (all Metropolitan Museum of Art); and paintings by Thomas Cole, John F. Kensett, and Asher B. Durand. The art exhibition drew more than 77,000 visitors, and for an additional charge, fairgoers could visit the private galleries of August Belmont and William H. Aspinwall.

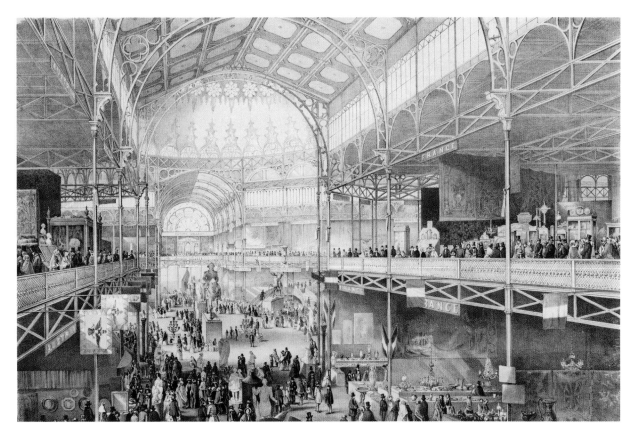

<figure>FIGURE 8 *An Interior View of the New York Crystal Palace* (C. Parsons, del. and lith.), 1853. Printed by Endicott & Co., New York, N.Y. Published by Geo. S. Appleton, 356 Broadway, N.Y. Lithograph printed in colors. The Museum of the City of New York.</figure>

Following on the heels of the New York event, Philadelphia's Great Central Fair took place June 7–28, 1864, as a joint effort of groups in Pennsylvania, Delaware, and New Jersey. Its art exhibition boasted a staggering 1,400 pictures, which a local publication called "beyond question the largest, most valuable, the most complete collection of paintings ever known in America," a comment that could only be taken as a challenge to the recent Metropolitan Fair.[9]

The art gallery at the Great Central Fair was hugely popular: average daily attendance was estimated at 12,000. By that measure, more than 220,000 people visited over the approximately nineteen days the exhibition was open, far outstripping the attendance at New York's Metropolitan Fair. Works on view included Henry Peters Gray's *The Wages of War* (Metropolitan Museum of Art), Remy Mignot's *Chimborazo* (Greenville County Museum of Art,

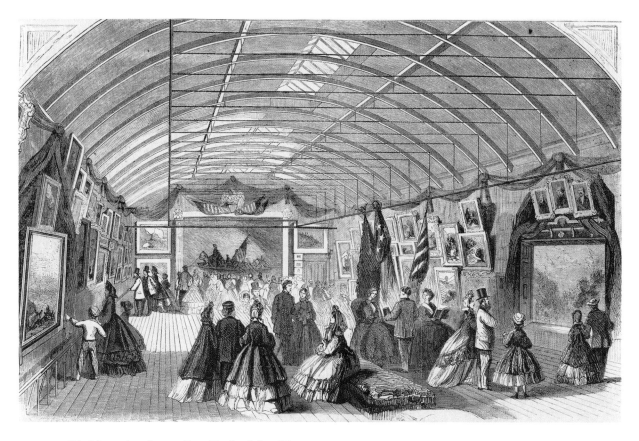

FIGURE 9 "The Metropolitan Sanitary Fair—The Art Gallery." From *Frank Leslie's Illustrated Newspaper*, April 23, 1864, 69.

South Carolina), and John Vanderlyn's notorious 1809–14 nude, *Ariadne Asleep on the Island of Naxos* (fig. 10). As Belmont and Aspinwall did in New York, the Philadelphian Joseph Harrison opened to the public his renowned collection.[10] The sanitary fairs set the stage for civic rivalries that would complicate the creation of a unified national art display in Fairmount Park, as cities compared the size, attendance, and financial success of their fairs and competed to surpass one another.[11]

Perhaps the experience with the sanitary fair benefited New York artists when it came to organizing the American art contribution to the 1867 Exposition universelle in Paris.[12] The National Academy of Design charged landscapists Church and Jasper F. Cropsey, as well as Edwin White, a painter of interiors and historical and religious works, to form a Selection Committee composed of "well-known connoisseurs of art" and suggested that "as the American school has furnished particularly

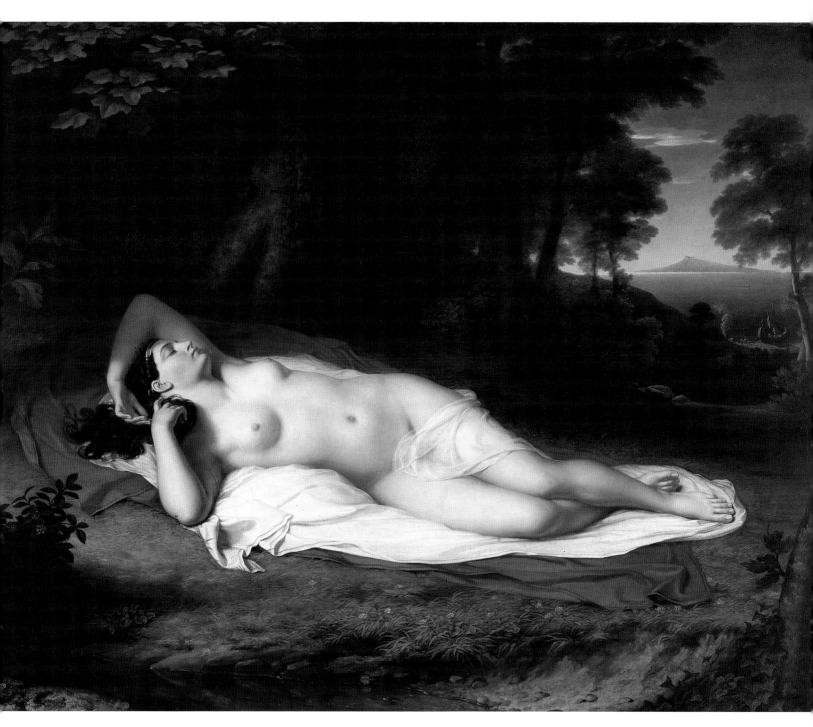

FIGURE 10 John Vanderlyn (American, 1775–1852), *Ariadne Asleep on the Island of Naxos*, 1809–14. Oil on canvas, 68 ½ × 87 in. (174 × 221 cm). Courtesy of the Pennsylvania Academy of the Fine Arts, Philadelphia. Gift of Mrs. Sarah Harrison (The Joseph Harrison Jr. Collection), 1878.1.11.

fine landscapes, a preference be given to paintings of this class."[13] Accordingly, the ninety-five works contributed were heavily weighted toward native subjects by New York artists. The official report noted the disadvantages of leaving the selection to collectors, suggesting that the works chosen were not always the artist's latest or best, and had they been consulted, many would have objected to their representation.[14] The foreign response was lukewarm at best. Beyond Church's *Niagara*, comments focused on whether the subjects were sufficiently representative of national life and suggested that Americans develop a style that was less imitative of British art. The overall reaction of American art critics and, importantly, of collectors was outright embarrassment for American provincialism and admiration for the sophisticated French style.[15]

Though rarely discussed today, the Vienna Universal Exposition of 1873 was of enormous interest to Americans, since it took place as work on the 1876 exhibition was beginning.[16] The U.S. Centennial Commission, the city of Philadelphia, and the state of Massachusetts sent delegations to Vienna, and their observations were published in voluminous official reports. The 1873 exhibition was still strongly in mind three years later, as accounts of the Centennial Exhibition often referred to Vienna's fair.[17]

In spite of the close attention paid to the Vienna exhibition, the U.S. art contribution fared poorly and pointed out the awkward interdependence between collectors and artists. A planning committee of collectors met with resistance because it included no artists, and the members resigned. Artists representing the National Academy of Design reluctantly agreed to spearhead the exhibition but found little cooperation from either artists or collectors, so they too resigned.[18]

In the end, about twenty pictures were sent, seventeen of which came from an unnamed private collector in Chicago.[19] This meager contribution had not even arrived at Vienna when the exhibition opened, and when it finally did, no space had been reserved for the paintings. One official decided that the works were not worthy of a place in the fine arts display and was not convinced to hang them until a very late hour.[20] The paintings were probably scattered throughout the galleries; it was reported that one of Bierstadt's paintings had the dubious distinction of being "skied" (hung so high that it was difficult to see) in the Salon d'Honneur, and G. P. A. Healy's portrait of Pope Pius IX was hung in the Belgian annex.[21] A *New York Herald* reporter writing on American art at the Centennial Exhibition still could not shake "the painful recollections of three years ago, at Vienna, where we did worse than nothing."[22] This ignominious showing just a few years before the Centennial Exhibition placed considerable pressure on the organizers of its American art display to redeem the country's reputation.

The accumulated experiences with various fairs highlighted the strengths and weaknesses of different forms of organization and of the groups that attempted to work within them. Sanitary fairs were organized largely by collectors as charitable projects. They were built on spirited civic rivalries that had to be set aside in the case of world's fairs, which focused on international comparisons. The history of American art at previous fairs reflects a gradual understanding of the importance of the country's representation of art, which was followed by tensions among competing cultural authorities and conflicts over who would create that representation. These experiences presaged the process that would take

place in forming the 1876 display. The art exhibition was initially conceived under the aegis of collectors, but it evolved into an artist-run affair. The artists involved soon understood the critical importance of their undertaking, and their conflicts, centered on the very questions of nationalism and international-ism that roiled the art world, were intensified by the magnitude of the event.

Preparations for the Fine Arts Exhibition

Centennial Exhibition organizers anticipated a fine arts display from the fair's inception. However, there is no record of any planning activity for the art exhibition until 1875.[23] Instead, attention was lavished on Memorial Hall, the facility that would house it.[24] The Centennial Exhibition was the first international exposition to include a significant permanent struc-ture dedicated exclusively to painting and sculpture.[25] An architectural competition had yielded designs that were far too expensive to implement, and the task of designing Memorial Hall and most of the other buildings on the fairgrounds fell to Hermann J. Schwarzmann, the head of Fairmount Park's Department of Engineering.[26] Ground was broken on July 4, 1874, and work was finished at the late date of March 1, 1876, little more than two months before the exhibition's opening.[27]

From its early stages, Memorial Hall was more than merely a display space. An address dated March 27, 1875, from a "Philadelphia Committee of Artists" announced that it was to become a national museum, and the Pennsylvania Museum was char-tered in February 1876.[28] At that time, the Corcoran

Gallery in Washington, D.C., and the Metropolitan Museum of Art in New York had been operating for at least six years, and the Museum of Fine Arts in Boston would open its new building later in the centennial year. Schwarzmann's Memorial Hall (fig. 11) was built from brick, granite, glass, and iron in the modern Renaissance style.[29] Erected at a cost of $1.5 million, the building (now housing the Please Touch Museum) measures 365 feet long and 210 feet wide.[30] The central hall and galleries combined could hold eight thousand people, making it almost twice the size of the largest hall in the country at that time.[31] Memorial Hall's capacity sounded a challenging note to other East Coast cities. It was considerably larger than the Metropolitan Museum of Art's modest quarters at 128 West Fourteenth Street, several times larger than the Corcoran Gallery (now the Smithsonian Institution's Renwick Gallery), and half again as large as the Museum of Fine Arts in Boston's Copley Square (the museum now occupies a much larger building on Huntington Avenue).[32] From its inception, the building took on the aura of a museum, with the attendant expectations that a carefully chosen exhibition would reside therein.

Planning for the art exhibition that would be housed in the august Memorial Hall was a buck-passing exercise that continually asked the question of who held sufficient authority to form a canon of the nation's living artists and construct a history of American art—or who was even willing to try. The art exhibition in Fairmount Park was widely expected to represent the entire country, but no state-sponsored national structure existed like the Royal Academy of Arts in England or the École des Beaux-Arts in France. While individual cities

FIGURE 11 Centennial Photographic Company (American photographer, nineteenth century), *Memorial Hall, Centennial International Exhibition of 1876, Philadelphia*, 1876. Silver albumen print. Free Library of Philadelphia.

had established artist groups and coteries of cultural leaders, it was unclear who should take the lead for an event of national significance. The unique task at hand was more complex than the work of the other departments of the exhibition. Rather than dealing with the mere logistics of enrolling and receiving individual commercial vendors (in admittedly vast numbers), the art exhibition also required careful selection and interpretation to orchestrate a blending of previously disparate parts. More than any other aspect of the

Centennial Exhibition, the art display exemplified the post–Civil War hopes for national reunion.

Various official and unofficial groups attempted to make plans and facilitate arrangements, including artist organizations, established civic groups, state boards, and informal committees of artists. The Centennial Exhibition's commissioners and its executive committee took little action, and many people might have expected Philadelphia artist organizations to provide leadership. The Pennsylvania Academy of

the Fine Arts was the obvious candidate to fill such a role, paralleling the strong part played by the National Academy of Design in New York. However, the Pennsylvania Academy had very little to do with organizing the Centennial Exhibition's fine arts display.[33] Its members and supporters were among those best suited and most needed, but they were working frantically to fund and build the Pennsylvania Academy's elaborate new High Victorian Gothic building, which opened in the centennial year.

Exhibition officials finally created a Bureau of Art as of April 30, 1875, just one year before the opening. No bureau chief or staff of any kind was named, but a volunteer Fine Arts Committee was formed.[34] The Fine Arts Committee was composed of prominent collectors and artists from New York and Philadelphia. It followed a long-established tradition of cultural leadership by powerful, civic-minded men, with numerous precedents such as the American Academy of the Fine Arts, the American Art-Union, the New-York Gallery of the Fine Arts, and the Pennsylvania Academy of the Fine Arts. (As an artist-run institution, the National Academy of Design was a prominent exception.) Fine Arts Committee members included the Philadelphians Henry C. Gibson and artist Peter F. Rothermel. The New York contingent was led by the enthusiastic collector John Taylor Johnston, president of the Central Railroad of New Jersey and founding president of the Metropolitan Museum of Art, and included William Tilden Blodgett, William J. Hoppin, and artist Worthington Whittredge (who would later clash with Sartain over the installation at Memorial Hall).[35]

The committee chairman was the Philadelphian James L. Claghorn, who had started his career at the family auction house of Myers, Claghorn and Co. and later became president of the Commercial National Bank. He was a longtime art enthusiast who wished to encourage native talent; at one point he owned more than two hundred paintings by American artists.[36] He was among the founding commissioners of Fairmount Park and a member of its Committee on Works of Art. As president of the Pennsylvania Academy of the Fine Arts he had the experience to lead a large and complex enterprise. However, Claghorn was a leader in name only. His interest in American art may have been merely patriotic, since it was noted that "many pictures he bought to help the artist, rather than for his own gratification as a collector."[37] His real love was European prints, and in the 1870s he was said to have the country's largest collection.[38] During the summer of 1875, which should have been a period of intense activity and planning for the centennial, Claghorn was overwhelmed with work on the Pennsylvania Academy's new building.[39]

Collectors had worked productively in the past on local projects such as sanitary fairs. However, a project of national scope may have proved too diffuse, too daunting, and too logistically complex, and the appeal of national pride may have been too distant and abstract compared to more concrete and pressing local concerns. Complaints about the Fine Arts Committee's inaction mounted in the late summer and early fall of 1875, particularly in the New York press.[40] The Boston *Daily Evening Transcript* echoed their concerns that "there is little doing . . . toward a systematic representation of American art at the Centennial exhibition."[41] Even the *Philadelphia Inquirer* admitted that nothing had been done "in order that the Art Department should be fairly

representative of the rise and progress of American art," while other nations were well advanced in their preparations.[42] By September 1875 the complaints had reached a fever pitch. The *New-York Tribune* reported a feeling among artists at home and abroad that "American Art is totally and designedly ignored."[43]

The barrage of criticism finally spurred the Fine Arts Committee to relinquish its authority (perhaps with some relief) and appoint a chief for the Art Bureau. After initially declining, Sartain accepted the position and began his work in mid-September, just eight months before the exhibition's opening.[44] He was undoubtedly Claghorn's choice. Claghorn left most of the academy's art business in Sartain's hands as a board member, secretary, and chair of several committees.[45] Sartain brought considerable administrative experience and a wealth of contacts and energy to his new position. Born in London in 1808, Sartain's family emigrated to the United States in 1830. Sartain established himself in Philadelphia as a successful engraver and a remarkably active member of its art community. He spent twenty-two years on the board of the Pennsylvania Academy of the Fine Arts and was responsible for resurrecting the institution after a dormant period following a fire in 1845. He spent fourteen years as vice president of the Philadelphia School of Design for Women, was manager of the Art-Union of Philadelphia, and served as an officer of the Artists' Fund Society. Most important, he organized the art exhibition of Philadelphia's 1864 Great Central Fair for the U.S. Sanitary Commission. A prolific writer and publisher, he issued *Sartain's Union Magazine* from 1849 to 1852 and edited compilations of art reproductions.[46]

Sartain was as much an impresario as an artist, and he embodied the tension between the ideal of high art and the reality of the market through which it moved. While he was well versed in the elevated values of the art world, Sartain was ultimately a businessman. He showed a keen interest in the art market and often noted the insurance values assigned to paintings. A master of self-promotion, he frequently welcomed the press into his home and shared stories about himself and his fellow artists.[47] Sartain was a complex and sometimes contradictory figure, by turns idealistic and pragmatic, a fervent supporter of progressive young artists, but not above extending special favors to his personal friends who were of a more conservative bent. Above all, he had a strong idea of what the American art exhibition should look like, and he was willing to bend the rules of propriety to bring it to fruition. Sartain took up his new position with great fervor, writing to a colleague that "the art exhibition is going to be superb, and my heart is in the American division of it."[48] His charge to organize the United States' art display encompassed three categories: works by living American artists, historical works by deceased American artists, and a "Loan Collection" of paintings by foreign artists in U.S. collections.

On November 22, 1875, the *New-York Tribune* anxiously asked, "Are we to have an embarrassment of riches, or an embarrassment of poverty?"[49] A survey of Sartain's correspondence illustrates the broad range of issues that he had to address: a letter to W. Grut in Paterson, New Jersey, for example, suggested that he might inquire with the Department of Industrial Art to submit his "Portrait of Washington made up of the hairs of distinguished men." Sartain's exasperation is evident in a letter dated October 16, 1875, asking another aspiring exhibitor, "Will you please inform me what description of 'Portrait of Washington' yours

is, that requires one hundred and ninety two (192) square feet of *table* space."[50]

Simply distributing information on the exhibition was an enormous task, and Sartain began by writing to various prominent figures, such as the chair of the Committee on Fine Arts at the Boston Athenaeum and William P. Blake of Chicago, asking for lists of "artists of repute" so that he could mail them circulars.[51] At the same time, Sartain began to shape the exhibition by actively soliciting work from certain artists. The most striking example is his encouragement of his friend and Hudson River School painter Albert Bierstadt. Within a month of his taking office, Sartain allotted Bierstadt 54 by 12 feet (a remarkable 648 square feet) of space and wrote the artist that if his pictures exceeded those measurements, "don't stand on modesty" (which Bierstadt, an aggressive self-promoter, surely would not), since "the largest surface covered should be by the *best* artists of the country."[52] Prominent artists gradually began to offer their applications, and on December 9, 1875, Sartain affirmed that based on the submissions to date, "the success of the American portion of the Art Department is assured."[53]

It quickly became clear in the fall of 1875 that Memorial Hall would not accommodate the number of works anticipated. Sartain envisioned unlimited space for the U.S. contribution, and he bargained with Great Britain, Germany, and Austria to cede some of their space,[54] but even these measures did not meet his requirements. Rather than decreasing the number of artworks to be exhibited, Sartain called for even more galleries, and in November 1875 his request to build an annex behind Memorial Hall was approved.[55] The Art Annex was an undistinguished brick building hastily designed by Schwarzmann and destroyed after the exhibition (fig. 12). It was nearly as

FIGURE 12 David J. Kennedy (Scottish-born American, 1816/17–1898), *Art Annex to Art Gallery, International Exhibition of 1876 at Philadelphia, U.S.*, 1876. David J. Kennedy Watercolors (V61), Historical Society of Pennsylvania, DAMS #3302.

large as Memorial Hall, but instead of long corridors flanked by galleries, the annex was a beehive of thirty small square galleries, which received fewer visitors and drew less attention, thereby privileging the works displayed in Memorial Hall. However, the added space allowed Sartain to include more pictures, rather than limiting their numbers.

A great deal of power was concentrated in Sartain's hands, including determining the character of the working committees that would choose and hang the works of art—contested subjects in previous exhibitions, and with good reason, since they would shape the national contribution. His frustrations began with the moribund Fine Arts Committee, which he diplomatically renamed the Advisory Committee. He charged the group of collectors with forming a Committee on Selection made up of artists to choose the works to be displayed and a Committee

on Arrangement made up of the heads of leading arts institutions to oversee the hanging of the exhibition. Convening the Advisory Committee, a group of businessmen from different cities, proved difficult. Sartain regretted that he had to wait for their approval of his plans while artists' complaints mounted; he lamented that "red tape ties my hands." His unilateral actions in later months were foreshadowed in his early comment that "the delays of Committees and the torture of red tapes [*sic*] makes one think better of one man power, notwithstanding the danger of its abuse." Sartain's correspondence from mid-October through late November 1875 documents his travails in prodding the Advisory Committee to invite artists to join the Selection Committee and in cajoling artists to participate. After a maddening few months of interlocking declines, suggestions, and rejections, Sartain complained that according to the Bible "it took but a tenth of the time to make the Universe as it has taken to make this Committee," but by late November the roster was complete.[56]

The final committee was composed of ten artist members: five from New York, three from Philadelphia, and two from Boston. The New York members were Daniel Huntington, portraitist and past president of the National Academy of Design; landscape painter Jervis McEntee; portraitist Thomas Hicks; and naturalist sculptors Henry Kirke Brown and John Quincy Adams Ward.[57] Of this group, only Hicks and Brown had received their training abroad, and Brown was a strong advocate of American subjects.[58] Representing Philadelphia were figures less familiar to modern readers, with stronger European ties. Howard Roberts had trained at the École des Beaux-Arts, and Samuel B. Waugh had studied in

France, England, and Italy. William H. Willcox was a landscape painter and illustrator who exhibited frequently at the Pennsylvania Academy in the 1850s and 1860s.[59] From Boston came Thomas Robinson and Richard Staigg. The former was a landscape and animal painter who had studied with Gustave Courbet and was a great friend of William Morris Hunt, Boston's foremost advocate of the French Barbizon style. The latter was also a colleague of Hunt's.

It is not surprising that the committee chose successful artists who were well known to them, rather than venturing to include younger or less commercially successful artists. As a result, the Selection Committee did not fully represent the American art scene in 1876 but rather reflected its established leadership, distinctly divided by city and by style. The New York contingent represented the nativist school, particularly the Hudson River School, eschewing foreign influences and valuing indigenous American themes. The other members were more open to internationalism. The Philadelphians, particularly Roberts and Waugh, had trained extensively abroad and supported the work of their expatriate colleagues. Boston had a history of close artistic ties to France, and the two Boston artists could be seen as stand-ins for William Morris Hunt (who had declined to serve) in bringing a French aesthetic to bear on the committee's deliberations.

The selection of works by Americans living outside the country was of increasing concern in the press and the artistic community. Almost a year before the opening, the *New York Commercial Advertiser* opined that if the Centennial Exhibition's art display accomplished nothing else, it would acquaint

Americans with their artists working abroad.[60] The late nineteenth century, beginning in the 1870s, was called Americans' heyday at the Paris Salons, with more than one thousand American artists exhibiting over a period of thirty years.[61] A number of American artists were also returning from Europe—many from Paris, but also key artists from Munich—and in 1876, tensions between many of them and the National Academy of Design were reaching a boiling point. Given the pivotal moment at which the centennial occurred, the selection of paintings and sculptures by expatriates was critical. Unfortunately, it is not entirely clear how those works were chosen.

Before Sartain took his office, Director General A. T. Goshorn had asked government officials in Rome and Munich to appoint committees on selection for American art. No documentation has been found confirming who was on those committees, but a committee of American artists was appointed in Paris. It was chaired by Regis Gignoux, an American student of the French academic painter Paul Delaroche and briefly a teacher of George Inness.[62] The other members were Henry Bacon, who studied at the École des Beaux-Arts and in the atelier of Alexandre Cabanel, and E. H. May, who exhibited at the National Academy of Design before studying with Thomas Couture in Paris, which became his permanent home.[63] An article in the Boston *Daily Evening Transcript* reported that as late as March 2, 1876, expatriates in Paris had not received specific instructions for packing and shipping, and many were reluctant to send their works. The *Transcript* account shows how sensitive the issue had become, concluding "either that the fine-arts department . . . is badly managed, or that the Centennial directors do not care for contributions from American artists in France."[64]

In an omission that would have significant consequences for the exhibition, no official representative was appointed to oversee the submissions of American artists in London. In February 1876, Sartain sent circulars to the secretary of the U.S. legation in London, asking him to inform any artists he might know about shipping arrangements, giving artists only a few weeks to prepare their works.[65] The American press responded with indignation. The *New York Herald* predicted that if American artists in Paris and Rome experienced the same neglect as those in London, "the representation of American talent in the Art Department will be lamentably unfair and inaccurate."[66] The British government came to the United States' aid, offering to send American pictures along with its contributions. In this way, George Henry Boughton submitted *Pilgrims Going to Church* (fig. 13). However, other artists declined, most notably James McNeill Whistler, who reportedly wanted to exhibit in the American department, but as of late March had no information on how to do so.[67] From an early stage, expatriate artists were at a distinct disadvantage compared to those residing in the United States. It seemed that their work, already subject to suspicion and some contention, would be underrepresented in the Centennial Exhibition's American School.

Forming the American School: The Selection Process and the "Committee on Rejection"

The Committee on Selection for artists residing in the United States was composed entirely of

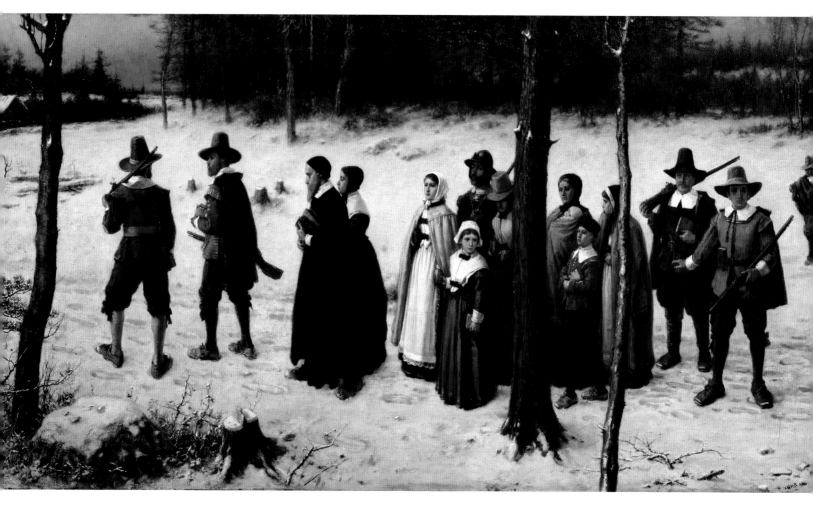

FIGURE 13 George Henry Boughton (English-born American, 1833–1905), *Pilgrims Going to Church*, 1867. Oil on canvas, 29 × 52 in. (73.7 × 132.1 cm). New-York Historical Society, S-117.

professional artists, an innovation that should have boded well for the jurying process. According to department regulations, their official charge was that "all works of art must be of a high order of merit" and by citizens of the United States, without regard to whether they had been previously exhibited.[68] The

jurors knew that their choices would be closely scrutinized, since the selected works would have a lasting impact on millions of Americans' understanding of their country's art, and the media anxiously echoed these sentiments. The *New York Herald* explained the selection process and the emphasis on a high

standard, since America must be able to "hold up her head unabashed" before other countries.[69] *Appleton's Journal* noted the many paintings awaiting the decision of the judges in Philadelphia and worried, "There is much reason to fear that it will be impossible to keep out a great many that, for the honor of the country, we could wish were anywhere else than in Memorial Hall."[70]

Indeed, the committee's standards were compromised when Sartain made a subtle distinction: he directed that in the tradition of the Paris Salon (as he understood it), the members should reject inferior work, rather than actively choose superlative work, and he wrote to Daniel Huntington, "Permit me to remind you that it is understood that the office of your Committee is '*simply to reject work of insufficient merit*.'"[71] This allowed Sartain to exercise his own discretion; for example, he assured John F. Weir that since the committee's task was really only to reject inferior works, Weir could forgo the selection process in New York and send his paintings directly to Philadelphia.[72] In transforming the Committee on Selection into a Committee on Rejection, Sartain cleverly retained the authority to make his own decisions about which works to include and thus kept a firm hand on the character of the exhibition.

The Selection Committee's task was a daunting one. The group met for the first time on February 12 in New York. The attendees were Robinson of Boston; Waugh and Roberts from Philadelphia; and Huntington and McEntee from New York. Director General Goshorn, probably unaware of Sartain's instructions, assured the group that the character of the American Art Department was entirely in their hands.[73] The *New York Herald* reported that the

committee would begin meeting every Wednesday.[74] It is unlikely that the Boston and Philadelphia members could travel to New York every week, so future meetings were probably dominated by the New York members, allowing them to consolidate their own plans for the exhibition.

Dealing with New York's art community was one of Sartain's greatest challenges. Many New Yorkers considered Philadelphia to be a provincial outpost, so any Philadelphian named as chief would have been disdained, and the appointment of Sartain—a practitioner of engraving, then considered a minor art form—was greeted with utter scorn. In New York matters, Sartain worked largely through the National Academy of Design. As might be expected, his relationship with the academicians was strained, and Sartain initially made light of the situation, writing, "The fish wife said that eels were used to skinning, but if she had said it of me there would have been more truth in it."[75]

Sartain did not place himself on the Committee on Selection and claimed not to have seen any of the works the committee rejected, only those that were approved, so he probably did not participate in the selection process.[76] However, he regularly circumvented the committee. He assured a collector, Mrs. A. E. Slocum, that "pictures by such names as these of yours need hardly pass under the scrutiny of the 'Committee on Selection.' . . . I will assume the responsibility of its being all right." There are numerous other examples throughout the spring of 1876.[77] In the meantime he continued to write to others that "*no definite allotment of space* is ever made to anyone" before passing through the Committee on Selection.[78] His audacity is startling and almost amusing. He

wrote on March 6, 1876, to his old friend Thomas Moran that the painter should bypass the selection process and send his work directly to Philadelphia, "only [in a biblical reference] 'tell it not in Gath, nor publish it by the Gates of Ascalon' as it would offend the dignity of the Committee"; the very next day he regretfully explained to T. W. Noble of Detroit, "I have no authority to take any part of the business out of the hands of the gentlemen composing the 'Committee on Selection.'"[79]

Like Sartain, the committee members held firm convictions about the character of the American School to be formed in Memorial Hall, and they made similar exceptions to the process. At the end of March, Jervis McEntee tried to cajole Church's chief patron, William Henry Osborn, to send a painting for the committee's approval. Osborn objected on the grounds that Church's work—exemplified by *Chimborazo* (fig. 4), which would appear at the Centennial Exhibition—was above such scrutiny. McEntee made it clear to the "fussy" owner (his term) that the work must be approved by the entire committee, but he wrote in his diary that there was no need to send the picture to Philadelphia until the galleries were ready, thus sanctioning its admission without the committee's formal judgment.[80]

The committee was scheduled to meet for selection in Boston on March 27–28, in New York on March 29–31, and in Philadelphia on April 2–3.[81] The selection process was organized by city for the convenience of those submitting artworks, but as a result, each session became a referendum on the host city's overall art scene and its place in the proposed national narrative. No notes have been found from these sessions, and there appears to be no record of

the works that were rejected. Fortunately, committee member Jervis McEntee was a conscientious diarist, and Henry Kirke Brown wrote several letters to his wife during those weeks.

The *New-York Tribune* provided a long list of Boston artists intending to contribute and noted that many were "ladies," probably from among William Morris Hunt's legions of female students.[82] About seventy works were rejected from a group of more than two hundred. Brown wrote that the committee took longer than expected to view all the Boston pictures, and "it was a pretty poor lot of stuff we had to judge of with a few exceptions." He added, however, that "we are having a very good time—all our decisions are arrived at with unity of judgment."[83]

The committee met in New York "behind closed doors" to make its choices.[84] To no one's surprise, the New York contribution was dominated by landscapes. One article complaining about the poor quality of the landscapes in the 1876 National Academy of Design exhibition theorized that artists had held back their best paintings for the Centennial Exhibition.[85] A modern scholar has suggested that Whittredge packed the New York contribution with the work of his Hudson River School friends.[86] Though he was not a member of the Selection Committee, Whittredge was head of the New York state delegation for the Centennial Exhibition and president of the National Academy of Design, so he had considerable influence. He may have been partly responsible for Brown's April 1 observation, "I have had some entertainment in observing the different characteristics of our Committee. . . . Their arguments in favor or against a work arise from personal consideration; consequently, we have many works which should have been rejected."[87]

Resentment grew between Sartain and members of the New York contingent, particularly in relation to Bierstadt's submission. Sartain had assured his friend of all the space he wished, and Bierstadt did not send any works to the Selection Committee, expecting the group to examine them in his studio. Many New York artists, however, had a low opinion of Bierstadt's aggressive promotional methods.[88] McEntee fumed, "Bierstadt has had fair warning that his pictures will not be examined at his rooms and defies the committee who are resolved to oppose his presumption to the bitter end," adding later that "if Bierstadt gets ahead of us he will be pretty smart." Bierstadt did "get ahead" of them, sending his paintings directly to Philadelphia. McEntee recorded that one of Bierstadt's works, *California Spring* (unlocated), was rejected by the committee there, though several other works were grudgingly admitted. McEntee commented that they "looked particularly poor and certainly do him no credit with intelligent people."[89] In spite of the committee's vote, in the end *California Spring* was included in the exhibition, no doubt with Sartain's intervention and to the consternation of McEntee and his colleagues.

By the time the committee convened in Philadelphia, the members were exhausted and animosities were high. McEntee called the committee's two days in Boston and its two days in New York "the most fatiguing work I ever did."[90] Brown reported to his wife that he was on his way to Philadelphia after "a most fatiguing and wearisome examination" of pictures in New York.[91] He was in Philadelphia April 4–8, and pictures were still arriving when the committee adjourned. The group, dominated by New Yorkers who were resentful of Sartain's leadership,

FIGURE 14 Frederick Gutekunst, photographer (German-born American, 1831–1917), *Pennsylvania Academy of the Fine Arts*, 1876. Courtesy of the Pennsylvania Academy of the Fine Arts Archives, Philadelphia.

met again on May 1–2, just days before the opening of the exhibition, to finish the task.[92]

At this time the Philadelphia committee members' attention was not focused on the exhibition in Fairmount Park. The centennial year marked the Pennsylvania Academy of the Fine Arts's first exhibition in six years, timed to coincide with the opening of its new building (fig. 14). The academy's exhibition was originally scheduled to close well before the May 10 opening of the Centennial Exhibition. Sartain had intended for the contents of the earlier exhibition to simply be transferred to Memorial Hall after its close—and before the Selection Committee's arrival in Philadelphia.[93] However, delays in the building's completion pushed the close of the Pennsylvania

Academy's exhibition to June 3, nearly a month *after* the Centennial Exhibition's opening. The academy works were indeed examined by the committee, which rejected almost all of them.[94] Brown called the pictures he examined at the academy "the worst lot of trash I ever looked at."[95] Sartain probably intended that the academy's exhibition would constitute the bulk of Philadelphia's artistic representation at Fairmount Park. That the Pennsylvania Academy's paintings and sculptures were deemed unworthy was an affront to Philadelphians' taste by a New York–dominated jury and an insult that Sartain must have felt keenly.

The selection process was simplified for sculpture. Artists were instructed to forward their work directly to Philadelphia rather than to Boston or New York, to be judged by the Selection Committee there.[96] The intention was to spare artists the expense and inconvenience of shipping their works to a point of selection and from there to the exhibition. However, it was a considerable financial risk for sculptors even to send their artworks to Philadelphia from wherever they might be, not knowing whether they would be accepted. As a result, the number of submissions in sculpture was relatively modest. The committee accepted 154 works from 64 sculptors, mostly large groups of sculptures from artists working in Rome and Florence, such as P. F. Connelly, M. Dickerson Eyre, James Henry Haseltine, Edmonia Lewis, and R. H. Park.

Blood and Sex: Tensions Explode

Conflicts were bound to erupt among men of widely different perspectives from proudly distinct cities. The clashes were built on local oppositions, but they also reveal much larger concerns about international rivalries. The controversy best known to modern scholars is the committee's rejection of Thomas Eakins's monumental *portrait d'apparat* titled *The Gross Clinic* (fig. 15). Sartain knew Eakins well as a lifelong friend of his son William, and he wrote in December 1874, "Tom Eakins is making excellent progress with his large picture of Dr. Gross, and it bids fair to be a capital work."[97] Eakins's official application to the exhibition bears the note "not enough space," a bland and inoffensive reason for excluding a controversial painting. Scholars have suggested that it was rejected by the conservative New Yorkers Hicks and Huntington with the influence of Whittredge, noting that New Yorkers were hostile toward it when it was exhibited there in 1879.[98] Other theories range from the sickening blood on Gross's hands to simple professional jealousy. William J. Clark wrote in the Philadelphia *Evening Telegraph*, "It is rumoured that the blood on Dr. Gross' fingers made some of the members of the committee sick, but, judging from the quality of the works exhibited by them we fear that it was not the blood alone that made them sick. Artists have before now been known to sicken at the sight of pictures by younger men which they in their souls were compelled to acknowledge were beyond their emulation."[99]

The committee's decision earned the painting some notoriety; it was exhibited as "rejected" in Salon des Refusés fashion at Charles F. Haseltine's gallery the day after it was presented to the committee. As it happened, the U.S. government wished to show portraits of prominent men in all its departments, and Dr. Samuel Gross, the subject of the painting, had written a centennial history of medicine and the *Manual of Military Surgery* used by both the Union and Confederate armies during the Civil War;

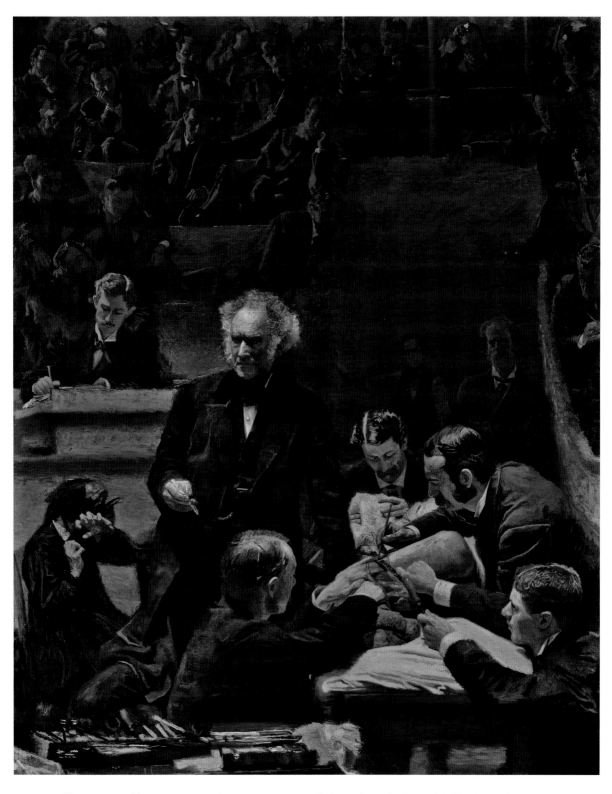

FIGURE 15 Thomas Eakins (American, 1844–1916), *Portrait of Dr. Samuel D. Gross (The Gross Clinic)*, 1875. Oil on canvas, 96 × 78 in. (243.8 × 198.1 cm). Philadelphia Museum of Art, Gift of the Alumni Association to Jefferson Medical College in 1878 and purchased by the Pennsylvania Academy of the Fine Arts and the Philadelphia Museum of Art in 2007 with the generous support of more than 3,600 donors, 2007-1-1.

FIGURE 16 *Hospital, International Centennial Exposition, Phila., Pennsylvania*, 1876, by unidentified photographer. Photograph. Library of Congress, Prints and Photographs Division, Washington, D.C.

he was also president of the Medical Congress in Philadelphia in 1876. Eakins's painting was displayed in the U.S. Army Post Hospital by late May (fig. 16), well after the exhibition opened, probably due to the efforts of Dr. Gross himself.[100]

Much has been made of *The Gross Clinic*'s rejection, but Eakins submitted three other paintings that were accepted, and two of them were displayed in prominent galleries. *The Chess Players* (Metropolitan Museum of Art) hung in Memorial Hall in the Central West Gallery. His portrait of Dr. Benjamin Rand (Crystal Bridges Museum of American Art, Arkansas) was placed nearby in Memorial Hall's Gallery C. One more portrait, *Lady at a Piano*

(Elizabeth Crowell at the Piano) (Addison Gallery of American Art, Massachusetts), was located in the Art Annex in Gallery 30.

In spite of this glowing endorsement, the rejection of Eakins's chef d'oeuvre was yet another insult to Sartain and his Philadelphia colleagues. The slight probably prompted Sartain to take an action that inflamed the art exhibition's greatest controversy—an incident little known today, but widely discussed by artists and critics in 1876. One of the handful of articles protesting the exclusion of *The Gross Clinic* also mentioned the rejection of a painting by Harry Humphrey Moore. Moore was born into a wealthy New York family and was deaf from age three. In the early 1860s, he studied in Philadelphia with Samuel Waugh (who later served on the Centennial Exhibition's Selection Committee) and at the Pennsylvania Academy of the Fine Arts with Thomas Eakins. Moore and Eakins became close friends and trained side by side in the Paris atelier of Jean-Léon Gérôme. They traveled in Spain in the winter of 1869–70 with another Philadelphian, John Sartain's son William. Moore remained there under the tutelage of another successful European academic, Mariano Fortuny, and made a study of Moorish life.[101]

The *Philadelphia Evening Bulletin* reported that "two large American pictures entitled admission to the Exhibition . . . were rejected by the committee for reasons which had nothing to do with the artistic merit of the works themselves."[102] Unfortunately Moore's painting, *Almeh: A Dream of Alhambra*, is thought to have been destroyed in a warehouse fire in 1881. A wood engraving from *Frank Leslie's Popular Monthly* shows Moore's masterpiece on the back wall of his studio (fig. 17). It depicts a scantily clad woman

FIGURE 17 "Studio of H. Humphrey Moore, a Distinguished
Deaf-Mute Painter" (detail). From *Frank Leslie's Popular Monthly*, May
1885, 560. General Research Division, The New York Public Library,
Astor, Lenox and Tilden Foundations.

performing a sensual dance in an exotic setting. She reaches out as if beckoning to the observer, and a man playing a guitar looks up at her. From the engraving it is hard to tell whether his gaze is adoring or leering. The painting not only demonstrates the vogue for Near Eastern subjects but also shows the technical mastery that the artist learned during his extensive training abroad. Moore finished the painting in his New York studio in the hope that it would be displayed in the Centennial Exhibition's Memorial Hall.

The jury probably identified the exotic subject in Moore's *Almeh* with Gérôme's 1863 painting *Dance of the Almeh* (fig. 18), in which a languid, nearly bare-breasted woman dances for a private audience. Though the term "almeh" originally referred to female entertainers, by that point it was understood to mean dancers who were also prostitutes. The Gérôme painting was acquired by the Knoedler Gallery of New York in 1866, so it was probably well known and even notorious among American art lovers.[103] The *Aldine* noted that the rejection of Moore's painting was greeted with vociferous public complaints by the artist's friends.[104] The *New-York Times* reported that according to Claghorn, the work was rejected for "indecency," probably referring to the voluptuous figure and her suggestive pose—though neither Claghorn nor Sartain had any objections to it. The writer regretted the committee's decision and thought *Almeh* would have been "one of the great pictures of the exhibition."[105]

The paired rejections of *Almeh* and *The Gross Clinic* crystallized the civic rivalry along the lines of the debate over internationalism, and they can only be fully understood in tandem. Both pictures were figure subjects that carried the whiff of Paris. In the late 1860s and into the 1870s, exhibitions in New York were dominated by landscapes, and those in Paris by figures.[106] Both works were products of study abroad under the same master, though Eakins applied his training to an American subject, and Moore applied his to a European one.

Sartain was well acquainted with both Eakins and Moore, given their study at the Pennsylvania Academy and his son's travels with the two in 1869–70 in Spain. Sartain probably knew of Moore's plans for *Almeh*, and he was well aware of *The Gross Clinic*. The rejection of most of the Pennsylvania Academy's paintings and sculptures was an insult to Philadelphia artists, and Sartain must have been further offended by the refusal of *The Gross Clinic*. The rejection of *Almeh* was the final straw. While *The Gross Clinic* was little known beyond Philadelphia, Moore's *Almeh* had already garnered acclaim, not in Philadelphia but in New York.[107] The *New-York Times* had lauded Moore's mastery of the figure and declared that "no finer example of anatomical drawing and flesh modeling has ever been produced by an American artist." The writer enthused that "it cannot fail to create a sensation," and "if it can be finished in time it will be exhibited at the Centennial."[108] After months of frustrations with New Yorkers and then this barrage of insults, Sartain responded by surreptitiously transferring *Almeh* and seven other rejected works from the Pennsylvania Academy into the American art exhibition in Fairmount Park.[109]

Of all the paintings that Sartain admitted on his own, *Almeh* received the most media attention because of its decidedly French style and its sensational subject. The painting's rejection paralleled the struggles of young foreign-trained artists to have their works displayed at the National Academy of Design:

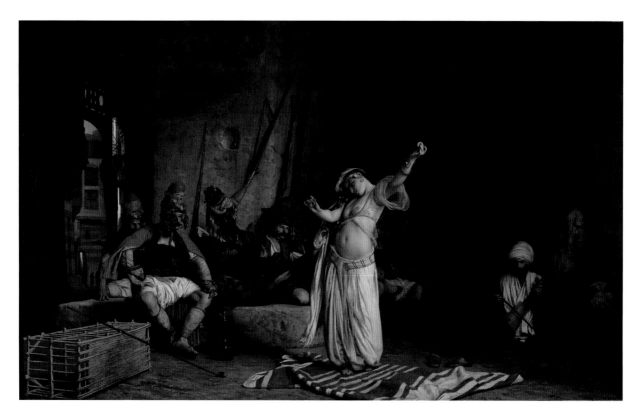

FIGURE 18 Jean-Léon Gérôme (French, 1824–1904), *Dance of the Almeh*, 1863. Oil on wood panel, 19 ¾ × 32 in. (50.2 × 81.3 cm). The Dayton Art Institute, Gift of Mr. Robert Badenhop, 1951.15.

all of the New York Selection Committee contingent were senior members there. In fact, the *Philadelphia Evening Bulletin* reported that the stalwart New York academician Thomas Hicks "cast the first vote against Moore's 'Almeh.'" The fracas over *Almeh* represented the most public confrontation yet between the opposing camps of New York and Philadelphia, supporters of native training facing off against those advocating European study.[110]

When they learned of Sartain's actions, Thomas Hicks and Daniel Huntington sent a letter of protest to Director General Goshorn on June 21. They reminded him of his promise that only works approved by the committee would be admitted and delicately suggested that "if [the Selection Committee's] decisions are to be thus despised, it will be necessary for them in their own defense to make a public protest."[111] They received no official response.[112] Sartain was aware of the New York artists' threats and responded sarcastically, "I expect nothing short of utter annihilation."[113] He was confident that if the incident were brought to light, it would only expose

the New York artists' lack of judgment. In response to the committee's protests, Sartain placed cards on the works he had admitted, which read "Accepted on the Authority of the Chief of the Art Bureau."[114] In his mind this advanced his case. He explained to Goshorn that the paintings' "character and quality will be the justification of my course of action with the public, who can there compare them with other works in the same and adjoining rooms whose merit (or lack of merit) had satisfied the same Committee that rejected these."[115] Sartain wanted to bring the debate about *The Gross Clinic* and *Almeh* to a public forum. Objections to the paintings were based not on skill but on the unsuitability of their subjects—in Eakins's case, blood, and in Moore's case, sexuality. The criticism centered on concerns that the European training of American artists would result in morally ambiguous subjects and in paintings that would be valued merely for technique and cleverness, rather than moral uplift.

The disgruntled New Yorkers did indeed make their complaints public, and Sartain faced serious opposition.[116] The conflict over *Almeh* was about subject matter and stylistic influences. However, the public's objections centered on the dynamics of curatorial power. By this time, artists and the public had come to perceive the exhibition as an official version of the American School of art, and as such it was not to be created by personal fiat but by the careful deliberation of a group of highly regarded experts. Sartain came to regret his decision to "right a wrong" by including the rejected works: "My persistent determination defeated much of [the New York contingent's] selfish planning and I am not to be forgiven, but abused with virulence in the New York papers continually."[117] The *New-York Tribune*'s official guide castigated Sartain, who "not only arbitrarily consulted his own taste" but "even personally accepted some pictures after their rejection by the Commission."[118] Sartain's crime was not that he chose poorly, but that he relied on his personal judgment when the display was expected to be the judgment of an authoritative body. Violating the sanctity of the process put the display's integrity in jeopardy.

The Committee on Arrangement: Sartain's "Assistants"

Though no records have been found of the Selection Committee's deliberations, Sartain commented that they rejected about 300 works. Against the approximately 850 paintings and sculptures that appeared in the exhibition, this was a rate of refusal of about 26 percent. The committee was far less selective than the Paris Salon that Sartain claimed as a model; salon juries rejected more than half the works submitted to their exhibitions in the early 1870s and into the 1880s.[119]

The Selection Committee was less than selective, and the overwhelming quantity of works in the U.S. exhibition created serious problems, first and foremost where and how the works would be displayed in a limited space. This concern was complicated by the period's practice of hanging paintings nearly from floor to ceiling. Some privileged works would be placed "on the line" at eye level, where they were easily seen. The rest would be hung at higher and higher levels until the paintings near the ceiling, those that were "skied," were hardly discernible at all. As a result, visitors and critics naturally focused on the more prominently displayed works. In the face of such profusion, the hanging of the paintings would be very important in determining which were seen,

remembered, and entered into the canon of American art. Sartain formed a Committee on Arrangement toward this end, and this group proved to be just as contentious and fraught with civic and ideological rivalries as the Selection Committee.

Sartain knew as well as his fellow artists did the importance of how the pictures would be hung. He understood that meaning is created not only through individual works of art, but through the company they keep. Artworks can take on new connotations depending on the objects around them: aspects of one painting might be reinforced by another, whether by similarity or contrast, and weaker works can either be elevated by being near stronger ones or have their flaws painfully exposed. Just as crucially, a painting (or sculpture) can take on greater or lesser importance depending on its placement, whether hung at eye level in the middle of the wall of a central, well-trafficked gallery or hung near the ceiling in an out-of-the-way location.

Sartain began thinking about the arrangement of the exhibition as early as November 1875, when he wrote to James Smillie: "One of the duties of my own office is the 'allotment of space' which it would seem includes the *individual location*. This involves the right to deputise [*sic*] others to assist," though Sartain added that he preferred that one person (namely, he) should do the work. Shortly after, Sartain explained to Smillie his plan to appoint "as my assistants in the arrangement" the presidents of the major artist organizations of New York, Philadelphia, and Boston in order to alleviate complaints from artists.[120] If this arrangement sounds like a mere formality, it is because that is exactly how Sartain saw it.

When inviting the presidents of organizations to participate, Sartain described their duties in helping to create a national presentation of American art, and he affirmed that each should also look to his own city's success: "The duties of the Committee are *combined, not local*, only it is intended, as it is right, that each party would especially care for his own region" so it would "appear to the best advantage."[121] The mandate was bound to create a conflict between the national charge and local loyalties. It, combined with Sartain's autocratic approach to the all-important work of hanging, caused the ruckus that ensued.

The process of appointing the Committee on Arrangement was considerably smoother than that for the Selection Committee, since Sartain simply invited the presidents of key artist organizations to participate. The committee was composed of seven members who represented a shift from New York's domination of the Selection Committee: four came from Philadelphia, two from New York, and one from Boston.[122] The members were Christian Schussele, president of the board of the Pennsylvania Academy; Isaac L. Williams, a Philadelphia-trained landscape painter who served as president of the Artists' Fund Society of Philadelphia; sculptor Howard Roberts, president of the Philadelphia Sketch Club; and Thomas U. Walter, president of the American Institute of Architects in Philadelphia. The New Yorkers were landscape painter Worthington Whittredge, president of the National Academy of Design, and painter and engraver James D. Smillie, president of the Society of Painters in Water Colors. Finally, Boston was represented by Charles C. Perkins, president of the Boston Art Museum.[123]

The committee convened on April 27, 1876. The group nominated Smillie as chair; he declined. Then the group elected Sartain, who "absolutely refused," and Smillie finally agreed to serve as temporary

chairman.[124] It is not clear why Sartain declined the chairmanship of a committee that he clearly felt he was in charge of. Perhaps it was a gesture (though an empty one) to give the members a sense of their importance. In any case, Smillie was a fortunate choice for posterity, since he kept a journal that provides glimpses into the committee's fractious labors.

Sartain planned to use the United States' space in Memorial Hall for a general representation of the most meritorious American art from every part of the country.[125] The great west hall designated as Gallery C would include one picture by each eminent artist, "his largest and best," or a group of pictures if the works were small.[126] Only after the paintings and sculptures designated for Memorial Hall were installed would the Art Annex be hung, and there works would be displayed by city, principally New York, Boston, and Philadelphia, "or any other special section."[127] Sartain's plan would ideally create a balance between the local and the national, with a unified presentation in the honored central spaces of Memorial Hall and local communities showcased in the Art Annex.

Plans to allow ample time for hanging fell by the wayside as the opening neared. World's fair planners had always experienced a mad rush of preparation in the last few weeks, and most exhibitions up to this point had opened either late or incomplete. Sartain originally planned to take the entire month of April to arrange the works, but as a result of delays in finishing both Memorial Hall and the Art Annex, works arriving late at Philadelphia, and the Selection Committee's difficulty in finishing its task, the arrangement took place in one frenzied week before the May 10 opening.[128] Construction of the Art Annex was not complete until a month *after* the opening, so the hanging of those galleries was further delayed. As a result, the committee concentrated its efforts on the works in Memorial Hall, which were intended to represent the American canon of the past and the American School of the present. Time pressure, simmering rivalries, and Sartain's presumption of total authority proved disastrous.

Smillie's diary records a contentious few weeks. He arrived with Worthington Whittredge in Philadelphia on April 24. The next day he noted that "the antagonism of Whittredge and Sartain [is] very apparent." The following day Smillie wrote that he was losing patience with Whittredge, who seemed "impractible [*sic*] and bad-tempered." Jervis McEntee also observed fierce arguments between Whittredge and Sartain.[129] Modern scholar Anthony Janson located the source of the trouble in Sartain's refusal to compromise on the poor placement of Whittredge's and other Hudson River School artists' paintings, as they would have interfered with Sartain's plan to give expatriate artists the best locations.[130] Smillie confirmed that Sartain tried to place the work of Whittredge and several of his compatriots in an obscure part of Memorial Hall. He wrote on May 5 that Sartain had "put [Whittredge] out of Mem. Hall (practically) and things had reached such a crisis that something had to be done."[131] Some compromise may have been reached, though perhaps only in the installation of the Art Annex. According to official reports, in that building the president of the National Academy of Design (Whittredge) hung the New York paintings, the president of the New York Society of Painters in Water Colors (Smillie) hung the New York watercolors, the president of the Boston Art Museum (Perkins) hung the Boston works, and so on.[132]

It is astonishing that initially Sartain had to cajole artists to serve on committees and had fretted

about whether enough would participate to make a respectable showing, and just nine months later, the exhibition had become so important to its organizers that Sartain all but locked his adversary out of the proceedings in order to control the shape of the American School. While much of the conflict over the installation was ostensibly based in civic rivalries, it was part and parcel with the controversies over *The Gross Clinic* and *Almeh.* The underlying concerns were embodied in the paintings from artists still abroad and under the direct influence of European technique and subjects, and those works had yet to arrive. In spite of the committee's (or, more accurately, Sartain's) efforts, the installation was far from complete for the May 10 opening, due in part to the late arrival of the works of Americans in Europe. The ship *Supply* finally arrived in Philadelphia around May 13 and began the weeks-long process of unloading the works and transferring them to Fairmount Park.[133] The *New York Herald* reported that the unpacking was still incomplete on May 27, commenting that where the works would be hung in an already crowded Art Department was a mystery.[134] Indeed, it is hard to imagine that expatriate works could have been given their due when they had to be wedged into leftover spaces in the display. Critics and artists awaited the American works from Europe with great anticipation. As late as June 1, Cook hesitated to begin his review because he was waiting for a promised "infusion of new life" that had not yet materialized.[135] The "new life" he awaited was no doubt the paintings and sculptures by expatriates.

In an unusual move for the period, artists were given complete responsibility for assembling not only a representative exhibition of American art, but the most important exhibition in its history. Their letters and diaries show that, charged with a significant mandate and unhindered by the agendas of lenders or nations, they were free to concentrate on philosophical issues of canon building, which turned out to be even more contentious than the issues that had vexed organizers of earlier displays. Sparks of rivalry flew among the artistic leadership of cities with distinct identities, at a time when those identities fell on opposite sides of an important national question. The tinder was the question of how the country's past would reconcile with its present: whether, in the year of the United States' apotheosis, artists should pursue a distinct cultural identity or follow the venerated and admittedly more sophisticated lead of Europe. The flame ignited was the larger question of who held the cultural authority to decide such matters, since the protests centered not only on the expected questions of nationalism and internationalism but also on the sanctity of the selection process.

A small group of painters and sculptors had accomplished the incredibly difficult, complicated task of creating the American exhibition. However, it was only a beginning. Their fellow artists were anxious to see whether their work was included and how well they would be represented. They would be joined by millions of Americans eager to take in the Centennial Exhibition's great summation of American art.

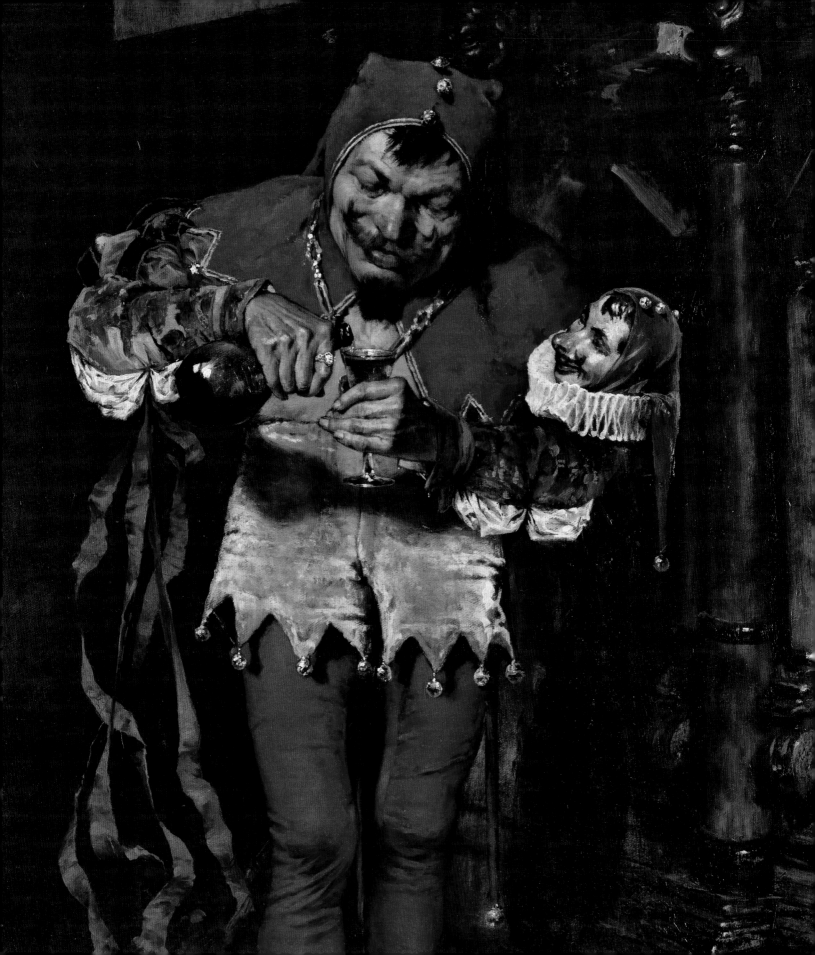

THE AMERICAN ART EXHIBITION
Arguments on the Walls

Several contentious months of planning and preparation produced a formidable exhibition of American art in Fairmount Park's Memorial Hall and the adjoining Art Annex. Artists in the United States were keenly interested in which works would be seen in the display and, just as important, how visitors would perceive the Centennial Exhibition's American art narrative.[1] The search for an underlying logic to the country's historical and cultural development spoke to the need for a triumphal account of American progress that would link the country's illustrious past to its troubled present. It was also a natural outgrowth of the evolutionary impulse that drove world's fairs to show a historical progression of the works of humankind as they moved from lesser to greater sophistication and accomplishment. The history of American art that the organizers created was shaped by their ideologies. Their conflicts sprang

from the difficulty of joining the past to the present. The American School of 1876 would be understood as the culmination of the previous hundred years—but what was its current character, and where was the break between the past and the present?

Most of the millions streaming into Fairmount Park knew little about art or curatorial practices. They would take the exhibition at face value as an accurate accounting of the country's past and a fair representation of its present. They might not have realized what most modern museumgoers have been trained to understand: the curator has a point of view and selects objects from a universe of possibilities that advance that point of view. The power inherent in interpretation is built on assumptions and arguments that are often invisible to the average visitor. It is related to the complex of ideas that French sociologist Pierre Bourdieu called the "habitus": the set of

unspoken dispositions and assumptions that generate common practices in that art world.[2] Another modern sociologist, Steven Lukes, listed three dimensions of power and identified the third dimension as control over which issues are discussed and which are suppressed.[3] He referred to decisions and selections so deeply buried that only those with the highest level of knowledge and authority realize that a choice is being made.

A great deal of power lay in the implicit trust between the organizers of the exhibition and the average visitor, since most fairgoers would unconsciously and unquestioningly accept the narrative set before them. In comparison to the many millions who absorbed the U.S. art display, only a small group of artists, critics, intellectuals, and collectors could identify the strategic placements and note the presences and absences in order to read the arguments presented in the galleries. Those experts could discern the oppositions that reverberated throughout the American galleries, pitting the past against the present, city against city, and nationalism against internationalism.

Though millions of Americans strolled the galleries of Memorial Hall and the Art Annex, there are few accounts of their impressions beyond those of critics writing for publication (whose reactions are addressed in chapter 4). One prominent exception was a 120-page text by painter Xanthus Smith. Born and raised in Philadelphia, Smith trained with his mother, Mary Priscilla Smith, an accomplished watercolorist. He served in the Union navy during the Civil War and painted a series of naval scenes into the 1870s. The detachment that Smith showed in his Centennial Exhibition text is remarkable, since

he was a member of the Pennsylvania Academy of the Fine Arts and would probably have heard about the Selection Committee's nearly wholesale rejection of Philadelphia artists. However, he was represented in the Centennial Exhibition by his painting *The Kearsarge and the Alabama* (Union League of Philadelphia).

As an artist and frequent lecturer, Smith's perspective was very different from that of the average visitor (discussed in the next chapter). He could understand the messages that warring parties had left in the galleries; yet after all the politics, intrigue, and tensions over the preparations, both behind closed doors and spilling into the press, Smith's account was fairly objective and almost entirely free from partisanship. His text provided an illuminating middle ground between the responses of average, relatively uninformed visitors and those of critics immersed in debates about national identity and the decline of the Hudson River School in the wake of new works by expatriates trained in Munich and Paris.

Smith's manuscript included no sweeping introductory or concluding remarks; in fact, it began and ended rather abruptly. He combined observations of technical matters with his aesthetic ideals of harmony, freedom, and originality. His assessments of dozens of key works tended to progress from a visual analysis of the action in the painting, to comments about technical aspects of the work, to more subjective responses to its general effect. Minute, objective observations of technique flowed easily into personal, emotional responses with a sense of confidence and authority natural to one familiar with the effort and craftsmanship involved; he was a veteran viewer who appreciated the importance of a painting's overall

impression. His account opens the way for a survey of the layout of the American art galleries and in particular the inclusions, exclusions, and juxtapositions that formed the exhibition's message about American art, both its status at the time and its future direction.

The artist reserved his comments on the artwork of the United States as the climax of his assessment. The American display was the object of intense attention and some anxiety about how the works would compare to their counterparts from abroad. Like many critics, Smith was pleasantly surprised, writing, "The art exhibit of the United States, taken as a whole, far exceeds my expectations. I felt almost certain that the New York artists would excel in landscape, but I am surprised and pleased to find that both in genre and in the more important figure subjects, we hold a very creditable position along side [*sic*] of the European nations."[4]

Landscapes were a prominent feature of the American galleries, and Smith studied them at length. He tempered his praise of the great names of the Hudson River School, particularly Frederic E. Church and Albert Bierstadt. He considered their work disappointing and noted that they "fall far short" of the paintings of Thomas Hill. Smith recommended that large pictures, which must be viewed at a distance, not be painted with smooth surfaces but rather should be "boldly and vigorously handled" or else they would appear "weak and flat"; he cited Church's monumental *Chimborazo* (fig. 4) as a "dead failure" for that reason.[5]

Smith moved from analyses of artworks to larger observations and comparisons, understanding that a close reading of an exhibition goes beyond individual objects to examine the meanings created

by their selection and arrangement. Similarly, this chapter includes analyses of emblematic works, but it will focus on the "big picture" that emerged from the accumulation of paintings and sculptures. The American art contribution was conceived as an event of national scope and significance, and it had become the most divisive and hotly contested exhibition in the country to that point, though it was part of a deeply felt historical anniversary at a festival intended to show national unity. The American paintings and sculptures in Memorial Hall and the Art Annex were arranged as a summary statement about the nation's art progress. Organizers were aware that their display was not just an interpretation of art over the previous century; the exhibition would itself become posterity, since it was assumed that the Fine Arts Department would be closely scrutinized and long remembered.

The U.S. contribution was divided into three sections: American art of the previous hundred years, American art of the present day, and foreign works owned by U.S. collectors. Though contemporary art was the largest and most-discussed aspect of the exhibition, all three areas were significant. The confrontation of nativist and expatriate paintings by living artists was manifested in the galleries, where huge, meticulously painted landscapes faced off against the suave and exotic figural subjects from recent students in Paris and Munich. The retrospective inspired a widespread consideration of the nation's cultural history, which was used in Memorial Hall to create a lineage legitimizing the emerging expatriates. The group of foreign works owned by Americans, known as the Loan Collection, was an abject failure. However, its link to a stunning success many miles from Philadelphia formed a dialogue

about the power of American collectors in the museum world that is the focus of chapter 6.

Forming an American Past and an American School

As a commemoration of the signing of the Declaration of Independence, the Centennial Exhibition was, by definition, a celebration of early American history, and Memorial Hall included contemporary works paying homage to the United States' revolutionary period. This celebrated period was the one best known to European artists and best suited to historical and allegorical treatment. For example, Charles-Edouard Armand-Dumaresq, a French painter known for modern historical scenes, sent his *Surrender at Yorktown* and *Declaration of Independence* (both unlocated). The Italian sculptor Pietro Guarnerio's *Apotheosis of Washington* (see fig. 63) caused a stir; in the words of modern scholar Susan Hobbs, "Americans were unaccustomed to seeing their leader portrayed as a Roman emperor and carried aloft by Jove's eagle."[6] Phillip Sandhurst dryly commented in his 1876 book, *The Great Centennial Exhibition*, "It is possible to have too much of a good thing."[7]

Naturally, several revolutionary themes appeared in the American section as well. Examples include Archibald M. Willard's *The Spirit of '76 (Yankee Doodle)* (possibly Abbott Hall, Marblehead, Massachusetts), Henry Bacon's *The Boston Boys and General Gage, 1775* (George Washington University Permanent Collection), Daniel Chester French's *The Minute-Man, 1775* (Minute Man National Park, Concord, Massachusetts), A. G. Heaton's *Washington as Ambassador at Fort Duquesne* (unlocated), G. W.

Maynard's *1776* (private collection), W. McDonald's *Bust of Washington* (unlocated), Imogene Robinson Morrell's *Washington Welcoming the Provision Train* (unlocated), and Schussele's *Zeisberger Preaching to the Indians* (Archives of Moravian College, Bethlehem, Pennsylvania).[8] Other works looked to the country's Puritan origins, such as Boughton's *Pilgrims Going to Church* (New-York Historical Society) and Morrell's *First Battle of the Puritans, Won by Miles Standish* (La Tour Camoufle, Paris). However, in spite of the Centennial Exhibition's commemorative occasion, the organizers' political priority was to demonstrate national unity a decade after the end of the Civil War, and subjects from the founding era were valued most as part of a reassuring narrative of American progress.

Since the exhibition was the anniversary of the colonial period's culmination, the display in Fairmount Park is sometimes cited as the genesis of the Colonial Revival, a return to the subjects and styles of the previous century. However, apotheosizing events from the past in history paintings—a centuries-old genre—should not be confused with a return to the colonial style. The Colonial Revival is mainly considered a phenomenon of architecture and decorative arts (which were displayed for the most part in the Main Building and treated as commercial goods), and it has been argued that interest in the nation's founding period began as early as the 1820s and continued well into the twentieth century.[9] The centennial was undeniably an occasion to reflect on the nation's origins, but there were surprisingly few manifestations of it outside a small number of works in Memorial Hall. As modern historian Michael Kammen has observed, the Centennial Exhibition "tended to celebrate the present at the expense of the

past."[10] The colonial presence in the art galleries, and in the Centennial Exhibition as a whole, was minimal.

Much has been made of the "New England Farmer's Home of 100 Years Ago" on the exhibition grounds (fig. 19), a small, rustic building bearing the legend "Ye Olden Time" and populated with women dressed in eighteenth-century costumes, who guided visitors through the parlor, kitchen, and bedrooms. However, this display was not only a celebration of the past, but an affirmation of progress; next to the farmer's home was a structure billed as a "modern kitchen," which included all the domestic conveniences that a century had produced. It was the best-known manifestation of colonial nostalgia at the Centennial Exhibition, but New England kitchen exhibits had become popular in the sanitary fairs that benefited Civil War soldiers in the previous decade, and they continued through the 1893 World's Columbian Exposition.[11] It has been argued that rather than the Centennial Exhibition, the World's Columbian Exposition was the turning point in the Colonial Revival movement because it included a number of features absent from the Centennial Exhibition, such as examples of period architecture, interior decorations, and historical artifacts, along with commemorative activities. Many state buildings presented displays of colonial objects in 1893.[12]

As artists, critics, and the public looked back on their collective past, the American art exhibition provided not just an opportunity but a mandate to gather the country's greatest art achievements from the previous century. The *New-York Times* confirmed these expectations a few months before the opening of the exhibition, assuring readers that "special efforts are to be made to send proper illustrations of the history of

FIGURE 19 *Log Cabin: Ye Olden Time* (detail), 1876. Stereoscopic print. The Miriam and Ira D. Wallach Division of Art, Prints and Photographs: Photography Collection, The New York Public Library.

American art, from the earliest period to the present day."[13] The *Art Journal*'s critic anticipated seeing the most notable American artists, "from Copley to the latest students of Munich."[14] The centennial organizers' early decision to include a retrospective element in the American art display was influenced by retrospectives' growing popularity during the late nineteenth century. The best-known precedent was England's 1857 Manchester Art Treasures Exhibition, which included an incredible sixteen thousand works of art, among them more than a thousand old master paintings.[15]

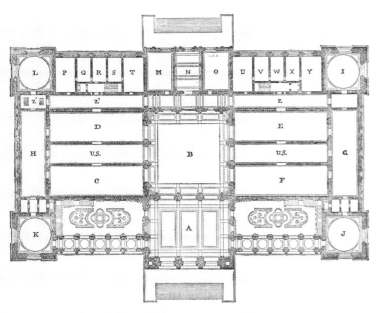

GROUND-PLAN OF MEMORIAL HALL.

A. Italy.	J. Germany.	T. Great Britain.
B. United States, Great Britain, Germany, France.	K. United States, Norway.	U. Italy.
	L. Great Britain.	V. Italy.
C. United States.	M. Russia.	W. Italy.
D. Great Britain.	N. Italy.	X. United States.
E. France.	O. Belgium.	Y. United States.
F. Germany.	P. Great Britain.	Z. Great Britain.
G. Austria.	Q. Great Britain.	United States.
H. Spain and Sweden.	R. Great Britain.	Germany and France.
I. France.	S. Great Britain.	

FIGURE 20 "Ground Plan of Memorial Hall." From U.S. Centennial Commission, *International Exhibition, 1876*, vol. 1: *Report of the Director-General* (Washington, D.C.: U.S. Government Printing Office, 1880), 136. Science, Industry and Business Library, The New York Public Library, Astor, Lenox and Tilden Foundations.

As world's fairs proliferated, organizers found it difficult to attract worthy contemporary works, since they sold quickly, and owners were reluctant to lend them to exhibition after exhibition. The International Exhibition of 1862 in London avoided the problem by displaying British art of the previous hundred years. In like manner, the London International Exhibition of 1871 combined the work of deceased and living artists, and the London International Exhibition of 1874 added a retrospective display of old masters of the participating countries.[16] A similar historicizing impulse developed in the United States. In 1872, the Brooklyn Art Association organized an exhibition of about 260 works billed as the "First Chronological Exhibition of American Art," which included paintings by early masters such as Washington Allston, Joseph Blackburn, John Singleton Copley, Gilbert Stuart, John Trumbull, and Benjamin West.[17]

Two prominent central galleries in Memorial Hall housed the much-anticipated history of American art. One was the long, narrow space that appears on the left half of the Memorial Hall ground plan, sandwiched between Galleries C and D (fig. 20). It is designated only as "U.S.," an exception to the rule of naming the galleries by letter; for lack of a better name, it was known as the Central Gallery West. According to the exhibition catalog, it included many works by widely recognized American old masters, predominantly portraits. Assembling the retrospective was relatively straightforward because the passage of decades had created a consensus about whose works had stood the test of time. At the Centennial Exhibition, Copley, Stuart, and Allston were designated as the founding fathers of the nation's fine arts tradition. William

Dunlap's 1834 *History of the Rise and Progress of the Arts of Design in the United States*, considered the first history of American art, devoted two chapters to Stuart and two to Allston, an honor most artists did not receive (except for Benjamin West and Dunlap himself; Dunlap's autobiography occupied three chapters). Copley, Stuart, and Allston each received a chapter in Henry Tuckerman's *Book of the Artists*, the next major attempt to trace the history of American art, published in 1867. The American Art-Union, a tremendously influential organization in the 1840s, issued medals depicting Copley and Stuart.[18]

The Central Gallery West showcased Copley's portraits of Sarah Morecock (Mrs. Thomas) Boylston (fig. 49) and John Adams (both at Harvard Art Museums); four portraits by Gilbert Stuart; four paintings by Washington Allston, including *Rosalie* (fig. 50) and *Spalatro's Vision of the Bloody Hand* (unlocated); and three portraits by Samuel F. B. Morse. Xanthus Smith commented on his country's historic mastery of the genre: "In portrait the Americans seem particularly to excel, and judging from what one sees in the present exhibition they are not surpassed at any period from a century ago down to the present day."[19] Stuart's and Allston's posthumous reputations were bolstered by more paintings in the Art Annex's Gallery 28. The Peale family of Philadelphia was recognized for contributions to portraiture. However, they were marginalized, just as living Philadelphia artists were: works by Charles Willson Peale and his second son, Rembrandt, were displayed in the Art Annex, scattered among Galleries 30, 40, and 44. Thomas Cole, the esteemed founding father of the reigning Hudson River School, was ubiquitous. His works appeared in numerous galleries in Memorial Hall and the Art Annex.

Such musings on the past inevitably led to an accounting of the present, particularly in the moment of self-reflection occasioned by a world's fair. Judging and selecting the work of living artists was one of the primary functions of international exhibitions. The host nation's purpose was to present itself as one of the foremost exemplars of modernity, so the organizers of the U.S. art exhibition were under considerable pressure to meet the contradictory mandate to show the most progressive works of art from across the country that would also stand the test of time. The opportunity to present a truly national exhibition of contemporary art was rare indeed. The Pennsylvania Academy of the Fine Arts and the National Academy of Design tended to be local in their focus, and private collections reflected their owners' interests. In this early period, major museums sometimes held loan exhibitions of the work of living artists, but they were slow to collect contemporary American art. Their reluctance may have been due in part to the difficulty of predicting which active artists would become part of the historical canon (as the Centennial Exhibition organizers were called upon to do), but it also reflected the museum leadership's low regard for the work of native artists.

The controversies that marked the preparations for the U.S. exhibition vividly illustrate how much was at stake in the representation of the country's contemporary art, and they reflected ongoing debates in the larger art world. A year before the centennial, critic Clarence Cook declared that "we are in the midst of an era of revolution."[20] He referred to the rising popularity of "new men" studying in Europe, such as Frederic A. Bridgman, William Merritt Chase, and Walter Shirlaw (figs. 28, 32, 33). As members of

what was proudly acknowledged as the first American School of art, Hudson River School painters had rightly considered their work to be a national movement. But the popularity of the American landscape school based in New York was swiftly declining by the time of the centennial.[21] Key figures were disappearing: its patriarch, Asher B. Durand, had retired from painting in 1869, Kensett died in 1872, Church developed inflammatory rheumatism in 1876, and, as modern scholar Anthony Janson has observed, the work of Sanford Gifford and Jasper F. Cropsey had become mannered, eccentric, and uninspired.[22] Cultural shifts also militated against the movement. Industrialization introduced a new attitude toward nature among wealthy patrons. Darwin's theory of natural selection shook faith in the moral foundations of the universe that the landscape paintings expressed. Increased travel after the Civil War introduced American artists and collectors to contemporary European styles, particularly that of France, which embraced figure subjects and the looser, more evocative Barbizon style of landscape. The same period also saw the burgeoning popularity of the Munich School.

Artists sensed the change, even if they could not explain it. Jervis McEntee complained that Eurocentric dealers formed public opinion and American artists could not get fair treatment. James Smillie vaguely cited the war, changes in the financial world, and the new accumulation of wealth as causes of the altered sensibility. Whittredge displayed the intense resentment that would erupt at the centennial when he wrote in 1871, "All I care about Europe is its art and artists and what they are doing. I am forced to admire it while I don't like it. I admire their knowledge but despise their souls if one can speak so."[23]

Tensions had been growing for some time between the National Academy of Design's old guard and the new generation of European-trained cosmopolites. The Barbizon-influenced painter George Inness was not elevated to the status of full academician until 1868, long after his more conservative contemporaries Church, Cropsey, and Gifford. In 1874, eight works by John La Farge were rejected from the academy's annual exhibition for a perceived lack of line, detail, and "sentiment."[24] The following year marked the advent of the "new coalition," a group of mostly Munich-based artists that included William Merritt Chase, Wyatt Eaton, and Toby Rosenthal, as well as Bridgman, who was trained in Paris. Chase's work was seen at the National Academy of Design for the first time, as was that of Frank Duveneck, the leader of the Americans in Munich.[25] However, paintings by John La Farge and students of the Boston-based, Barbizon-influenced William Morris Hunt were marginalized. The paintings of Helena de Kay Gilder, Maria Oakey Dewing, Francis Lathrop, and Albert Pinkham Ryder were poorly hung, and other works were rejected outright.[26]

In response, Lathrop and La Farge organized a "protest exhibition" later in 1875 at the Cottier Gallery in New York. It was billed as an exhibition of independent artists, perhaps in imitation of the infamous 1874 Salon des Indépendants in Paris, which marked the debut of the Impressionists. The 1875 exhibition was dominated by Barbizon-influenced works, making it the first such display in the United States. In order to distinguish it from academy exhibitions, La Farge insisted on decorative works, such as his *Fish* (fig. 21), rather

than landscapes and portraits. It was a huge critical success, and in response, the leaders of the National Academy of Design promised fair treatment of the younger artists. Modern scholar Jennifer Bienenstock has suggested that the academy's promise and artists' anticipation of the Centennial Exhibition caused the "new coalition" to delay further action until after 1876.[27] This implies that there were specific expectations for the American art exhibition in Philadelphia and that the Centennial Exhibition played a role in the conflict between the two factions.

Just a few months before the opening of the Centennial Exhibition, a writer for New York's *Evening Telegram* acknowledged the accumulated stresses of the moment: "We have no wish to drag the Centennial into the matter more than is inevitable, but . . . we are cutting our national wisdom teeth. Probably some of the painters at present represented on the walls of the Academy do feel that now or never is the time to justify the wishes and expectations that have been formed for them."[28] The actions of the younger artists were later called "the rebellion of 1876."[29] The following year, some of these artists and sympathetic critics would form a breakaway group called the Society of American Artists. But during the centennial year, the unresolved conflict was vividly illustrated in the American art display at Fairmount Park. Though the formation of the society and its first exhibition in 1877 have received more scholarly attention, that small and relatively isolated event for an elite audience cannot compare with the Centennial Exhibition in the numbers of people who saw it, the coverage in the national press, and the breadth of its contemporary impact.

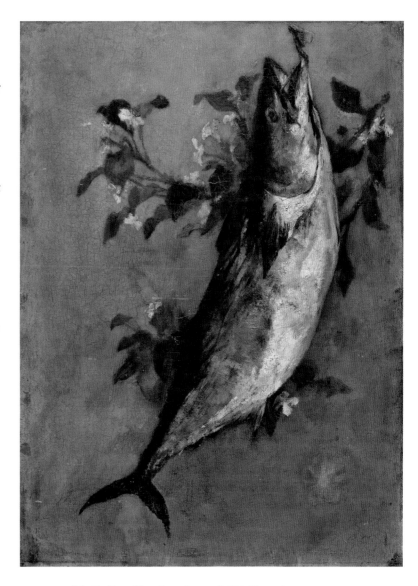

FIGURE 21 John La Farge (American, 1835–1910), *Fish (Decorative Panel)*, 1865. Oil on wood panel, 23 ¾ × 17 ½ in. (60.3 × 44.5 cm). Harvard Art Museums / Fogg Museum, Bequest of Grenville L. Winthrop, 1943.138.

Perusing the Galleries in Memorial Hall and the Art Annex

The display of U.S. paintings and sculptures occupied several galleries in Memorial Hall and the Art Annex. Floor plans of the buildings (figs. 20 and 30) informed visitors which spaces were designated for each country; letters denoted the Memorial Hall galleries and numbers indicated the Art Annex galleries. In the privileged space of Memorial Hall, two central galleries showcased the most esteemed works of the American School. One was the long, narrow Central Gallery West, which also included most of the retrospective of American old masters.[30] More a throughway than a destination, it was a long, narrow corridor connecting the central rotunda to the gallery housing the contributions of Spain and Sweden. A photograph of the gallery (fig. 22) shows a space that seems confined even with no one present. When the galleries were open to the public, it must have been a congested area that made viewing difficult. Unfortunately, the only known image was taken from a sharp angle that offers an excellent view of the pictures' frames—hung from about knee height and extending up to the ceiling, as was customary for the period—but the paintings themselves are difficult to identify. So while the catalog lists the works installed there, their exact positions are unknown.

After months of tensions between Sartain and the New York art community, and his violent squabbles with Whittredge about the arrangement, the galleries evidenced a kind of rapprochement. In addition to early American paintings, the Central Gallery West included a large body of contemporary works by New Yorkers. Hudson River School artists Asher B. Durand, Jasper F. Cropsey, Sanford Gifford, and John F. Kensett (recently deceased in 1872) were abundantly represented. Xanthus Smith warmly praised Kensett's works for being "complete and admirable in design, artistic in effect, the features admirably drawn, the colouring quiet and agreeable."[31] Other New Yorkers also featured prominently: Daniel Huntington of the Selection Committee showed two portraits, and Whittredge himself was present in force with four pictures. Additional notables were Eastman Johnson with four paintings, including his widely acclaimed *Negro Life at the South* (*Old Kentucky Home*) (fig. 36). Numerically, contemporary New York artists were preeminent, with 84 of 141 works in the gallery, in contrast to 12 from Philadelphia and just 3 from Boston. However, some European-influenced painters were represented there, including John La Farge, working in a Barbizon-inspired style; Eugene Benson, an expatriate in Rome; and Thomas Eakins, whose *Chess Players* (Metropolitan Museum of Art) provided something of an antidote to *The Gross Clinic*'s ignominious relegation to the U.S. Army Post Hospital display.

The United States' most prominent space in Memorial Hall was Gallery C, the large gallery in the lower left part of the ground plan. Gallery C was more than twice as large as the cramped space of the Central Gallery West, so visitors could step back to take in larger works, and benches allowed them the opportunity for prolonged contemplation. Sartain's purpose for this space was to showcase the nation's most highly esteemed artists. The south and west walls of this gallery were photographed (fig. 23), and modern scholar David Sellin identified the paintings there (fig. 24), so they can be studied as a representative example of the installation scheme. In general, paintings were

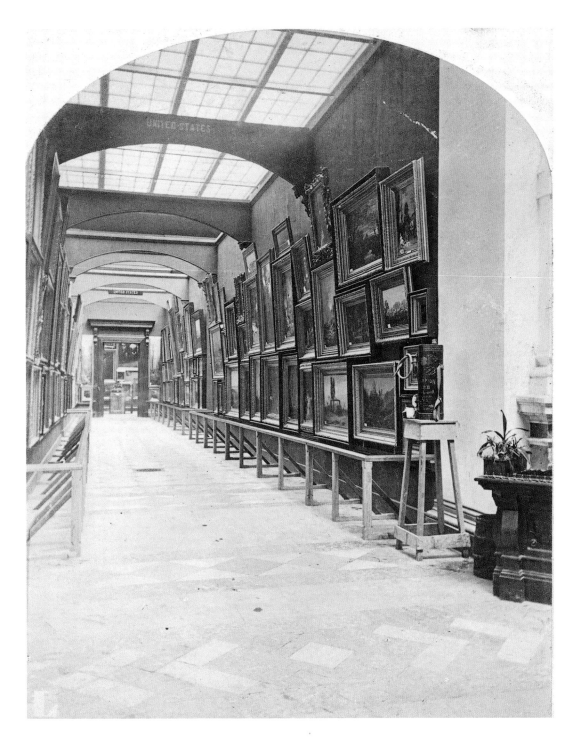

FIGURE 22 Centennial Photographic Company (American photographer, nineteenth century), *Memorial Hall, American Department, Centennial International Exhibition of 1876, Philadelphia (Central Gallery West)*, 1876. Stereoscopic print. Free Library of Philadelphia.

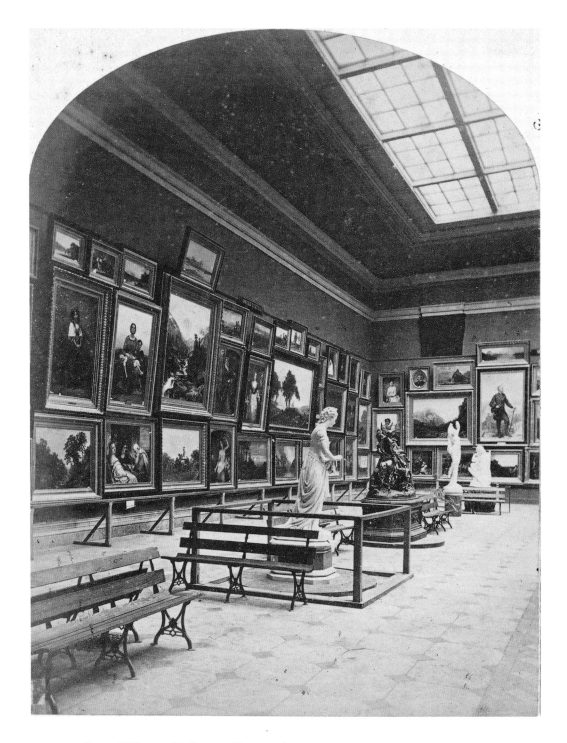

FIGURE 23 Centennial Photographic Company (American photographer, nineteenth century), *Memorial Hall, American Department, Centennial International Exhibition of 1876, Philadelphia (Gallery C)*, 1876. Stereoscopic print. Free Library of Philadelphia.

= requested

= located

= deceased by 1876

UNITED STATES
MAIN GALLERY
IN MEMORIAL HALL

139 H. Roberts, *The First Pose*
140 J. W. Bailly, *Spring*
141 P. F. Connelly, *Honor arresting the Triumph of Death*
142 P. F. Connelly, *Ophelia*
185 E. Johnson, *The Wandering Fiddler*
186 S. R. Gifford, *Fishing Boats of the Adriatic*
187 J. B. Irving, *The End of the Game*
188 W. T. Richards, *The Wissahickon*
189 C. S. Pearce, *L'Italienne*
190 M. Kollock, *Midsummer in the Mountains*
191 C. M. Clowes, *Cattle at the Brook*
192 M. Kollock, *Early Morning in the Mountains*
193 S. J. Guy, *Supplication*
194 D. Huntington, *Sowing the Word*
195 E. Johnson, *The Old Stage-Coach*
196 T. Moran, *The Mountain of the Holy Cross, CO*
197 J. A. Suydam, *Berkeley's Seat, Newport*
198 V. Colyer, *Pueblo—Indian Village*

199 T. Sully, *Portrait—Mrs. T. Sully*
200 H. P. Gray, *The Apple of Discord*
201 W. Whittredge, *Twilight on the Shawangunk Mountains*
202 A. M. Lea, *Portrait*
203 H. Martin, *Adirondacks*
204 E. Seligman, *Love and Pride*
205 C. H. Miller, *A Long Island Homestead*
206 F. Waller, *Tombs of the Caliphs, Cairo*
207 A. Bierstadt, *The Settlement of California*
208 G. H. Smillie, *Lake in the Woods*
209 A. Parton, *Stirling Castle*
210 T. Cole, *Kenilworth Castle*
211 G. H. Story, *Echoes of the Sea*
212 I. Waugh, *An Egyptian*
213 G. H. Story, *The Young Mother*
214 R. M. Staigg, *The Chestnut-Gatherer*
215 J. F. Weir, *The Gun-Foundry*
216 P. F. Rothermel, *Amy Robsart interceding for Leicester*
217 F. James, *Interior of a Smoking Car*

218 J. Neagle, *Portrait of John Taggart*
219 T. H. Smith, *Portrait*
220 G. P. A. Healy, *Portrait*
221 D. Johnson, *Old Man of the Mountain, Franconia Notch*
222 J. McEntee, *Autumn*
223 A. D. Shattuck, *Lake Champlain*
224 E. J. Gardner, *Corinne*
225 H. A. Loop, *Portrait*
226 T. Le Clear, *Portrait—Parke Godwin*
227 C. T. Dix, *Capri*
228 H. Herzog, *Sentinel Rock, Yosemite*
229 E. Leutze, *The Iconoclast*
230 T. W. Wood, *Village Post-Office*
231 J. F. Kensett, *Conway Valley, N. H.*
232 T. Hicks, *General Meade*
233 V. Colyer, *Cascade Mountains*
234 R. C. Minor, *Evening*
235 W. Hunt, *Portrait [Barthold Schlesinger]*
236 J. M. Hart, *A Summer Memory of Berkshire*

FIGURE 24 David Sellin, "United States, Main Gallery in Memorial Hall," ca. 1974. Smithsonian Institution Archives, record unit 459, box 6, folder 47.

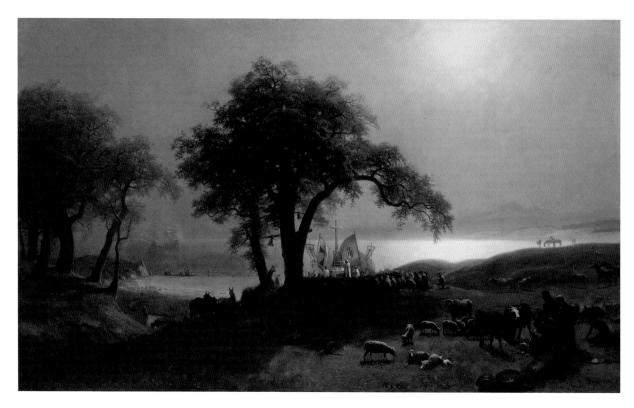

FIGURE 25 Albert Bierstadt (German-born American, 1830–1902),
*Entrance into Monterey (The Settlement of California, Bay of Monterey,
1777)*, 1876. Oil on canvas, 72 × 122 in. (182.9 × 309.9 cm). Collection of
the U.S. House of Representatives.

arranged with large pictures on the line at eye level and
smaller works in rows above and below.

Several large works by well-known artists were
privileged by being hung on the line in prominent
locations, including the expected mammoth land-
scapes, such as Bierstadt's *Entrance into Monterey
(The Settlement of California, Bay of Monterey, 1777)*
(fig. 25). Bierstadt's behemoth depicted a Mass held
under a huge oak tree, which marked the founding of
Monterey, California. It was an eminently appropri-
ate centennial subject that reminded viewers of the

nation's vastness and its religious roots, and Bierstadt
was aggressively lobbying Congress to purchase it for
the House chamber as a pendant to his 1874 *Discovery
of the Hudson River.*[32] Smith objected to Bierstadt's
works, calling them all "very indifferent and two of
them are complete failures from the same cause [inap-
propriately employing minute, careful detail on a large
canvas]."[33] Thomas Moran, Bierstadt's rival for Capitol
commissions, contributed his painting of the storied
mountain in Colorado, *Mountain of the Holy Cross*
(fig. 26), whose northeast face formed a snowfield in

the shape of a cross. This was also a western subject with rich associations to the national feeling of divine dispensation. Fairmount Park was just the latest stop in the painting's tour, which had started the previous year in New York, Boston, and St. Louis.

But other genres took center stage alongside the landscapes, including Eastman Johnson's *The Old Stagecoach* (fig. 27). Smith called it the artist's best work and relished describing the children playing on the abandoned body of a stagecoach. He was particularly charmed by the artist's rendering of the boy climbing onto it from behind, calling it "a capital piece of painting, tender, sunny, and touched in with that happy precision which conveys a good thing without apparent labour or effort."[34]

It is not surprising, given the short time frame and difficult circumstances surrounding the hanging process, that the arrangement does not suggest a purpose or pattern. Little can be inferred from artworks' actual placement in the galleries, but some conclusions can be drawn from which paintings and sculptures were selected for these important spaces. The narrow, confined Central Gallery West housed twenty-eight works by artists of the past—that is, deceased artists—suggesting that this gallery represented the historical canon. By contrast, the more expansive Gallery C included only twelve works by dead artists, and of those, most were recently deceased, such as Kensett, Emanuel Leutze, Thomas Sully, and J. A. Suydam.[35] Gallery C included many more works by emerging young American painters. For instance, while there were no paintings by Winslow Homer in the Central Gallery West, two were hung in Gallery C: *Snap the Whip* (Metropolitan Museum of Art) and *The*

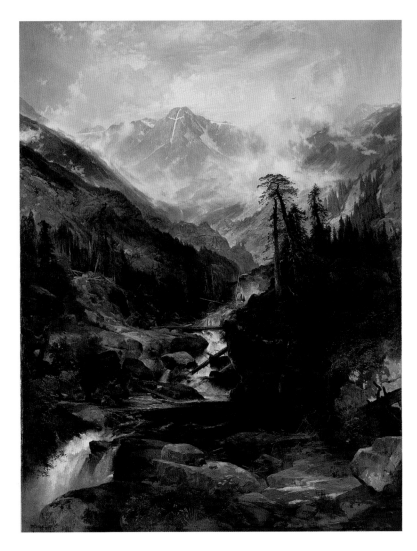

FIGURE 26 Thomas Moran (English-born American, 1837–1926), *Mountain of the Holy Cross*, 1875. Oil on canvas, 82 ⅛ × 64 ¼ in. (208.6 × 163.2 cm). Autry Museum, Los Angeles, 91.221.49.

FIGURE 27 Eastman Johnson (American, 1824–1906), *The Old Stagecoach*, 1871. Oil on canvas, 36 ¼ × 60 ⅛ in. (92.08 × 152.72 cm). Layton Art Collection, Inc., Gift of Frederick Layton, at the Milwaukee Art Museum, L1888.22.

American Type (unlocated).[36] Four paintings by the Dusseldorf-trained Eastman Johnson were there, including *The Old Stagecoach* and the figure piece *Catching the Bee* (Newark Museum, New Jersey). While the Central Gallery West represented the nation's history, Gallery C was dominated by artists of the present day.

Gallery C included more than twice the number of paintings by artists from Boston and Philadelphia, cities that tended to support expatriate artists, than did the Central Gallery West. It also included a strong representation of artists who had either trained abroad or still resided in Europe, such as Benson, Bridgman, Eakins, G. P. A. Healy, Hunt, La Farge, H. H. Moore, H. M. Nilson, Charles Sprague Pearce, and Toby Rosenthal. Xanthus Smith considered Bridgman's *The Peacock Fan (Flower of the Harem)* (fig. 28) "a rich powerful work" and a representative example of the artist's abilities as "a strong colorist, and a wonderful realizer of characters and still life objects. He draws and models well, and introduces a great deal in his pictures."[37]

Bridgman exemplified the strong presence of expatriates at the Centennial Exhibition. In 1876, he was considered one of the most promising young Americans working in Paris. His exotic subjects inspired by his trips to North Africa were well received by U.S. collectors; in fact, his five paintings in the Centennial Exhibition were all lent by Americans.[38] Unlike Moore, whose risqué *Almeh* provoked controversy, Bridgman tempered his work in ways that suited U.S. patrons. He sometimes used Western models instead of citizens of African countries (who were often reluctant to pose). Some viewers might have been startled by the artist's close up portrait of a dusky woman in a dazzling exotic costume, who gazes directly and sensuously at the viewer. However, until later in his career, he declined to follow the example of his master, Jean-Léon Gérôme; he rarely painted exposed limbs, but draped his figures in layers of silks and voiles.[39]

Sculpture in Gallery C was dominated by expatriates such as P. F. Connelly and Howard Roberts, whose full-scale *La Première Pose* (fig. 80) sexualized the ideal nude by capturing the cringing modesty of a new artist's model. The emphasis on foreign-trained artists is confirmed by the fact that the only prominent painting in the room by a long-deceased American old master was John Vanderlyn's *Ariadne* (fig. 10). Smith considered this monumental nude to be one of the most important figure subjects in the exhibition.[40] Painted by the country's first well-known expatriate to Paris, it connected the works of foreign-trained painters to the early history of the country's artistic development.

While the crowded, congested Central Gallery West was dominated by the paintings of deceased

FIGURE 28 Frederic A. Bridgman (American, 1847–1928), *The Peacock Fan (Flower of the Harem)*, 1875. Oil on canvas, 28 ¾ × 23 ½ in. (73 × 59.8 cm). Bonhams, November 6, 2013, lot 90.

artists and the Hudson River School, the grand Gallery C represented the young artists of the day, with a high proportion of foreign-trained painters and works from Philadelphia and Boston, cities known for their sympathies to those influences. It seems that Sartain cleverly linked the New York landscapists to the past and European-influenced figure painters to the present. In this way, the Hudson River School artists could not inherit the mantle of history—they already were history. The two galleries subtly conveyed the message that the time of the New York landscape

FIGURE 29 Edmonia Lewis (American, 1844–1907), *The Death of Cleopatra*, ca. 1876. Marble, 63 × 31 ¼ × 46 in. (160 × 79.4 × 116.8 cm). Smithsonian American Art Museum, Gift of the Historical Society of Forest Park, Illinois, 1991.4.17.

While the comparison of nativist landscape artists with expatriates was a focus of attention, other galleries in Memorial Hall were of interest as well. The grand Central Hall, also called Gallery B, was a large square space in the middle of the building that showcased forty-five pieces of American sculpture. As might be expected, the sculptors represented were almost entirely expatriates, since at that time instruction, resources, and opportunities were still most easily found abroad. Most were originally Philadelphia natives whose work was available in local collections.[41] The neoclassical style, though quickly falling out of vogue, still held sway in Rome and Florence, and Gallery B included large groups of neoclassical works such as P. F. Connelly's *Thetis and Achilles* (Metropolitan Museum of Art), William W. Story's *Medea* (Peabody Essex Museum, Salem, Massachusetts), and Vinnie Ream's *The West* (Wisconsin State Capitol, Madison). Even the young Augustus Saint-Gaudens, who would soon bring the Parisian Beaux-Arts style to the United States, contributed his bare-shouldered bust *William Maxwell Evarts* (fig. 84), which showed the effects of his time in Rome.

The remaining U.S. spaces in Memorial Hall were smaller and less prominent. Gallery K, in the southwest corner of the building, housed the very popular *Death of Cleopatra* (fig. 29) by Edmonia Lewis, an orphan who was half African American and half Chippewa (Ojibwe). *Cleopatra* caused a stir because it depicted the Egyptian queen in her death throes, rather than in her more composed state just before being bitten by a poisonous snake, as in William Wetmore Story's famous version of 1858 (Metropolitan Museum of Art).[42] The *New-York Tribune* noted that a brightly colored canopy had been erected over *Cleopatra*, and the artist appeared

school had passed, and the expatriates' time had come. The installation thus was more than a motley accumulation of pictures hung cheek by jowl. Sartain had fought fiercely to carry out his plan, and his juxtapositions legitimized the expatriates as the continuation of an American tradition while relegating the Hudson River School to the dustbin. While acknowledging the school's importance, the arrangement also placed it firmly in the realm of the past.

at 6:00 P.M. every day to dust the statue and cover it with a cloth.[43] The *New York Herald* reported that Lewis was also present daily at a stand in the Art Annex near her *Old Arrow Maker* (Smithsonian American Art Museum) and her busts of the abolitionists John Brown and Charles Sumner (both unlocated).[44] Lewis received considerable media notice, not only for her gender and her novel origins, but also for her sensational sculpture and her striking presence at the exhibition. It has been suggested that she exploited her heritage and courted attention with her unconventional methods.[45] Such efforts, whether intentional or not, helped her break through the barriers of race and gender.[46]

The U.S. spaces in Memorial Hall were intended to create a unified, national American School, but in the Art Annex, civic identity was openly acknowledged. The United States occupied several rooms on the west side of the annex, the lower left-hand side of the ground plan (fig. 30). In contrast to Memorial Hall, where Sartain appears to have dominated the arrangement, the annex galleries were arranged by the presidents of representative organizations from each city. Though the overarching goal of the American art display was to present a single narrative, the strong civic identities manifested in the annex bespoke resistance to this nationalizing impulse, which would grow weaker as New York took its place as the country's cultural center.

Galleries 6 and 14 in the lower left part of the ground plan were the U.S. spaces closest to the main entrance. They were arranged by Worthington Whittredge and largely displayed more paintings by the old guard of the National Academy of Design, including two each by Bierstadt, Cropsey, Durand,

GROUND-PLAN OF ART ANNEX.

1. ITALY.	16. UNITED STATES.	29. PORTUGAL.
2. ITALY.	SUPERINTENDENT'S OFFICE.	BRAZIL.
3. ITALY.	17. ITALY.	30. UNITED STATES.
4. ITALY.	18. UNITED STATES.	31. SPAIN.
5. NETHERLANDS.	19. ITALY.	32. FRANCE.
6. UNITED STATES.	20. UNITED STATES.	33. BELGIUM.
7. NORWAY.	21. FRANCE.	34. FRANCE.
DENMARK.	NETHERLANDS.	35. FRANCE.
8. UNITED STATES.	22. UNITED STATES.	36. FRANCE.
9. ARGENTINE REPUBLIC.	23. BELGIUM.	37. FRANCE.
CHILI.	NETHERLANDS.	38. FRANCE.
MEXICO.	24. UNITED STATES.	39. BELGIUM.
10. UNITED STATES.	25. SPAIN.	40. UNITED STATES.
11. SWEDEN.	SWEDEN.	41. BELGIUM.
12. UNITED STATES.	26. CANADA.	42. UNITED STATES.
13. NETHERLANDS.	27. PORTUGAL.	43. FRANCE.
14. UNITED STATES.	ARGENTINE REPUBLIC.	44. UNITED STATES.
15. NETHERLANDS.	BRAZIL.	45. FRANCE.
	28. UNITED STATES.	

FIGURE 30 "Ground Plan of Art Annex." From U.S. Centennial Commission, *International Exhibition, 1876*, vol. 1, *Report of the Director-General* (Washington, D.C.: U.S. Government Printing Office, 1880), 138. Science, Industry and Business Library, The New York Public Library, Astor, Lenox and Tilden Foundations.

and *Cotopaxi* (Detroit Institute of Arts). *Chimborazo* would have dominated the small space of Gallery 6. Smith criticized Church's careful technique as inappropriate for a canvas so large: it was "wrought up in every part with the utmost minuteness of touch & detail, and smoothness of surface, as if it were no more than a foot square."[48] The small galleries of the Art Annex must have contributed to that impression, since, as Smith pointed out, such large works required sizable spaces so that the viewer could properly appreciate them from a distance.

A stereoscopic view (fig. 31) shows Gallery 14 with Chauncey Ives's sculpture *Nursing the Infant Bacchus* (unlocated) at the far left, G. Turini's sculpture *The Rainbow* (unlocated) in the foreground, Huntington's *Philosophy and Christian Art* (Los Angeles County Museum of Art) in the lower left corner, and Henry Peters Gray's *The Wages of War* (Metropolitan Museum of Art) diagonally above it on the right. The most acclaimed works in the gallery were Whittredge's three contributions, *The Pilgrims of St. Roche* (Adams Davidson Galleries, Washington, D.C.), *Woods of Ashokan* (Chrysler Museum of Art, Norfolk, Virginia), and *Rocky Mountains, from the Platte River* (Century Association, New York); the latter can be seen to the right of the Huntington painting.

Gallery 28, just across the transverse corridor, was arranged by Charles C. Perkins, president of the Boston Art Museum. It contained pictures by Boston's old masters Allston and Stuart; multiple works by less familiar names, such as W. M. Brackett; and paintings by Boston Selection Committee members Thomas Robinson and R. M. Staigg. It also included a healthy representation of artists who worked and studied abroad, such as J. Foxcroft Cole, Frank D. Millet, and

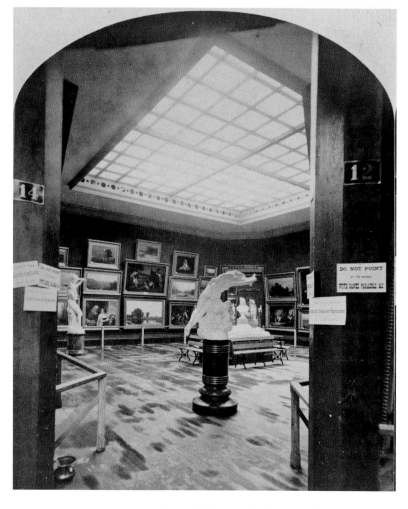

FIGURE 31 Centennial Photographic Company (American photographer, nineteenth century), *Memorial Hall Annex, American Department*, 1876. Stereoscopic print. HSP Collection of Centennial Exhibition Records (Coll. 1544), Historical Society of Pennsylvania, DAMS #13946.

and Kensett; three by Whittredge; and five each from Gifford, Huntington, and McEntee.[47] Church's mammoth *Chimborazo* (fig. 4) continued the tradition of his much-heralded South American scenes, such as *Heart of the Andes* (Metropolitan Museum of Art)

Edwin Lord Weeks, and most notably Hunt's *The Boot Black* (unlocated). Daniel Chester French's bronze *The Minute-Man, 1775* provided a rare glimpse of the naturalistic style that would characterize American sculpture in the coming decades.

Gallery 30, next door, included paintings by Philadelphia luminaries (such as Peter F. Rothermel and Christian Schussele) and may have been hung by Sartain himself. The gallery also held works from painters residing in Paris, Rome, and Munich and a few paintings from artists of Chicago, Baltimore, and other cities. In addition, it included three paintings by Sartain's friend Thomas Moran, who, as a resident of Newark, New Jersey, might otherwise have been seen in the New York gallery.

Gallery 40 included a mix of works from farther-flung cities, such as New Orleans, Minneapolis, St. Louis, and San Francisco (lest viewers forget that art was being created outside New York, Philadelphia, and Boston). Gallery 42 became infamous for housing the works that Sartain had smuggled in from the Pennsylvania Academy, in particular Moore's *Almeh: A Dream of Alhambra* (fig. 17). Gallery 44 was dominated by portraits, many by deceased artists, along with eleven sculptures by R. H. Park of Florence. In Gallery 22, sculptures by Edmonia Lewis and John Rogers were installed among etchings and lithographs.[49]

Gallery 10, on the leftmost edge of the ground plan, held for the most part paintings from Americans in Rome, Paris, and Munich. Many of these came from stateside collections and so were probably available for hanging at an early point, but others may have been late arrivals that were shipped from Europe. One of the most notable

was Chase's *"Keying Up"—The Court Jester* (fig. 32). Chase's rendering of a jester taking a drink before his performance was painted in Munich, where comic costumed scenes were popular. The rich red and brown palette and his remarkable facility identified the work with his training there. Another was Walter Shirlaw's *Toning the Bell* (fig. 33); the well-realized figures, strong tonal contrasts, and limited palette evidenced his study in Munich, as did the subject, a bell founder and a violinist, taken from Bavarian life.[50]

Overall, only about 100 paintings of approximately 700 in Memorial Hall and the Art Annex were from Philadelphia artists, compared to 252 from New York and 90 from Boston. Because the Selection Committee had rejected most of the works at the Pennsylvania Academy's spring exhibition, in terms of sheer numbers New York artists dominated the exhibition.

The American School in Transition

Specific presences and, just as important, certain absences at the exhibition shaped its polemical character. Earlier studies characterized the American contribution to the Centennial Exhibition in terms of the Hudson River School's dominance, which is understandable given the size of the works and their placement in the central galleries of Memorial Hall.[51] However, close examination reveals a strong challenge from foreign-trained artists. The Centennial Exhibition took place at the height of the Munich School's popularity. Eighteen canvases from expatriates in Munich were displayed, and while not large

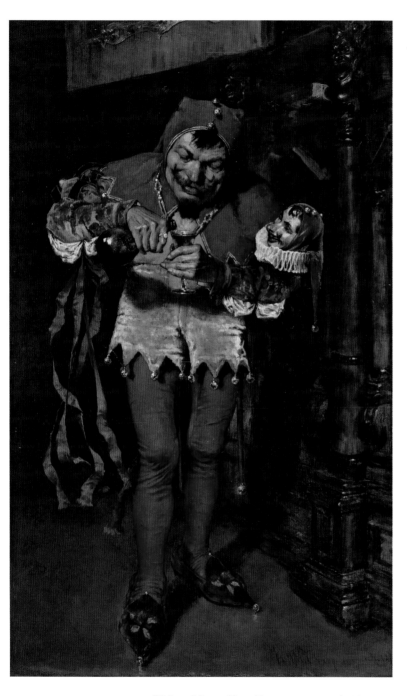

FIGURE 32 William Merritt Chase (American, 1849–1916), *"Keying Up"—The Court Jester*, 1875. Oil on canvas, 39 ¾ × 25 in. (101 × 63.5 cm). Courtesy of the Pennsylvania Academy of the Fine Arts, Philadelphia. Gift of the Chapellier Galleries, 1969.37.

in number, the contribution included the best works of its most esteemed painters, including Chase's and Shirlaw's pictures and Toby Rosenthal's large narrative work *Elaine* (fig. 48), which was prominently displayed in Memorial Hall's Gallery C.

Paris was just beginning to emerge as a center for Americans studying abroad, and it was well represented at the centennial—though its strong presence was not immediately apparent and has passed unnoticed by scholars, probably because of a patriotic deception. According to the exhibition catalog, seventeen artists contributing twenty-five works listed their residence as Paris, including E. F. Andrews, Henry Bacon, Elizabeth Jane Gardner, and Clementina Tompkins. The catalog provided somewhat misleading information for another eleven artists with an additional thirty paintings, more than doubling the number. They were designated as U.S. residents, but the cities listed appear to have been their homes when stateside, rather than their current locations, since these artists, including Edwin Howland Blashfield, Bridgman, G. P. A. Healy, and Charles Sprague Pearce, all exhibited paintings at the Paris Salon of 1876 and listed Paris addresses in the salon catalog.[52] Most of these works were submitted to the Centennial Exhibition not by the artists themselves but by collectors who, for some reason, perhaps nationalistic pride, listed the artists' stateside homes as their residences. These artists were known for their embrace of orientalism and the Beaux-Arts ideal, and they provided a strong cosmopolitan counterpoint to the Hudson River School's presence in Memorial Hall.

There were several expatriate works in the Central Gallery West and 10 in the prestigious Gallery C, including 3 by the orientalist Bridgman (including *The Peacock Fan [Flower of the Harem]*, fig. 28) and 1

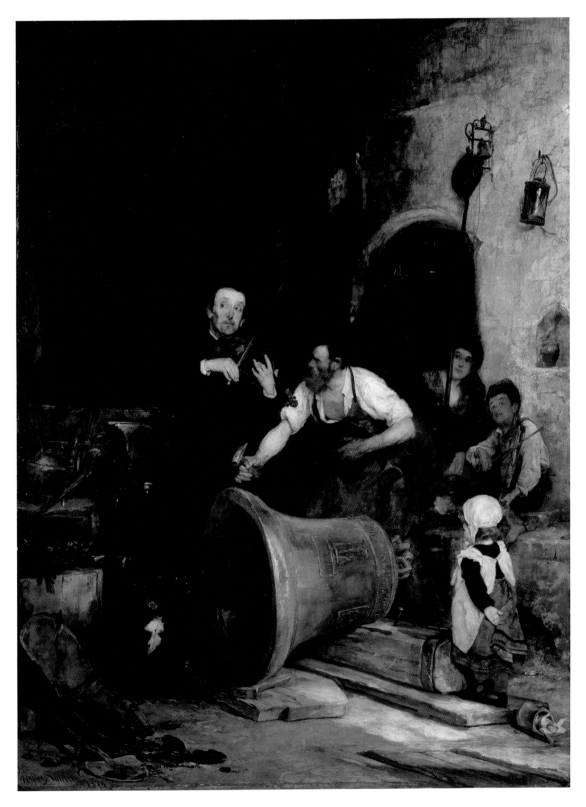

FIGURE 33 Walter Shirlaw (American, 1838–1909), *Toning the Bell*,
1874. Oil on canvas, 40 × 30 in. (101.6 × 76.2 cm). The Art Institute of
Chicago, Friends of American Art Collection, 1938.1280.

by Charles Sprague Pearce. Several of the galleries in the Art Annex were seeded with 4 or 5 paintings by Paris expatriates, and in Gallery 10, 18 of 55 paintings, or one-third, came from American hands influenced by French teaching and practice. Overall, paintings by expatriate artists totaled 106, far exceeding the 78 that represented the Hudson River School.[53] Of course they were displayed less advantageously, since only 22 were installed in Memorial Hall, but many were in Gallery C, a space prominently devoted to the artists of the present. Against all expectations, the expatriate presence rivaled that of the resident landscapists.

The overwhelming majority of paintings and sculptures were from eastern states, with only about thirty works from the Midwest, mostly Chicago and Cincinnati; four from the far West (namely, San Francisco); and a small group from southern cities such as Lenoir, North Carolina, and Louisville, Kentucky. Most of the remaining works (except those of the expatriates) were from the large East Coast cities of Boston, New York, and Philadelphia, with a few from Washington, D.C. The Centennial Exhibition was a graphic demonstration of the East Coast's continuing cultural hegemony.

The most notable void in the display was the lamentably minimal showing of the American Barbizon landscape school. While the average visitor would not have noticed the absence, artists and critics would have regretted the yawning gap in the representation of these American landscape paintings. The school's two chief practitioners were George Inness and William Morris Hunt. Inness was broadly recognized in 1876 and had been a member of the National Academy of Design for several years. Unfortunately, during 1875 and 1876 he was involved in a lawsuit with

the Doll and Richards Gallery in Boston that tied up his paintings with the plaintiff.[54] None of his works appeared at the Centennial Exhibition, and he did not contribute to the National Academy of Design exhibition that year either, so he may have been distracted from painting by his difficulties and was unable to lend any finished works.

William Morris Hunt was Boston's leading advocate of the Barbizon school, and he was still active in the 1870s. However, Hunt was a famously insular painter with a growing cantankerous streak, and he had little interest in being involved in the centennial art exhibition. When queried, he answered, "I don't know why I should take the time and trouble to go about and collect my pictures, and send them off at my own risk. I have nothing in my studio that I care to send. If those who own pictures of mine would send them, I should not object to it, but I don't care enough about the matter to waste time over it."[55] Hunt was probably not exaggerating when he said he had nothing that he wished to send. A tragic fire in 1872 had destroyed the contents of his studio, and his recent works were on exhibition at the Boston Art Club.[56] He was represented by two loans from collectors, but neither was a landscape.[57]

Homer Dodge Martin, who would become one of the leading exponents of the new landscape school, was that very year on a pivotal trip to Europe that would convert him to the new aesthetic. His *Adirondacks*, lent to the Centennial Exhibition by New York's Century Club, reflected his earlier, more traditional style, not the one that would characterize his work from 1876 on. The exhibition did include a few Barbizon-influenced works, such as La Farge's *Bishop Berkeley's Rock, Newport* (Metropolitan Museum

of Art), but overall the unfortunate confluence of circumstances surrounding Inness, Hunt, and Martin left a void in the representation of the Barbizon style in the United States that could have bridged the gap between the extremes of the American landscape and foreign figural styles. In their absence, the two seemed even further apart and virtually irreconcilable.

Xanthus Smith made only one remark that betrayed any interest in the debates playing out in the galleries at Fairmount Park: he noted that "from the circumstance of some of our painters studying solely our own scenes and others working abroad in different European schools, the subjects and modes of treatment are extremely various, and if originality is to be considered as one of the first qualities in a painter, then our home workers have the advantage."[58] In spite of his approval of a number of expatriate works, he offered the palm to his country's native painters, largely represented by landscapes, contributing to a long-standing impression that the Centennial Exhibition's American art exhibition represented the apotheosis of the Hudson River School.

However, in spite of the Hudson River School's strong presence, Sartain's efforts yielded a vivid representation of rising foreign styles. The Hudson River School paintings were large, well placed, and easily recognizable, making the expatriates' visual challenge a remarkable feat. The display that Sartain orchestrated signaled the decline of the American landscape school and brought the issue of an American School to a national forum. Artists fought over the selection and installation precisely because they understood the Centennial Exhibition's potential power in shaping a narrative of American art. In 1876, artists emerged as arbiters of culture and flexed their muscles in a curatorial role. It was not the first time, but never before had the stakes been so high, nor so universally and publicly recognized. The importance is only confirmed by the subtle but unmistakable messages that Sartain conveyed with a strategic and judicious (albeit autocratic) installation.

The conflicts over the installation and the ideological messages that it conveyed were based on the exhibition's significance as an educational exercise for a national and international audience of millions, many of whom were having their first encounter with fine art in a museum setting. Their experiences in the galleries made the Centennial Exhibition a singular event, and their responses were an important gauge of the art display's success. The art world usually watched intellectuals, critics, and collectors for their reactions to important exhibitions. But now that world turned, with some trepidation, to the everyday visitor to Memorial Hall.

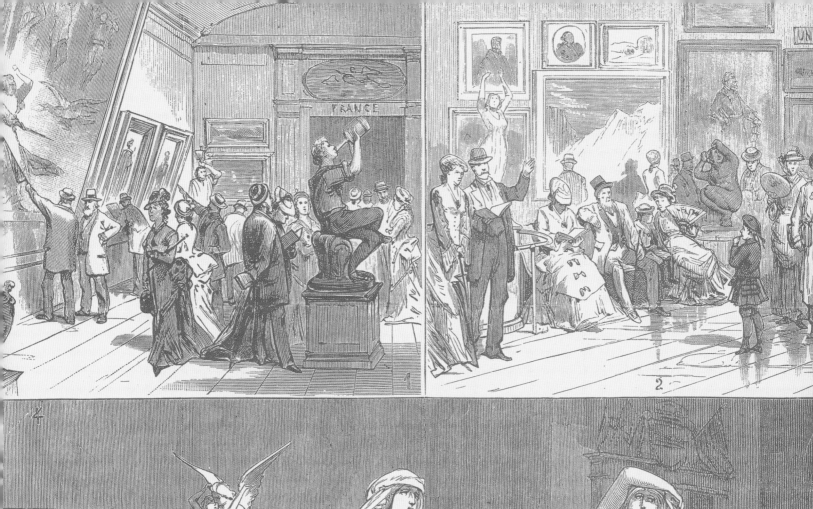

PART II

VIEWERS
AND CRITICS
Responses to the Exhibition

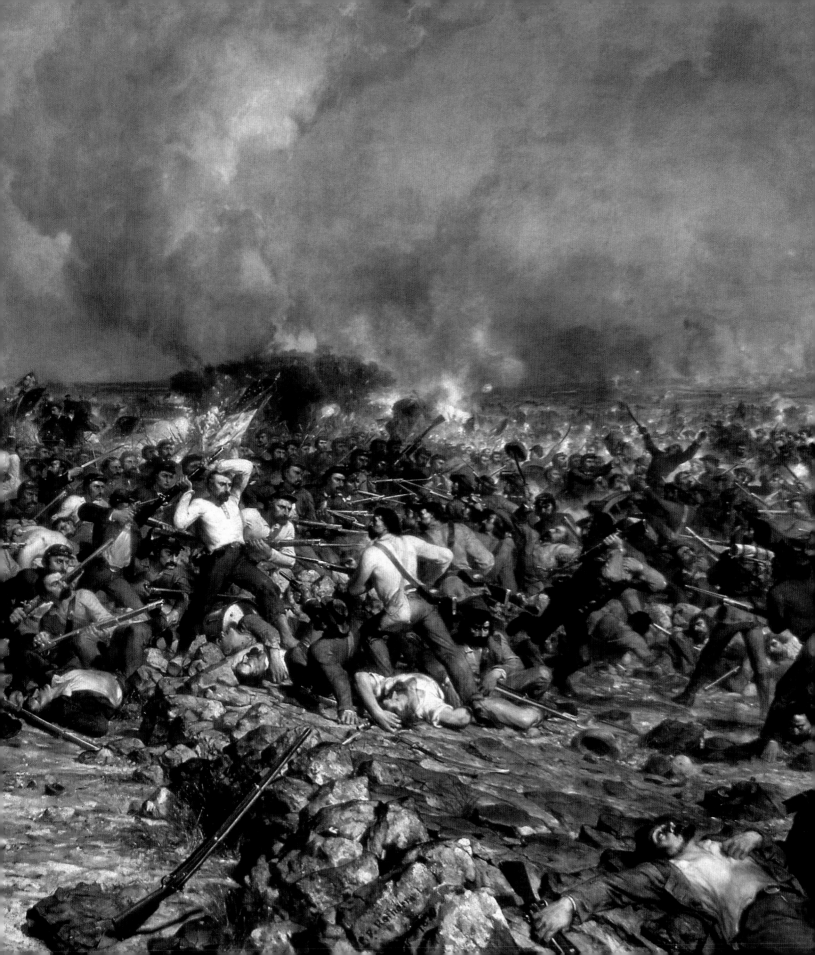

EXPERIENCING THE NATION'S FIRST BLOCKBUSTER EXHIBITION

The Centennial Exhibition was perhaps the first event in U.S. history that was a shared national experience demanding each citizen's participation; every American had to decide whether he or she would travel to Philadelphia to honor the nation's birth and see the spectacle there. The masses of visitors to the city became a point of rueful humor for local residents; there were cartoons like "A Time to Remember One's Relations" (fig. 34), in which a stranger tried to convince a Philadelphian that they were kin so that his group could stay at the Philadelphian's home. The song "The Great Centennial: A New View of the Matter" described one citizen driven to the ultimate transgression:

> Now what on earth is one to do?
> From London, Paris, and Peru,
> I've even heard from China too

> About the Great Centennial
> This gush of friendship's very well
> But I shall have a tale to tell,
> My house is not a great hotel,
> As vast as the Centennial.

> I think I know what I shall do
> When opens the Centennial—
> I'll let my house just as it starts,
> Pick up my traps, and maps, and charts,
> Be off and visit foreign parts
> And shirk the Great Centennial.[1]

Written accounts of the fair proliferated. For those who attended, they served as a souvenir, and for those who did not, they were a surrogate for experiencing the great event. One of the most popular was Marietta Holley's travelogue *Josiah Allen's Wife as a*

FIGURE 34 American School, "A Time to Remember One's Relations," 1876. Lithograph. Free Library of Philadelphia.

P.A. and P.I.: Samantha at the Centennial. It was part of a series of humorous books narrated by the fictional character Samantha Allen, a solid, middle-aged woman, unsophisticated but brimming with common sense, warm feelings for her compatriots, and affection for her cantankerous husband. Her travels bring her into contact with a variety of people and places that she observes with folksy wisdom, advocating for women's rights, temperance, and racial tolerance while lampooning exaggerated sentiment, fashion, and the literary caricatures of women that populated

many of the day's romantic novels.[2] During her lifetime, Holley was placed on a footing with Mark Twain, who paid her the kind of backhanded compliment that can only come from a competitor when he called *Samantha at the Centennial* "brilliant, a grand improvement on [her] first [book]."[3]

Samantha and her husband, Josiah, are country folk for whom everything is new, but they are not rubes; rather, their unsullied vision allows them to point out cosmopolitan foibles with native common sense. Though Samantha Allen was fictional, Holley's readers expected to learn about the real exhibition in Fairmount Park from her tale, and the book includes detailed descriptions of the various buildings through Samantha's eyes. However, readers might have been surprised to learn that Samantha's observations were fiction too, based on other written accounts. The author never visited the Centennial Exhibition; she drew her account of the fair, including a chapter devoted to the art galleries, from the many available maps, guidebooks, and published descriptions, as she did for all of her "travel" books.[4] Samantha served as a surrogate for those who did not see the great fair and an aide-mémoire for those who did. The Centennial Exhibition's ubiquity demanded that everyone experience it, but some had the distinction of seeing it with their own eyes, and others formed impressions of the exhibition based on written accounts.

The public assumed an unprecedented significance at the Centennial Exhibition. The world's fair took place during the founding era of great art museums, and the question of who would visit them was of heightened concern to the exhibition's planners. In 1870, George Fisk Comfort had called for the establishment of encyclopedic art museums

in major American cities. The decade that followed saw the founding of the Museum of Fine Arts in Boston, the Corcoran Gallery in Washington, D.C., and the Metropolitan Museum of Art in New York. In 1876 these institutions were in their precarious years of infancy and were far from the august temples of art revered by the faithful today. During the centennial year, the Museum of Fine Arts inaugurated an impressive new building in Boston's Copley Square, but few paintings were exhibited through the 1880s, and some, especially the Dowse collection of watercolors, were dim copies of European paintings, intended for educational purposes. The Metropolitan Museum of Art occupied a townhouse on West Fourteenth Street and was just beginning to build its collection. In 1871, the institution had taken possession of an impressive group of 175 old master paintings, mostly by sixteenth- and seventeenth-century Flemish and Dutch painters, including van Dyck and Rubens. However, in the years following, the institution remained dependent on gifts, which ranged widely in character and quality. The Corcoran differed in nature, having been built from the funds and collection of one private benefactor, William W. Corcoran, rather than by a group of citizens from the ground up. Corcoran's impressive collection was housed in the building that is now home to the Smithsonian Institution's Renwick Gallery.

The support and sanction of the U.S. government made Memorial Hall a model national museum that was meant to include masterworks from all over the world, far surpassing any other museum in the country at that time in size and scope. The exhibition it housed attracted an audience of unprecedented size from beyond the East Coast, who came to have what was, for many, their first fine art experience. Their overwhelming numbers made the general public a force to be reckoned with, and collectively they would play an important role in defining the nation's popular engagement with the fine arts.

The crowds that filled the galleries did not know what power they wielded. During a period newly occupied with proper deportment, their unconscious responses to the physical environment and the paintings and sculptures, their remarks, their gestures, and their level of comfort, ranging from awkwardness to dangerous presumption, were carefully noted—and interpreted—by observers and commentators. Visitors' responses became not only a referendum on the state of American culture but also a national lesson on codes of behavior and modern modes of perception. For those who attended, the exhibition was a tutorial imposed by their cultural "betters" and enforced by the press as part of a national taste-making project. Those who did not attend learned from admonitions in newspapers, journals, and accounts like Samantha Allen's. For most Americans in 1876, their history was still largely transmitted from popular texts, from the pulpit, in the classroom, or at the home hearth, which formed collective memories and legends. The national impression of the fine arts exhibition would be similarly conveyed through innumerable individual experiences. The collective memory of those shared experiences would inform how the public would engage with art in their own communities all over the country when they returned home.

In examining the fine arts exhibition, the works on the walls tell only half of the story. The museum

encounter is a dialogue between viewers and works of art; the visitor completes the encounter by contemplating the art object and responding to it. Fairgoers' perceptions were affected by the environment of the galleries, including the lighting, the temperature, and the sounds they heard. They were often stymied by the American art display's overwhelming size and confusing catalog. Even other visitors' behavior affected their experience. Recreating the circumstances of the American art display gives a sense of how the public and critics perceived the paintings and sculptures they saw as they wandered from gallery to gallery and how certain paintings shaped their overall experience. It also illustrates the development of a new kind of perception and the enforcement of new codes of behavior on a massive scale, as millions of visitors were given lessons in viewing and understanding works of art, even some that inflamed passions and stirred painful memories.

Strolling in the Galleries

The Centennial Exhibition buildings were open every day until 7:30 P.M.; the buildings were closed in the evenings because lighting them by gas lamps ran the risk of fire.[5] The fair was closed on Sundays, in spite of protests that it was the only day when working people could visit. This was arranged in advance, and the *Christian Union* congratulated the centennial commissioners on their plan before the exhibition opened, but Samantha Allen takes credit, in a sly bit of humor, for running into Joseph Hawley, president of the U.S. Centennial Commission, and convincing him to respect the Sabbath.[6]

Memorial Hall stood immediately behind the Main Building, and its principal entrance was directly opposite. A walk through the Main Building's central corridor deposited the visitor squarely in front of Memorial Hall. Its prominent placement affirmed that the fine arts were considered a barometer of cultural progress, even if those of the United States showed room for improvement. Rev. Henry W. Bellows conceded, "We are reconciled to the slow or futile progress of arts . . . because of the fair promise of a national basis for it . . . at a later period."[7] The opening and closing ceremonies were held in the space between the two buildings, with stages positioned at each entrance.[8]

The fine arts exhibition triumphantly opened on the appointed day of May 10—an accomplishment that many other international exhibitions did not achieve. But the Art Department was far from complete and promptly closed for repairs the following day.[9] As of May 16, several rooms in Memorial Hall were not yet open to the public, and more than half of the galleries in the annex "present[ed] a chaotic tableau of boxes and litter."[10] It was reported that the Austrian art exhibition did not open until May 17, and the German exhibition was closed that same day for unspecified reasons.[11] Eventually the various art exhibitions were open continuously, but in the meantime visitors witnessed a gradual transformation in the galleries as late-arriving works were added.

Memorial Hall provided an impressive backdrop for the art exhibits. The building was planned to house a museum-quality display during the world's fair and was expected to function as a museum afterward, so its galleries were arranged in the fashion

typical of the time, with a central rotunda flanked by galleries flowing off to the left and right.[12] Also typical of museums built in the late nineteenth century, the galleries were large, open spaces that encouraged an orderly traffic flow (in theory) and the easy viewing of other visitors, which encouraged self-surveillance and critique.[13] The layout provided visitors with options for routes that would take them along carefully planned itineraries that privileged those countries considered to be the most sophisticated, in keeping with the evolutionary impulse that guided world's fair organizers.

A central square gallery led to three rectangular galleries on each side, which were the most prominent display spaces. The outer walls were lined with smaller spaces and punctuated by domed corner galleries. The United States occupied two of the central rectangular galleries and a few of the outer galleries (see fig. 20). The interior of the great south hall was embellished with wainscoting of colored marble, but the rest of the ornamentation was white; it was crowned with a magnificent crystal chandelier.[14] Sartain had chosen the color scheme in the Art Annex; the ceilings and cornices were greenish-gray and the walls reddish-brown.[15] The annex was laid out as a honeycomb of square galleries arranged in a Greek cross. Works from the United States filled fourteen of the forty-five galleries (fig. 30).

Lighting had been the subject of some discussion. In Memorial Hall, the galleries and the central hall were illuminated by skylights, and the pavilions around the perimeter had windows along the sides. The annex was built with skylights as well. Natural light is usually most desirable for exhibitions; however, a few problems were noted. *Scribner's Monthly* complained that in the rotunda the glare of light from the dome made the sculptures indistinguishable from the white walls of the room (fig. 35).[16] The New York *Evening Post* expected that in the galleries the width of the roof from the side walls to the skylight sashes would cast a perpetual shadow on the works hung on the upper line.[17] If that prediction turned out to be true, it would have rendered many paintings virtually invisible to viewers and critics. Only a few images exist that document the galleries, and in each case the top row of artworks is perfectly legible, but it may have been artificially lit for the photograph.

The summer of 1876 was unusually hot, so for much of the period of the exhibition, paintings and visitors were exposed to extremes of temperature and humidity. It had been hoped that Memorial Hall would be one of the coolest buildings on the fairgrounds and would serve as a refuge during warm weather. Unfortunately the opposite was true: it was reported that in July and August the large buildings on the grounds were all shady and airy—*except* the art galleries.[18] Visitors to the annex suffered the same fate, as the *New-York Tribune* commented: the "temperature and ventilation [are] as bad as they can be."[19] The *New York Evening Mail* warned that during very dry weather, water was sprinkled on the floors in the annex early in the morning, so that by noon the atmosphere was like a hothouse.[20] This is verified in a stereoscopic image of the Art Annex that shows water streaks on the floor (fig. 31). The conditions of the galleries in the middle months of the exhibition made extended viewing an uncomfortable experience (and created hazards for the artworks themselves) and did not encourage the

FIGURE 35 Centennial Photographic Company (American photographer, nineteenth century), *Memorial Hall, Centennial International Exhibition of 1876, Philadelphia (Interior)*, 1876. Silver albumen print. Free Library of Philadelphia.

kind of prolonged contemplation hoped for by the organizers.

The most striking first impression of the U.S. galleries was the overwhelming quantity of works on display. The Selection Committee's process had resulted in a group of more than 700 paintings and 150 sculptures.[21] The process of "rejection" had required jurors to eliminate the very worst instead of seeking out the very best, and the Selection Committee seems to have set its standard for rejection too low. As Art Department chief John Sartain had planned, paintings were hung from floor to ceiling, according to the practice of the period. In order to accommodate the huge number of paintings, partitions were installed in the four main galleries, and paintings were hung on them.[22] This further overwhelmed viewers and divided the expansive galleries into smaller, more crowded spaces. Numerous writers complained that because

of the partitions, the main galleries were "wanting in grandeur"; there were "no impressive perspectives"; the architectural effects of the interior were "seriously impaired"; and the overall effect produced "cultural indigestion."[23] The partitions do not appear in official photographs of the galleries. Their absence points out the difference between the actual experience of the exhibition and how it would be documented and remembered.

After the dramatic disputes over hanging the works, some considered the arrangement of the American exhibition to be a disappointment. The French visitor Louis Simonin quipped, "Do you love disorder? You will find it everywhere."[24] The display was called "a hopeless jumble of pictures of every epoch, hung only in respect to their size and shape, mak[ing] the inspection task of little pleasure and much mental effort, to say nothing of the physical discomfort."[25] One guide to the exhibition referred to "the inevitable fatigue of picture-seeing," and Charles Briggs of the *Independent* noted "the bewilderment which so great a number of pictures causes."[26] These remarks illustrate how the physical conditions of the exhibition affected viewers. Facing a confusing morass of pictures in an acutely uncomfortable atmosphere made heavy demands on the goodwill of people trying to understand the display and discern its message.

The problem of profusion was not unique to the U.S. art galleries but was endemic to the entire Centennial Exhibition. Statistics on the accumulation of objects and the impossibility of seeing them all were flaunted in the media with a kind of pride. One writer observed that it would require a walk of two miles to see all the works in Memorial Hall.

Another marveled at the fact that "if each object [in the whole fair] were examined but two minutes, the entire exhibition would require a century." Contemporary reactions showed ambivalence: there was wonder at the abundance of things to see and horror at the thought of having to see them all. Samantha Allen remarks that there is "no use tellin' what I *did* see, but I could tell you what I *didn't* see in half a minute." A writer for the *Galaxy* observed, "This crowd was left quite without guidance; not so much indeed as to what they should see as to what they should *not* see." Stories circulated of fairgoers dying of "overexcitement of the brain" from trying to process all the information and stimuli that the displays provided.[27]

While the American art exhibition as a whole exceeded observers' admittedly low expectations, writers found many specific aspects to criticize. The Selection Committee received its share of brickbats for the overwhelming size of the exhibition. Francis A. Walker, chief of the Awards Bureau, made the biting observation that "it did not seem to occur to the administration that an American citizen had no more natural right to hang his canvas on the walls of Memorial Hall than to hang his linen on the gates of the park." The *Atlantic Monthly* more gently suggested that "our own artists make a respectable show, which would be more impressive if [their numbers] could be decimated." As chief of the Art Bureau, Sartain was a focus of attention. The New York critic Clarence Cook was characteristically sharp-tongued as he lamented what might have been "if it had been our lot to have had the direction of the Art Department put into hands fit to wield it—a man of education, with organizing power." Critics harshly condemned

Sartain for the paintings from the Pennsylvania Academy of the Fine Arts's spring exhibition that he unilaterally inserted into the exhibition. The *American Architect and Building News* wrote that "if the decision of the committee had been final, perhaps there would have been less in the department to shock a refined taste; and certainly there would have been no necessity for crowding the pictures so abominably." Walker related how the decisions of the Selection Committee were set aside, and "an amount of rubbish [was] admitted to the galleries of the Exhibition of which it is difficult to speak within bounds."[28] The critics' vehemence seems out of proportion to the tiny fraction of the total that the Pennsylvania Academy's ten works represented, but it suggests once again how important they considered the exhibition's integrity to be.

Samantha Allen's lament—"we had seen so much that we didn't see nothin'"[29]—described Americans' difficult transition from a culture of intensive experience to one of extensive experience. Modern scholar Jonathan Crary noted that nineteenth-century viewers of paintings had to digest a proliferating range of images. They were forced to develop new ways of seeing to heighten the eye's ability to take in more and varied optical experiences while preventing distraction.[30] Another modern scholar, Adam Kaufman Goodheart, agreed that at the Centennial Exhibition in particular, viewers were "learning to process information and sensations as selectively as one must in an environment of excess."[31] The Centennial Exhibition was an exercise in selective vision for the entire nation; fairgoers were compelled to look and think independently and to make their own choices of which objects and exhibits to linger at and which to pass by.

Many sought help from guidebooks and catalogs, a common feature of large exhibitions. Guidebooks often included advice on the foremost attractions of the exhibition and, more important, which displays could be skipped without great loss.[32] For fairgoers who had little or no previous experience viewing works of art, catalogs might have alleviated their bewilderment and offered helpful insights toward forming their own impressions. Many privately published guides included commentary that would have influenced visitors' perceptions of the exhibition and of specific works, as discussed in chapter 4. But the official exhibition catalog was of little assistance.[33] It was called "wretchedly bad" and of "miserable character," containing one page of advertising for every two of catalog content, and was considered a "useless and irritating performance."[34] The first version included dozens of pictures that were not in the art galleries, no doubt works that were promised but for some reason were not delivered. Besides being incorrect, the first edition of the catalog was difficult to use. No more than a list of works in alphabetical order by artist, it required visitors to look at the number assigned to the painting or sculpture and leaf through the listings for more information; the *Boston Globe* complained that "the arrangement is such that it takes the visitor five minutes to find any given title or proper name."[35] Later editions wisely listed artworks by gallery. In the end, at least fifteen editions were printed, and comparing the later versions to newspaper accounts, even they remained incomplete.

Late nineteenth-century gallery visitors often carried a catalog in hand that included the artist, the title of the work, the lender, and sometimes an explanatory text, such as the event being portrayed

or a quote from the literary work being depicted, but the official catalogs of the Centennial Exhibition did not function that way for much of the run of the exhibition. Most visitors would likely have become frustrated and simply drifted through the galleries, stopping at paintings that caught their attention, an exercise often dictated by size, familiarity, or a sensational subject. This led them to the exhibition's most controversial painting, which defined the experience of many Centennial Exhibition visitors.

The Presence and Absence of the Civil War

The Civil War's legacy affected the mood of the Centennial Exhibition and shaped every aspect of the visitor's experience. The fair was planned to showcase national harmony and healing in a precarious balance of forced presence and enforced absence. The Centennial Committee prohibited the display of battle flags in the ceremonies.[36] However, poetry and songs composed for the exhibition's opening included such highly wrought and reassuring lines as "toil, when wild brother-wars new dark the Light / Toil and forgive, and kiss o'er, and replight"; "softly they murmur, the palm and the pine / Hushed is our strife in the land of the free"; and "in our nation's heart embedded / O'er our Union newly wedded."[37] In the last act at the closing ceremonies, officers from the Union and Confederate armies drank from a memorial cup, and the *New-York Tribune* complacently reported that the centennial "has united us as a nation—revived to a great extent the old genial feeling of good fellowship among natives of different sections."[38]

The exhibition swelled many patriotic hearts, and rightly so, as a celebration of a century of monumental achievements and difficult challenges, but the greatest of those challenges was still painfully fresh. In spite of Northern sentiments and pronouncements, the desired reconciliation could not be accomplished without the South. *Scribner's Monthly* considered Southerners to be "the guests without whom we cannot get along—without whom there would be bitterness in our bread, sourness in our wine, and insignificance in our rejoicings."[39] However, the Southern absence from Fairmount Park was palpable. Official guides to the exhibition exhorted Southerners specifically: "It is our Centennial as well as the Centennial of the Northern people. We are part of the Union. . . . Let all bitter memories be forgotten."[40] A publication entitled *The International Exhibition Guide for the Southern States* (with "by a Southern Editor" conspicuously noted on the cover) began with the question "that is asked probably in the South thousands of times a day—'Shall we go to the Centennial?'" It predictably concluded that the answer should be yes.[41]

However eager Northern states might be for Southern participation, the war was still a daily presence for many: in 1876, Union troops still occupied much of the South. Arkansas, Maryland, Mississippi, Missouri, Tennessee, and West Virginia sponsored state buildings in Fairmount Park, representing about one-third of the total, but only 37 of the 2,751 exhibitors in the Main Building were from the South. Much was made of the great disparity in material progress between the two regions and of Southerners' amazement at Northern industrial development and manufacturing. The *Atlantic Monthly* "reported" on

a Southern visitor at the "New England Farmer's Home of Ye Olden Time," a re-creation of a typical early settler's cabin (fig. 19): "looking on all sides for what drew the crowd; he could see nothing but what he had seen all his life. . . . Suddenly a Yankee remarked, 'And this was the sort of house we lived in two hundred years ago.'"[42] Whether or not the incident was genuine, the author's point was clear.

Simonin wrote poignantly that "only the cities of the South were silent amidst all these evidences of joy." Even U.S. Centennial Commission president Joseph Hawley had to admit that the minimal Southern presence was the only way that the exhibition "did not quite come up to our expectations." The South was not present at Fairmount Park in any significant way, and history was being written by the victorious North.[43] This was true in the American art exhibition as well, where Southern artists were represented by six paintings and one sculpture from Baltimore, Maryland, and one painting each from Lenoir, North Carolina, and Louisville, Kentucky.

African Americans also hoped that the Centennial Exhibition would be a moment of reconciliation and national acceptance of their recent freedom, and they too were disappointed. Publications such as the *New National Era* encouraged black citizens to ensure their proper representation at the world's fair. The 1875 Convention of Colored Newspaper Men in Cincinnati envisioned an eighteen-volume "Centennial Tribute to the Negro" and commissioned a statue of Bishop Richard Allen, founder of the African Methodist Episcopal Church, from African American–Chippewa sculptor Edmonia Lewis. African American women were encouraged to help organize the Women's Pavilion.

However, nothing came of the planned tribute volume; the statue of Allen was not unveiled until November 2, a week before the exhibition closed; and black women had to fight the exclusionary tactics of the Women's Centennial Committee in order to participate in planning the Women's Pavilion. On opening day, Philadelphia police barred the black abolitionist Frederick Douglass from taking his designated place on the main platform of dignitaries, and he was only admitted after being vouched for by a white senator. Finally, in a time of high unemployment, it appears that no black workers were hired to help construct the buildings or to serve as guards for the fair.[44]

The legacy of the Civil War shaped the art exhibition as well. Many sanitary fair organizers, both collectors and artists, were involved in the Centennial Exhibition's American art display.[45] These men applied the principles that had guided them during the Civil War to the 1876 fair; however, times and goals had changed drastically. The sanitary fairs had advanced a political agenda that was unwanted more than a decade later at the Centennial Exhibition. Just as the Sanitary Commission's aim was to support Union troops, the fair organizers encouraged pro-Union artworks, such as Louis Lang's *The Soldier's Widow* (unlocated), Francesco Augero's *The Goddess of Union Attended by Peace and Plenty, Dismissing the Fury of Rebellion and Her Victims* (unlocated), and Henry Peters Gray's *America in 1862* (unlocated), which depicted a slave looking up into the eyes of the "genius of America." Some artworks depicted actual battles, such as Victor Nehlig's *Gallant Charge of Lieutenant Henry Hidden, at Sangster's Station, Virginia* (New-York Historical

Society). The Centennial Exhibition, however, was conceived as an opportunity to heal the wounds of the Civil War and reunite the North and South, so Civil War subjects were officially prohibited; in a letter to Director General Goshorn, Sartain referred to Goshorn's "decided objection to all that class of pictures that were calculated to awaken ill feeling in our Southern visitors."[46]

It is a curious contradiction that in spite of attempts to play down Civil War subjects in the Art Department, the emphasis on postwar reconciliation made it a strong, if largely unacknowledged, presence. Modern philosopher Paul Ricoeur identified a complex relationship between commanded forgiving, in the form of amnesty, and commanded forgetting, in the form of amnesia. Both deprived those who experienced the horror of the Civil War of collectively grappling with and reconciling themselves and their national identity to the traumas of the past.[47] Memories of the Civil War were not easily reconciled or repressed. Modern scholar Kirk Savage observed that the massive changes caused by the Civil War demanded that the country and its population "reimagine themselves." In the postwar decades, public monuments proliferated as citizens attempted to understand the new country that had emerged from the Civil War. The war and its aftermath "forced itself into the domain of memory, there to be reckoned with in one way or another—suppressed, integrated, romanticized."[48]

However well intentioned, the attempt to bar the specter of the Civil War from Memorial Hall was unsuccessful. The war was still a fresh wound, and artists and audiences alike sought commemoration and healing through the art exhibition, where a few paintings alluded to the recent conflict. African American ties to the Northern states were emphasized in Thomas Waterman Wood's triptych *A Bit of War History: The Contraband*, *The Recruit*, and *The Veteran* (Metropolitan Museum of Art), which showed an emancipated man's transformation from fugitive to Union soldier to proud veteran. In the final painting, the subject, having lost a leg in the war but saluting, affirmed that any sacrifice was justified by the cause of freedom that he—and the North—had fought for. One of the most visible and highly praised American paintings was Eastman Johnson's *Negro Life at the South* of 1859 (fig. 36). By then it was seventeen years old, but it was well known for its depiction of what was presumed to be an enslaved family relaxing in their decrepit quarters on a Southern plantation. At lower left, a young couple appears to be courting; at right, a fatherly figure plays the banjo, and a matronly woman dances with one child while another reclines next to her. A white woman, thought to be their owner, steps in for a visit. The picture may have won such broad acclaim because of its ambiguity: for abolitionists, it reinforced black people's humanity and their strong familial bonds, and it was often compared to Harriet Beecher Stowe's famous novel *Uncle Tom's Cabin*. On the other hand, for many Southerners, the relatively idyllic view of enslaved people's lives helped justify the institution and the need for paternalistic supervision of a "simple" people.[49]

In spite of Goshorn's dictum, there were even more pointed references to the Civil War in prominent galleries. A "place of honor" was reserved in Memorial Hall for Thomas Hicks's portrait of Union general George G. Meade, the hero of Gettysburg and Philadelphia's foremost soldier.[50] It

is not surprising that an exhibition in Philadelphia would pay tribute to its greatest military leader. The heroism of the opposing army was represented as well, and the *New York Herald* took note of a nearly full-length portrait in Gallery C of Memorial Hall of Confederate general Robert E. Lee by an artist identified as Albert Gmerry (possibly Albert Guerry).[51] This work does not appear in the exhibition catalog, so it may have been a late, unofficial addition. In this way, the two generals who met at Gettysburg were reunited at the Centennial Exhibition in the same gallery, and the political implications were greatly heightened by the presence of the exhibition's most controversial painting.

The most visible and inflammatory reminder of the Civil War was Peter F. Rothermel's *The Battle of Gettysburg* (fig. 37). One of the largest American paintings ever created, it measures more than thirty-one feet wide, and it dominated an entire wall of the gallery. Given its size, subject matter, and placement, it would have drawn the immediate and passionate attention of many visitors, especially those unfamiliar with the great names of American art, and may have been the most vividly remembered painting for the majority of visitors. The painting depicts a day that was remembered as the turning point not only of the battle, but of the entire war. It conflates incidents that took place at different points during the day and conveys the chaos and confusion of war, with waves of soldiers clashing in the middle of the canvas and savage fighting stretching into the distance. The impact of the painting was magnified by the way it was hung in Memorial Hall. It was installed with the lower edge of the canvas near the floor, putting visitors at eye level with the dead and dying figures sprawled in the foreground. Some might

have felt that the artist made the scene more polemical by rendering Confederate soldiers fleeing in panic; there is also a group of fallen Southern soldiers in the center. Union soldiers, on the other hand, are shown carrying a wounded comrade off the field of battle, while a patriotic drummer boy dies in the arms of a compassionate officer.[52]

How the painting made its way into the Centennial Exhibition, where Civil War subjects were prohibited, is a byzantine tale of personal influence and local politics. The state of Pennsylvania had commissioned Rothermel to paint *The Battle of Gettysburg* in 1866. Governmental bodies of the United States were (and are) often castigated for their reluctance to patronize the arts, and it is remarkable that a state government recovering from the financial and emotional toll of a costly war would spend $25,000 (equivalent to more than $386,000 at the time of this writing) to commemorate its bloodiest battle. The decision was probably meant to honor General Meade as a Philadelphian and a founding commissioner of Fairmount Park and also to memorialize a pivotal battle that took place on Pennsylvania soil.

Though he is not widely known today, Rothermel was intensely admired in Philadelphia as an accomplished history painter in the grand manner. *The Battle of Gettysburg* was Rothermel's first major attempt at rendering a contemporary event; his subjects were generally taken from literature, the Bible, or early American history. Rothermel was not at Gettysburg—he did not serve in the army—but he spent three years conducting interviews and making sketches. Rothermel was commissioned to create a painting no less than fifteen by thirty feet, but the state had no government building large enough to accommodate

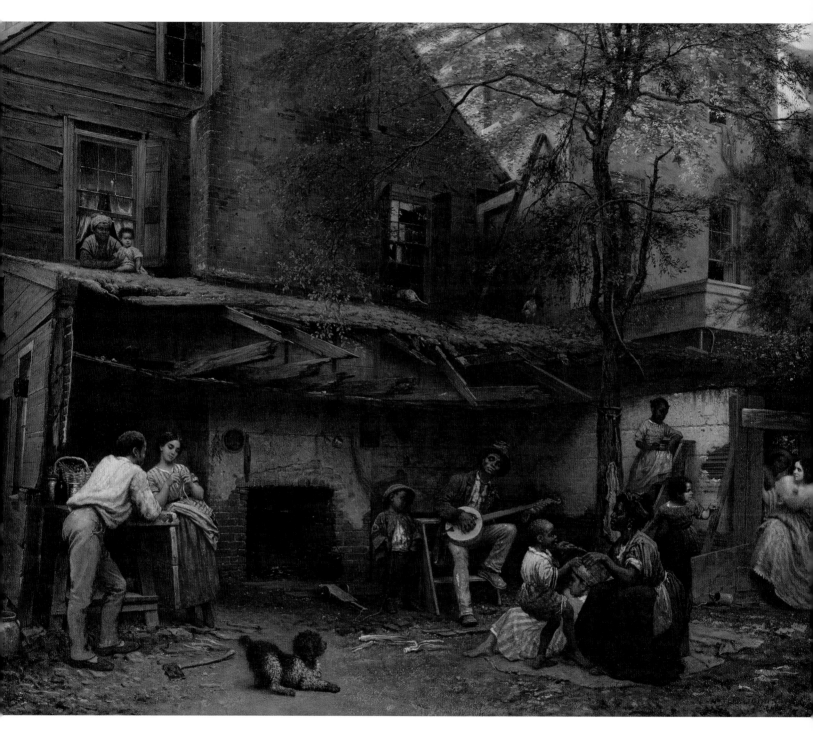

FIGURE 36 Eastman Johnson (American, 1824–1906), *Negro Life at the South* (*Old Kentucky Home*), 1859. Oil on linen, 37 × 46 in. (94 × 116.8 cm). New-York Historical Society, S-225.

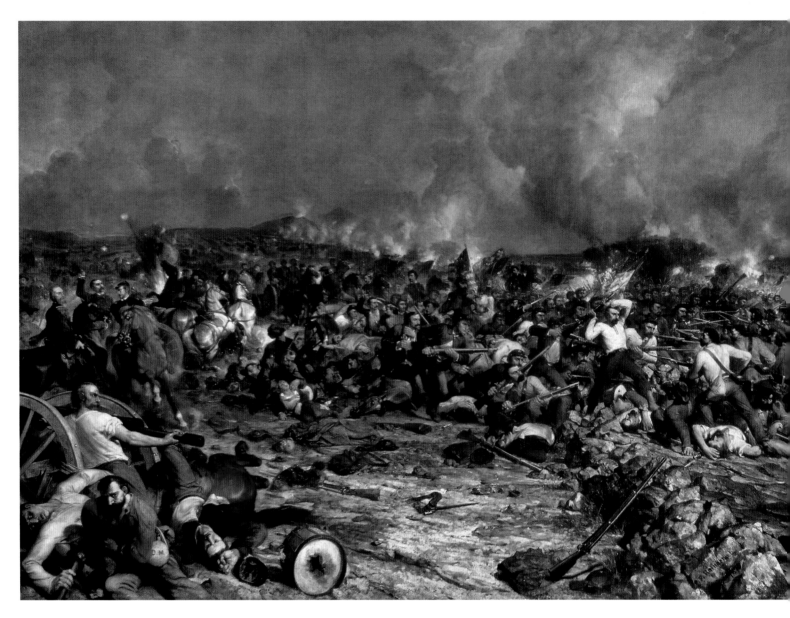

FIGURE 37 Peter F. Rothermel (American, 1817–1895), *The Battle of Gettysburg—Pickett's Charge*, ca. 1870. Oil on canvas, 94 × 377 in. (238.8 × 957.6 cm). Courtesy of the State Museum of Pennsylvania, Pennsylvania Historical and Museum Commission.

the mammoth canvas. The legislature agreed that the artist could publicly exhibit the painting, and after an initial showing in Philadelphia, *The Battle of Gettysburg* was displayed in Boston, Pittsburgh, and Chicago.[53]

In 1870, the Fairmount Park commissioners expressed a need for a free art gallery in the city, and the Fairmount Park Art Association was established the following year. The group quickly grew to thirteen hundred members. The Park Art Gallery was built between 1872 and 1873 by Hermann J. Schwarzmann, who designed most of the Centennial Exhibition buildings, including Memorial Hall. It was an unassuming 140-by-43-foot structure: a cast-iron skeleton with masonry construction, skylights, plastered walls, and a cement floor (fig. 38). The gallery was created with the Centennial Exhibition in mind; a contemporary writer connected the Park Art Gallery to the state appropriation for Memorial Hall. However, unlike Memorial Hall, the gallery would not be permanent, and the materials for the building would be used in other structures "when this temporary building may no longer be necessary." A centennial guidebook described the Fairmount Park Art Association's mission as an interim repository for works of art, "forming a nucleus to the more elaborate exhibition in the Memorial Art Gallery." The Park Art Gallery was defined by one particular work: Rothermel's *The Battle of Gettysburg*.[54]

It is likely that the Fairmount Park Art Association thrust *The Battle of Gettysburg* into the American art exhibition in spite of an official ban on Civil War subjects—an inclusion for which Sartain was later blamed. It does not appear that the association made any other planning efforts for the American art exhibition, but its likely advocacy for Rothermel's

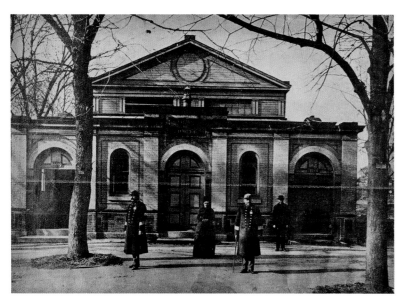

FIGURE 38 *Gallery of Pompeiian Views* (Park Art Gallery), n.d. Newspaper clipping. Fairmount Park Historic Resource Archive.

painting was sufficient to lay the groundwork for the political and artistic controversy that followed. His bloody memorial to the epic battle loomed over an event billed as a celebration of national peace and unity.

The painting was placed in a central position in Memorial Hall's Gallery C along with four accompanying studies. Sartain mentioned it as a particular example of the type of work that Director General Goshorn worried might "awaken ill feeling."[55] It is not clear whether Sartain approved of the inclusion or whether he acquiesced to the wishes of prominent Philadelphians, but he certainly had a financial stake in the painting's success. Sartain and Rothermel had a working relationship that eventually extended over fifty years, with Sartain engraving at least twenty-six of Rothermel's

paintings.[56] Rothermel contracted with Sartain in 1875 to engrave *The Battle of Gettysburg* in time for sale at the centennial, a potentially lucrative venture. However, the engraving was not finished in time for the exhibition, and Sartain did not complete work until 1879, leaving Rothermel to denounce him bitterly as someone whose "word of honor is useless."[57] In any case, the engraving would probably have been a financial failure, given the work's poor reception at the Centennial Exhibition. The painting's enormous size made it unavoidable for visitors and critics, and its prominent position strongly implied that the organizers considered it among the greatest works of American art. Its controversial subject combined with its placement ignited a firestorm of condemnation, and *The Battle of Gettysburg* quickly became the painting that people loved to hate.

Rothermel's painting depicts in graphic detail the fury, carnage, and confusion of battle, and its subject sparked a war of words. The *Art Journal* scolded, "Our space forbids us to dwell much on the ill taste, to say nothing of the bad art, of such pictures as the 'Battle of Gettysburg,' which, even if it were a fine picture, which it is not, would be an unsuitable reminder, at this Centennial time, of discords that are past and troubles which will scarcely be renewed."[58] The *New-York Tribune* critic Cook condemned the inappropriateness of the subject, saying that Rothermel's painting depicted not heroism but "horrors piled upon horrors for a central show-piece at the Centennial feast of peace and goodwill!"[59] Bricktop's humorous account of the Centennial Exhibition included a cartoon of veterans of the two armies "fighting the battle over again" before the painting (fig. 39). The Northern veteran at left wears a kepi

FIGURE 39 "Before the Great Picture of the Battle of Gettysburg—Fighting the Battle over Again." From Bricktop, *Going to the Centennial, and a Guy to the Great Exhibition* (New York: Collin and Small, 1876), 32. General Research Division, The New York Public Library, Astor, Lenox and Tilden Foundations.

cap with dark pants and a fitted jacket, which may be his old uniform. His Southern adversary is clad in patched pants and a baggy shirt and jacket that may be castoffs; his unkempt hair and beard add to the impression of poverty and neglect. He points angrily, perhaps at the group of slaughtered Confederates at lower left, and the Union veteran leans in with a clenched fist. Each has lost a leg in the fighting, but their shared tragedy does not unite them, and their animosity remains fierce, belying hopes of reunion in the centennial year.

The most vehement objections to Rothermel's painting dealt not with its merit as an artwork (though there were some), but rather with the appropriateness of its subject at a national festival of reunion. Visitors were confronted with the most horrifying aspects of a war they had come to Philadelphia to lay to rest. Viewing *The Battle of Gettysburg* was not just an exercise in museum etiquette but an emotional and intellectual experience that raised questions and prompted discussions. Ironically, it was the kind of serious art encounter that illustrated how the circuit of communication must be completed: concentrated attention, paid via proper deportment, engaged the viewer's personal experiences to create an emotional connection (albeit a negative one for many) and an exchange of ideas.

The Great Classroom

A guidebook for the 1901 Pan-American Exposition in Buffalo warned visitors, "Please remember when you get inside the gates you are part of the show."[60] The admonition would have been just as fitting a quarter century earlier in Philadelphia. The U.S. display in Fairmount Park has been aptly called "the first real introduction of American artists to the American public."[61] The *New-York Tribune* recognized that "full of defects as was the art exhibit in the eyes of critics and connoisseurs, to the great majority of visitors it was a new revelation of beauty."[62] It was expected that while the Centennial Exhibition would teach foreign visitors about American industry and manufacturing, Americans themselves would learn about art, taste, and culture.[63]

At the centennial moment, art viewers were undergoing a profound shift. In the early nineteenth century, cultural audiences were fairly heterogeneous, in keeping with the blurred lines between high art and popular culture. In the years following the Civil War, divisions between art forms sharpened, and newly established art museums were seen as a form of moral uplift rather than as entertainment, reinforcing fragmentation along lines of class, wealth, and ethnic background. World's fairs were a striking exception to this trend. They brought together huge and hugely varied populations, making them a remarkably fertile site for study and learning both by the observers and the observed. As one modern scholar remarked, "International exhibitions were as much experiments in public civility as displays in technological progress."[64] Part of the intended function of late nineteenth-century museums and world's fairs was to "civilize" visitors. Museums and fairs were meant to create useful citizens by enforcing proscriptions on undesirable behavior, such as eating and drinking in the galleries and touching objects, and by providing models of appropriate middle-class behavior, which might be observed in other visitors.[65] Just a few years before the centennial, art critic James Jackson Jarves put it most succinctly in his book *Art Thoughts*: "What we want now is to train the public to comprehend the true nature and functions of art."[66]

Many of the visitors who thronged the galleries were U.S. citizens from beyond the East Coast who had had few opportunities to see original works of art by Americans or others.[67] Often living in places that lacked local galleries, museums, or exhibiting organizations, most were unfamiliar with art beyond a few prints that might have decorated their walls. They were also strangers to the conventions of behavior in a museum setting. There were few widely circulated models of propriety to emulate, but one example was illustrated in the national magazine *Harper's Weekly* in 1870 (fig. 40). Visitors to the National Academy of Design modeled proper conduct: the well-dressed trio of ladies and a gentleman at left gaze raptly at a painting from a respectful distance, and the gesture of the woman in profile suggests that they are engaged in discussion about it. At right, another trio does not appear to be conversing about art, but they are discreetly located away from the main action of viewing. At left, a fashionably dressed little girl seems to stare at us almost impudently; as a child, she is not expected to know and adhere to the rules, but the adults are and do.

FIGURE 40 "New York National Academy of Design—At the Head of the Staircase." From *Harper's Weekly*, May 14, 1870, 316.

For most visitors, Memorial Hall and the Art Annex became classrooms for learning codes of deportment. The emergence of a prosperous and striving class of newly wealthy Americans in the post–Civil War years generated feverish interest in the rites and behaviors befitting their position. As a modern author noted, the new middle class "knew the fear of sex, of God and of the wrong fork."[68] The desire for instruction was buttressed by concerns about waves of recent immigrants from overseas and crowds of country folk moving to urban centers. In the decade or so after the Civil War, national magazines such as the *Galaxy*, the *Round Table*, *Appleton's*, *Atlantic Monthly*, *Lippincott's*, and *Putnam's* addressed the need to raise general standards of behavior with regular references to proper etiquette and with articles devoted to dining, railway manners, serenades, and chaperones. Etiquette guides proliferated at the rate of five or six new releases each year from 1870 to 1917, a meteoric rise from the antebellum period.[69]

A fervent interest in proper behavior coincided with the emergence of what was, for many, an uncertain and precarious new social situation—the art museum visit. During the early and mid-nineteenth century, East Coast cosmopolites could visit the modest art galleries of the National Academy of Design in New York or the Pennsylvania Academy of the Fine Arts in Philadelphia. But the best-known museums tended to follow the model of the *Wunderkammer*, or cabinet of curiosities, assembling eccentric collections of sensational artifacts (some of questionable authenticity), as in Barnum's American Museum, which operated in New York from 1841 until 1865, when the building burned. Upon its demise, a writer for the *Nation* did not lament the loss of this "dangerous man-trap," with its dusty and disorderly display, but appealed for "a real museum," a rationalized, scientifically ordered museum that would address all the arts and sciences.[70] A more stolid and earnest display could be found in Peale's Museum in Philadelphia and its branches in New York and Baltimore. Peale's Museum combined a portrait gallery of worthy Americans with taxidermic specimens that offered an education in the nation's political and natural histories. It presaged the Victorian interest in classification, rationalization, and the museum as a moralizing influence, though Peale did not attempt an encyclopedic representation of the history of the visual arts, as the organizers of the Centennial Exhibition's art display would.[71]

Art lovers might also have seen the great collections assembled by civic-minded collectors who opened their private galleries to the public to offer examples of great works of art that could not yet be seen in American museums. Prominent collectors in the early nineteenth century included New Yorkers Luman Reed and Thomas Jefferson Bryan. August Belmont and William H. Aspinwall opened their homes for New York's Metropolitan Fair in 1864, and Philadelphian Joseph Harrison did the same for the Great Central Fair a few months later. During the 1870s, New York railroad magnate John Taylor Johnston welcomed visitors to his gallery every Thursday, and manufacturer George Whitney's collection was listed in a Philadelphia guidebook as an attraction for out-of-town visitors.[72] However, in February 1876, *Appleton's Journal* reported that this practice was on the wane, and rather than indicting collectors, the writer called visitors to account: "The public are to blame. . . . So outrageously was the privilege thus accorded abused by persons who went not to study art but to gratify vulgar curiosity, that cautious restrictions became necessary in pure self-defense."[73] According to this writer, many visitors did not understand the codes of proper behavior in a museum-like setting.

In the years leading up to the centennial, the would-be lady or gentleman found little guidance on how to navigate an art gallery. A survey of several etiquette manuals from the 1870s finds elaborately detailed instructions on making calls or attending a fancy dinner, but few addressed the subject of viewing art. Cecil B. Hartley's *Gentlemen's Book of Etiquette* advised young men, "In the present day an acquaintance with art, even if you have no love for it, is the *sine qua non* of good society." A few basic hints were offered for gallery behavior: conversation should be quiet, visitors should refrain from loud laughter or gesturing, and those engaged in conversation should not block others' view of the works.[74] Samuel Roberts

Wells's *How to Behave* admonished, "A gallery of paintings or sculpture is a temple of Art.... Loud talking, laughing, pushing before others who are examining a picture or statue, moving seats noisily, or any rude or discourteous conduct, seems like profanation in such a place."[75] The basic nature of both authors' advice suggests that they considered their readers to be absolute beginners in their understanding of museum deportment.

The press stood ready to evaluate visitors' behavior at the Centennial Exhibition as a measure of the country's cultural progress. Though their stories were sometimes exaggerated for effect, it is fair to imagine that they contained a kernel of truth, a warning about which actions were appropriate and which would be met with derision. The scant advice from etiquette guides directly addressed the comically naïve behavior attributed to some visitors to the fair in general and to Memorial Hall and the Art Annex in particular. Fukui Makoto, the Japanese commissioner to the exhibition, offered his impressions of the opening-day bustle at the fair as a whole: "The first day crowds come like sheep, run here, run there, run everywhere. One man start, one thousand follow. Nobody can see anything, nobody can do anything. All rush, push, tear, shout, make plenty noise, say damn great many times, get very tired, and go home."[76] Titus Munson Coan of the *Galaxy* agreed, "Everybody was walking, running, or riding; everything was seen by glances, and but few were attentively looking at what they had come to see. I might say rather that people seemed to be looking at everything and seeing nothing."[77]

The humor writer Bricktop concurred in his illustration "The Chap Who Attempts to Do the

FIGURE 41 "The Chap Who Attempts to Do the Exhibition in One Day." From Bricktop, *Going to the Centennial, and a Guy to the Great Exhibition* (New York: Collin and Small, 1876), 29. General Research Division, The New York Public Library, Astor, Lenox and Tilden Foundations.

Exhibition in One Day" (fig. 41); his long-legged visitor with his nose buried in a guidebook seems not to notice a wailing child beneath him in his hurry to reach the next attraction. One guidebook lampooned the visitor who bragged that he saw everything in one day, but on being questioned remembered seeing the great Corliss engine in the Women's Pavilion (it was actually the central display in Machinery Hall), marveled at the "five-legged calf," and considered the best thing in the show the "Cheese of Paris." When his rural friend asked, "You mean the [panorama on view on Broad Street in Philadelphia titled] 'The Siege of Paris,' don't you?" he responded, "It looked like cheese to me."[78]

FIGURE 42 "Character Sketches in Memorial Hall and the Annex."
From *Frank Leslie's Illustrated Historical Register of the Centennial
Exposition 1876*, ed. Frank H. Norton (New York: Paddington, 1974), 144.

If fairgoers were in a hurry, they were likely rushing to see the art exhibition, since numerous accounts attested that the galleries were "really thronged" and "crowded to excess," particularly the Italian galleries with their many nude sculptures (fig. 42, lower left).[79] One visitor threw up her hands and wrote home that "it is ridiculous to attempt to view the paintings; the crowd in the Art Gallery is a pushing, jamming, seething one."[80] With several million attendees, the art displays in Memorial Hall and the Art Annex were the nation's first blockbuster exhibition.

Civic and regional differences were noted among the visitors as well as the artworks. The *Atlantic Monthly* described how to determine American fairgoers' origins from their comments: "The New Yorkers could have done it so much better, the Bostonians would not have done it at all; the real admirers are the Southerners and Westerners."[81] It is no accident that the writer attributed more

admiration and less discrimination to visitors from beyond the East Coast. The flow of fairgoers from the western United States was described as "the migration of races," and "farmers came in great bands."[82] Elizabeth Johns's study *American Genre Painting* traced the evolution of the collectively constructed types that Americans used to assuage their anxieties about the nation's changing social order. Johns identified one of them as the "yeoman," the idealized independent farmer who was seen to form the backbone of the country and was regarded with fondness and nostalgia in changing times. Another was the "Yankee" type familiar to East Coast writers, who was "insular, socially clumsy, and peculiar in his dialect."[83] A third type common in late nineteenth-century literature was the "Pike," a crude, uncouth Westerner who was the antithesis of the man from the East.[84] Lampoons of the Centennial Exhibition audiences drew from these stereotypes.

Marietta Holley's fictional character Samantha Allen also represented a caricature of out-of-town visitors. Samantha decides that she will call Memorial Hall the "Artemus Gallery" since "when any man takes such pains as Artemus has, to git such a splendid assortment of pictures and statues together for my pleasure, and the pleasure of the Nation," she must pay him the respect of using his full name.[85] Though the visitors were stereotyped and parodied, commentators such as Bellows recognized that they represented the nation's future growth: "The country west of the Alleghanies [*sic*] is become the body of the nation, and contains its young and high-beating heart."[86] The reactions of these presumably unsophisticated art-world naïfs were observed and interpreted to evaluate the country's overall cultural progress.

Pierre Bourdieu and Alain Darbel's 1991 study of French museumgoers noted the diffident shyness of working-class visitors, who feared drawing attention to themselves by some inappropriate action.[87] American visitors to the Centennial Exhibition, emerging from the antebellum era of Jacksonian democracy, were unhampered by any such compunction. Their native confidence was bolstered by Mark Twain's *The Innocents Abroad*, a comic chronicle of his 1867 journey to Europe and the Holy Land on the ship *Quaker City*. It had originated in Twain's letters to the *Daily Alta California* of San Francisco and the New York *Tribune* and *Herald*, and the 1869 book that resulted became one of the best-selling works of Twain's storied career. He lampooned the sacred cows of European society and culture and disabused his readers of their concerns about understanding art's lofty mysteries. "It vexes me to hear people talk so glibly of 'feeling,' 'expression,' 'tone,' and those other easily acquired and inexpensive technicalities of art that make such a fine show in conversations concerning pictures. There is not one man in seventy-five or a hundred that can tell *what* a pictured face is intended to express."[88] He dismissed the religious old master paintings of Venice, commenting, "When I had seen one of these martyrs I had seen them all."[89] Twain punctured the superiority of European culture, affirming American judgment—shrewd, skeptical, and bitingly ironic—with an assurance that was reflected in the behavior of American visitors to Fairmount Park's Memorial Hall.

As throngs of curious and confident Americans filled the galleries, newspapers and periodicals began to report all kinds of abuses that would seem shocking and horrifying today. John Sears of the *Aldine*

FIGURE 43 "Donkeys at the Centennial." From *Harper's Weekly*, July 1, 1876, 536.

noted with alarm the lack of safeguards for the paintings, suggesting that masterworks such as Eastman Johnson's *Negro Life at the South*, hung at shoulder height in the narrow, congested Central Gallery West, should be corded off. Exhibition regulations prohibited glass over any paintings, so they and the sculptures were at risk. Toes were broken off marble sculptures, and the Austrian gallery was temporarily closed in May after an important painting was cut with a knife. Signs were installed imploring people not to touch the paintings with canes or umbrellas (see fig. 31), and an article in the *Philadelphia Evening Bulletin* decried the "Poking Propensity of People."[90]

Today, codes of museum behavior are so universally inculcated that transgressors, especially those who cause damage, are quickly identified as aberrant, mentally unbalanced, or criminals. In 1876, blame was placed on an entire class of people for lacking the necessary breeding, and offenses were met with a media campaign of ridicule against the country "hick" who was presumably responsible. The cartoon "Donkeys at the Centennial" (fig. 43) depicts visitors as four-legged furry creatures who thrust their umbrellas at paintings (and even their heads through them) and scrape sculptures with knives, as well as the shocked dismay of the artist upon receiving his figure sculpture back with its hands broken off. Another cartoon titled "Gratifying Two Senses" (fig. 44) shows a family enjoying a meal in the galleries. Their mouths are open impossibly wide and their vacant expressions suggest how oblivious they are to their faux pas.[91]

The typical vandal was described as "the Western statesman of the Democratic type, [who] wanders through the Art Department, punching the Madonna's nose with his umbrella to emphasize

GRATIFYING TWO SENSES.

FIGURE 44 American School, "Gratifying Two Senses," 1876. Lithograph. Free Library of Philadelphia.

his opinion that 'thisyer woman ain't no beauty.'" Bricktop related seeing a man "evidently fresh from Memorial Hall where he had been 'testing' things with his big hickory walking club," who described his attempts to determine whether the statue of George Washington outside Philadelphia's Independence Hall was of brass or marble: "If it's made of marble I can knock one of his fingers off with this 'ere stick; if it's brass I can't." Another article, "The Centennial Pawnees," labeled such visitors "clumsy, rustic,

uncouth" people who used their "long and ugly paws" to mutilate everything within their reach, "especially . . . the Art Galleries."[92] The vignettes in *Frank Leslie's Illustrated Historical Register* (see fig. 42) were not caricatures, but when compared to the staid dignity of the urban elites depicted at the National Academy of Design (fig. 40), they showed the lack of decorum that was thought to mark the rural and working classes. At lower right, a woman touches a painting; at lower left, visitors ogle nude sculptures; at upper right, the gallery serves merely as an arena for flirtation; and the man in the French gallery at the upper left raises his umbrella to point at a painting, ignoring the sign over his shoulder entreating him not to.

The *New-York Times* suggested that the problem could be solved if each offender was "caught, labeled, and exhibited for twenty-four hours on a conspicuous pedestal" and was "constantly prodded with a sharp umbrella by some loud-voiced lecturer upon his moral and physical peculiarities."[93] The cartoon "Donkeys at the Centennial" similarly included a furry visitor biding his time in a pillory "for defacing works of art." Such measures proved to be unnecessary, according to accounts that the problems waned as the exhibition progressed. Titus Munson Coan reported for the *Galaxy* that time seemed to be checking audiences' tendencies toward "squeamishness and vandalism."[94] Amazingly, the constantly changing crowds in the galleries seemed to learn, whether by word of mouth, social pressure, or outright ridicule in the press, how one should act in an art gallery. Samantha Allen describes the same lesson in relation to the Main Building: overwhelmed by the immensity of the space, her husband advises her to walk along as others are doing.[95]

The lessening "squeamishness" referred to reactions to the many nudes in the galleries, particularly, but not exclusively, in the Italian galleries. Reception of the nude can be considered a historical barometer of American openness to art that extended back for decades.[96] Frances Trollope related with astonishment in her 1832 *Domestic Manners of the Americans* that when she visited the Pennsylvania Academy of the Fine Arts, she was advised on when she could sneak into the antique sculpture galleries in order to see the nude statues without damaging her reputation.[97] Even the most sophisticated East Coast audiences still had a long-standing reluctance to see the nude, or nearly nude, figure as a suitable subject, rather than merely as a naked body, as was demonstrated when H. H. Moore submitted his exotic painting *Almeh* (fig. 17) for inclusion in the American art exhibition at Fairmount Park. The gradual change in public behavior suggests that American audiences were learning to look beyond surfaces and curiosities. Whether by providing models for emulation or by shaming through the ridicule of the press, the cultured class brought a powerful collective pressure to bear on the behavior of visitors in the galleries and on those waiting at home, who would be guided by their example.

Journalists' careful study of the crowds in Memorial Hall and the Art Annex reflected the stock taking inspired by the centennial moment. Visitors became qualified spectators trained in the internal workings of selective vision and outward codes of behavior. After making humorous perceptual mistakes, such as talking to mannequins and to herself reflected in a mirror, a humbled Samantha Allen admits, "Experience keeps a good school."[98] At a more substantial level, visitors were opened to

an increased receptivity to the visual arts that helped spur the founding of galleries and museums across the country in the decades that followed.

Navigating the art exhibition challenged viewers with profusion, commercialism, physical discomfort, and confrontation with difficult memories, all while under the watchful eyes of their fellow visitors. Memorial Hall became a theater of spectatorship, precipitating a role reversal that made the observers the observed and made the galleries a training ground for viewing and understanding works of art. Visitors to Memorial Hall and the Art Annex, though largely unaware of it, held the collective power to demonstrate American cultural progress. At the opening of the Centennial Exhibition, they displayed a deficient state of sophistication, but remarkably, they improved on it. Newspaper accounts concentrated on outward behavior not merely as an indicator of social refinement but as evidence of a productive art encounter that could lead to understanding and enjoyment.

Millions of visitors returned to their homes with an experience of fine art and a museum setting (if an imperfect one), as well as an enduring interest. A writer for the *Aldine* noted two years later "the growing interest manifested by large classes of the American people in every branch of the fine arts" and attributed it to the recent world's fair.[99]

The visitors' experience plays an important role in understanding reactions to the exhibition, but it can only be extrapolated from contemporary descriptions of the galleries and some diaries and letters. The responses of critics and contemporary writers, on the other hand, were available in quantity. During a moment when art criticism was emerging as an increasingly professionalized part of the art world, reviewers brought another set of perspectives to bear that played a crucial role in how the fine arts exhibition would be understood and remembered.

CRITICS' RESPONSES

American Progress and Imaginary Exhibitions

Earl Shinn must have agonized over where to begin with his new project, perhaps the most ambitious yet in his young career as a writer. He had spent several years studying to be an artist, training at the Pennsylvania Academy of the Fine Arts, in Paris at the École des Beaux-Arts, and in the atelier of the acclaimed French academic painter Jean-Léon Gérôme. His poor eyesight led him to consider a career as an art critic, and beginning in the late 1860s he had written articles for the *Philadelphia Evening Bulletin*, the *Nation*, *Lippincott's Magazine*, and the *Art Amateur* under pseudonyms such as Sigma, L'Enfant Perdu, and Edward Strahan. His first book, *The New Hyperion*, was a fictionalized reminiscence of a middle-aged American's travels abroad, filled with amusing incidents and colorful characters. However, at the end of the book, Shinn advised the reader, "If you want a career to be eternal instead of transitory, hand it over to art."[1]

In spite of this counsel, he recognized the hazards of writing about art and the ever-present pressure of time. In 1874, he wrote to a friend about an article on recent art developments that he had submitted to the New York *Daily Graphic*: "The machinery of showing it around, getting it from one editor to another, takes time, and meanwhile your precious information is staling [*sic*] in your hands, and presently becomes no news at all."[2] The pressure of the ticking clock weighed on him even more heavily for his latest endeavor, a book titled *A Century After: Picturesque Glimpses of Philadelphia and Pennsylvania*.

It may not have been the topic he would have chosen to further his career as an art critic, but it was a substantial publication intended to introduce the throngs of centennial visitors to the sights of his native city and the wonders of the exhibition in Fairmount Park, particularly the art in Memorial Hall. Shinn narrated a fanciful stroll with the

reader through the Centennial Exhibition grounds. Upon mounting the stairs leading to the entrance of Memorial Hall, Shinn did not deign to describe the paired monumental bronze sculptures of Pegasus on either side, one accompanied by the muse Calliope and the other by Erato, by Austrian sculptor Vincenz Pilz. Instead, he wrote that "we prefer not to notice" them. Readers might have been puzzled by his diffidence, as well as by his vague and tentative assessment of the American art contribution. Shinn did not name the artists represented, merely assuring the reader, "It is safe to say that the pictures of no American painter, living or dead, that are worthy of being seen, are absent." He declined to describe the works on view in the galleries: "Can we retain what we receive and reproduce it in words? We cannot and we shall not attempt to." Shinn obliquely commented on the debate over international influences on American art: "If the best art of America is not here it is not because the committees have not selected from the art societies of the Continent" (a circuitous way of saying that expatriate artists produced the nation's finest art). Finally, he concluded his tour by pronouncing of American art, "We are sure of her in landscape and in sculpture. If America has not attained the highest eminence in art she will attain it. With this cud for critics to chew, we proceed to Horticultural Hall."[3]

Shinn's refusal to describe or comment on the art exhibition seems utterly bewildering and entirely at odds with his aspirations as a critic—until the reader notices that the book was published in 1875, the year *before* the Centennial Exhibition, no doubt to take the earliest advantage of sales to centennial pilgrims. Shinn had taken on the unenviable task of describing an exhibition that had not yet been mounted and whose character was, at the time he was writing,

entirely unknown (in fact, there was some speculation in 1875 that an exhibition of American art could not be assembled, given the late start). Shinn's account was not firsthand, like John Sartain's letters, James Smillie's diary, or Xanthus Smith's written impressions, nor even based on a pastiche of documentary sources, like Marietta Holley's narration of Samantha Allen's visit. In the awkward position of having to anticipate the American art exhibition, Shinn could only express his assessment of the current state of American art—its eminence in landscape and sculpture and his convictions about the merits of expatriate artists—and abdicate his professional role for the moment, leaving "this cud for critics to chew."

The Centennial Exhibition was a landmark moment in art criticism, but not because it was the beginning or the end of any particular art movement. Rather, its significance lay in the unprecedented nationwide dialogue it inspired and how that dialogue spread and shaped the character of art discourse throughout the United States among the general public and among critics and commentators. Shinn's parting comment acknowledged the monumental task ahead for critics pondering the American art exhibition in Fairmount Park—including himself. Writing later for the *Nation*, he complained of continued eye troubles and fatigue from overwork during the Centennial Exhibition.[4] Shinn's words also epitomized commentary about the fair as an imaginative exercise, based as much on the writer's personal hopes and fears as on the facts of the exhibition.

The centennial year marked the first time that art criticism of one event was circulated nationally in different forums among a range of readers that extended far beyond the East Coast intelligentsia. There was as much at stake for critics as there was for artists; they

could speak to a new and untried audience with the potential of a much broader reach and a larger circle of influence. The exhibition occurred at a moment when forms of art information were exploding. Critics, growing in sophistication, skillfully exploited these opportunities and the powerful new national media to assert their authority as cultural arbiters. While artists had chosen the works that graced Memorial Hall and the Art Annex, critics would pass judgment on them through their praise, their condemnation, or their neglect. Their commentary would affect not only bewildered and overwhelmed visitors but also dealers and collectors, influencing the shape of their participation in the art market.

Earl Shinn's groping summary of the fine arts exhibition a year *before* it was on view illustrates critics' trepidation about the American art display and how they would assess it. Critics' accounts were also important for posterity, since their written responses would remain after the exhibition closed and would inform those who could not attend which works were most worthy. In keeping with French philosopher Paul Ricoeur's explanation of how historical accounts develop, the general public's recollections and impressions of the Centennial Exhibition and the American art there took the form of collective memory, and critics' written summaries took the next step in attempting to analyze and understand the display.[5] They used the art exhibition as a point of departure to form their own histories of art and move from undiscriminating boosterism to a new form of commentary characterized by a more selective and sophisticated analysis. Their commentary also laid the groundwork for the emergence of a national art community with an international accent.

Shinn was likely aware of the complexity of his task and the diverse skills needed to accomplish

it. Traditionally, critics have been distinguished by knowing the history of the medium or genre under discussion, the characteristics of different styles and periods, artists' biographies, and the merits of different positions on key issues and by having the ability to respond intellectually and emotionally to the various permutations of the vocabulary of the medium the artist employs. Further, criticism involves not only assessing individual works of art, but also formulating a set of standards for determining which works are meritorious and which can properly be called art. Those functions fall under the category of aesthetics, the study of the arguments people use and the systems they construct to judge and classify art. Critics apply aesthetic systems to particular works of art to arrive at judgments of their worth that produce reputations for artists. These systems are subject to constant revision; new theories must arise if existing ones cannot account for new, widely accepted work.[6] In the nineteenth century, those calling themselves critics were often engaged in the work of aestheticians as well, discussing and determining the standards that they would then use to assess works of art.

The dual roles expected of critics placed prominent art writers in a tremendously influential position in shaping the long-term legacy of the fine arts at the Centennial Exhibition. They not only brought new standards to bear on the works of art in Fairmount Park but also took the lead in forming those standards, giving these writers control over the intellectual apparatus that underlaid the canon-building exercise at the Centennial Exhibition. As Pierre Bourdieu observed, "Every critical affirmation contains, on the one hand, a recognition of the value of the work which occasions it . . . and on the other hand an affirmation of its own legitimacy."[7] Critics

effectively legitimized their own authority by exercising it, using the standards they had set to identify works that were more or less meritorious.

The critics' fitness for those roles was questioned in the years around the Centennial Exhibition, along with the fundamental question of what their standards should be. In 1867, writer and landscape painter Christopher Pearse Cranch lamented the "pretension, the audacity, the fault-finding spirit, the inconsistencies, errors and half-truths that have abounded in many of the articles on our exhibitions."[8] A few years later, the fledgling art periodical the *Aldine* flatly asserted, "The difference between Criticism and Art is, that one is a serious thing, which demands the knowledge of a life-time, while the other demands no knowledge at all. . . . Anybody can criticize art . . . and there is no standard of opinion to which [the artist] can appeal, no bar of judgment before which he can bring his accuser."[9] The *American Architect and Building News* complained, "The criticism that we have is mostly either of the easy-going kind that pervades the average daily papers,—a 'genial criticism,' which receives with admiration whatever comes along,—or that which lays about unsparingly, and confounds the work with the author in irritating contempt." The author agreed with the *Aldine* that "there exists no recognized system of working to furnish canons by which the excellence of [artists'] work can be judged."[10]

The conversation itself suggests that criticism was suddenly being taken seriously around the centennial year, and so expectations were high. The nation would be reading the critical reactions to the fine arts at the Centennial Exhibition, and the gathering of the world's art, along with the American canon, was a previously unimagined opportunity for critics not only to make their voices heard on a national stage

but also to reassess the state of criticism and perhaps introduce new criteria by which to make their judgments. Art historian S. G. W. Benjamin suggested that after determining what the artist's purpose was and keeping in mind the age, country, and temperament of the creator, the critic should discuss whether the artist had reached his or her goal.[11] Others, like Shinn's book and the *Centennial Eagle*, published expressly for visitors to the exhibition, adopted the "historic" method of French critic Hippolyte Taine, who considered works as products of their time and place, their national or racial origins, and the overall state of art during the period.[12]

In the post–Civil War years, critics emerged as an increasingly influential force in the dialogue on American art.[13] Publications of all kinds began to employ experienced art writers who brought distinctive points of view to their readers, though articles were often unsigned, so the author's identity was not always clear. Major metropolitan newspapers began to cover fine art in the 1850s; their wide circulation gave critics' comments particular weight with the general public.[14] For instance, the well-established *New York Herald* was said to be unrivaled up until the 1880s; the newspaper had grown its readership by funding projects such as Henry M. Stanley's expedition to Africa in search of the explorer David Livingstone in 1871. At the time of the centennial, its circulation was more than a hundred thousand. The *New-York Tribune*, which even William Cullen Bryant, editor of the rival New York *Evening Post*, called a "paper for gentlemen and scholars," boasted a circulation in the tens of thousands. Clarence Cook, the *Tribune*'s critic from 1864 to 1883, brought a new rigor along with a notoriously sharp and caustic tone.[15] The principal *New-York Times* critic starting in 1876 was Charles

de Kay, a great promoter of American art and art organizations.[16] The *Philadelphia Evening Bulletin*, the centennial city's first successful evening paper, provided exhaustive fine arts coverage for its readers.

After the Civil War, the American art magazine emerged as an established genre; these publications grew quickly in size and in quality of illustrations, and they employed seasoned art writers who offered distinctive points of view. The *Art Journal*, founded in 1875, offered essays on the history of art and on contemporary works, both European and American. The conservative *Aldine* began as a literary magazine but shifted to the fine arts, publishing in New York between 1868 and 1879. The more progressive *American Architect and Building News* was established in 1876.

Just as important, general interest magazines began to discuss art happenings and to review key art exhibitions. The *Atlantic Monthly* was edited by William Dean Howells, whose article "A Sennight of the Centennial" remains a well-observed summary of the exhibition; the magazine boasted a dedicated Art Department as of 1872. In addition to serialized short stories and articles on literary criticism, history, biography, and science, the New York–based *Galaxy* established an Art Department in 1868. Though it was one of the leading magazines of the day, its circulation never exceeded twenty-three thousand and was probably far less in 1876. The *Nation* was a showcase for writing on current events by some of the greatest minds of the time, including Howells, Charles Eliot Norton, Asa Gray, Francis Parkman, and Charles Francis Adams. Though its circulation was only about twelve thousand, its prestige made it highly influential, and it was often quoted by other publications. *Appleton's Journal* offered short, readable articles on a variety of current topics with a distinctively New

York–centered point of view; *Appleton's* was also marked by an interest in foreign travel and included serials by European authors. *Scribner's Monthly* had a column titled "The Old Cabinet" written by poet and critic Richard Watson Gilder, who followed matters of art and literature. By 1880 its circulation topped a hundred thousand, making it one of the most popular magazines of the period, along with *Harper's*, which flourished as one of the chief literary monthlies.[17]

In addition to criticism, readers' interest was piqued by the proliferation of art reproductions. *Scribner's Monthly*, the *Independent*, the *Nation*, and even the *Christian Union* printed images of artworks with accompanying commentary, using increasingly sophisticated methods that moved from woodcuts to wood and steel plate engravings. In fact, by 1883, a writer for the *North American Review* complained that the *Century* included so many pictures that it was becoming tiresome.[18] The increased coverage of art in general interest magazines stimulated public awareness, which contributed significantly to the popularity of the Centennial Exhibition's Art Department.

The art exhibition in Fairmount Park was part of a larger event of national significance, so in addition to commentary in newspapers and magazines, exhibition guides discussed the displays in Memorial Hall and the Art Annex. The official catalog consisted largely of comprehensive lists of the exhibits (and too many advertisements, some complained). Numerous private publishers issued their own guides that provided more general visitor information, directed toward a range of audiences and different points of view. Some publications assisted visitors while they were on the grounds, and others, particularly those with a number of images, such as *Frank Leslie's Illustrated Historical Register of the Centennial*

Exposition, or with piquant commentary, such as the *New-York Tribune Guide to the Exhibition*, could be enjoyed at home, either as a fond souvenir for those who attended or as a way to vicariously experience the event for those who did not.[19]

Some guides appealed to visitors' anxieties about navigating the fair with reassuring titles like *What Is the Centennial? And How to See It* and *Hand-Book to the Centennial Grounds and Fairmount Park: Where to Go and What to See.*[20] Several presented widely available general information in the context of a travelogue, which would have struck a chord with the untold numbers of people making the journey to Philadelphia.[21] Others appealed to a specific group, such as *Something for the Children; or, Uncle John's Story of His First Visit to the Centennial* and *The International Exhibition Guide for the Southern States.* Another popular approach was the book-length guide that was also a patriotic celebration of American progress. Titles such as *The Century: Its Fruits and Its Festival* and *American Enterprise: Burley's United States Centennial Gazetteer and Guide* traced the development of many fields of American endeavor, including art.[22] They were penned by generalist writers for a generalist audience. The author of *American Enterprise* explained, a little apologetically, that he would treat art "in a somewhat popular style for the general reader not for the art critic—a fact which we hope may be remembered by any of the latter class into whose hands this work may come."[23] However, guidebook authors did not hesitate to present the history of American art and to include a few comments on its current state as manifested in Fairmount Park, and they enriched the commentary on the American art display by offering a layperson's point of view.

The widespread interest in the art exhibition and the keen desire for expert guidance are demonstrated in an engraving titled "The Art Critic" from the *Centennial Exhibit 1876 Philadelphia Scrapbook* (fig. 45), which depicts a crowd of men gathered around one who appears to be holding forth about a painting. He and others point to it as they lean toward him with interest. The range of dress and physical type suggests they are from different social classes and different parts of the country, and all are eager to discuss the object at hand. *Scribner's Monthly* also attested to "the universal devotion to the art galleries," which were always full; moreover, "however rapidly other departments may be skimmed over, here the crowd lingers."[24]

Critics took a variety of approaches to their coverage of the art exhibition. Some commented on Memorial Hall and the Art Annex in the most general terms, observing the status of the galleries and the behavior of the visitors. Others examined the display in fanatical detail. The Philadelphia *Evening Telegraph* published approximately fifty installments on various aspects of the entire Art Department.[25] The *Philadelphia Evening Bulletin* devoted the most attention to the American art exhibition, at least in terms of sheer space. The paper published a series of eighteen installments that, incredibly, covered the majority of the more than seven hundred American paintings on view and the sculptures as well.[26] These articles read like a walk through the display. Each picture was referenced with its catalog number and a description; most were praised, with only a few mild qualifications.

A stunning amount of time, ink, and column space was expended on this type of timid, old-fashioned criticism, which applauded any American effort and failed to exercise discrimination.

THE ART CRITIC.

FIGURE 45 American School, "The Art Critic," 1876. Engraving. Free
Library of Philadelphia.

Expository criticism that focused on the artist and his subject matter had predominated before the Civil War, but was quickly falling out of favor.[27] On the occasion of the 1867 Exposition universelle in Paris, publisher Frank Leslie complained about "the absence of sound and judicious criticism" and about pictures that "obtain undeserved and sweeping commendations from injudicious friends" who "overlook defects."[28] Just a few years later, art writer James Jackson Jarves commented, "There are already too many either absolutely ignorant critics or those who wish to make everyone feel comfortable at the expense of truth and the hindrance of real progress."[29] In spite of the many columns the *Philadelphia Evening Bulletin* writer devoted to his topic, he was aware of the need to choose the best works from the overwhelming number of possibilities, describing the visitor's task of picking out creditable works "from amidst their unfortunate surroundings."[30] The *Bulletin*'s choice to abdicate its critical function and mention virtually everything was not feasible for other publications. In most cases, critics had to select

and discuss only the works they considered most important. The profusion of works in the American department forced most writers to dispense with the old forms of criticism, which deemed any effort meritorious because it was American, and to make their own assessments for their readers, whether they were cultivated connoisseurs or eager novices.

Responding to the American School: Nationalism Versus Internationalism

The vast majority of the American works on view fell under the first of the three categories mentioned earlier: paintings and sculptures by living artists. Most commentary focused on two intertwined issues that drew artists, collectors, and the general public into a great debate: first, could the United States have a national school of its own, and second, its corollary, what was American art's proper relationship to that of Europe?[31] Artist John F. Weir insisted that "the art of a nation is a true exponent of the habits of mind and feeling peculiar to its people." But his view was challenged by an article in the *Galaxy* of June 1876 that asked the burning question in its title, "Have We a National Character?"[32]

Given the intense rivalries leading up to the exhibition, it is not surprising that expressions of civic identity by critics complicated the question of national identity. The *Press* of Philadelphia commented on the success of the May 10 opening: "Even the jealousy of the New Yorker and the Bostonian could go no further in the expression of Philadelphia for having secured and made a grand success of the Exposition than to 'damn with faint praise.'"[33] Sartain felt the

sting of criticism strongly and grumbled to James Smillie, "It is characteristic of [New York] to studiously ignore all the good and find all the fault possible with the exhibition."[34] The *Philadelphia Evening Bulletin* accused New York artists of obnoxiously overloading the exhibition with their own works and asserted, "New York art has always been distinguished by oppressive, multitudinous mediocrity."[35]

New York and Boston traded barbs as well. Boston's *American Architect and Building News* observed that pictures from Boston were kept to a high standard, but those from other areas were too many in number and too low in quality.[36] The Boston-based *Atlantic Monthly* was particularly pointed in its criticism of the Hudson River School: "Bostonians may well laugh at the old-time niggling, the smoothly finished, highly polished surfaces and tense lines of the New York painters." The writer went on to laud progressive Bostonians, since "every artist worth mentioning can show something *en rapport* with modern tendencies," and further suggested that New York artists could take a hint from those of Boston and borrow "some of her finer fancy and later-day suggestiveness of treatment, thus mellowing the hardness of line."[37] Such internal sniping, however, was overshadowed by the debate between nativists and advocates of international influences.

Several accounts of American art at the Centennial Exhibition have portrayed it as a triumphal moment for the Hudson River School, and that school certainly carried the day in the sheer quantity of notices in publications catering to a variety of readers.[38] The historic occasion and the grand gathering of American works inspired many critics to think in even more ambitious terms of their own ideas

for the exhibition. A writer for the New York *Daily Graphic* wished for an entire gallery of monumental American landscapes, enthusing, "Would not such a panorama of United States American scenery be fine, grand, super-magnificent?"[39] Joaquin Miller of the *Independent* proclaimed with patriotic fervor that "the best pictures to be seen here [in all the galleries of the Art Department] are American landscapes by American painters."[40] Works by Albert Bierstadt, Sanford Gifford, John F. Kensett, Jervis McEntee, Thomas Moran, and Worthington Whittredge were most frequently acknowledged, along with Eastman Johnson, who was at the zenith of his reputation as a genre painter, and Winslow Homer, who would soon surpass him.[41] Works by those well-known artists were easily recognized in the bewildering mass of pictures, and critics seized upon them eagerly, whether they were located in Memorial Hall or in the Art Annex.

However, accounts of the American exhibition also tell a subtler story of a country in transition. Susan Nichols Carter in the *Art Journal* called Gifford's paintings "lovely poems," full of "completeness and repose." McEntee's work (for example, fig. 46) was considered "particularly pleasing," and the *Atlantic Monthly* lauded his ability to show sentiment without overrefinement or lack of breadth. The *Philadelphia Evening Bulletin* praised Whittredge's "wonderfully luminous and delicately-painted works," which were "poetical as well as realistic." Finally, the *New York Herald* called Kensett "charming" for his "vigorous yet delicate" handling as he anticipated the movement from, as the *New York World* characterized it, "realism" to "eloquence."[42] These most-admired landscapists from the second generation of the Hudson River School were known for small-scale works characterized by stillness,

FIGURE 46 Jervis McEntee (American, 1828–1891), *Frosty Morning*, n.d. Oil on canvas, 18 × 30 in. (45.7 × 76.2 cm). Unlocated.

quietude, and domesticity. They were praised for reasons of technical mastery and evocation of mood—qualities that pointed toward the Barbizon landscape school of France and away from the Hudson River School's traditional qualities of great size and topographical precision.

The luminaries of the Hudson River School's "operatic" moment, with their huge canvases covered in painstaking detail, were not as well received. Shinn, standing before large paintings such as Bierstadt's *Entrance into Monterey (The Settlement of California, Bay of Monterey, 1777)* (fig. 25), felt that "an admiration is expected of us which can only be felt by falsifying our point of view." Bierstadt's "monster scenes" (so called by the *Daily Graphic*) included *The Great Trees, Mariposa Grove, California* (private collection), which the *New-York Times* critic felt "challenges the admiration of the undiscerning, but it will be hard to discover in it any artistic qualities." Edward Bruce's

FIGURE 47 Thomas Moran (English-born American, 1837–1926), *Fiercely the Red Sun Descending / Burned His Way Along the Heavens*, 1875–76. Oil on canvas, 33 ⅜ × 50 ¹/₁₆ in. (84.8 × 127.2 cm). North Carolina Museum of Art, Raleigh, purchased with funds from the North Carolina State Art Society (Robert F. Phifer Bequest).

The Century: Its Fruits and Its Festival condemned Frederic E. Church's *Chimborazo* (fig. 4) for its raw color and substandard quality. One guidebook called Thomas Moran's *Dream of the Orient* (unlocated) a "hideous nightmare of conception and color," and his *Fiercely the Red Sun Descending / Burned His Way Along the Heavens* (fig. 47) was condemned as "simply color gone mad," with the *New-York Times* calling it "a complete failure."[43]

Other observations on the mammoth American landscape contributions, with their magisterial views and meticulous brushwork, point to a growing disillusionment. The *American Architect and Building News* assured readers that "the standard works of the landscapists are all assembled" and sardonically observed how "the photographic illustrations of Bierstadt challenge the crisp, metallic studies of

[California landscape painter] Thomas Hill." The same writer noted, "The courageous and conventional attempts of a hundred aspirants to fame as disciples of the American school of landscape-painting flash out in crudely-colored sunsets, impossible perspectives of mountain-views, curious freaks of nature in rock-formation, and all the wearisome succession of map-like prospects of cultivated country." Edward Bruce's guidebook questioned the huge size of these works and "the necessity of placing these colossal scenes upon correspondingly colossal canvases." The *American Architect and Building News* agreed, commenting hopefully that in the future "American landscapes shall be known by their artistic merits, and not solely by their wall-covering capacity."[44] Critics were tiring of the Hudson River School, and their responses were divided between the movement's extremes. The commentaries show a growing disdain for the meticulously rendered panoramas that epitomized the movement. Reviewers responded more warmly to small, intimate works that showed French influences in their evocation of mood and looser handling, hinting at the possibility of a middle ground where American subjects met foreign techniques.

In the first installment of his lengthy account of the American art exhibition, Clarence Cook pointed out that he had delayed beginning his review because he was waiting for "an infusion of new life."[45] Cook was referring to the late arrival of expatriate works being shipped from Europe. In calling these works "new life," he echoed the widespread sentiment that these artists represented the country's future. Several young expatriates attracted favorable notice from a range of publications: specialist journals, local newspapers, and souvenir guidebooks. The *American*

Architect and Building News praised orientalist Frederic A. Bridgman (fig. 28) for his "skill and confidence" and called his work "excellent in design, color, drawing, and composition." The Paris-trained Charles Sprague Pearce's *L'Italienne* (fig. 5) was commended by the *Philadelphia Evening Bulletin* for its grace and simplicity. The paper also lauded Anna M. Lea (later known as Anna Lea Merritt), an expatriate living in London, for her bold touch, free execution, and original sense of color, and *Frank Leslie's Illustrated Historical Register of the Centennial Exhibition* noted her "unsurpassed skill with textures and flesh tints." Among the students of the Munich School, William Merritt Chase's *"Keying Up"—The Court Jester* (fig. 32) was singled out by several writers; in particular, the *New-York Times* admired his "broad, dashy style" and "love of gorgeous coloring." The *National Republican* declared that Chase's fellow expatriate Toby Rosenthal's *Elaine* (fig. 48) "attract[ed] the greatest admiration." The same newspaper called H. H. Moore's controversial *Almeh* (fig. 17) "brilliantly beautiful," and one guidebook considered it "the most beautiful painting of its speciality." Earl Shinn, writing for the *Nation*, credited Moore with an artistic maturity beyond his years and considered *Almeh* "one of the most satisfactory [paintings] in the American department." The *Philadelphia Evening Bulletin* expressed a vision for an ideal exhibition when the writer called for a central arrangement of works by European-trained artists, including Bridgman Eakins, La Farge, Lea (Merritt), Moore, Rosenthal, and Walter Shirlaw, which were "fairly deserving notice among a crowd of mediocrities."[46]

Eakins's paintings in Memorial Hall and the Art Annex, which still bore the influence of his years in

Paris, were highly praised. However, little was said of *The Gross Clinic* (fig. 15). The *Philadelphia Evening Bulletin* included the painting in its review of the Department of Fine Arts, though it was displayed in the Medical Department since it had been rejected by the Selection Committee. The writer considered it, along with Moore's *Almeh*, among the works most entitled to be shown, explaining that it was declined for reasons unrelated to artistic merit. *The Gross Clinic* was addressed again in the *Philadelphia Evening Bulletin*'s review of the Medical Department, where it was called "a splendid work of art in itself," affirming its status as fine art, rather than as the large illustration it may have appeared to be among the displays of bedpans and hospital beds.[47] In an article in the Harrisburg *Daily Telegraph* a few days before the opening of the exhibition, William J. Clark offered high praise: "This portrait of Dr. Gross is a great work—we know of nothing greater that has ever been executed in America." However, beyond these few mentions and notices in a handful of medical journals, it was all but ignored in the mainstream press.[48] Only Pennsylvania papers addressed the fate of Eakins's great work, painted by a promising young hometown artist with the city's Centennial Exhibition in mind. Other critics may have simply missed the painting in its unusual location. It received little attention during the centennial, though it would garner considerably more at future exhibitions.[49]

At the same time that they praised expatriate works, critics voiced concerns about the overwhelming influence of foreign masters on their American students. The American department was called "a Paris salon with the important pictures left out." This unflattering remark acknowledged the inescapable influence of French art, which would become an increasingly common point of reference for Americans through the remainder of the century. In his guide to the Centennial Exhibition Sylvester Burley commented on the vogue for Gallic culture: "French paintings dominate in the private collections of the country, and French types of form, color and design have been reproduced." The *New York Evening Mail* lamented, "We have striven in vain to find anything in the American painting which is really distinctive. We can discover only old methods and the Old World reproduced." Shinn complained that after study abroad artists lost their individuality; having trained with Gérôme, perhaps he spoke from personal experience. Shinn called Bridgman's *Nubian Story-Teller* (unlocated) "European and conventional," and he even pointed out a European lineage in two of the painters considered to be most American, citing Bierstadt's debt to the German artists Karl Friedrich Lessing and Andreas Achenbach and Thomas Moran's borrowings from J. M. W. Turner. Shinn declared that "we rightly wish for American originality to have an accent apart from European originality."[50]

Critics' discontentment with a perceived lack of "Americanness" centered on vague, undefined concerns about style and subject. After decades of advocating for a national school of art that focused on American subjects, critics confronted the same dilemma that artists did: what should an American School look like, and how could an artwork's "Americanness" be judged, whether by style or subject? The Hudson River School's second-generation landscapists were praised for employing a more European aesthetic, while the expatriates raised fears

FIGURE 48 Toby Edward Rosenthal (American, 1848–1917), *Elaine*, 1874. Oil on canvas, 38 ⁹⁄₁₆ × 62 ½ in. (97.9 × 158.8 cm). The Art Institute of Chicago, Gift of Mrs. Maurice Rosenfeld, 1917.3.

about too fond an embrace of mere technique. The question of European influence was not a new one, and critics and artists alike continued their struggle to create a usable understanding of nationality, a middle ground where the benefits of European training were harnessed in the service of American subjects. The centennial mandate for a summary of the state of American art made public a debate that had been circulating quietly for years among specialists and art publications. It began a widespread conversation about the question of European influence that

marked public discourse about American art for many decades after, periodically coming to a head during the world's fairs in 1889, 1893, and 1900.[51]

Responding to the Past: Retrospectives, Real and Imagined

The second category of American contributions, those from artists of the past, included far fewer works but had an outsized impact on the assessments of

American art that followed. History was very much on Americans' minds in the centennial year, and parallels can be drawn between writing the history of the country and writing the history of its art, as critics followed historians' techniques and methodologies, progressing from the great man model, centered on individual biographies, to romantic narratives marked by a celebratory patriotic spirit.

Histories of American art before the centennial year were organized as collections of biographies. William Dunlap's 1834 *History of the Rise and Progress of the Arts of Design in the United States* piled one life story upon another, many taken directly from the subjects. As Dunlap wrote, "The author calls this work a history. . . . His history shall be given by a chain of biographical notices." Dunlap considered himself a chronicler and a biographer. Emphasizing artists' character (or lack thereof) as much as their works, he spoke of Benjamin West's "unsullied life as a man" and delicately commented on Gilbert Stuart's mercurial personality: "with Stuart it was either high tide or low tide."[52]

C. Edwards Lester acknowledged that his 1846 book, *The Artists of America: A Series of Biographical Sketches of American Artists*, followed Dunlap closely. Continuing Dunlap's biographical focus, Lester discussed artists' personalities, their own recollections, and the testimonies of friends. This emphasis is apparent in his choice of illustrations: with one exception (Henry Inman's *Mumble the Peg*), all are engraved portraits of the artists themselves, rather than images of their work.

Little was written on sculpture before the centennial year, but Pickering Dodge's *Sculpture and the Plastic Art* (1850) made a flying survey of American sculpture, skipping from Native American pottery and the Stone Tower at Newport, Rhode Island (then speculated to be from the Middle Ages), to the U.S. Capitol Building. He demurred that "it is foreign to our purposes to attempt anything like a criticism of the works of living American sculptors," only briefly noting the work of Hiram Powers and Thomas Crawford. Future writers would express the same worries about characterizing the work of living artists. Dodge had no hesitations, however, about discussing dead sculptors, and he enthused for four pages about the recently deceased Shobal Clevenger.[53]

Henry Tuckerman intended his 1867 *Book of the Artists* to go beyond the biographical model to provide a survey of American art. Its extended title is *American Artist Life, Comprising Biographical and Critical Sketches of American Artists: Preceded by an Historical Account of the Rise and Progress of Art in America.* A "publisher's advertisement" at the beginning of the book asserted that "a candid and comprehensive survey of the Progress of Art in the United States has for some years appeared to be an essential want in our literature" and assured readers that Tuckerman's work would answer that need. However, only two pages later the publisher tempered this claim, writing that "this work is essentially a Biographical History of American Art," and indeed, the author continued Dunlap's biographical model for the most part.[54]

However, Tuckerman's book showed hints of the teleological approach that marked writings on American art around the centennial year. His introductory "historical account" provided some background on the country's art market and discussed institutions such as the National Academy of Design and the American Art-Union. But his history quickly turned to polemic as he addressed what he considered the deficiencies of artists and patrons of the day and

their preoccupation with money; he also complained about the lack of private and public patronage.[55] Most important, Tuckerman raised the possibility of an American style and exhorted artists to draw on their surroundings and to reflect the "national character" in their work.[56] He felt of the country's art that "its grand deficiency is want of character," and he rightly worried that the lack of support at home was sending its best practitioners to Rome, Paris, and Düsseldorf, "where ample facilities, abundant sympathy and the 'honor' which never attends 'a prophet in his own country,' await the earnest student."[57]

Modern scholar Elizabeth Johns observed that between 1875 and 1905, "the writing of American art history was a confused matter," and authors attempted to "compartmentalize the past in the interest both of finding patterns larger than biographical and of underlining the achievements of the present."[58] Indeed, writings on American art before 1876, such as those of Dunlap and Tuckerman, cannot be called histories of art in the modern sense; they are more accurately described as collections of biographies. But the American art retrospective at the Centennial Exhibition inspired efforts to create narratives that would bring order to the confusion and incompleteness critics discerned there and to form the story of progress that they had hoped to find. This new consideration of the nation's art resulted in the first real narrative histories that encompassed trends, schools, organizations, and outside influences.

Some accounts of the American retrospective at Fairmount Park took the form of modest newspaper articles, and others were full-length books of unprecedented sophistication and nuance. These new histories turned away from Dunlap's biographical model, but his *History of the Rise and Progress* remained an important primary text that was often integrated into the new narrative vision. Writers worked to form teleological accounts of American art, creating theories of development and trying to identify where the United States stood within those frameworks. They also began to consider economic and sociological approaches to American art that presaged current scholarly methodologies. And of course, questions of European influence and native subjects continued to loom large.

Critics lavishly praised the approximately ninety works by deceased artists, many of them in the Central Gallery West, a few in Gallery C, and about half scattered throughout the Art Annex among the galleries installed by the city. Often, the earlier paintings were used as a springboard to express concerns about contemporary paintings. Shinn touched on discussions of an American School when he noted, "The want of accent and anxious gentility of most of the modern American pictures causes us to linger with considerable tenderness among their predecessors, the colonial or early Revolutionary canvases. Here at least is the distinction of a past school of thought."[59] Most popular was the triumvirate of John Singleton Copley, Gilbert Stuart, and Washington Allston. It was easy for critics to crown them as American old masters since they had already been enshrined by two key historians of American art, William Dunlap and Henry Tuckerman. According to these two early art writers, Copley's portraits were "among the few significant Art-memorials of the past encountered in this country," and he had "raised himself nearly to a level with the best portrait-painters of England."[60] Stuart received three chapters in Dunlap's book, filled with piquant anecdotes, and Tuckerman praised his "eminently practical" genius.[61] Allston "most nearly

FIGURE 49 John Singleton Copley (American, 1738–1815), *Sarah Morecock Boylston (Mrs. Thomas Boylston) (1696–1774)*, 1766. Oil on canvas, 51 × 40 ³⁄₁₆ in. (129.5 × 102 cm). Harvard Art Museums / Fogg Museum, Harvard University Portrait Collection, Bequest of Ward Nicholas Boylston to Harvard College, 1828, H16.

resembled our ideal of an old master," and Dunlap quoted Thomas Sully calling him "number one" among American painters.[62]

Shinn paid Copley the backhanded compliment that "the worst of these [colonial] painters was able to distinguish the fact that his age had a particular social tone . . . and to get it expressed on canvas." The *American Architect and Building News* noted the presence of Copley and Stuart "to the great disadvantage of the feeble and uncertain efforts of all later portraiture painters." The *Philadelphia Evening Bulletin* called Copley's portrait of Sarah Morecock (Mrs. Thomas) Boylston (fig. 49) "full of dignity," and the *Nation* declared Stuart's portrait of Mrs. Nathaniel Coffin (Danforth Art Museum) a "masterpiece." Allston's work was "fit to be companions of the great Italians," according to Susan Nichols Carter in *Appleton's Journal.* They were closely followed in esteem by the late lamented Thomas Cole, who was called "one of the fathers of American landscape."[63]

Critics also took advantage of the centennial mandate to expand on the American art exhibition in Fairmount Park and create their own ideal exhibitions, composed of their personally curated lists of meritorious works, along with historical narratives that justified them. They anticipated by seventy years the French art theorist André Malraux's "Imaginary Museum," a collection of photographs of artworks of his choosing from around the world and throughout history.[64] Malraux's canon went beyond the walls of any one museum, just as the Centennial Exhibition writers' imagined exhibitions reached past what they saw in Memorial Hall. A number of writers, especially authors of long-format souvenir books, responded to the American art exhibition by listing the important works they would have included. For many, conveying their imagined exhibition was just as

important as reporting on the actual one. These commentaries went beyond the works on display, as critics eagerly seized the retrospective as an opportunity to write a history of American art.

Shinn wrote two articles in the *Nation* that took a fairly positive view of the retrospective, commenting that "the history of our painting back to the time when it was homogeneous with that of England is represented . . . and the successes that have become legendary are revived to the sight among fresher and more heavy-looking works."[65] Though the exhibition itself was not arranged chronologically, Shinn organized his articles as a short history of American art. He devoted a great deal of space to paintings from the colonial and federal periods, including those of Allston (fig. 50), Charles Willson Peale, Stuart, Sully, and John Vanderlyn. Shinn also went beyond the paintings in the exhibition and arranged his narrative in the historical terms of generations and successions. He addressed genre painting by discussing Gilbert Stuart Newton and William Sidney Mount and sighed nostalgically: "from these dead anecdotists and jesters we come down with a little fatigue to those who support the same roles at present."[66]

New-York Tribune critic Clarence Cook devoted five installments to his ostensible analysis of the American art exhibition. All were entitled "The Fine Art Department: American Pictures," but more than any other writer he departed from the American art display to develop his own history of American art. Cook had spent the years leading up to the Centennial Exhibition translating and editing German art historian Wilhelm Lübke's *Outlines for a History of Art*, and the book was released the year

FIGURE 50 Washington Allston (American, 1779–1843), *Rosalie*, 1835. Oil on canvas, 36 ½ × 30 in. (92.7 × 76.2 cm). Courtesy of Historic New England. Gift of William Sumner Appleton, Mrs. R. H. F. Standen, Mrs. George F. Weld, and Gladys H. Winterbottom, 1941.1697.

after the centennial, so during 1876 Cook was particularly sensitive to art-historical narratives. Cook called his five articles "attempted sketch[es] of the outlines of painting in America."[67]

Cook included artists and works that he felt should have been part of the exhibition: colonial portraitist Joseph Blackburn, miniaturist Edward Malbone, John Smibert's *Bermuda Group* of 1728 (fig. 51), and portraitists Henry Inman, Chester Harding, and John Wesley Jarvis. His articles included extensive discussions of Copley, West, Stuart, and Allston. His analysis of early American artists began with Copley, whom Cook praised for his ability with "the luster of satin, the shine of silk, . . . the reflecting surface of a mahogany table." Cook decided that West was not truly American, since his mature work was done abroad. He called West's *Death of General Wolfe* (fig. 52), on display in the English department in Memorial Hall, "absurdly over-praised" and "only a contribution to literature" with "no relation whatever to Art." He considered Stuart to be "the first real painter that our country knew after she became independent of Great Britain," and argued that with his generation of artists who remained in America, "[art's] history in this country really begins."[68]

In keeping with the Centennial Exhibition's apotheosis of American progress, several general-interest accounts of the American art display took the form of narratives that treated the country's art as yet another manifestation of its continual improvement, including *The American Centenary* by Benson John Lossing, *The Great Centennial Exhibition* by Phillip T. Sandhurst, and Burley's *American Enterprise*. The title of Edward C. Bruce's book is worth citing in full, since it describes his and other authors' attempts to write a historical assessment of American achievements: *The Century: Its Fruits and Its Festival: Being a History and Description of the Centennial Exhibition, with a Preliminary Outline of Modern Progress*. S. S.

Conant touched on the recurring theme of American advancement in his essay "Progress of the Fine Arts" from the 1876 book *The First Century of the Republic: A Review of American Progress*. The centennial moment gave free rein to a widespread, pent-up need to organize, classify, and explain American history in general and American art in particular and to form a narrative that would make sense of the tumult that characterized contemporary art. A range of critics and commentators made the most of their growing influence, the singular occasion, and access to a large readership to create their own versions of American art history. The works on view were merely a jumping-off point, an occasion to create a coherent and reassuring past.

The centennial stock-taking moment called for a reckoning that went far beyond the fair. The exhibition in Fairmount Park was conceived as a physical manifestation of a national mythos of progress and unity. Any absences or shortcomings, such as the lack of Southern participation or the roiling of bitter memories caused by Rothermel's *The Battle of Gettysburg* (fig. 37), were all the more keenly felt because they intruded on a collective (if unreachable) ideal. Critical accounts of the fine arts displays at the Centennial Exhibition responded to the mandate to write a history of American art's past and a summation of its present, with an eye toward the difficult and ongoing problem of forming a framework for national identity in an increasingly internationalized culture. Many responded to the art exhibition by expressing their own ideals—not just where the exhibition met their vision or fell short, but also what they had hoped to see. Responses to contemporary art in the years leading up to the Centennial Exhibition had focused

FIGURE 51　John Smibert (Scottish-born American, 1688–1751), *The Bermuda Group (Dean Berkeley and His Entourage)*, 1728, reworked 1739. Oil on canvas, 69 ½ × 93 in. (176.5 × 236.2 cm). Yale University Art Gallery, Gift of Isaac Lothrop, 1808.1.

FIGURE 52 Benjamin West (American, 1738–1820), *The Death of General Wolfe*, 1770. Oil on canvas, 60 × 84 ½ in. (152.6 × 214.5 cm). National Gallery of Canada, Ottawa, Transfer from the Canadian War Memorials, 1921 (Gift of the 2nd Duke of Westminster, Eaton Hall, Cheshire, 1918), Acc. 8007.

on the question of European influences, and the close proximity of foreign and American artworks in Fairmount Park stirred up sensitive questions about the United States' nascent cultural identity. Critics' simultaneous condemnation of the Hudson River School's large, theatrical panoramas and their praise for evocative landscapes that employed looser brushwork hinted at the exhibition that they wished for and suggested a possible middle ground between the poles of nationalism and internationalism.

This idealizing impulse was most strongly manifested in writings about the retrospective works. The centennial mandate to form a history of American art captured the imaginations of a number of critics, and the writings it inspired spurred new ways of thinking about that history. These publications underscored the Centennial Exhibition's most lasting legacy: its life in printed commentary. They also pointed toward the aesthetic consolidation that would accompany the overall movement toward a unified national identity in business, politics, and popular culture, albeit one inflected by the United States' growing role as a key player in the international community. The rich variety of commentary on the art exhibition created lasting impressions among those who attended and those who did not (including modern scholars). As Shinn's writings demonstrate, the art exhibition was the site of a critical debate about American identity, couched in longing for an ideal that differed from one writer to the next. These publications formed a body of not just opinion but aspiration, a vision that germinated in the form of new narrative histories of American art and a new sense of critics' power to shape history.

Shinn continued as an art critic for the *Nation* until his death in 1886. In the decade after the centennial, he authored a number of books that documented other gatherings of fine art—both those amassed by individual collectors, as in his monumental three-volume opus *The Art Treasures of America*, and those brought together at later world's fairs.[69] He authored the *Fine Art* volume of *The Masterpieces of the Centennial Exhibition*. Like his book *A Century After*, it was published in 1875, before the exhibition opened, but instead of being a speculative exercise, his volume of fine art masterpieces included extensive commentary on specific works of art and beautifully engraved illustrations; they were probably assembled from existing prints of works known to be coming to the 1876 exhibition. Like many critics, Shinn filled in perceived gaps in the art display with his own international history of nineteenth-century art, beginning with the neoclassicism of the Frenchman Jacques-Louis David, the American Benjamin West, and the German Anton Raphael Mengs. His commentary meandered from nation to nation, sometimes doubling back and sometimes drawing connections among nations.[70] This book and later volumes by Shinn testify to a broad and growing interest in foreign art, particularly from France; he wrote a book on the masterworks of the 1878 Exposition universelle in Paris, a monograph devoted to his former teacher Jean-Léon Gérôme, and books titled *Modern French Art* and *Études in Modern French Art*.[71] But the interest in French art was already strong in 1876: visitors flocked to Memorial Hall not only to see the American art on view, but to compare it to a highly anticipated gathering of masterpieces by the acclaimed artists of that nation and its neighbors.

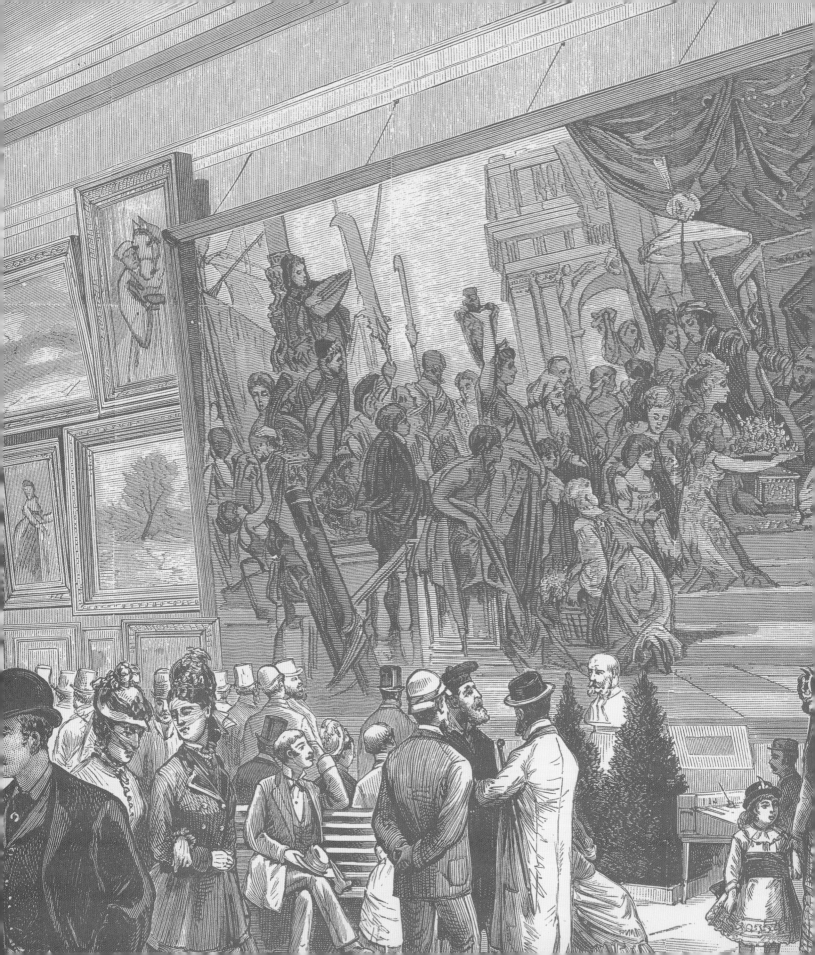

BUYERS AND SELLERS

Defining a New Art Market

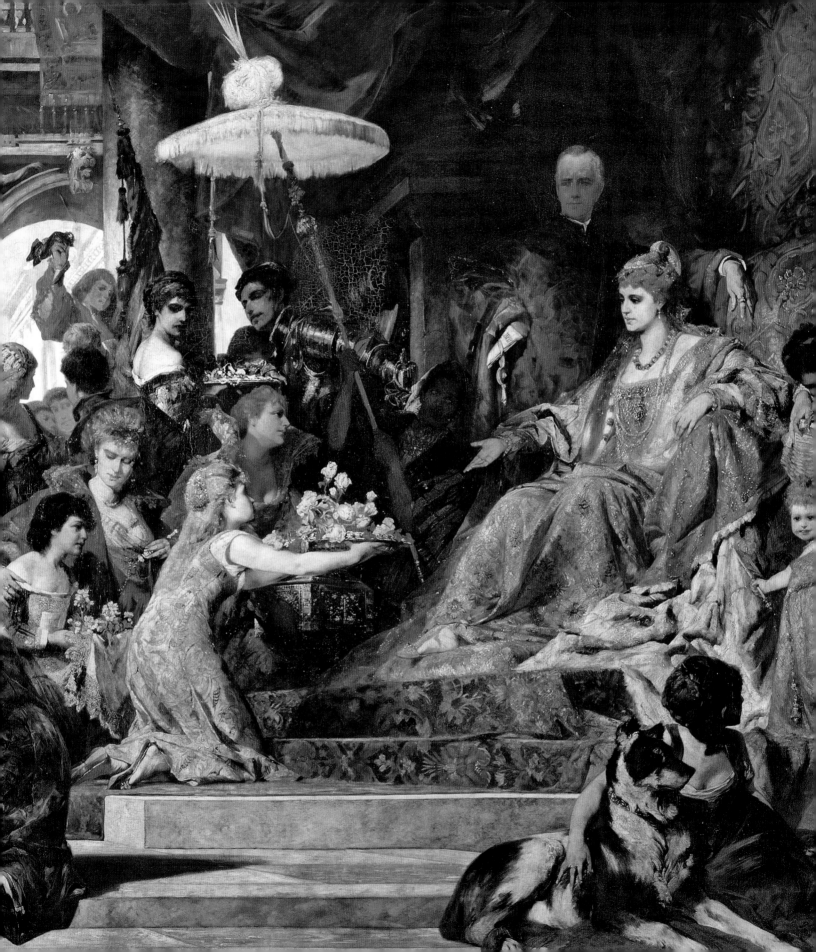

THE FOREIGN EXHIBITORS AND THE AMERICAN "TASTE TEST"

Among the many pieces of "centennialiana" that bombarded the American public was Nathan Appleton's 1877 play, *The Centennial Movement*.[1] Soon after the curtain rises, the protagonist, the old, conservative Philadelphia merchant James Everton, rails against his new acquaintance, the young, energetic, and well-traveled Josiah Whirligig. Everton is bewildered by Whirligig, confiding, "How I do hate these so-called cosmopolitans, with their pretended knowledge of every thing [*sic*], and their real ignorance of most things, certainly most good things!" Whirligig seems to believe in change for its own sake, whether good or bad. When Everton suggests that someday his prosperous brother Charles might experience a reversal of fortune, Whirligig blithely responds, "That won't do him any harm. There is nothing in the world like change and movement."[2] As the story progresses, Charles Everton coerces Whirligig into asking each

of Charles's three daughters to marry him in order to "save" them from their foreign suitors, who are in town for the fair. The threat of losing his great treasures, his daughters, reflects Americans' long-standing concerns about preserving their cultural identity in the face of European influences. It also tacitly acknowledges the often-used plot line of the alliance between a wealthy American girl and a pedigreed but poor European in an exchange of dollars for culture, which brings to mind the complex of tensions among collectors, artists, and museums in 1876.

The author of the play, Nathan Appleton, followed his military career with extended travel abroad; in 1869 he served as a delegate of the Boston Board of Trade to the opening of the Suez Canal, and in 1875 he was a delegate to a conference for the codification and reform of the law of nations at The Hague. After authoring *The Centennial Movement*, he continued

to work for peaceful commerce between nations, including serving as president of the U.S. Board of Trade.[3] Appleton was uniquely suited to address the ways that interactions with foreign nations shaped the American experience of the centennial. Though he brought a light touch to the play, his reach in it is both far and accurate. His comedy of manners introduces an international cast of strong-willed characters pursing sometimes conflicting aims against settings that shift from the halls of Fairmount Park to the salons of New York and beyond. The characters articulate the stresses between old and new generations of Americans and their attitudes toward commerce, cultural authority, and the increasingly unavoidable influence of Europe, all of which were forced to a confrontation at the exhibition in Fairmount Park.

While it was not a classic of theatrical art, *The Centennial Movement* represented a novel way to address the issues that the exhibition raised. Appleton's familiar romantic plot was used to address larger concerns about American identity and offered a shared experience similar to perusing the galleries of Memorial Hall and cataloging the "types" to be found there. He applied well-known tropes: the skeptical, cantankerous Yankee; the eager, go-getting urbanite; and the spirited, independent-minded American girl (in act 1, scene 1, one of Charles Everton's daughters stamps her foot and exclaims, "I will not keep silent unless I happen to want to").[4] In Appleton's hands, the world's fair was not just an event to be described in itself, whether that description was based on direct experience, like Xanthus Smith's, or on published descriptions and illustrations, as Samantha Allen's was, or on virtually nothing, as in Earl Shinn's pre-fair musings. Appleton's play turned the experience of

the Centennial Exhibition into a platform for more complex and layered social commentary.

Chapters 5 and 6 examine the connection between artists who tried to contribute to the European displays and their intended audience, American buyers. It was hoped that the highly anticipated foreign art contributions would comprise didactic, museum-quality exhibitions and that the participating nations would send works representing their own countries' histories of art to educate visitors. However, most sent something akin to a gallery show of works of art for purchase, with some of middling quality at best, perhaps sent in the hope of sales to undiscriminating Americans. Their low estimate of the fairgoers and their commercial focus seemed just another example of the cynical self-promotion that had become all too familiar in the United States. The foreign exhibitions were soon perceived as a test of, rather than a lesson for, developing American taste. With a few exceptions, the foreign artworks were a disappointment, stirring decades-old resentments.

Questions about the state of American taste loomed large at the Centennial Exhibition, and the American response to the foreign exhibitions—that is, which works were acclaimed and which were spurned—shows the emergence of collectors as an important power in the American art world. Like Charles Everton's three daughters, American visitors, and collectors in particular, were courted by European exhibitors at Fairmount Park. The collectors' decisions were placed in the national spotlight at the Centennial Exhibition, highlighting the important role they played in influencing the direction of contemporary art, both foreign and American.

Howard Becker's thorough study of art worlds recognizes the need for a means of distribution that connects artworks to the economy or, in more human terms, artists to collectors.[5] In today's art world, galleries and auction houses are considered the principal outlets of distribution for the works of living artists (though the internet is gaining ground). In the nineteenth century as well, intermediaries played a key role in facilitating American art-world commerce. In New York at the time of the fair, Michael Knoedler was showing and selling American artists at Goupil and Company.[6] Philadelphia boasted two commercial galleries carrying American art, James S. Earle and Son and the Haseltine Galleries; the jewelry retailers Bailey and Co. and J. E. Caldwell and Co. made their windows available for artists' displays.[7] Bostonians patronized the Vose Galleries, which are still in operation, specializing in American art. Commercial galleries, however, were just one option. Collectors could purchase paintings and sculptures, whether finished works or commissions, directly from artists' studios. They might occasionally purchase works at auction, sometimes from other collectors, and sometimes from artists who needed a quick infusion of cash. Private organizations held selling exhibitions, such as the Century Club in New York and the Union League Club in Philadelphia. Artists organized regular exhibitions, such as those at the National Academy of Design, the Tenth Street Studios, and the Dodworth Building, all in New York, and the Boston Art Club. The Pennsylvania Academy of the Fine Arts had not held an annual exhibition since 1869 during construction of its new Frank Furness building, but it resumed the practice in 1876.

In addition to its increasingly complex and sophisticated network of exchange for American art, the United States was a key player in the international art market. During the previous decade American collectors, and consequently American dealers, had favored foreign artworks over the productions of their fellow citizens. In 1875, the *New-York Tribune* assuaged fears of sparse foreign participation in the upcoming fair by assuring readers that "the current belief among foreign artists that America is a very Eldorado of a market for their productions will have its effect."[8] The author referred to the growing number of well-to-do Americans purchasing the works of living European artists; this was stoked by increased travel to the Continent, which doubled its prewar figure by the 1880s.[9] Travel to the Continent had become nothing less than a requirement for cultured Americans: Mark Twain told the story of an acquaintance who "came at last to consider the whole nation as packing up for emigration to France" to see the 1867 Exposition universelle in Paris, and when a shop clerk confessed that he was *not* going to Paris, Twain's friend was certain he must be lying.[10]

At a moment when Americans were amassing huge fortunes and attempting to translate their wealth into social standing, involvement with the arts—and European art in particular—became a means of entry into high society. Some new collectors were driven not only by the love of art but also by a desire to demonstrate their cultural fitness before a tough audience and to advance the social aspirations of themselves and their families. In 1846, Michael Knoedler had opened a New York branch of the successful Parisian Goupil Gallery, beginning with engravings and expanding into contemporary

French, British, and American art. One of his employees, William Schaus, formed his own gallery in 1852. Twelve years later, Samuel Avery opened a gallery with the intent of selling American art, but after his involvement with the 1867 Paris Exposition, he quickly expanded to offer European paintings as well.[11] In the 1870s, Americans purchased the work of French academic painters such as William-Adolphe Bouguereau, Alexandre Cabanel, Jean-Léon Gérôme, and Jean-Louis-Ernest Meissonier in sharply increasing numbers and often directly from Parisian dealers like Goupil.[12]

Unlike American artists, whose works could be acquired on their own soil through multiple outlets, the options in the United States for buying the works of European artists were limited to a few galleries. However, more options were available abroad. While the financial resources and sheer purchasing power of American collectors were unquestioned in Europe, their taste and sophistication were still in doubt. Newly rich Americans were repeatedly warned of the dangers of fraud and, worse yet, embarrassment at the hands of unscrupulous intermediaries. European galleries' access to a fashionable commodity gave them a great deal of power, and they wielded it shrewdly. In the past, some had offered Americans dubious "old master" paintings, perhaps because they could make a sale without sacrificing a better-quality or more securely attributed piece that could be saved for a more discriminating purchaser. The prolific art writer James Jackson Jarves warned, "The responsible party of art-frauds is less the doer who caters to the taste of pseudo patrons than the buyer whose guileless ignorance and pretentious taste creates the demand for false work."[13] The transaction thus became a test in

which buyers had to demonstrate their sophistication against would-be hucksters, who would reward them with works of no higher quality than their taste and knowledge merited.

The foreign exhibitions in Fairmount Park brought these questions to the fore. The long-standing interest in European art made the foreign art displays one of the most anticipated features of the Centennial Exhibition. Each nation organized and controlled the selection and hanging of its contribution. Substantial displays ranging from 150 to 500 works were sent from Great Britain, France, Germany, Italy, Austria, Spain, Belgium, the Netherlands, and Canada, with smaller numbers contributed by Denmark, Sweden, Norway, Russia, Mexico, Brazil, and the Argentine Republic.[14] A total of more than 540 sculptures and 1,891 paintings provided an overwhelming range of works to compare to the nearly 900 American paintings and sculptures on view.

A writer for the *Art Journal* noted that the art exhibition's main purpose was "to compare the artistic skill of different peoples, to ascertain how the arts . . . in our Centennial year stand by the side of other countries, and to gather instruction by comparison of our native work with the designs and methods of our rivals." Painter John Ferguson Weir's report on the fine arts display called this opportunity one of the most striking features of the exhibition. Americans were keenly aware that their culture and taste (or, to their dread, the lack of it) would be on display at Fairmount Park, and Weir recognized the perils of what he called "this severe and uncompromising test of juxtaposition, where [works of art] enter into close competition and fill the eye in rapid succession."[15] In the planning stages of the exhibition and in the

fair's early days, discussions of the foreign exhibitions centered around the United States' relation to Europe, punctuated by a nervous sense of national self-consciousness.

The *Art Journal* raised another critical expectation that an exhibition of artworks from other countries would represent "the first time that the American public have had the opportunity to study, in anything like an adequate manner, the peculiarities and the style of artists whose pictures are familiar to us by name and also by engravings."[16] It was widely expected that the foreign art exhibitions in Memorial Hall and the Art Annex would be filled with some of the most important works from the major galleries of Europe and that they would become a great classroom for educating the masses of American visitors who would never travel abroad to see them. While the fledgling museums in the United States were still populated largely by plaster casts and copies of famed European works, it was hoped that the art exhibition in Fairmount Park would function as a temporary museum, housing not just a gathering of contemporary art from around the globe but also great original works of Western art throughout history. An early notice to American artists for participation appealed to their patriotism, since "contributions to the Exhibition will undoubtedly be made by the most celebrated foreign artists."[17]

However, these expectations were frustrated by fundamental misunderstandings of the nature of world's fairs and the economic forces that drove them. Since world's fairs were fundamentally commercial enterprises, paintings and sculptures teetered on the thin line separating art and business. The American encounter with the foreign art exhibitions opposed two constituencies: European sellers (largely artists) and American audiences. Each eagerly anticipated the great event, but for completely different reasons, which inevitably led to misunderstandings and disappointment. The confrontation laid bare the transatlantic art market's low assessment of Americans' taste and called on Centennial Exhibition visitors, whether viewers or potential buyers, to register their responses and be judged on their level of sophistication.

Memorial Hall as Marketplace

The fine arts contributions were shaped not only by the international art market but also by the character of world's fairs. In spite of hopes for the foreign art display, some Americans understood that, as modern scholar John Maass put it, "the business of the Victorian exhibition was business."[18] A full year before the Centennial Exhibition opened, the *New-York Times* acknowledged, "On a grand scale, and with certain limitations, the Exhibition is, after all, a method of advertising."[19] World's fairs were a tremendous opportunity for trade not just in cultural ideas but in goods, as well as a chance to create new commercial ties abroad.

But the Centennial Exhibition took place during a period of high American protectionism. Tariffs on foreign goods were intended to stave off competition for U.S. products, much to foreign business owners' chagrin, since other countries imposed much lower tariffs: in 1876, Great Britain and France, two major participants in the fair, carried the lowest tariff rates in their history. The *American Builder* reported,

"Nearly all foreign exhibitors are severe in their remarks on the American tariff system." The French writer Louis Simonin concurred that the European exhibitors were united in their complaints. The rate varied for different types of goods, but the average tariff levied by the United States was 42.8 percent, an onerous burden on visiting exhibitors trying to sell their wares in Fairmount Park.[20]

The tariff on imported art, however, was considerably lower at 10 percent, and works destined for educational institutions, such as schools or museums, were exempt. This was still in stark contrast to America's neighbors: since the early nineteenth century, the United States was the only country to tax incoming artwork.[21] Protectionism was equated with patriotism and the virtues of supporting American craftspeople. It resonated with arguments in the art world about whether American cultural identity should be guarded against the influence of schools and artists abroad; in a more prosaic fashion, it was also meant to protect the American art market from foreign works.[22] The tariff on art signaled Americans' ambivalence about the purchase of foreign paintings and sculptures, but it was not high enough to discourage the well-to-do from buying or European artists from the heady prospect of selling to a huge market.

Discussions about the tariff were an uncomfortable reminder to artists of the fine arts' dual status. Modern scholar Bruno Giberti observed that at the Centennial Exhibition, art objects "flickered back and forth between commodity and object lesson," creating a volatile situation for their special status in comparison to the manufactured goods that surrounded them on the fairgrounds.[23] Until this point, most displays of art in the United States usually had some commercial

element: auction houses, galleries, and even the National Academy of Design, the Pennsylvania Academy of the Fine Arts, and the Century Club's displays were geared toward sales. Exceptions were privately organized galleries, and even then commerce was implied in the owners' business success, which allowed them to purchase the works and control access to them. Not until major metropolitan museums were founded in the early 1870s was a large-scale noncommercial alternative available.

Memorial Hall, understood as a future museum site, awkwardly straddled the boundary between the commercial and the commemorative. The appearance of commercial concerns would compromise the sacralized aura that the organizers of the fine arts exhibitions desired. They continued a decades-long struggle against the commodification of art at fairs previous to the Centennial Exhibition and a tradition of strenuous efforts to separate art from commerce. American mechanics' fairs had provided organizers with decades of experience in developing temporary art exhibitions for a broad public, and standards were raised ever higher over the years as fine arts exhibitions began to be grouped together and separated from commercial wares.[24] As was noted earlier, some artists went so far as to boycott the 1853 Crystal Palace exhibition in New York because the art display was not sufficiently distinctive.[25] The Civil War sanitary fairs were driven by commerce (to aid the Union cause), and they offered artists much-needed exposure and income in a period when their work was difficult to sell. This open commercialism caused practical and philosophical difficulties at the Centennial Exhibition as the organizers, particularly Art Bureau chief John Sartain, attempted to frame the American art display

as a didactic exercise, rather than one shaped by the hope of financial gain. He repeatedly insisted that he planned for "an exhibition, not a bazaar."[26]

World's fairs leading up to the Centennial Exhibition increased concerns about rampant commercialism, since it was a common practice for exhibitors to display tags noting the price of their goods. Organizers paid close attention to the 1873 Vienna exhibition for any lessons to be gleaned, and the lessons came fast and furious because the American part in it was a humiliating failure. American newspapers were filled with accusations that some fairground concessions for taverns and bars, and the very posts of the U.S. commissioners, were purchased. Moreover, the U.S. commissioner general, Thomas R. Van Buren, was not only complicit in these transactions but also benefited from them. He was relieved of his duties, and several commissioners were suspended. The agent of one of the country's largest companies (who was left unidentified) was accused of trying to bribe the president of the jury for his exhibiting group. The *New York Herald* called it "America's failure," and the *New-York Tribune* condemned the "frauds, incompetence, pretensions and the utter social and intellectual insignificance" of the organizers. As for the art exhibition, the *International Review* scathingly called it "not an art-collection, but a business-show."[27]

Accounts of the Centennial Exhibition as a whole often noted instances of commercialism run amok, such as "the so-called bazaars outside the Exhibition buildings at Philadelphia, in which thinly-disguised Germans or Irishmen sold sacred relics or the characteristic wares of various oriental countries, of which John Street and Maiden Lane [in

New York City] afforded an unfailing supply on the shortest notice."[28] William Dean Howells cynically observed, "yonder are a Norwegian bride and groom in their wedding-gear, the bride wearing a crown and ornaments of barbaric gold,—which in this case were actual heirlooms descended from mother to daughter in one peasant family through three hundred years. All was for sale."[29]

Museums today are often criticized for their ubiquitous gift shops and restaurants, which are seen as crass attempts to enhance income that interfere with the art encounter, but they are discreet and restrained compared to what Centennial Exhibition visitors encountered in Memorial Hall. An article in the *New-York Times* warned visitors against the uniformed men and boys at the entrance of Memorial Hall selling so-called official catalogs, which were incomplete and full of advertisements. The fictional visitor Samantha Allen is shown fighting off a man insistently trying to sell her a guidebook (fig. 53). Vendors of medals, photographs, flowers, and opera glasses "loudly hawked their wares" in the galleries. Two Philadelphia porcelain dealers set up advertising displays in the Art Annex. There was even a mechanical wax figure of Cleopatra that advertised a museum of anatomy in Philadelphia.[30]

Maintaining the art exhibition's integrity was the task of John Sartain, whose experience as an engraver and a publisher combined the perspectives of artist and entrepreneur. Sartain often found himself navigating the fine line between the two roles. Though he did not organize the foreign art exhibitions, he tried to set the proper tone throughout the galleries. He refused an inquiry about installing a stand for the sale of an artist's prints with the familiar protest that "the

FIGURE 53 "In the Crowd." From Marietta Holley, *Josiah Allen's Wife as a P.A. and P.I.: Samantha at the Centennial* (Hartford, Conn.: American Publishing Company, 1877), 379. General Research Division, The New York Public Library, Astor, Lenox and Tilden Foundations.

Commission makes an exhibition and not a Bazaar." More than once, he instructed vendors to remove from the premises unauthorized tables selling inappropriate objects. He complained about a photography company that was allowed to sell pictures of Italian

sculptures outside the Italian department; given the sensation caused by the Italian "boudoir" sculptures, the photographs were probably popular items indeed. Sartain repeated the chorus of protests that the various stands in Memorial Hall made it "more like a Bazaar than an Art Exhibition" and that the building was "filled with a swarm of men and boys who shout continually The Art Catalogue for sale."[31]

There were inherent conflicts in trying to present an educational exhibition in a highly commercialized context, and Sartain's pragmatic nature often had him paying mere lip service to his ideals. In the months leading up to the exhibition, he explained to various inquirers that there would be no salesmen in the galleries, but he personally would do his best to facilitate sales at no charge "out of goodwill to the artistic profession."[32] By August 1876, he had apparently reversed his policy. He wrote to James Smillie that "measures have been taken to provide facilities for selling pictures and other works of art," and he suggested to the owner of a mosaic table that she station a young man nearby to broker its sale for a commission.[33] A few months later, he made reference to a Mr. H. Teubner as the agent for the sale of paintings in the Art Department, asking that he be allowed to bring potential buyers into the galleries when Sartain was out of town and presumably on Sundays, when the exhibition was closed.[34]

There are hints that Sartain even tried to create a commission arrangement for himself. In February 1876, he wrote regretfully to John Carbutt of Philadelphia that Director General A. T. Goshorn was "so averse to infringing the principal [*sic*] that all persons employed and paid by the Commission must abstain from receiving commissions and fees from Exhibitors for services

rendered, that I fear it will bar the arrangement we were planning." He may have pursued the possibility with someone else, however; several months later, he wrote mysteriously to George A. Leavitt and Co. that they should not include his name on an unspecified circular of theirs, since "my position is peculiar and I am obliged to be very discreet."[35]

It is understandable that some enterprising artists would try to take advantage of the best-attended American art exhibition ever, and the Centennial Exhibition regulations for the Art Department provided that works of art intended for sale would be so indicated in the catalog.[36] The potential commercial advantages of exhibiting in Fairmount Park were obvious to even the most established and high-minded artists. Jervis McEntee wrote in his diary: "My pictures at the Centennial exhibition have had a number of very favorable notices. . . . I only wish it would induce our picture buyers to think more of my work, and I think it will in time."[37] However, the U.S. art exhibition was less of a commercial endeavor than those of other countries. The exhibition catalog listed 235 U.S. paintings and sculptures for sale, less than one-third of the total. In spite of efforts to reduce the exhibition to a business proposition (even by Sartain, its chief), the relatively small number of American artists submitting works for sale shows that they considered the Centennial Exhibition's art display not a sales outlet, but a statement about American art.

In the case of the foreign art exhibitions, many Americans hoped to see each country's greatest works of historical art. However, most countries sent works for sale by living artists, and many pieces were not by their most esteemed artists. Critics and

organizers were quick to vent their disappointment. The *American Architect and Building News* opined that "nowhere . . . is the commercial spirit more obtrusive, than in the art department."[38] Francis Walker, chief of the Centennial Exhibition's Bureau of Awards, reported that in the Fine Arts Department "the commercial interest here fails altogether, or takes its lowest form, in a desire to obtain a purchaser for the article immediately exhibited."[39] Obviously such claims were not true. The "commercial spirit" was far more prevalent in spaces like the Main Building, where it was absolutely integral: manufacturers set up booths organized by type of product within a national classification. For businesspeople, the fair was designed as an opportunity to promote and sell their products both domestically and abroad. However, the expectations for the art exhibition were entirely different; it was intended as an educational exercise and meant to be minimally tainted by commercial interests. Critics thus reacted with disproportionate disappointment.

The Austrian contribution displayed a number of traits common to the foreign displays (fig. 54). The exhibition was of a decidedly commercial character, with 114 out of 121 works designated for sale in the exhibition catalog. Critic Earl Shinn underscored the mediocre quality of the Austrian paintings by listing the contemporary luminaries who were absent, such as Anton Romako and Mihály Munkácsy.[40] There was also some consternation about the "needless exposures" of nude flesh, and the *New-York Times* noted (perhaps with a cringe of embarrassment) how "the country cousins from Oshkosh regard these with astonishment, which very frequently breaks into loud laughter."[41]

FIGURE 54 "Austrian Gallery, in Memorial Hall." From *Frank Leslie's Illustrated Historical Register of the Centennial Exposition 1876*, ed. Frank H. Norton (New York: Paddington, 1974), 263.

The Austrian exhibition was dominated by one large, spectacular, and attention-grabbing work, Hans Makart's *Catherine Cornaro Receiving the Homage of Venice* (fig. 55). A huge, sumptuous historical subject, it occupied more than half the eastern wall of the long east gallery (Gallery G, see fig. 20) and was said to draw the largest crowds of the entire art exhibition. The queen, whose face was modeled after the artist's wife, Amalie, was widowed soon after her marriage in 1468 and forced by the republic of Venice to abdicate

her throne. It is not clear whether Makart's painting depicts her departure in 1472 or her return in 1489, when she was granted the seat of Asolo near Treviso as compensation. The sweeping, richly hued composition shows her seated on an elevated platform, graciously receiving gifts and tributes. The painting was universally acclaimed upon its debut at the 1873 Vienna Universal Exposition a few years before; it inspired comparisons to Venetian sixteenth-century painting and earned Makart acclaim as the "new

FIGURE 55 Hans Makart (Austrian, 1840–1884), *Catherine Cornaro Receiving the Homage of Venice*, 1872–73. Oil on canvas, 157 ½ × 417 ⅜ in. (400.1 × 1060.1 cm). Österreichische Galerie Belvedere, Vienna.

Veronese" as well as international stardom. The painting was almost always noted in accounts of the Centennial Exhibition because of its sheer size and the throngs that perpetually surrounded it. *Catherine Cornaro* was commissioned by the Viennese art gallery Miethke and Wawra, which offered the mammoth canvas for sale for a reported $45,000.[42]

Unfortunately, owners were usually not listed in the Centennial Exhibition catalogue, so it was not clear to visitors in 1876 who was responsible for the foreign contributions, whether dealers such as Miethke and Wawra, private collectors, or the artists themselves. But it was well known that most of the foreign artworks were available for sale. The foreign art exhibitions, expected to be an instrument of education, became a test of sophistication. Would

audiences perceive the low quality of many of the works sent for their delectation, or would they be seduced by these European "suitors" into admiring and buying substandard works fobbed on them by sophisticated Europeans, as American collectors of dubious "old masters" had been decades before?

The Foreign Suitors in Memorial Hall

The largest contributions of foreign art came from Great Britain, France, Germany, Italy, and Spain, and those countries were also of the greatest interest to Americans because of their relative familiarity and their influence on American art. Great Britain, France, and Germany were given pride of place

along with the United States in the central galleries of Memorial Hall. Their location paralleled their status as leaders of industry; they were also given the most prominent positions in the center of the Main Building for their commercial exhibits. Echoing this ranking, in Appleton's play, the American Josiah Whirligig diplomatically greets each of the foreign dignitaries, who are also courting Charles Everton's daughters, with equal enthusiasm, assuring each one that his country's presence is absolutely the most important to the great fair's success.

As was true of the American art display, accounts of the foreign art contributions appeared in virtually every major publication that covered the art scene, as well as in many popular magazines and guides to the fair written for the general public. Reporters for art publications and some metropolitan newspapers were specialists who wrote for an intellectual audience with some background and interest in art, whereas those writing for a broader readership were often less experienced and represented the point of view of the average fairgoer seeing works of art from across the ocean for the first time. Studying the entire spectrum of criticism offers an overall sense of the ways that visitors responded to the taste test put before them. Also in keeping with the American art display, many critics relished long narrative descriptions of works of art that caught their attention—usually those that were the largest and most sensational. They were often quick to warn their readers of the incompleteness of the foreign contributions by naming important artists who were *not* represented, hinting at their ideal imagined exhibitions. In line with the nationalist impulse of the centennial moment, there was a keen interest in whether works of art expressed the character of their country of origin and whether they offered a means to define American culture by way of comparison. As Edward C. Bruce's guidebook claimed, "In art, as in other things, 'blood will tell.'"[43]

The most admired contribution by far was that of Great Britain, which occupied one of the large central spaces. In *The Centennial Movement*, Whirligig greets Lord FitzGibbon, whose sentences are punctuated with caricatured "aws" and "you knows," by describing a speech Whirligig gave in London about the upcoming centennial, appealing to the country's historical ties and explaining that "there was only *one nation* that really we expected to have make [*sic*] a fine exhibit at Philadelphia, and that nation [constituted] our own progenitors and cousins."[44] Critic James Jackson Jarves acknowledged the influence of English civilization on the United States, commenting fondly, "Impatient of shams and equally beguiled by material interests, the American is England's own child."[45] The British commission sent 193 paintings and 15 sculptures, and unlike most of the other foreign exhibitions, the owners were listed in the catalog. Many of them were from the Royal Collection and the Royal Academy, and a number came from prominent private collections. Only Britain sent the kind of display that Americans desired: it offered some of the great historical works familiar to art lovers and provided newcomers with a proper education in the country's national characteristics. One obvious corollary is that since most of the works on view had permanent homes, very few were for sale, proving that Britain's contribution was sent with the didactic intentions that American organizers had hoped for.

Critics were lavish in their praise, particularly since Britain's generosity was so singular at the

Centennial Exhibition. Walker lauded the display for not being motivated by "commercial instinct." The *American Architect and Building News* considered it "the only thoroughly creditable and representative collection of pictures from abroad." William Dean Howells reflected, "They had sent us of their best, and not of their second-best . . . and there was a kindliness of intent and manifest good feeling toward our fair, and toward our nation, to which every American must at once respond." The National Academy of Design even petitioned the British commission to send the entire collection to New York for exhibition (but the academy was refused).[46] Prominent critics Earl Shinn and Clarence Cook expressed disappointment at the thin representation of the "younger men" and the Pre-Raphaelites. But even Shinn called Great Britain's the best of the foreign exhibits, appreciating the nation's generosity in sending pictures that would be inconsolable losses if they were lost at sea or damaged once they reached Memorial Hall (a legitimate concern, given some visitors' behavior).[47]

Critics from East Coast newspapers and art journals noted with interest the contributions of British masters, such as John Constable's *The Lock* (now known as *A Boat Passing a Lock*, Royal Academy of Arts, London), though Shinn sniffed at it as a mere diploma picture, which the academy required of artists upon their election; Thomas Gainsborough's *Duchess of Richmond* (National Trust, Rothschild Collection, Ascott); J. M. W. Turner's *Dolbadden Castle, North Wales* (Royal Academy of Arts, London); and Joshua Reynolds's *Self Portrait* (Royal Academy of Arts, London), which Cook praised for its "easy mastery." Shinn and Cook agreed on the excellence of Lawrence Alma-Tadema's classicized

vision in *Convalescence* (unlocated), *The Mummy—Roman Period* (unlocated), and *The Vintage Festival* (National Gallery of Victoria, Melbourne). They also admired Frederic Leighton's orientalist views, including *Interior of a Jew's House, Damascus*, and *Summer Moon* (both in private collections) and *Eastern Slinger Scaring Birds in the Harvest Time—Moonrise* (unlocated).[48]

The American public's thirst for narrative subjects was gratified by the English contribution. Luke Fildes's *Applicants for Admission to a Casual Ward* (Royal Holloway, University of London) attracted considerable public attention, moving some and repulsing others with the pathos of a line of cold, hungry, and despairing homeless people awaiting tickets that will give them a night's shelter.[49] Audiences and many writers found endless amusement in Edwin Henry Landseer's animal allegories *The Sick Monkey* and *The Traveled Monkey* (both at Guildhall, London).[50] Most attention was paid to William Powell Frith's two monumental subjects, *Marriage of H. R. H. the Prince of Wales* (Royal Collection) and *The Railway Station* (fig. 56). The latter had created a sensation in London in the previous decade; Frith's paean to industrial progress is a panorama of Paddington Station inhabited by a fascinating range of humanity from the streets of London, from a new bride in white bidding farewell to her bridesmaids, to a con artist being apprehended by the police just as he is about to escape onto the train at far right, to the central family group sending off two sons to boarding school, modeled after the artist's own family and including a self-portrait. *The Railway Station* attracted continuous crowds and press notices, in part because of its size and subject

FIGURE 56 William Powell Frith (English, 1819–1909), *The Railway Station*, 1862. Oil on canvas, 46 × 101 in. (116.8 × 256.5 cm). Royal Holloway, University of London.

and also because, according to the somewhat condescending *New-York Tribune*, its "hard, honest, careful realism is instantly understood by the multitude." One of the few British paintings for sale, *The Railway Station* could be purchased for $30,000.[51]

Critics were quick to identify the national characteristics that made the British paintings attractive to American audiences. Howells confessed that, though an amateur in art, he could say that the British artists interested him above all others because they "have not merely painted well, but they have painted about something; their pictures tell stories." Clarence Cook and the *American Architect and*

Building News agreed that the great English strength was in storytelling; hence, Cook explained, "we find the English pictures very much to our mind." Some, however, expressed concerns that British artists were in danger of becoming "mere mechanics," making pictures with literary, but no artistic, value. The *New-York Times* writer "Gar." put a finer point on it when he wrote that in English paintings, the picturesque impulse was subordinated to storytelling, which is "the first thing which the uneducated think of, but the last thing in the artist's consideration. This is simply death to art."[52] His harsh assessment not only applied to the English artists themselves but also

attempted to prescribe standards of taste for their adoring American audiences, since among intellectuals in the art world, the merits of technique were overtaking those of "mere" narrative.

The British paintings were welcomed so warmly because many of them were already known to Americans through engravings. Edward C. Bruce explained that the pictures were bound to be appreciated "in a country whose household engravings were from [William] Hogarth, [David] Wilkie, Landseer, Frith." He warmly recalled that "they came to us like relatives whose photographs had been long in our albums."[53] The wonder of seeing distant and long-revered works of art strongly identifies the British display with the museum experience that was hoped for in Memorial Hall; indeed, Shinn called the historical pictures there "a little National Gallery on the shores of America."[54] The British contribution was an exhibition of revered historical works of museum quality that would serve as an educational tool. The elevated experience of the British display and the storytelling paintings struck a chord with Americans, whereas a jarring note was sounded by the art exhibition of France.

Comparing the displays of Britain and France, a writer for the *New York Herald* dryly opined that the French "have not exerted themselves" as the English had.[55] American audiences had great expectations of the French exhibition: in Appleton's play, Whirligig explains to Count Turbigo, a "French swell," that in his speech on the centennial in Paris, "I made it clear as crystal to my audience that France was the *one* and *particular nation* that ought to do its darndest to be well represented at our great show."[56] And so it was with great disappointment that Americans greeted

a contribution that was large, with 301 paintings and 74 sculptures, but far from representative, lacking works by France's greatest artists (fig. 57). Shinn produced a long and doleful list of omissions: "It is painful to pass to the French rooms, deprived of all the classical names—without a single example of Ingres, Gleyre, Millet, Rousseau, Gérôme, Baudry, Flandrin, Delaroche, Hébert, Meissonier, Corot, Daubigny pere, Couture, Regnault, Bonnat; without even the new and rising names, such as Delaunay, Gustave Moreau, Vollon, and Laurens." Simonin insisted that his country maintained its preeminence, but he admitted that only a small number of its most beloved artists were represented. Jules-Émile Saintin concurred in his official report that all were sorry that the French masters were not present. A chorus of condemnation greeted the exhibition, with critics calling it "plodding," "strangely inert," "an admirable presentation of the mediocrity of French art," and "the sweepings of many studios, including some ghastly attempts at historical painting." The exhibition was still being installed a week after the May 10 opening, when one critic submitted a tongue-in-cheek review of the superb display of French packing boxes in the Art Annex. Work was suspended on May 21, reportedly because the French chief was piqued over the harsh criticism of the pictures hung to that point in Memorial Hall.[57]

The French contribution was organized by the government under the direction of Commissioner Alexandre du Sommerard. About 60 percent of the inquiring artists were accepted into the French department at the Centennial Exhibition, a more liberal proportion than the less than half who were admitted to the Paris Salon during the period.[58] In

FIGURE 57 "French Gallery, in Memorial Hall." From *Frank Leslie's Illustrated Historical Register of the Centennial Exposition 1876*, ed. Frank H. Norton (New York: Paddington, 1974), 232.

much the same manner as the salon, interested artists wrote letters with the titles and sale prices of the pictures they wished to submit, affirming that virtually all were available for purchase.[59] In comparison, at France's 1867 Exposition universelle, almost all of the French paintings were from national or royal collections, with less than 5 percent listed as "property of artist" and therefore potentially for sale.[60]

In a sea of unfamiliar paintings by unfamiliar artists, visitors (and most critics) were attracted to the few that they recognized and to the large and the sensational. A. F. Clement's *The Death of Julius Caesar* (unlocated) was called, among other things, "a large and fatiguing piece of classicism." Dumaresq's imposing history painting *Congress of Geneva, 1873* (L'Hotel de Ville, Geneva) attracted attention as "a specimen of fearful portraiture." Louis Priou's *School for Young Satyrs* (unlocated) was admired as a lively and vivid effort. Carolus-Duran's huge equestrian painting of his sister-in-law, *Equestrian Portrait of Mademoiselle*

Croizette (fig. 58), depicted the young actress Sophie Croizette in a severe riding costume, seated on a bay horse on the beach at low tide. The painting had earned accolades upon its debut at the Paris Salon of 1873. In 1876, critics paid attention to it as perhaps the only example from a well-known contemporary painter. It was called "clever and dashing" and said to attract the most "intelligent attention," though Bruce grumbled that "had it been painted the size of a handkerchief, and not that of a very large barn door, it would have been but little discussed."[61]

The most controversial painting in the French gallery was Georges Becker's mammoth *Rizpah Protecting the Bodies of Her Sons* (unlocated; see fig. 59 for an engraving after the painting). Loosely based on an obscure episode from the Bible (2 Samuel 21:10), it depicted an Israelite mother ferociously fighting off the vultures trying to feed on the bodies of her sons. Though innocent, they were killed to propitiate the enemy Gibeonites for wrongs done to them by the victims' father, Saul, in order to lift God's curse from the nation. The woman's dramatic pose and bulging eyes combined with the gruesome spectacle of the dead bodies was irresistible—though largely incomprehensible—to audiences and critics. The painting drew complaints similar to those aimed at Peter F. Rothermel's *The Battle of Gettysburg* (fig. 37) for its gratuitous violence, such as "gloomy yet repulsive," "shrill and displeasing," and the *New-York Times* writer's pronouncement, "the worst picture anyone ever painted."[62] *Rizpah* became the butt of jokes when *Harper's Weekly* reported on a conversation supposedly overheard in the galleries: "What does that great picture represent, with them men hanging up, and that woman fighting that bird? . . . Oh, I know now:

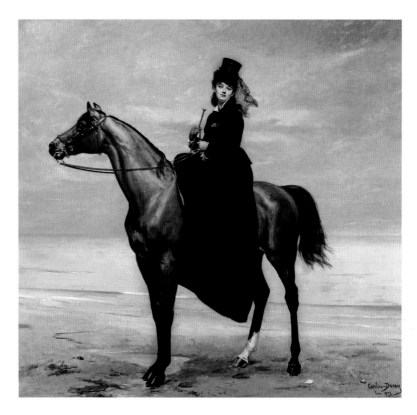

FIGURE 58 Carolus-Duran (Charles-Auguste-Émile Durand) (French, 1837–1917), *Equestrian Portrait of Mademoiselle Croizette*, 1873. Oil on canvas, 133 ⅞ × 122 ⅞ in. (340 × 312 cm). Musée des Beaux-Arts, Tourcoing, France.

It's the Goddess of Liberty with the American eagle hanging the rebels."[63]

Observers were quick to recognize that, given the growing American market for contemporary French art, many of these maligned pictures were sent to sell, perhaps in an attempt to palm off substandard pictures on credulous Yankees. Walker explained that America was such a good market for pictures that the chance to exhibit before millions of fairgoers had attracted a number of paintings that were not properly representative of French art.[64] The exhibition

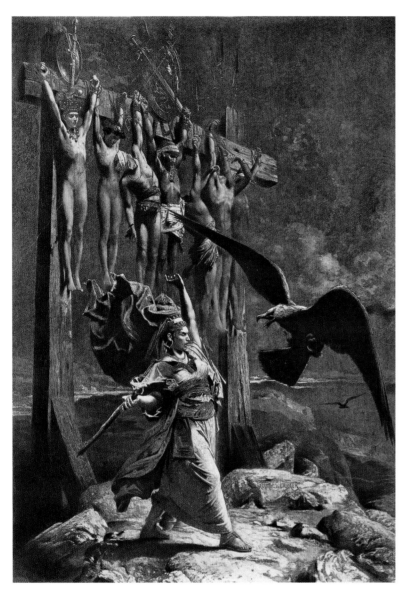

FIGURE 59 After Georges Becker (French, 1845–1909), *Rizpah Protecting the Bodies of Her Sons*, 1873–83. Photogravure. Art and Picture Collection, The New York Public Library, Astor, Lenox and Tilden Foundations.

catalog does not note any objects for sale in the French display, but neither does it list owners. It is likely that works were marked for sale in the galleries, since it was obvious to the *New-York Tribune* that "such a large proportion are offered for sale [that it] suggests a commercial speculation on the part of the artists rather than a genuine representation of the [country's] contemporary art."[65]

Shinn felt that a better representation of French artists should have been sent out of gratitude for American patronage. Coan reasoned that, to the contrary, the worst pictures were sent from the countries most visited by Americans, where such tourists were "at once a joy and a profit to the natives." He lamented of the low estimate of American taste, "Can it be that where we are the best known we are after all the least understood?" Saintin's official report confirmed Coan's fears: he acknowledged that American collectors already pursued the works of France's master painters and that few key artists had unsold paintings in their studios. He also managed a dig at Art Bureau chief John Sartain, writing that Americans were not sufficiently selective with the U.S. contribution, and they had to bargain with foreign exhibitors to give up some of their space and build the Art Annex to handle the overflow; Europeans simply followed their lead and were less than discriminating in their choices.[66]

Seeing the British and French paintings together inspired comparisons of the French emphasis on technique to the British stress on narrative. American artist John F. Weir quoted an English writer's comment that aesthetic criticism oscillates between the poles of form and expression, and he placed English and French art at the two respective poles. Gar. was

less diplomatic, calling French painters "not sound, honest artists, but simply tricksters, who dazzle by sham wonders of prestidigitation. . . . [Their pictures] have an appearance of brilliancy of finish and of power which has dazzled the eyes of American buyers, tickled their senses, captivated their judgments, and depleted their purses." These assessments reflected the drift away from narrative, the province of English art, and the increasing fascination with French "tricks," which attracted American collectors and artists alike in the years immediately following the centennial. The Frenchman Saintin congratulated American artists on their progress, attributing it to a more serious study of French art.[67]

Whirligig related to the German baron Highenstein that in his speech about the coming world's fair in Berlin, Whirligig had praised the German population in the United States, saying that "they were our best citizens; that we wanted more of them; and that Germany was naturally the *one country* that ought to be the best represented at Philadelphia."[68] The German display was another disappointment to American hopes, but critical responses once again showed an increasing sophistication about international trends. The overall German contribution earned such epithets as "intolerable," "weak and meagre," "dull and commonplace," and significantly, "consistently commercial."[69] Critics felt that it recalled the Düsseldorf school, whose work had been popular in the United States in the 1840s and 1850s.[70] They recognized that most of the paintings sent did not reflect the latest developments in German art, which were centered on the rising Munich Royal Academy, led by Karl von Piloty, and the dash and spontaneity advocated by the influential

Munich artist Wilhelm Leibl. Both were mentors of Americans such as William Merritt Chase and Walter Shirlaw, whose works attracted attention in the American art galleries. The *American Architect and Building News* regretted that rather than seeing the work of younger artists, visitors had to "linger over the tag-ends of the old theoretical and formal school." The *New-York Times* agreed that artists of "the [modern] Piloty School . . . have made but a feeble impression here."[71]

Of 145 German paintings, the few that garnered specific critical attention were by familiar names, such as Andreas Achenbach's *Storm at Vlissengen* (unlocated),[72] or of the "classic" school of history paintings. Three versions of an important German victory in the recent Franco-Prussian War were displayed: L. Braun's *Capitulation of Sedan*, Count von Harach's *Capitulation of Sedan*, and C. Steffeck's *The Crown Prince of Germany, on the Battle Fields of Worth and Weissenburg* (all unlocated). Though the paintings drew crowds by virtue of their size, writers objected to the subject: the former two depicted the decisive 1870 battle that assured Prussia's victory over France. Critics and commentators were in no mood for mammoth war scenes after the controversy surrounding Rothermel's *The Battle of Gettysburg*. Worse yet, the German paintings celebrated an even more recent incident: the humiliating defeat of a major exhibitor. Braun's was said to violate fact and taste, and it was called "no better than the *Battle of Gettysburg*."[73] Steffeck's painting was called "in wretched taste" and an "outrage," since it depicted a triumph of despotism.[74]

Spain's contribution fared better with critics, and their responses show a concerted effort to discern

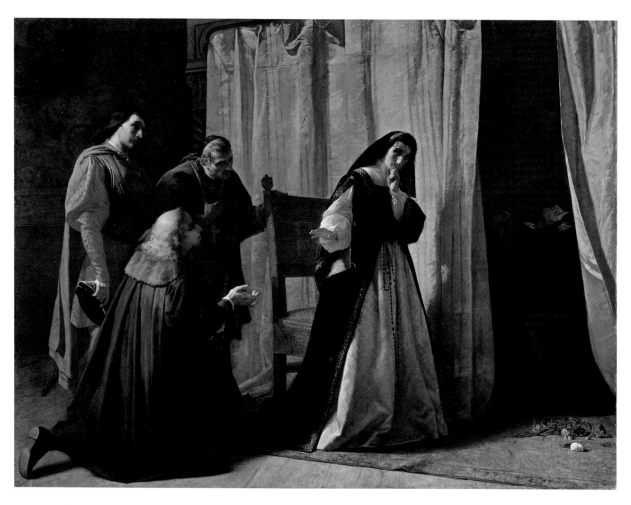

FIGURE 60 Lorenzo Valles (Spanish, 1831–1910), *The Insanity of Doña
Juana de Castilla*, 1866. Oil on canvas, 92 ¾ × 123 ¼ in. (235.6 × 313 cm).
© Museo Nacional del Prado.

each nation's characteristics and put it neatly in its
place in relation to the United States. At 147 paint-
ings and 27 sculptures, the Spanish contribution
was not especially large and thus shared a gallery
with Sweden, a juxtaposition that was said to create
interesting contrasts.[75] Spain was praised for good
intentions: most of its works were contributed by

artists and a few by private collectors. Furthermore,
critics noted that a number of the paintings (even if
they were not all of a high caliber) came from the
Museum of Fine Arts of Madrid and the academies
of Manila (Philippines) and Seville.[76] Centennial
Exhibition Awards Bureau chief Francis A. Walker
lauded "the earnest desire of the government to

do credit to the art of its people." The display was praised, sometimes generously; Shinn commented that the paintings gave "a more surprising sense of alertness of genius and versatility of resource than any other in the Fair," and Gar. called them a revelation.[77]

The Spanish contribution included a sampling of old master paintings, which drew grateful attention, including Bartolomé Esteban Murillo's *Christ on the Cross*, Jusepe de Ribera's *Saint Jerome*, Luis de Morales's *The Nazarene*, and a Diego Velázquez portrait (all unlocated). Critics noted the strong presence of religious themes, and indeed, the Spanish display was punctuated with many Madonnas, saints, and biblical episodes. History paintings also focused on religious subjects, such as Alejo Vera's *Burial of San Lorenzo at Rome* (unlocated), which earned distinctly mixed reviews from "profound" and "noble" to "weak and sentimental."[78] Catholicism was still viewed with discomfort and suspicion by many Americans, and critics responded accordingly: the *New-York Tribune*'s guide to the Centennial Exhibition observed that these subjects "give an almost cloistral character to the hall," and the *New York Herald* pronounced them too serious, heavy, and "overworn."[79]

The gallery included many works whose titles suggest genre subjects, but the greatest attention was paid to historical and religious paintings in the style of the old masters. Antonio Gisbert's *Landing of the Puritans in America* and Dióscoro Teófilo Puebla's *Landing of Columbus* (both unlocated) paid homage to American history; the paintings were prominently placed and praised for their technical merits.[80] Probably the most popular painting was Lorenzo Valles's large, dramatic *The Insanity of Doña Juana de Castilla* (fig. 60). Rendered in a style and palette reminiscent of

the Spanish Baroque painters, Valles depicted the sixteenth-century queen refusing to let her dead husband be buried, admonishing those around her that he is only sleeping. It piqued Americans' fascination with exoticism spiced with madness, and perhaps it offered visitors a reassuring affirmation of American progress in the face of European backwardness and superstition. Modern scholar M. Elizabeth Boone observed that during this period, American interest in Spanish art was based on its glorious past, but Spain's present culture was dismissed as retrograde and degenerate.[81] *Scribner's Monthly* observed that *all* the works seemed to have been painted two hundred years ago, and it is telling that Appleton did not include a Spanish representative in his cast of characters in *The Centennial Movement*.[82]

The Spanish display was another mix of the sacred, in the form of museum-quality objects, and the profane, that is, works of art for sale. The catalog listing of Spain's fine arts contribution was headed by an announcement that information on purchasing works of art could be obtained at the office of the Spanish commission in the Main Building. The specific works for sale were not designated, so it is unclear how many were offered, but the prices were observed to be especially high. For instance, an untitled portrait attributed to Velázquez was reportedly for sale for $25,000.[83]

As with many of the other European contributions, the Spanish display lacked examples of the best-known contemporary painters, and Gar. of the *New-York Times* regretted the absence of the followers of Mariano Fortuny, "for whom the picture-loving communities of New York and Philadelphia are acquiring so strong a relish." Weir insightfully

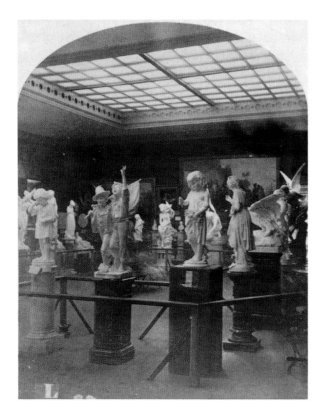

FIGURE 61 Centennial Photographic Company (American photographer, nineteenth century), *Italian Dept., Memorial Hall, Annex* (detail), 1876. Stereoscopic print. The New York Public Library Digital Collections, The Miriam and Ira D. Wallach Division of Art, Prints and Photographs: Photography Collection, The New York Public Library.

remarked that many of the best contemporary Spanish painters, such as Ignacio de Leon y Escosura, Raimundo de Madrazo y Garreta, and Eduardo Zamacois, had studied in Paris for so long that they were classified with the French school.[84]

If the foreign contributions to the Centennial Exhibition amounted to tests of culture and sophistication for the American public, then the Italian display was the final exam. The Italian galleries

comprised the entrance and exit of Memorial Hall, as well as the entrance of the Art Annex, so that every visitor unavoidably came into contact with them. Whirligig explained to the Italian marquis de Tamborino that when in Genoa he had made a great hit by saying that "as Christopher Columbus discovered America, of course Italy was the *one land . . .* that would claim our especial attention" at the Philadelphia exhibition.[85]

More than any other display, the Italian contribution was most obviously geared toward sales to an American audience, and it was the least likely to further Americans' understanding of Italian art. It was thronged with 334 sculptures, many of which were widely recognized as decorative work by stonecutters, rather than the original conceptions of sculptors; the exhibition was called "empty of art," and the marbles were "*not*, of course, sculpture" (fig. 61).[86] Rather, they were high-end souvenirs that constituted a key part of the luxury goods market in Italy. During the nineteenth century, Italian workshops maintained a lively trade in small bronzes, casts, and marble copies of famous ancient and modern sculptures, as well as decorative works like mosaics, columns, and fireplace surrounds. Italian guidebooks included advertisements for firms producing such sculptures; they were popular items that allowed upper middle-class British and American travelers to display their sophistication on a budget.[87]

The Italian sculptures were overwhelmingly either treacly renderings of precious children or risqué female figures characterized as "boudoir art." They were called the superficial, mediocre works of "fourth-rate modelers" with the monotonous themes of "maternal and paternal, mortals and immortals,

blind and deaf, all the graces and virtues." In spite of, or more likely because of, a long-standing American squeamishness with the unclothed figure in art, the forest of lasciviously posed nudes made the Italian exhibition undeniably popular, and it became fodder for humorists (fig. 62). Jarves demonstrated the reservations about the figure when he called French nudes "offences against morality, and consequently against civilization." Colored by a virulent anti-Catholicism, he held the same bias against Italian culture more generally. Though Italy was synonymous with beauty, he condemned the country's "unmentionable filth and blatant immodesty."[88]

Several international artists offered paintings and sculptures on subjects related to the American founding era, but in the context of the Italian display's blatantly mercantile nature, the many Italian examples seemed to be little more than pandering. There were multiple versions of revolutionary leaders as precocious tots, with three different makers showing versions of George Washington with his hatchet and Benjamin Franklin with his whistle.[89] Lot Torelli's portrayal of Eva St. Clare from Harriet Beecher Stowe's wildly popular novel *Uncle Tom's Cabin* also attracted considerable attention.[90] Pietro Guarnerio's huge marble *Apotheosis of Washington* (fig. 63) showed the founding father being conveyed to paradise on the back of an eagle. The *New York Commercial Advertiser* cited it as an example of how "the Italian sculptor, when specially catering to American taste, may be led to wild extravagance if not held in some restraint."[91] Gar. considered it "funny in its quaint absurdity."[92]

As in the French display, no Italian works were designated for sale in the catalog, but nearly all of the statues bore signs saying that agents were on hand to

FIGURE 62 "Samantha in the Art Gallery." From Marietta Holley, *Josiah Allen's Wife as a P.A. and P.I.: Samantha at the Centennial* (Hartford, Conn.: American Publishing Company, 1877), 477. General Research Division, The New York Public Library, Astor, Lenox and Tilden Foundations.

negotiate a sale. It was agreed that "the commercial venture of Italy exceeds that of any other country." Joaquin Miller of the *Independent* huffed, "The Italian pictures and statues were sent over here to sell" and

FIGURE 63 After Pietro Guarnerio (Italian, 1842–1881), *Apotheosis of Washington*. From Earl Shinn, *The Masterpieces of the Centennial Exhibition* (Philadelphia: Gebbie and Barrie, 1875), 1:156.

were "cut down to the level of the American understanding" in an insulting manner. The Centennial Photographic Company capitalized on the popularity of the Italian works by setting up a table outside the Italian department to sell pictures of the most popular sculptures (fig. 64). Sartain complained vociferously to the centennial officers and asked that it be removed, but he was overruled.[93]

More than that of any other country, the Italian display was greeted as a transparent attempt to dupe Americans into purchasing objects that were not even works of art—some were of poor quality, others might

have been forgeries—and at least some commentators and visitors were taken in. The condemnation and dismay of art experts and specialized publications were countered by kudos from general interest publications, which reflected the public's approval. *Harper's Weekly* commented, "No feature of the art collection at the Centennial affords more pleasure or excites more general admiration than the Italian statues. Critics may find fault with them, but they attract lingering crowds of spectators from morning till night."[94] According to J. S. Ingram's *The Centennial Exposition*, the Italian works were "by the mass of visitors, we think, preferred and better appreciated even than the generally solemn and mysterious productions of high art, which they had not the time to study or understand."[95]

Contemporary accounts vehemently warned visitors and condemned those who would fall prey to such attempts. If the Centennial Exhibition was supposed to be an instrument of education, this was a horrifying example of what *not* to aspire to. Intellectuals worried about the Italian display's effect on American taste and mounted a campaign of ridicule and social pressure similar to the one concerning the public's behavior in the galleries, implying that anyone who would buy such works was an ignorant hick. In an article titled "Italian Art-Frauds vs. American Art-Imposture," Jarves warned that in Italy, the most successful artists were those who did sham work, "prostituting their talents to the low level taste of ignorant patrons."[96] William M. F. Round of the *Independent* called the sculptures "such as Mrs. Parvenu buys for her parlor."[97] Gar. declared, "They have sent us their dregs, their offal" and asserted that such low-quality works "are now rejected even by the bankers and railway men of Sioux City."[98]

FIGURE 64 Centennial Photographic Company (American photographer, nineteenth century), *Sculptures, Centennial International Exhibition of 1876, Philadelphia*, 1876. Photograph. Free Library of Philadelphia.

All eyes were on the major European cultural powers and their contributions to Memorial Hall. But an important display in the Main Building proved to be an unexpected delight. Japan brought a wide array of goods to the Centennial Exhibition, including forty-nine ceramics, twenty-five pieces of furniture, twenty-six sculptures, and seventeen paintings.[99] With the opening of Japan to the West in 1854, Europeans and Americans alike were slowly seeing more examples of Japanese artwork. In 1865 the American painter John La Farge produced one of the earliest examples of Japonism in his painting *Fish* (fig. 21), and by the 1870s the Japanese aesthetic was very fashionable in France. However, the Centennial Exhibition provided the first opportunity for Americans to view Japanese works en masse, and they proved to be remarkably

FIGURE 65 Centennial Photographic Company (American photographer, nineteenth century), *Shippokuwaisha's Exhibit, Japanese Section, Centennial International Exhibition of 1876, Philadelphia*, 1876. Silver albumen print. Free Library of Philadelphia.

popular; it was reported that the Japanese display in the Main Building was consistently crowded (fig. 65).

The Japanese works not only blurred the boundaries between fine and decorative arts (which were otherwise strictly observed at the Centennial Exhibition), but they also introduced an aesthetic completely unfamiliar to most Western eyes (fig. 66). The Japanese display did not receive the same volume of critical attention as those of other countries, but it fascinated viewers and critics, and even seasoned

writers struggled to find a vocabulary to describe it. The *Atlantic Monthly* made a futile attempt: "An enumeration of even the most striking objects in the Japanese department would be the driest of catalogues; description can give no idea of them. . . . After the Japanese collection everything else looks in a measure commonplace, almost vulgar."[100] Even the usually caustic Clarence Cook expressed a sense of dazzled bewilderment, calling the Japanese contribution "the despair of the newspaper writer, who is at a loss to know how to convey to his readers any adequate conception of the marvels of skill and ingenuity that meet him at every step."[101] The exhibition was probably seen by millions of people, including artists, and reviews and reproductions likely caught the attention of many more.[102] The display was an important introduction of the Japanese aesthetic that would influence numerous artists in the following decades.[103]

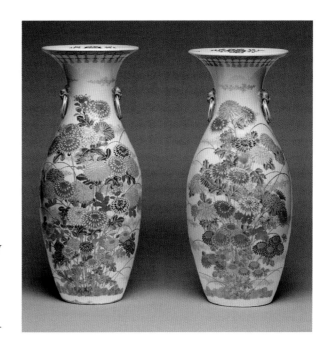

FIGURE 66 Artists/makers unknown (Japanese), vases, Meiji period (1868–1912). Glazed earthenware with overglaze enamel decoration (Satsuma ware), 20 ½ × 9 in. diameter (52.1 × 22.9 cm). Philadelphia Museum of Art, Gift of Mrs. T. Ellwood Zell in the name of her husband, 1908-673.

Passing the International Taste Test

It appears that Americans behaved creditably by *not* purchasing inferior foreign works in great numbers. While exact sales records have not been located for each country, Sartain reported that more artworks were sold than expected, but he was careful to note the quality of the works purchased, assuring readers that among them were "the best foreign canvasses and statues."[104] In the case of the French contribution, only 12 paintings and 2 sculptures were sold out of a total of 375 objects.[105] American collectors' response, or rather, the lack of it was considered a triumph of discerning American taste, and newspapers and journals echoed with self-congratulation. The *New-York Tribune* explained that "it should be written down to our credit, not that our merchant princes have had the money to buy any pictures offered in the European markets, but that they have so soon learned what to buy," and the author observed the "gratifying fact" that "none of the trashy works sent from Europe have found purchasers."[106] The *American Architect and Building News* wrote that "this country, which has so long had the reputation of an easy picture-market, is fast gaining credit for the taste and good judgment of its citizens in the selection of foreign works of art."[107] Even into 1877, the *Art Journal* noted that "it seems to have been thought that everything which would not sell in Europe would

be welcome in America. It is a satisfaction to know that this speculation was a failure."[108]

Appleton's play *The Centennial Movement* narrated a confrontation of national and international ideas; it ends with the foreigners' inevitable triumph in sweeping off their American sweethearts, but only after each carefully considered which culture she would espouse. As the play closes, one of the Philadelphian Charles Everton's daughters is engaged to marry the cosmopolitan American Josiah Whirligig; one will marry the English lord FitzGibbon; and the other is desired by the royalty of Russia, Germany, France, and Italy. Everton decides that his last daughter is too young to marry and that the group will meet again at the 1878 Paris Exposition, where she will announce her decision. His cantankerous brother James Everton finally confers his blessing, adding, "As I have so often heard at the end of a French play, *Soyez heureux, mes enfants, soyez heureux.*"[109]

The scenario is rich with parallels to the situation of America's art: being "betrothed" to newly sophisticated cosmopolites, naturally mindful of its English roots, and "courted" by the various influences of the Continent, uncertain of which will prevail in the upcoming "marriage." While American artists were already going abroad, the Centennial Exhibition accelerated the public's acceptance of cultural internationalization by bringing the possibility to a national forum far broader than the small group of elites who were able to cross the Atlantic. Among artists and critics, the exhibition paved the way for the revolutionary changes that quickly followed. For decades, foreign artists and dealers had found the United States to be a ready, and perhaps less discriminating, market for their productions. If they were surprised by their poor sales in Philadelphia, they quickly learned that American collectors had become a force to be reckoned with. Along with their growing pocketbooks, American buyers now exercised growing discernment as they built renowned collections of contemporary European paintings.

Art critic Susan Nichols Carter seemed to address the foreign lenders when she explained that the New York public had become used to seeing great works of contemporary French art in the commercial galleries and the private collections of their city. The galleries in Philadelphia's Fairmount Park simply did not measure up, "since we in America really possess the masterpieces of Gérôme, Meissonier, Millet." In disgust, she suggested, "We ourselves could probably have made a much better exhibit of Continental pictures than could possibly have been brought from the other side."[110] As she wrote those words, she probably knew that such an effort was about to be realized. Just a few weeks later, New Yorkers opened a competing exhibition meant as a dramatic response to Philadelphia and to the world, showing exactly what American taste had accomplished and making a public demonstration of collectors' newfound power and influence.

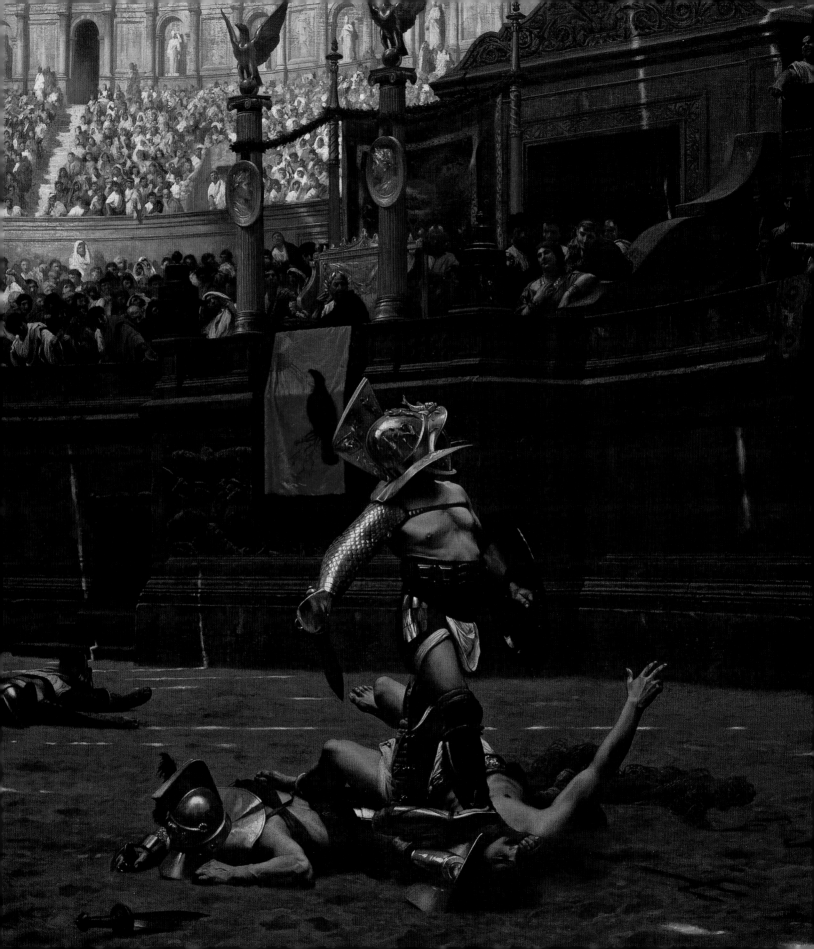

THE COLLECTORS' RIPOSTE

The New York Centennial Loan Exhibition

Though the Centennial Exhibition does not receive much attention today as a landmark in American history, cultural or otherwise, it enjoyed a momentary revival of interest at the nation's bicentennial in 1976. A modest exhibition at the Smithsonian Institution reunited twenty-six artworks from the original show, and Gore Vidal released one of his lesser-known novels, titled *1876*.[1] The protagonist, journalist Charles Schermerhorn Schuyler, has returned to New York after a thirty-nine-year absence in Europe, financially ruined by Jay Gould's gold speculation and the subsequent collapse in prices. He hopes to scratch out a living for himself and find a husband for his daughter, who had married European nobility but found after her husband's sudden death that his fortune had also disappeared. Schuyler secures some writing assignments for various newspapers, including one from his old friend (and actual historical

person) William Cullen Bryant to cover the world's fair in Philadelphia for the New York *Evening Post*. The story takes the form of Schuyler's journal, which he calls "the quarry from which I hope to hack out a monument or two to decorate the republic's centennial, as well as to mark my own American year."[2]

At the age of sixty-two, Schuyler likens himself to Rip Van Winkle, returning to New York to find most of his old friends dead and his native land unrecognizable. Schuyler is quickly divested of his hopes about his former home and the resurrection of his career, and he is caught up in the corruption and favor seeking that seem to pervade the political and social realms. Vidal masterfully reversed the literary tropes of the late nineteenth century: rather than an American traveling to Europe in the tradition of Henry James, gaining enlightenment and sophistication tinged with cynicism and decadence,

Schuyler travels back to America for a darker lesson about the corruption that has developed during his absence. He expresses a high regard for European culture and voices suspicions about American crudeness and venality in a bilious attack against one of the best-known books of the time, Mark Twain's humorous 1869 travelogue: "If I could burn every copy of *The Innocents Abroad* I would. . . . The professional vulgarian wandering amongst the ruins and splendours of Europe, making his jokes, displaying his contempt for civilization, in order to reassure people back home that in their ignorance, bigotry and meanness they are like gods." His fears are confirmed, notably in a conversation with wealthy businessman William Sanford about bribery, when Sanford replies casually, "Who gives a goddamn if a bunch of congressmen take money for services rendered? That's the way you get things done down there [in Washington, D.C.]."[3]

Vidal also showed the darker side of the common plot line of the rich American girl courted by European nobility and its implied monetary exchange, a narrative that appeared in abundance and formed the basis of Nathan Appleton's blithe 1877 play, *The Centennial Movement.* Schuyler's daughter Emma, a royal by marriage, is left impoverished after both her father's and her husband's financial ruin. Vidal's *1876* brings the interplay between the old and new worlds to New York, where Schuyler, a stranger to the transformed city, and his daughter, raised in France, must navigate its treacherous social and political circles. Fears of European decadence encroaching on American idealism are belied in Vidal's tale by their opposites, as the cool, sophisticated pragmatism of the daughter of Europe finds its match in

the cynical, boorish opportunism of Sanford, the American businessman on the make.

Written a full century after the event, Vidal's thoughtful, elegiac re-creation of the period possesses a complexity and scope that may have been impossible for writers on the Centennial Exhibition to capture in their own time. Many insisted on the United States' moral and commercial health and its primacy in the world, but some decried the corruption that seemed to pervade American politics. *Scribner's Monthly* considered "the corruption in high places, so freely exposed . . . and advertised to the world" to be a humiliation during the anniversary year.[4] Walt Whitman mourned, "The depravity of the business classes of our country is not less than has been supposed, but infinitely greater. The official services of America, national, state, and municipal, in all their branches and departments, except the judiciary, are saturated in corruption, bribery, falsehood, maladministration; and the judiciary is tainted. The great cities reek with respectable as much as non-respectable robbery and scoundrelism."[5] Even the most celebratory moments were shadowed by a sense of shame. Orations commemorating the most joyful Fourth of July in the nation's history also included accusations that "the vile mercenary spirit has invaded all departments of life" and calls for a return to ancestral virtues in place of "greed, speculation, corruption, indolence and vice."[6]

Though *1876* was not written during the period, Vidal's chosen genre of historical fiction is eminently appropriate for the centennial moment. In the nineteenth century, historical fiction was acclaimed as a way to learn about history, most notably in Sir Walter Scott's wildly popular novels. Historical

novels were considered to be even more effective than traditional histories as guides to the everyday life of different times. According to modern historian David Lowenthal, some felt that historical fiction was more truthful than history itself: whereas history often presents falsities as truths, historical fiction only claims that much of its content is true to life and acknowledges that some is fictional, leaving the reader to decide which is which.[7] Vidal's protagonist Charles Schuyler agrees, writing in his journal, "There is no history, only fictions of varying degrees of plausibility. What we think to be history is nothing but fiction."[8]

Interestingly, the Centennial Exhibition itself does not figure largely in Schuyler's journal. He describes the great spectacle in a handful of pages, noting the difficulty of finding a hotel and the overwhelming noise and crowds. He records the opening ceremonies and the audience's silent, chilly response to the appearance of President Ulysses S. Grant, who realizes at that moment (in Vidal's account) that he has lost favor with the American people and that his political career is at an end.[9] Schuyler's (and Vidal's) neglect of Philadelphia and focus on New York resonates with the view of many New Yorkers in the centennial year that, in spite of the fair, their city remained the most important in the nation and should be recognized as such.

As preparations for the art exhibition at Fairmount Park progressed in early 1876, New Yorkers, not to be outdone, began to plan their own exhibition, which had significantly different aims. The New York Centennial Loan Exhibition (fig. 67), as it was called, is not mentioned in Schuyler's journal. Even scholars of American art are not familiar with it, so Vidal would not have thought to include it in

FIGURE 67 *Catalogue of the New York Centennial Loan Exhibition of Paintings* (New York: n.p., 1876).

Schuyler's memoir. However, it was one of the signal events of the centennial year in New York. Benson John Lossing included it in his 1884 *History of New York City* as "evidence of the interest taken by the public in the exhibitions of works of art."[10] Rather than presenting a history of the nation's artistic development and the current state of American art, the New York exhibition celebrated the city's collectors.

Its spectacular success graphically demonstrated their power and influence and set the tone for collecting for the rest of the century, sending a strong message to American artists about the aesthetic that collectors wished to support.

Collectors play a linchpin role in the art world, but their importance is often underestimated, and the influence of the art market is downplayed in favor of more idealized notions about what moves its participants. In the absence of government support for the arts, late nineteenth-century artists were almost entirely dependent on collectors to purchase their works. Collectors' motives varied, but most fell into a few distinct categories. Some were driven by the sheer love of art. Others considered collecting American art to be a patriotic act that helped support the nation's cultural development. Still others were motivated, at least in part, by the promise of social mobility. New wealth could not purchase entrée to the upper echelons of society, but an acceptable art collection could demonstrate the requisite taste and sophistication that opened doors.

Modern scholar Gordon Fyfe explained the relationship between museums and commerce as a continuum with national patrimony at one extreme and the art market at the other.[11] But in 1876, the two poles were more intimately connected. Major museums were still in their infancy and had little or no professional staff. Trustees, most of them collectors, ran museums in almost every detail, from raising and donating funds, to taking care of planning and logistical details, to providing the works that hung on the walls. They deserve all due credit and gratitude for their pioneering efforts. They laid the groundwork for the unimaginably rich and complex institutions that

now educate and enlighten many millions each year. However, in 1876, their own needs and agendas could not help but shape museums' taste, programming, and acquisitions.

The decades following the centennial year represent a high-water mark of American collectors' newfound power in the international art market and their influence on young museums, particularly the Metropolitan Museum of Art in New York. In its first decades, the Metropolitan Museum's collection was so small that it did not fill its modest space, a former private home at 128 West Fourteenth Street designed by James Renwick. Works from local collections played a critical role in its exhibitions. Paintings moved back and forth from private homes to the museum, their status fluidly transforming from objects of private enjoyment to sanctified exemplars of the Western fine arts tradition that educated the public—all the while redounding to the owners' good taste. The New York Centennial Loan Exhibition vividly illustrated the complexities of the close contact between museums and the marketplace in a period when the two were closely linked via private collectors. It also highlighted collectors' power to influence what and how artists painted and which works received the sanction of appearing in museum settings.

The New York Centennial Loan Exhibition was rooted in an intense civic rivalry that had begun in the previous decade.[12] A heated congressional debate raged from 1869 to 1871 over where the Centennial Exhibition would take place, with Philadelphia and New York as the top competitors. Tremendous financial benefits were at stake, along with the honor of representing the country's past and, more important,

its future. On March 3, 1871, a bill was signed into law designating Philadelphia as the host city.[13] The *New-York Times* was barely conciliatory, writing that "New-York tenders the hand of good fellowship, and gives unmistakable token that she will do honor to herself and the exhibition by taking that important and prominent part to which her history and position as the foremost commercial City of the Union so well entitles her."[14] The city's bitterness is apparent in the New York press's hostility toward government support for the exhibition: the *New York Sun*, the *New York World*, and the *New York Herald* all opposed a congressional appropriation.[15] Even after the exhibition opened, the *New-York Tribune* teased Philadelphians about exploiting their guests, assuring readers that "it must be a slander that nobody is allowed to register at a Philadelphia hotel who does not have at least one trunk marked 'Greenbacks.'"[16]

New Yorkers' plan for a loan exhibition was a confrontational gesture indeed, since it duplicated—and ultimately surpassed—plans for an identical loan exhibition in Philadelphia.[17] Official notices of the organizers' intentions for the American art contribution to the Centennial Exhibition outlined three desired classes of works: those by living artists, those by deceased American artists, and those by foreign artists belonging to U.S. residents.[18] Organizers were eager to assure foreign visitors of Americans' discriminating taste, and the part of the exhibition known as the Loan Collection was intended to demonstrate that the collectors of the United States were not only aware of European art but also sophisticated enough to choose the finest works from among the masses of dubious old master paintings and the rafts of canvases imported from Europe, good and bad, by

contemporary painters. A successful Loan Collection in Fairmount Park would have been an answer to the poor quality and blatantly commercial character of most of the foreign art exhibitions and would have offered the millions of visitors examples of works by artists who were absent from the foreign galleries.

Unfortunately the Loan Collection at the Centennial Exhibition proved to be embarrassingly small and was relegated to the Art Annex. With just forty-three paintings, it did not even completely fill one gallery. The artists listed in the catalog include distinguished names such as Domenichino, Albrecht Dürer, Bartolomé Esteban Murillo, Andrea del Sarto, and Anthony van Dyck, but attributions of old master paintings were sometimes overly optimistic during this period and must be approached with caution. Also included were some works by well-known contemporary academics, such as Hans Makart of Austria (whose *Catherine Cornaro Receiving the Homage of Venice* [fig. 55] was a highlight of his country's display) and Alexandre Cabanel. Notably, there were four paintings by Gustave Courbet from the collection of A. H. Reitlinger: *The Huntsman*, *The Bather*, and two works listed as *Castle of Chillon, Lake Leman* (all unlocated). The Loan Collection did little to honor American taste, and its small size and obscure location attracted minimal attention from the press. It was easily eclipsed by New York's assertion of cultural superiority.

New York Collectors Unite

In November 1875, when the Centennial Exhibition's Art Bureau chief John Sartain was in the midst of his

difficulties with New York artists, the Metropolitan Museum of Art passed a resolution supporting the Centennial Exhibition, and Sartain wrote a letter of thanks to John Taylor Johnston, president of the Metropolitan and a member of the Centennial Exhibition's Fine Arts Advisory Committee.[19] However, discontentment still simmered in New York's art community, and it was not long before its members began to consider an exhibition of their own. They were well equipped to do so, as more and more of the wealthy had been building their collections in recent years: in 1870, critic James Jackson Jarves had observed that "private galleries in New York are becoming as common as private stables."[20]

The following month, the *New-York Times* assured its readers that when foreign art lovers visited the Centennial Exhibition in Philadelphia, most would come to New York as well, and the National Academy of Design's exhibition for the coming spring would be "truly national."[21] In February 1876, the New York publication *Appleton's Journal* suggested that the city should organize an exhibition of works from its private collections, reasoning that "it would be something to the glory of our city, and of great value to those of our people who long to see examples of foreign artists but cannot go abroad to do so," adding "there is no reason why Philadelphia should have a monopoly of Centennial attractions."[22] The *New-York Tribune* chimed in that New York's private galleries should be opened to the public, as was being done in Philadelphia.[23]

A committee was formed with Johnston as its chair, and plans were made to present the exhibition in the galleries of the Metropolitan Museum of Art and the National Academy of Design. Serving

as president of the Central Railroad of New Jersey since the tender age of twenty-eight, Johnston had built an impressive art collection housed in two galleries in his home at 8 Fifth Avenue, which were open to the public two days a week.[24] As founding president of the Metropolitan Museum of Art, he and his fellow Centennial Exhibition Fine Arts Advisory Committee member William Tilden Blodgett scouted out and secured the group of Dutch and Flemish paintings that formed the core of the Metropolitan's collection.[25] The New York Centennial Loan Exhibition's long list of sixty-eight committee members included a number of Metropolitan Museum of Art board trustees and many citizens who would become the most important collectors of the late nineteenth century, including Parke Godwin, Henry G. Marquand, Mrs. A. T. Stewart, Catharine L. Wolfe, and William H. Osborn; the dealers Samuel Avery and William Schaus; and artists who served on the board of the National Academy, including John G. Brown, Seymour Joseph Guy, Thomas Hicks, Daniel Huntington, Eastman Johnson, T. Addison Richards, and Worthington Whittredge.[26]

Many distinguished New York collectors and their spouses were new to wealth and to the city's social circles. Their financial success in fields such as railroads, real estate, and banking made them the first generation of Americans able to compete for artworks with European buyers, and they were making their mark across the Atlantic. The city's art lovers were guided by the experiences of their predecessors: American collectors had been warned away from pursuing old master paintings because of the many dubious or outright fraudulent paintings passed off on well-intentioned but naïve collectors earlier in the

nineteenth century (perhaps some of them were present in the Centennial Exhibition's Loan Collection in Philadelphia). The European works amassed by ambitious early nineteenth-century New Yorkers such as Thomas Jefferson Bryan and Luman Reed include many "old master" paintings that no longer bear their original attributions.[27] In 1871, even Johnston and Blodgett realized the dangers of purchasing supposed old master paintings for the Metropolitan Museum of Art: Blodgett graciously offered to absorb the cost of any works that proved not to be authentic, and later scholarship showed that in many cases, his concerns were justified.[28]

Instead, well-to-do Americans began to collect the work of contemporary European artists, particularly French academic painters, both from dealers abroad and in the United States (see chapter 5). They also commissioned portraits of themselves and their families on their travels abroad, such as William-Adolphe Bouguereau's portrait of young Cortlandt Field Bishop (New-York Historical Society), painted in Paris in 1873.[29] The subject was the son of David Wolfe Bishop of the Wolfe family, known for their real estate holdings, and Florence Van Cortlandt (Field) Bishop, who was from a distinguished old New York Dutch lineage. Though they are less valued today, commissioned portraits might have been an even greater mark of prestige than subject paintings, because they evidenced the owner's foreign travel and personal contact with the great master. Many renowned painters were in high demand for portraits, and securing a commission was in itself a sign of the sitter's status.

When the collector Parke Godwin suggested to Whittredge the idea of a New York exhibition, Whittredge hurried back to New York from his work on the Centennial Exhibition in Philadelphia in order to begin the arrangements.[30] Whittredge wrote in his autobiography that he hoped such an exhibition could raise money for the debt-ridden National Academy of Design. It may be that the acrimony between Sartain and Whittredge had already ignited and that Whittredge was also happy for an opportunity to upstage the Philadelphia exhibition.

Forming an exhibition drawn from New York collections was much simpler than creating a comprehensive display from all over the country and across the Atlantic, as Sartain was striving to do in Philadelphia. New Yorkers were seasoned veterans at arranging such displays, having gained experience during the Civil War through U.S. Sanitary Commission fairs, which were organized to raise funds to aid Union soldiers at the front. Great displays of private collections were included in the larger sanitary fairs, and some collectors opened their homes to the public during the course of the exhibitions.[31] Many of the organizers of New York's 1864 Metropolitan Fair reprised their roles for the New York Centennial Loan Exhibition, including Johnston, former governor Edwin D. Morgan, August Belmont, John H. Sherwood, Osborn, and the artists Huntington, Hicks, Johnson, and Whittredge.

As in Philadelphia, the New York organizers formed subcommittees to address various aspects of the exhibition, but in contrast to the U.S. contribution to the Centennial Exhibition, which was organized by artists, the New York exhibition was directed largely by the owners of paintings. In practical terms, collectors held considerable curatorial power during the period, not only for the obvious reason of their wealth, but also because, before the

rise of the professional museum curator, there were few others—artists among them—who were willing or able to take on the task.[32] Further, the small size of early museum collections meant that loans from local collectors were crucial to filling out their exhibition programs. The Boston Art Museum's early exhibitions were largely based on the Boston Athenaeum's collection and loans from local collectors.[33] The sparseness of the Metropolitan's collection allowed the *Aldine* to write, apparently without fear of giving offense, that "New York has, unfortunately, no great permanent public art exhibitions of which to boast herself; but . . . no city in the whole world could show so fine an exhibition of contributions from modern artists."[34]

Though the Metropolitan did not own contemporary paintings, they were a common sight at the museum; local collectors sent their pictures for loan exhibitions from 1873 through the 1880s.[35] One prominent example was J. M. W. Turner's *Slave Ship* (fig. 68), then owned by the museum's president, John Taylor Johnston. Annual reports from the early 1870s through the 1880s make particular note of the status of the loan collection. The 1881 report noted that one of the museum's major expenditures was shipping these works to and from their owners.[36] In the Metropolitan Museum of Art's early years, its galleries were arranged by collector, and individual families carefully guarded the interests of "their" galleries.[37]

The Committee of Management for the New York Centennial Loan Exhibition included two artists (Whittredge and Hicks) and collectors Johnston, Morgan, Theodore Roosevelt (father of the future president), Godwin, and J. W. Pinchot. The Selection Committee did not include any artists at all, only the owners of the paintings.[38] New York

collectors were eager to showcase their city's culture and sophistication, so the Selection Committee had an abundance of works to consider. The *New-York Tribune* exulted that within a few days, the organizers had secured as many pictures as could be hung.[39] The New York *Evening Post* boasted that enough pictures were offered to form a second exhibition, attributing the enthusiasm to "local pride."[40] Johnston, untroubled by his commitment to the Philadelphia world's fair, contributed just five American paintings to the Centennial Exhibition and offered the balance of his vast collection—ninety-six works—to the New York display.[41] Morgan too offered his entire collection of more than eighty paintings. Other prominent contributors of around twenty pictures each included Mrs. Paran Stevens, Edward Matthews, John H. Sherwood, Charles S. Smith, and a young J. P. Morgan.[42] August Belmont agreed to open his gallery to the public for a limited period.[43]

Vidal's *1876* protagonist Charles Schuyler comments on one of the lenders, Mrs. Paran Stevens. She was known for her Sunday evening gatherings but was not a member of the highest social stratum. In Vidal's novel, Ward McAllister, the gatekeeper for doyenne Caroline Schermerhorn Astor (both were actual historical people), calls Mrs. Stevens "disreputable. . . . She pushes herself onto people. And she is nobody, don't you know? Just the wife of a hotel manager and the daughter of a grocer from Lowell, Massachusetts, of all places!" When Schuyler visits, he responds similarly, calling her home "distinguished but complacently rich with too many of the wrong *objets*, not to mention *sujets*."[44] In a period when old New York viewed rich arrivistes with suspicion, art collecting offered an alternative avenue—though not

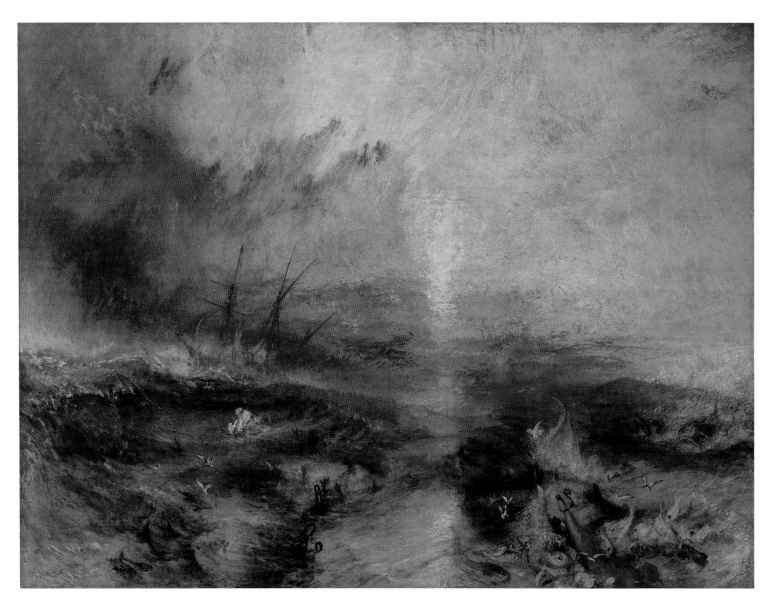

FIGURE 68 Joseph Mallord William Turner (English, 1775–1851),
*Slave Ship (Slavers Throwing Overboard the Dead and Dying, Typhoon
Coming On)*, 1840. Oil on canvas, 35 ¾ × 48 ¼ in. (90.8 × 122.6 cm).
Museum of Fine Arts, Boston, Henry Lillie Pierce Fund, 99.22.

a guarantee—for social acceptance, making patronage a high-stakes game for both artists and collectors.

The Hanging Committee included both. Pictures were grouped by collector for the most part, and the catalog listed the paintings by owner. Accounts differ on whether the display at the Metropolitan Museum of Art was hung by Johnston or the museum's assistant superintendent, H. G. Hutchins, but it seems likely that Johnston would have played an active role in any case. Huntington, Hicks, and Whittredge arranged the works at the National Academy of Design. They called it "the greatest as well as the most perplexing undertaking that they [had] ever been involved in."[45] Whittredge politely declined to mention his recent wranglings with Sartain over hanging American artworks at the Centennial Exhibition. Certainly the artists organizing the New York exhibition would not have wished to mar the proceedings, which were dominated by important art patrons, with internecine fighting, and they would have been reluctant to raise any issue that might cast aspersions on the works of art involved, since the paintings belonged to those patrons. Their outward harmony was in stark contrast to the Centennial Exhibition, where the arrangements were left to artists to make a statement about the art of the nation and its history.

The New York exhibition differed from that of Philadelphia in several crucial respects. As already mentioned, whereas the Philadelphia exhibition was organized mainly by artists, New York's involved artists working in collaboration with a group of collectors, who were their most promising patrons. New Yorkers took advantage of two already established organizations, the Metropolitan Museum of Art and the National Academy of Design, while Sartain had to go through the laborious process of recruiting his organizers without the assistance of Philadelphia's most important arts organization, the Pennsylvania Academy of the Fine Arts. The New York organizers were not concerned about the construction progress of a new building as Sartain was (though in 1876 the Metropolitan was making plans for its new building along Central Park). And importantly, the New York venues of the Metropolitan Museum of Art and the National Academy of Design had already been consecrated as sites dedicated to the highest aims of art, and they were less vulnerable to the taint of commercialism that plagued the organizers of the Centennial Exhibition's art display.

New York Eclipses Philadelphia

The New York Centennial Loan Exhibition, presented from June 23 to November 10, comprised three parts: 398 paintings at the National Academy of Design, then located at the corner of Twenty-Third Street and Fourth Avenue; 182 paintings at the Metropolitan Museum of Art's modest first home at 128 West Fourteenth Street (fig. 69); and 93 works in the private gallery of collector August Belmont, located in his palatial home at 109 Fifth Avenue. His doors were open from June 19 through 22 and again from October 10 through 13.[46] Newspapers proudly reported that the insurance value of the displayed paintings exceeded $1 million, a measure of the exhibition's importance that all Americans (perhaps most especially New Yorkers) could appreciate.[47] Proceeds from admission fees were divided between the Metropolitan and the National Academy.

With a total of 673 works in three venues, the New York Centennial Loan Exhibition eclipsed the Centennial Exhibition's U.S. Loan Collection in size and the French art exhibition in quality. The New York exhibition consisted largely of modern works centered on the figure by Paris-based artists—exactly the kind of style and subject matter being taught to Americans abroad. The composition of the collections was remarkably homogeneous: the list of the artists includes many well-known names with multiple works contributed by several different owners, suggesting that New York collectors had a "short list" of artists who were of interest to all, resulting in a surprisingly unified, if not very adventurous taste. Ironically, many of the paintings that graced the walls of the Metropolitan Museum of Art and the National Academy of Design were the models for the expatriate paintings under bitter dispute by numerous academicians at that very moment, and the New York exhibition affirmed collectors' interest in this kind of art.

The galleries of the Metropolitan Museum of Art and the National Academy of Design were dominated by masterworks of William-Adolphe Bouguereau, Jean-Léon Gérôme, Alexandre Cabanel, Thomas Couture, Paul Delaroche, and Hugues Merle.[48] Gérôme's work was a focus of attention, particularly two paintings from the collection of Mrs. A. T. Stewart. *Pollice Verso* (fig. 70) is one of his most famous and most accomplished works. His powerful and meticulously detailed depiction of a group of vestal virgins demanding death (thumbs down) for a defeated Roman gladiator in the arena was the result of years of painstaking labor and research.[49] It was installed in a "place of honor" and considered a "center of interest" for visitors.[50]

FIGURE 69 James Renwick (American, 1818–1895), architect, *The Metropolitan Museum of Art, 128 West 14th Street, New York, NY*, ca. 1875, by unidentified photographer. Photograph. The Metropolitan Museum of Art.

Belmont's collection included works by the French artists Rosa Bonheur, Bouguereau, Gérôme, Meissonier, and Horace Vernet and by the Düsseldorf painter Andreas Achenbach. The New York *Evening Post* reported with excitement that Belmont's collection had only been opened in this way two or three times over the previous fifteen years and then only in connection with charitable enterprises.[51] The charge for admission was fifty cents, twice the amount for admission to the exhibitions at the Metropolitan and the National Academy, suggesting the extent of the privilege being extended to the public. It was also the same amount as a day's admission to the entire Centennial Exhibition. One of the most admired

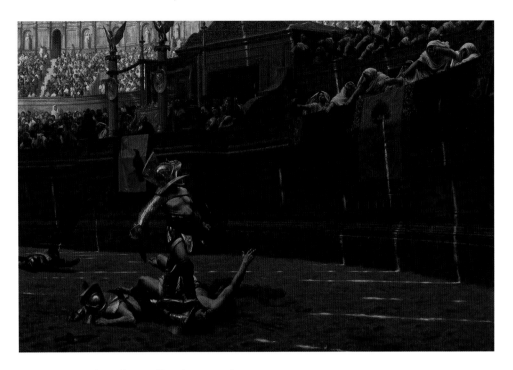

paintings in Belmont's collection was Bouguereau's *The Twins*, probably the work now titled *Charity (Reduction)* (National Palace Museum, Taipei, Taiwan). It is a smaller version of *Charity* (fig. 71). The artist executed the reduction for the Parisian dealer Paul Durand-Ruel, who sold it to Belmont in 1865.[52] Bouguereau's idyll of a mother cradling two sleeping babes in a pastoral setting recalls a Renaissance Madonna. The New York *Evening Post* called it "a superb specimen of foreign art, the best by Bouguereau in this country."[53]

In the New York and Philadelphia exhibitions, the designation of nationality was paramount, but each treated the issue in crucially different ways that reflected changing ideas. According to the conventions of world's fairs, exhibitors at Fairmount Park were organized by their country of origin or, in the case of artists, the country of their birth. At the New York Centennial Loan Exhibition, artists were classified by the city in which they currently lived and worked, making nationality a matter of choice; their work was defined by the school they chose, rather than the one dictated by their place of birth. For instance, the esteemed Spanish artists Leon y Escosura, Madrazo, and Zamacois; the Belgian painter Alfred Stevens; the Italian Giovanni Boldini;

and the Germans Adolf Schreyer and Meyer von Bremen were all classified by virtue of their residence in Paris.[54] The *Newark Daily Advertiser* conducted an analysis along those lines, reporting that of nearly 400 pictures installed at the National Academy of Design, 192 were by Paris residents.[55] The huge number of Parisian artists represented in these much-admired collections sent a strong message to visitors, and especially artists, about the styles and subjects that interested prominent collectors. Classifying artists by their residence, rather than their native country, suggested that nationality was mutable, and American artists viewing the exhibition might likewise choose their own paths.

The *Newark Daily Advertiser* also noted eighty-six paintings by American artists at the National Academy of Design, less than one-quarter of the total.[56] American artists had enjoyed growing financial success in the decades leading up to the centennial, and their status among collectors of their own country would improve considerably in the last quarter of the century. However, in 1876 they still struggled for patronage and were often neglected in favor of fashionable European academics. With this in mind, the American showing at the New York Centennial Loan Exhibition was, relatively speaking, quite strong and included a number of iconic works. Indeed, *Baldwin's Monthly* declared that "they bear themselves well in contrast with their foreign rivals."[57]

The Hudson River School was well represented by works of Albert Bierstadt, John Casilear, Thomas Cole, Jasper F. Cropsey, Asher B. Durand, Sanford Gifford, and John F. Kensett and by a stunning group of paintings by Frederic E. Church, including *Niagara* (fig. 72), *Twilight in the Wilderness* (Cleveland

FIGURE 71 William-Adolphe Bouguereau (French, 1825–1905), *Charity (La Charité)*, 1859. Oil on canvas, 54 ⅞ in. × 44 ¼ in. (139.4 × 112.4 cm). University of Michigan Museum of Art, Bequest of Henry C. Lewis, 1895.96.

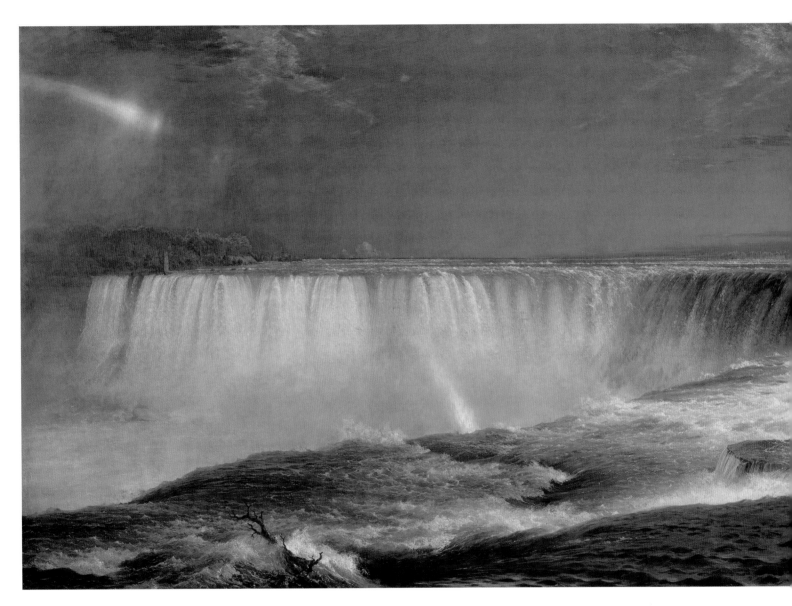

FIGURE 72 Frederic E. Church (American, 1826–1900), *Niagara*,
1857. Oil on canvas, 40 × 90 ½ in. (101.6 × 229.9 cm). National Gallery
of Art, Corcoran Collection (museum purchase, Gallery Fund),
2014.79.10.

Museum of Art), *New England Scenery* (George Walter Vincent Smith Art Museum, Springfield, Massachusetts), and *Twilight in the Tropics* (private collection). A generous representation of genre paintings included works by John G. Brown and Seymour Joseph Guy and several paintings by Eastman Johnson, including *The Pension Claim Agent* (fig. 77). Other works of note included Winslow Homer's extremely popular *Prisoners from the Front* (fig. 73), a Civil War subject that raised no objections in this context, in contrast to the angry responses to Peter F. Rothermel's *The Battle of Gettysburg* at the Centennial Exhibition (fig. 37).

Since these works were in the New York exhibition, they were not available for the U.S. display at the Philadelphia Centennial Exhibition. A few of those paintings, such as the ones by Church and Homer, had already reached the status of icons, and their absence from the Centennial Exhibition diminished its comprehensiveness and impact. For instance, Church's monumental *Niagara* would have been particularly welcome there, since the acclaimed artist was represented by only one work at Fairmount Park (fig. 4). *Niagara*'s debut in 1857 made Church the country's most famous and admired painter, and it accomplished what many thought impossible: capturing the awesome majesty of one of the nation's greatest natural wonders. The painting's remarkable scope and meticulous detail, combined with Church's daring choice to dispense with the foreground, placing the viewer in the midst of the rushing water, met with universal acclaim.[58] The organizers of the exhibition in Fairmount Park would have been struck by the irony of the *New-York Tribune* making the opposite complaint, that there were fewer American pictures

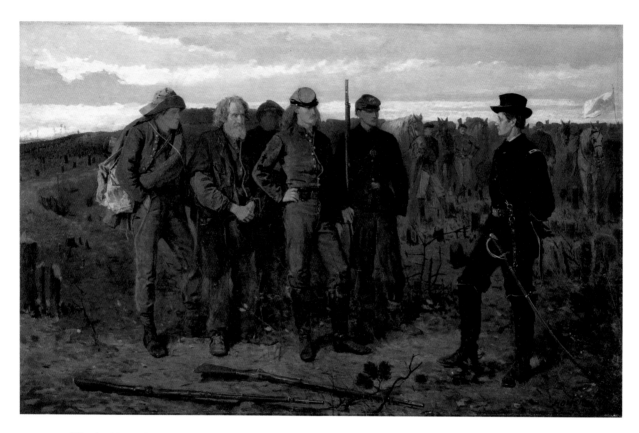

FIGURE 73 Winslow Homer (American, 1836–1910), *Prisoners from the Front*, 1866. Oil on canvas, 24 × 38 in. (61 × 96.5 cm). The Metropolitan Museum of Art, Gift of Mrs. Frank B. Porter, 1922 (22.207).

in the New York exhibition because of the demands of the Centennial Exhibition.[59]

The American artists represented at the New York Centennial Loan Exhibition demonstrated the conservative taste that might be expected of a new generation of collectors who had not yet developed the confidence to make bold decisions outside the mainstream of current fashion. For instance, in contrast to the Philadelphia display, none of the "new men" being trained in Paris or Munich

could be found. However, there were a number of well-established Americans who had blurred geographic boundaries by spending significant time abroad. Three paintings by Elihu Vedder, for example, were on view. His location was listed as Rome, where he had been in residence since 1866 and would remain for the rest of his life. The highly esteemed George Henry Boughton was present in force with thirteen paintings; the depth of his representation was surpassed only by Bouguereau. English

by birth, Boughton was raised in Albany, New York, and returned to England in 1862 at the age of twenty-nine. Most of the catalog listings designated him as a London artist, as might be expected, but all included the "N.A." that signified his membership in New York's National Academy of Design and affirmed his ties to the United States. At the Centennial Exhibition, his work appeared in both the United States' and Great Britain's galleries, and in New York he demonstrated the dilemma of blurring cultural boundaries, spurring American concerns about the changing nationality of accomplished American-bred artists who went abroad.

Just before the National Academy of Design's walls were filled with the masterworks of European painters, they had been covered with paintings by Americans for its 1876 annual exhibition. A few critics acknowledged the centennial year and wished for more celebratory subjects—Alfred Wordsworth Thompson's *Annapolis* (unlocated), a large-scale depiction of cavalry about to depart Annapolis in July 1776 to join General George Washington, was often cited as an example.[60] More reviews mentioned the academy's "blundering course" in declining the work of young foreign-trained artists the previous year, and critics noted that several of the artists rejected in 1875 were represented in the current year's exhibition, including Maria Oakey Dewing.[61] Some called for a more expansive, more "truly national" display of American art that acknowledged the new French-influenced aesthetic: the *Atlantic Monthly* desired an exhibition that was "national, cosmopolitan, and conducted for the benefit of the artists of the whole country."[62] For others, "national" meant that the subjects and styles of the works were free from foreign influences. The *New York Evening Mail* complained, "we do not like to see American artists sending home original pictures which are in some sense imitations of French art," and the *Art Journal* was disappointed that "instead of meeting with a distinctive American method of treatment" its critic had found "the germs of a dozen foreign schools."[63] However, the overwhelming success of the New York Centennial Loan Exhibition, which was dominated by French works, appeared to confirm American collectors' view on the question.

*Un*critical Responses to the New York Exhibition

Contemporary reviews of the Loan Exhibition were uniformly flattering and rightly so; it was a truly remarkable assemblage of paintings. However, writers were also acutely aware that the exhibition was as much a celebration of collectors as a celebration of art, and many of the owners were important figures in the city's commercial and political circles. Gore Vidal chose William Cullen Bryant, editor of the *Post*, to illustrate the pitfalls of dealing with New York's rich and powerful. In *1876*, Bryant is an esteemed old friend of Schuyler, and throughout the narrative, Schuyler's colleagues hint that his role model has taken bribes from the corrupt Boss Tweed in exchange for favorable reporting. Vidal also credited Mark Twain with supposedly calling Bryant "as sanctimonious an old weasel as ever got loose in a henhouse."[64] The press's careful treatment of the New York Centennial Loan Exhibition reflected their understanding of who had organized it and what their aims were (but of course there was not the slightest hint of any wrongdoing).

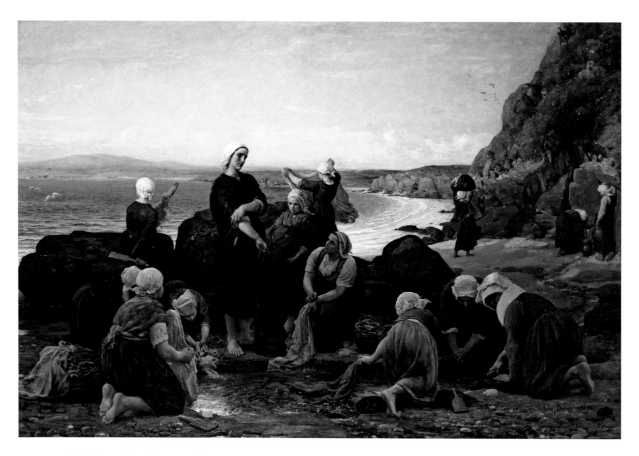

FIGURE 74 Jules Breton (French, 1827–1906), *Washerwomen on the Coast of Brittany*, 1870. Oil on canvas, 53 ¼ × 79 ¼ in. (135.3 × 201.3 cm).

Any shortcomings that writers might have discerned in the paintings were overtaken by encomiums to the contributors, expressing gratitude for their generosity in lending. And indeed, the 1876 display was a singular opportunity. The museum mounted annual loan exhibitions from 1873 into the early 1890s, but most of the works on view in the Loan Exhibition had never been seen at the Metropolitan before and would not be seen in the years following.[65] The *New-York Times* added, "The collection is taken from the private galleries of prominent New York citizens, whose wealth is the parent of culture and refinement, and who are, therefore, not apt to have indifferent works among their art treasures." In one fawning account, Bryant's New York *Evening Post* called Johnston's collection "one of the best selected and most valuable owned in this country"; his choices "indicate a refined and cultivated taste on the part of the owner." Other newspapers responded with similar superlatives, with reviewers calling it probably the most magnificent

display of paintings ever assembled on the continent. The official report was equally congratulatory (in this case, self-congratulatory), asserting, "It reflects the highest credit upon our wealthier citizens who indulge a taste for the fine arts that their private stores contain so many of the masterpieces of modern genius." The *New-York Times* agreed: "The Americans of wealth have shown themselves more appreciative of the new masters of the art world than the Europeans."[66]

In describing specific works, critics reserved their highest praise for the best-known French academic painters. The *Newark Daily Advertiser* marveled that Bouguereau's *After the Bath* (Salvador Dali Museum) "does not seem, it is."[67] Cabanel's *The Italian Girl* (unlocated) was called "superb"; Gérôme's *Death of Caesar* (Walters Art Gallery, Baltimore) and *The Race of the Charioteers* (Art Institute of Chicago) were praised for their dramatic power and beauty. Breton's *Washerwomen on the Coast of Brittany* (fig. 74) drew attention for being "forceful and impressive." The Munich painter Gabriel Cornelius von Max's *The Last Token* (fig. 75) was "of painful interest" for its subject of a Christian woman about to face wild beasts in the Roman Colosseum. The German Schreyer was represented by nine paintings, and his *Wallachian Teamster Entangled in the Marshes of the Danube* (unlocated) was considered one of his best efforts. He was listed as a painter of Paris, having spent several years there in the late 1860s, even though he had returned to his native country in 1870. Düsseldorf painter Achenbach's *Storm* was called "superbly finished." Zamacois died in 1871 and was listed as a Paris painter, though he was Spanish. He received several notices, particularly for *Education of a Young Prince* (fig. 76), which was said to have a worldwide reputation.[68]

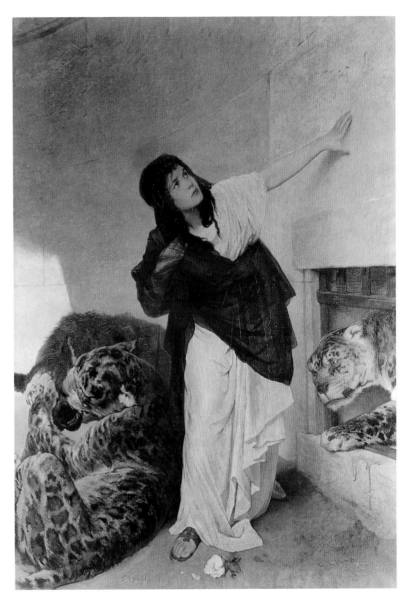

FIGURE 75 Gabriel Cornelius von Max (Czech-born Austrian, 1840–1915), *The Last Token: A Christian Martyr*, n.d. Oil on canvas, 67 ½ × 47 in. (171.5 × 119.4 cm). The Metropolitan Museum of Art, Catharine Lorillard Wolfe Collection, Bequest of Catharine Lorillard Wolfe, 1887 (87.15.58).

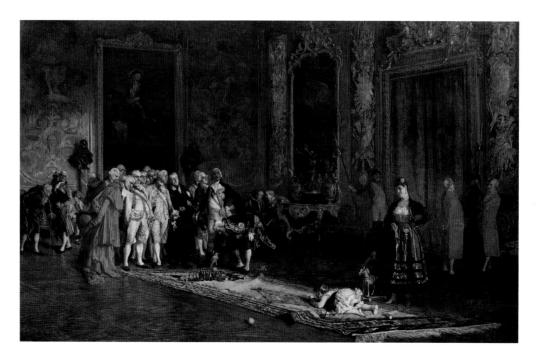

FIGURE 76 Eduardo Zamacois (Spanish, 1841–1871), *Education of a Young Prince*, 1870. Oil on canvas, 25 × 39 ⅜ in. (63.5 × 100 cm).

But American artists also received high praise. Church's *Niagara* was called "unequaled" and his *Twilight in the Wilderness* "magnificent." John F. Kensett, who had died just a few years before, was clearly a favorite of New York collectors with eleven works on view, and he was considered to be "an eminent master." Eastman Johnson's *The Pension Claim Agent* (fig. 77) was called the most interesting painting in the room; given the fascination with French academic painters, this was high praise, since the gallery also included works by Bouguereau, Cabanel, Bonheur, and Gérôme.[69]

The New York Centennial Loan Exhibition was viewed as a sacralized museum experience that brought highly esteemed works of art to a broad audience that would not otherwise have had access to them. As was the case with Great Britain's contribution to the Centennial Exhibition in Philadelphia, critics noted the fame of these works through reproduction and the thrill of seeing the originals. The *Aldine* reported, "Many of the pictures here gathered are, perhaps, too well known to make any criticism of them either advisable or necessary."[70] The New York *Evening Post* reported that Morgan's collection included many pictures never before exhibited in public, though many were known through reproductions by Goupil. The same was said of Gérôme's painting *Death of Caesar*, owned by John Taylor Johnston.[71]

The most striking feature of critical accounts of the New York Centennial Loan Exhibition is

FIGURE 77 Eastman Johnson (American, 1824–1906), *The Pension Claim Agent*, 1867. Oil on canvas, 25 ¼ × 37 ⅜ in. (64.1 × 94.9 cm). Fine Arts Museums of San Francisco, Mildred Anna Williams Collection, 1943.6.

the widespread understanding that the display was intended as a response to the foreign art exhibitions in Philadelphia's Fairmount Park, and it was seen as a successful answer to European dealers' perceived disdain for American taste and discernment. Earl Shinn's reviews of foreign paintings in Memorial Hall often mentioned works in the New York exhibition.[72] Clarence Cook of the *New-York Tribune* was more direct, using the Turner painting *Dolbadden Castle* (Royal Academy of Arts, London) displayed in Philadelphia as an excuse to praise Johnston's famous Turner painting *Slave Ship* (fig. 68) at length. When bemoaning the subpar William Holman Hunt

painting in Great Britain's galleries, Cook suggested that readers see Holman Hunt's *Isabella and the Pot of Basil* (Laing Art Gallery, Newcastle upon Tyne), also owned by Johnston, in New York instead.[73]

More general comparisons consistently gave the palm to the New York exhibition over the European displays in Philadelphia as a demonstration of American collectors' sophistication. The *American Architect and Building News* reported that visitors to both cities were apt to say that New York's exhibition was much more interesting than that in Fairmount Park.[74] The *New-York Times* reported that connoisseurs familiar with European salons and previous world's

fairs all agreed that New York's exhibition "far eclipsed" the one in Philadelphia.[75] Gar. of the *New-York Times* hoped that the display in New York could remain open through the end of the Centennial Exhibition "so that foreign visitors may carry away with them something like a correct idea of the cultured art taste of this country, which can nowhere be so well studied as in a few hours' visit to this rich collection."[76]

Collectors' Triumph

The New York exhibition did extend until the Centennial Exhibition's closing date, and it was a triumph by almost any measure. At least 150,000 people attended, more than twice the number of visitors to the Metropolitan Museum of Art in the entire previous year.[77] In the early weeks of the exhibition, when it was still a novelty for New Yorkers and when the attendees were mostly local, the *New-York Times* delightedly described how "yesterday the place was crowded by the best and most aesthetic people in the city, and there was a contagion of delight in the air" with elevated discussions of the works on view that reminded the writer of the salons of Italy or Germany.[78] The audience declined somewhat in the heat of the summer, but with the coming of the fall and cooler weather, attendance grew, and the business manager of the exhibition reported that ninety of every hundred visitors to the exhibition were "strangers," that is, they were from out of town or newcomers to the art world.[79]

Apparently some visitors required tutelage on the "proper" behavior in an exhibition of this caliber, since the editors of the New York *Evening Post* chided readers that "it is extremely bad manners for a pair or a group to stand before the pictures and exchange congratulations and family news."[80] But the *Aldine* gave attendees credit for their gentility and sophistication (especially in comparison with early visitors to Memorial Hall). The author praised the public, "whose appreciation of those works has . . . shown such fears [of damage to artworks] to have been unnecessary."[81] *Baldwin's Monthly* asserted that it was the most popular, refined, and thoroughly appreciated entertainment ever offered in the city.[82]

The proceeds from the exhibition benefited the debt-ridden Metropolitan Museum and National Academy, and success was declared in that arena as well. The official report stated that receipts totaled $51,250.75 and expenses $13,343.67, for net income of $37,907.08.[83] The funds were distributed with 60 percent to the academy and 40 percent to the museum. Though the exhibition did not completely erase both organizations' debts, it did, in the diplomatic prose of the *Evening Post*, "leave them free from serious embarrassment."[84]

However, the effects of the international depression that followed the Panic of 1873 created financial embarrassment for Johnston, who was forced to sell his entire collection in December 1876 to save the Jersey Central Railroad. His was considered to be the most important private collection in the nation, and art aficionados from all over the country attended the sale, which was organized by art dealer Samuel Avery. The event realized an unprecedented $328,286, with the largest price of $12,500 paid for Church's *Niagara*.[85] Since both Johnston and Avery were in leadership positions with the New York Centennial Loan Exhibition, one must wonder whether they were

already in discussions about a possible sale as they were planning the show. Perhaps Johnston's great generosity in offering to lend nearly his entire collection, and then giving over the entire ground floor of the Metropolitan Museum of Art for its installation, was a promotional exercise for the sale that he knew would follow. Similarly in Philadelphia, five months after the Centennial Exhibition closed, the Philadelphia *Press* announced that James L. Claghorn would sell all of his paintings and devote himself completely to engravings and etchings.[86] The sales were grim reminders of the reality of collecting. These important objects might be displayed in museum settings temporarily, lending them distinction and enhancing their value. However, they were ultimately private property and could be dispersed to the winds at any moment.

The New York exhibition, though featuring the work of private collectors, took place in a museum and at an artists' organization, and it conferred their institutional sanction on treasures hidden behind the doors of New York's mansions. Such showcases of American taste were complicated by the practicalities of ownership. While most art forms, such as music or literature, can be duplicated for wide enjoyment, singular works of visual art have one owner, who might restrict their availability. In the case of John Taylor Johnston, visitors to the New York Centennial Loan Exhibition benefited from his generosity in lending his superb collection for public view. At the same time, having his collection exhibited in a museum setting no doubt increased its value for later sale. The tension between public accessibility and private gain parallels the difficulties encountered in balancing art and commerce at Fairmount Park's Memorial Hall, and it is one that museums must still consider carefully.

Taken together, the foreign art exhibitions in Fairmount Park and the New York Centennial Loan Exhibition formed a great international dialogue on the art market and its complicated relationship to artists and museums. Both exercises took place in settings that had the imprimatur of museums in the context of a national celebration, lending the events gravity and giving them widespread impact. European dealers hoped to dictate American taste to meet their own needs, which they had done successfully in the past. Collectors responded by asserting their discrimination and self-confidence and, by extension, their newfound ability to set their own terms in the international art market. If the foreign art contributors to the Centennial Exhibition can be considered the sellers of art, largely driven by commercial interests, then the organizers of the New York exhibition represented the buyers, the Americans who collected foreign artworks, and the collectors sent an unmistakable message about their level of sophistication. The *New-York Times* wrote, "No more striking rebuke could have been devised by the wit of man to the money-grubbing and inartistic spirit which has pervaded the French and some other exhibitors of paintings at the Centennial." The author further suggested that foreign correspondents should visit the New York exhibition "so that they might understand the class of pictures which Americans of wealth and taste purchase. They may rest assured that paintings of an inferior grade will never be received in this country with any other feelings save those of contempt and grieved surprise."[87]

The New York collectors represented in the exhibition proved themselves to be not just wealthy, but also connoisseurs, possessed of taste and discernment.

Their answer to the foreign exhibits in Philadelphia repudiated the perception that Americans were guided only by greed and lacked higher ideals, which helped to ease the difficult transition from the country's fondly remembered past to its dubious present and its uncertain future. The New York exhibition made public the vogue for contemporary French art, and perhaps its most important message was that this included works not only by native French artists, but also by those of other nationalities residing in Paris. It sent a clear signal to American artists about what type of work their patrons desired. In the years following, ever greater numbers of them traveled to Paris for training.

The New York Centennial Loan Exhibition provided an impressive demonstration of American collectors' prowess, and elegant volumes memorializing great collections and their owners proliferated after the centennial year. For example, *Lights and Shadows of New York Galleries* included works from the collections of Belmont, Blodgett, Bryan, and Jonathan Sturges, among many others; it first appeared in 1864 and was reissued in 1888.[88] The practice was epitomized by the Centennial Exhibition critic and writer Earl Shinn. His books *The Art Treasures of America* of 1879–80 (which included a number of works that were on view in the 1876 New York Centennial Loan Exhibition) and *Mr. Vanderbilt's House and Collection* of 1883–84 were gorgeous luxury objects in their own right. They were filled with paeans to collectors and engravings of works in their collections as an acknowledgment of their primacy. Shinn celebrated the years immediately following the centennial as "the right moment, prompt and opportune, when wealth is first consenting to act the Medicean part in America, to patronize the inventors, to create the arts, and to originate the forms of civilization."[89] Collectors would continue to play a key role in the development of major museums, though they would grow less active in operational matters as museums became more professionalized.

In spite of the New York exhibition's popular success, the Metropolitan Museum of Art did not actively collect the work of living European or American artists until the twentieth century.[90] Wealthy New Yorkers did little to change the situation. For reasons that are unclear and almost without exception, late nineteenth-century New York collectors chose *not* to give or bequeath their contemporary European paintings to the Metropolitan, but rather sold them or, in a few cases, passed them on to their descendants (with the notable exception of the magnificent Catharine Lorillard Wolfe bequest of 1887). It has been suggested that since many of the collectors were businessmen, the paintings' inflated prices made them too valuable to give away. It was not until the twentieth century, after many of the paintings were out of fashion and far less financially valuable, that they began to enter public collections in great numbers.[91]

The New York exhibition's organizers' undertaking of moving collections from their owners' homes to the Metropolitan and the National Academy of Design, keeping them intact according to owner, was much simpler than that of the artists directing the American contribution in Fairmount Park. The contentious troubles of the Centennial Exhibition organizers show the messy complexity of trying to envision a fair representation of not just a country's

finest contemporary art, but its precedents as well; trying, though not always successfully, to come to a workable agreement about that vision; scouring the nation searching for works of art to fulfill it; entreating individual owners to participate; dealing with the prosaic but essential details of shipping across the country and the Atlantic; and finally devising a scheme of installation that would convey that vision. Their task echoes how modern museums assemble the loan exhibitions that have become their greatest visitor attraction and life's blood. In this way, the art exhibition in Philadelphia's Memorial Hall, rather than the one in New York, presaged what museum exhibitions would eventually become.

Collectors' activities underpin the art market while also playing a role in the artist's hoped-for journey toward immortality through eventual acquisition by a museum. The New York Centennial Loan Exhibition glorified the collectors who organized it under the aegis of the Metropolitan Museum of Art and the National Academy of Design. Recalling the French art theorist André Malraux's argument that museums do not so much reveal masterpieces as create them, collectors' use of those sanctified spaces demonstrated their influence over artists and museums, and their exercise of power sent a clear message to artists and dealers. The exhibition also contributed to another, possibly unexpected development. John Taylor Johnston's wildly successful auction of his collection suggested that art could be a lucrative investment, creating a new motivation for collecting that is still much discussed today, though success stories remain anecdotal and risks high.

The New York Centennial Loan Exhibition was a surprise adjunct to the art displays at Fairmount Park that offered a masterful riposte to low European estimates of American taste. Though it worked strongly to the detriment of the exhibition in Philadelphia, it was a great success in its own right, and it might be expected to complete the 1876 international artistic dialogue in fine style. Schuyler's story in Gore Vidal's *1876* prepares the reader for an ending on a similar note, conclusive if a little ambivalent: Schuyler's beautiful, cultured, European-bred daughter Emma marries the rich and uncouth William Sanford, the widower of her best friend, who recently died in childbirth. It is not a fairytale ending, but it seems to secure the futures of both father and daughter. However, Schuyler finds out that Emma plotted with Sanford to bring about his wife's death, and Schuyler's despair at his daughter's betrayal leads to his own demise. His eulogy is delivered by his old (and, according to Vidal, probably corrupt) friend, William Cullen Bryant. Vidal leaves his readers with a reminder that ideal plans are always tarnished to a greater or lesser degree by human frailty or misguided ambition. Similarly, there is yet one more episode in the centennial narrative in Fairmount Park that needs to be told, a final controversy that demonstrated continued American anxieties in relation to Europe and represented one last attempt to assure that the final accounting of the fair would affirm the United States' cultural prowess.

CONCLUSION

Rewriting History

The Awards Controversy and the Afterlives of the Centennial Exhibition

After John Sartain's tireless (though not always scrupulous) work organizing the American art exhibition at Fairmount Park, it is fitting that decades later he published his own memories of the event. The fair effectively marked the end of his career at the age of sixty-eight. After 1876, he stopped taking engraving commissions, and he resigned from the Pennsylvania Academy of the Fine Arts two years later.[1] His memoir, *The Reminiscences of a Very Old Man, 1808–1897*, summed up his life in the same manner in which he had organized the centennial's American art display, shaping the events as best he could to assert his own vision.

Sartain assiduously defended his role as chief of the Art Bureau for the Centennial Exhibition: "Few could imagine the difficulties and trials that beset a man in a position of such responsibility as I had assumed. . . . My resolve to be strictly impartial in the discharge of my arduous duties brought me into frequent antagonism with one and the other." He quoted an 1897 letter from Centennial Exhibition director general A. T. Goshorn assuring him that "no one could have succeeded more acceptably in a similar position. . . . Your mild, equable temper, modest bearing and unselfish interest in the work were admirable." Sartain mentioned his innovation of putting doors in the corners of the annex galleries to allow for more wall space and that he was created an "Officer of the Royal Equestrian Order of the Crown of Italy" for his efforts on behalf of Italian art—an ironic honor, given the poor quality of the Italian contribution. Sartain quoted other high officials on the positive results of the art exhibition, and he personally considered it "on the whole, a remarkable

success."[2] He criticized the French and German contributions, praised the English display, and noted the attention attracted by the Italian exhibition—but made no mention of American art.

It is puzzling that Sartain was so eager to take credit for the foreign contributions to the exhibition, which were not in his direct purview, and yet was so silent on the American contribution, where he once said that his heart lay. He might have been unhappy with the results of the American art display and still stinging, more than twenty years later, from the harsh criticism he had endured. Sartain's own assessment can only be gleaned from a tepid comment in his official report: "All impartial people appear to agree that it was an undoubted success, and that the American portion of it was highly creditable to a country so young in art."[3]

Sartain's attempt to shape the public understanding of the Centennial Exhibition, effectively rewriting history by effacing aspects that he wished to forget, highlights the importance of the fair's legacy for those involved. It was positioned not only as an anniversary, but also as a stock-taking moment that was expected to mark a turning point in the nation's history. In the same way that artists, visitors, critics, and collectors all played their roles and worked to put their stamp on the Centennial Exhibition's reckoning of American art, many retrospective accounts attempted to control how the Centennial Exhibition would be remembered, and Sartain's was no exception. In avoiding the topic of the American art presence at Fairmount Park, he might have also wished to forget one final scandal: the organizers' attempt to rewrite history by intervening in the awards process.

The power that the Centennial Exhibition's American art exhibition offered was the chance to write history, to form and legitimize a national canon. As discussed earlier, the collective need for a national history sprang from the universal individual urge to make meaning of one's own life. Sartain's memoir demonstrated the personal desire that drove the larger movement to affirm American progress, which also inspired the awards controversy. In a continued effort to preserve a museum-like setting in the midst of a world's fair, jurors struggled to maintain the integrity of the art awards in a system designed for commercial goods, while also being mindful—perhaps too mindful—of how the final results would bear on American art's place in the world. Both aspects affirm the Centennial Exhibition's significance. Its impact on the American art world in the years following can be gauged in the tributes from critics and commentators, a museum boom in the Midwest, and the formation of the Society of American Artists, whose members put the lessons of the Centennial Exhibition and its transformed power relations to use.

The "Medal Muddle"

Organizers of the great world's fairs in the United States and abroad took on a monumental task: to create a system of order that included and explained all the products of humanity, both commercial and cultural, and to produce, as Italian philosopher Umberto Eco put it, "a final recapitulation in the face of a hypothetical end of the world."[4] The nineteenth-century preoccupation with creating order is evident in the careful attention paid to the

minute details of classification in early exhibitions.[5] Order meant not only classification, but rank. As guidebooks attested, the Centennial Exhibition was intended to show not just American progress, but American progress in relation to the world. Comparison and evaluation were at the heart of the art displays at the Centennial Exhibition. Millions of Americans came to Memorial Hall hoping not only to see great works of art, but also to compare them to other works and form an understanding of where they stood in relation to one another. This concern implied an imposition of order through officially recognized awards.

Awards at recent world's fairs had been tarnished by controversy. At the 1867 Exposition universelle in Paris, organizers and exhibitors protested that since jurors were unpaid, they were not always experts in their respective fields, and they could not be counted on to finish their work. Some judges felt that their responsibility was simply to secure as many medals for their own country as possible. Further, the makeup of juries was weighted toward the countries that occupied the most floor space, and awards were made anonymously, with no explanation.[6] The jurying for the fine arts at the 1873 Vienna exhibition was considered equally unsatisfactory. The number of judges appointed from each country was proportional to the number of exhibitors from that nation, and as a result of the United States' minuscule contribution, no Americans were jurors. However, in spite of the extremely unenthusiastic response to the American contribution upon its arrival, the United States won sixteen fine arts medals, which included nearly every work displayed.[7] Later reports bemoaned the "lavish and indiscriminate distribution of medals and

FIGURE 78 American School, "Award Medal." From *Centennial Exhibit Scrapbook*, 1876. Color lithograph. Free Library of Philadelphia.

diplomas" and complained that "artists not rewarded with medals are the exception, not the rule."[8]

In response to these complaints, a new "American system" of awards was created for the Centennial Exhibition. The Bureau of Awards was headed by Francis A. Walker, a noted economist, a Civil War general, and the director of the 1870 U.S. Census.[9] Under the new system, all awards were the same type of medal (fig. 78), rather than graduated bronze, silver, and gold medals, and they were based on a written report—to be signed by one judge but agreed upon by a majority. The report was considered to be the real award, and organizers hoped that having to write such reports would stimulate juries to consider each object seriously.[10] The media were quick to

recognize the enormity of such a task. The *Journal of the Franklin Institute* mused, "The anticipation that the power of permutation of adjectives might be exhausted in the 700 favorable reports on art subjects, is quite pleasant to entertain, or at least entertaining to suppose," and Louis Simonin bemoaned the "unhappy labor of the juries, who must fill up . . . thousands of forms, without scarcely knowing how to vary the eulogium."[11]

A corps of 233 judges was recruited from experts in each field, approximately half of them American and half foreign—a more equitable proportion than in previous fairs. They were paid a substantial $1,000 each for their service (the equivalent of more than $21,000 as of this writing).[12] Twenty judges were appointed for Group 27, the fine arts. Nine of them were designated as experts in painting: Charles West Cope of England, Carl Schlesinger of Germany, Jules-Émile Saintin of France, Count Donadio of Spain, Guglielmo de Sanctis of Italy, Hendrik Dirk Kruseman van Elten of the Netherlands, and from the United States, George Ward Nichols, Frank Hill Smith, and John F. Weir.[13]

However, a system of awards created with manufactured goods in mind was bound to be incompatible with the evaluation of fine art. The standards for judging included "originality, invention, discovery, utility, quality, skill, workmanship, fitness for purpose, adaptation to public wants, economy, and cost."[14] As early as September 1875, the New York *Evening Post* warned, "In our judgment it would be better to leave the fine arts out in any scheme of awards. . . . We cannot see the propriety of subjecting [art] to an arbitrament which seems to belong to the judicial sphere of the Patent Office."[15] The writer

correctly anticipated that the official criteria would be entirely irrelevant to art, and to apply them would threaten its status as a unique branch of human "production."

The fine arts judges began their task on May 25 and worked daily for four weeks.[16] It soon became clear that the procedures given to them could not be applied to the "goods" they were being asked to judge. Nichols related how "it was found that no two of the judges could agree in all respects in a criticism of a work of art, while it was not difficult to agree as to its *general artistic character*."[17] As was discussed in chapter 4, American art criticism was moving from patriotic boosterism to more rigorous, sophisticated consideration. But judges, like critics, were plagued by the long-standing lack of objective, measurable standards. Unlike a machine, works of art could not be judged by numerical assessments of efficiency or productivity. As a result, the group decided to limit the written report to the phrase "for artistic excellence."[18] In addition, the judges assessing the paintings agreed that one would write an opinion and the majority would sign it, rather than having only one judge sign, according to the official procedure.

In another departure, the judges of the paintings agreed to limit the number of awards given, and they set a fixed number that they would not exceed.[19] This decision was in response to the profusion of awards given at the 1873 Vienna exhibition, which diluted their value and made them all but meaningless.[20] Indeed, in other areas of the Centennial Exhibition, judges were later criticized for giving too many medals, and the *New-York Times* sarcastically concluded that "the tradesman without a medal must be the one who was selected from among the multitude

of Centennial exhibitors as the fittest person to receive the rare honor of no medal whatsoever."[21]

The paintings jury wrapped up its work on June 25, and its foreign members returned home, while the judging for most of the other groups dragged on through mid-September. Complaints surfaced, and the liberties taken with the rules came to light. The judges were accused of refusing to consider any more paintings after reaching their limit of medals; the official report claims that as of June 15 they declared the awards closed and would not allow the names of "certain exhibitors" to be submitted for a vote.[22] Stories circulated that the judges had contacted the Duke of Richmond, president of the Royal Academy in London, and asked whether the older academicians might forgo their medals so that they could be given to younger artists, all so that the judges might stay within their preset limit.[23] American judge Frank Hill Smith refuted the charge, pointing out that the fine arts judges gave fewer medals than their limit so that they had awards to spare, and moreover, transatlantic correspondence took so long that they could not have written a letter to London and received a response in time to have any effect.[24]

Smith further asserted in response to the *New-York Times* article "The Medal Muddle" that "there had been no 'muddle' in this affair except that the Centennial Commission attempted to put in practice a system of awards which could not be applied to objects of art."[25] Awards Bureau chief Walker recommended that in the future, awards should only be considered for makers of objects "of a commercial character," such as an organization that could produce two hundred watches a day, rather than the watchmaker who carefully crafted a few watches

of great merit, which could not be reproduced. Continuing the analogy, Walker concluded that "the commercial interest is, after all, the main-spring of action" for world's fairs.[26] Modern scholar Bruno Giberti pointed out that privileging mass-produced items threatened to put all exhibits to the same measure and to commodify art.[27] The judges recognized this threat, and their actions against it strongly asserted the artworks' standing as unique and didactic objects in an age of increasing mass production.

In spite of the jurors' complaints about the impossibility of applying objective criteria to a subjective field, they could not help creating a hierarchy of awards. Most accounts state that the comments in the reports were limited to "for artistic excellence." However, in the final report there were three different standardized responses, which cited "merit," "excellence," and "eminence."[28] While these words are not as instantly recognizable as third, second, and first—or bronze, silver, and gold—they clearly implied a ranking. The fine arts jury streamlined the process to its basic elements and created awards that were meaningful in their scarcity and hierarchical in their verbiage. In doing so, they insisted on the arts' special status.

But the fine arts awards controversy was just beginning. After complaints from general exhibitors about omissions and errors in the judging process, the Centennial Commission established a Committee on Appeals that added a total of 628 new awards across the entire exhibition.[29] Sartain, on behalf of Director General Goshorn, attempted to reconvene the paintings committee to revisit its stringent process, but most of the members had returned home, many overseas. A group of eight met so that "further

recommendations for awards in painting would be considered." Two of the original judges, Smith and Nichols, attended the meeting but refused to serve in protest. Goshorn appointed a group of three: the Americans John F. Weir and Brantz Mayer and Jacob Eduard van Heemskerck van Beest from the Netherlands. Of the three, only Weir had served on the original jury.[30] Weir was a distinguished painter, a longtime member of the National Academy of Design, and the first director of Yale University's School of Fine Arts. Mayer was a historian, an author, and a founder of the Maryland Historical Society.[31] Van Beest was a member of the Dutch royal navy before leaving to pursue marine painting.[32]

The new group hastily recommended 128 additional medals, more than doubling the original 85 awards.[33] Most of the new awards were given to artists of the United States, bringing its total from the original 12 to 41. In this way, the United States conveniently pulled ahead of France and Great Britain to garner the greatest number of awards for painting. Though it may have been driven by patriotic intentions, it was a disingenuous attempt to assure Americans of the merits of their native art in the face of increasing interest in the works of other nations.

The manipulation of the awards must be understood in the context of other international expositions. It was something of a world's fair tradition for the host nation to win the most awards. At the 1867 Paris Universal Exposition, France won 32 of 67 awards for painting and an even more decisive 23 of 36 awards for sculpture.[34] At the 1873 Vienna Universal Exposition, Austria won a total of 5,991 awards, far more than any other country (the United States won an undistinguished 442).[35] The judges

for the supplementary awards at the Centennial Exhibition must have realized how transparent was their bid for American artistic supremacy, and they must have anticipated the storm of protests it would raise. They attempted to have all the additional awards signed by Director General Goshorn and Secretary John L. Campbell rather than by themselves, to relieve them of personal accountability. Awards Bureau chief Walker protested, and the so-called scheme to deflect responsibility for the awards was defeated.[36]

The incident was front-page news, and protests were many and vehement. The *New York Herald* complained that having non-artists (a reference to Mayer) making the awards lessened their value, since the "American system" of awards was built on having each area judged by specialists. The supplementary awards lost their prestige, and the winners of the original medals were quick to distinguish themselves. An anonymous artist wrote to the New York *Evening Post* asking that a distinction be made between the original awards and those added later, since "it is proper that we should know the difference between a medal and a muddle." Weir wrote to Jervis McEntee in October, reassuring him that McEntee's award was among the original group. Philadelphia artist Xanthus Smith (whose impressions of the American galleries were discussed in chapter 2) wrote that the additional awards were made "with so little apparent consideration of fairness that these supplementary medals were rendered utterly valueless." A notice in the Boston *Daily Evening Transcript* on Anna Lea Merritt's *A Patrician Mother* (fig. 79) was quick to point out that it had received one of the initial medals. And the *Aldine* condemned H. H. Moore's

controversial *Almeh: A Dream of Alhambra* (fig. 17) in what it considered the most damning terms possible: it was not medaled by artists, but was given a supplementary award, and a fact "more damaging to the reputation of a picture or an artist we could hardly imagine."[37]

The complaints were entirely justified, and the awards' credibility was severely compromised. Nonetheless, the additions did not change the judges' overall assessment of American art.[38] Of the forty-one American artists receiving medals, fifteen can be identified with the Hudson River School style of landscape painting.[39] Hudson River School artists were represented by a large number of well-placed works and received a respectable number of awards. But foreign-trained artists working in the figural tradition were just as abundantly honored, receiving fifteen awards—a remarkable accomplishment given their less prominent hanging.[40] The proportions of the original awards are about the same, with four medals going to Hudson River School landscapists and the same number conferred upon foreign-trained painters.[41] The painting awards, both the original and the supplementary versions, demonstrated that foreign-trained artists had come into their own and were considered to be on the same level of merit as the dominant Hudson River School.

The jurying of sculpture, by contrast, excited no controversy or even comment. Awards were given to five sculptors in the initial judging, and none were added by the later jury. The proportions were the same as those for painting. Of the five, two were firmly in the nativist camp: Erastus Dow Palmer declined study abroad, and John Rogers cut short his European training to a mere five months. Another

FIGURE 79 Anna Lea Merritt (American, 1844–1930), *A Patrician Mother*, 1875. Oil on canvas, 58 × 34 ½ in. (147.3 × 87.6 cm). Hudson River Museum, Gift of Mr. and Mrs. John Bond Trevor Jr., 71.28.1.

FIGURE 80 Howard Roberts (American, 1843–1900), *La Première Pose*, 1873–76. Marble, 51 ¼ in. (130.2 cm) high. Philadelphia Museum of Art, Gift of Mrs. Howard Roberts, 1929-134-1.

two were F. Montague Handley of Rome, whose works *Diana*, *Bacchus*, and *Flora* (all unlocated) suggested the neoclassical tradition, and Howard Roberts, who served as the torchbearer for the coming Parisian Beaux-Arts ideal, exemplified in his *La Première Pose* (fig. 80). Little is known of the fifth honoree, Isabella Gifford, who was listed as a resident of New York.[42]

The fine arts awards' credibility was called into question by the imposition of additional medals, but in the end the jurying accurately reflected the emergence of expatriate artists. Unfortunately, because the awards were considered compromised, they could at best reflect acclaim for established artists, but they could not create it for emerging ones. The lesser-known recipients were not catapulted to lasting fame; rather, they remain, in many cases, unfamiliar to modern scholars. A vivid illustration is the example of Canadian-born Edward M. Bannister, a black painter who won a medal for *Under the Oaks* (unlocated). His *Oak Trees* (fig. 81), painted in the centennial year, shows the type of landscape idyll that won him acclaim. Bannister established a reputation in the 1860s in Boston, where he was one of the town's most popular artists, and he earned similar esteem when he moved to Rhode Island in the 1870s. At the Centennial Exhibition, his painting was praised for its masterful effects of light and shade, and it garnered such plaudits as "admirable" and "quite a startling representation."[43]

Bannister later recalled the prejudice that he faced at the Centennial Exhibition while trying to find out whether he had indeed been honored with an award. The crowds in the awards office and even officials questioned, "Why is this colored person

FIGURE 81 Edward Mitchell Bannister (Canadian-born American, 1828–1901), *Oak Trees*, 1876. Oil on canvas, 33 ⅞ × 60 ¼ in. (86 × 153 cm). Smithsonian American Art Museum, Gift of H. Alan and Melvin Frank, 1983.95.155.

here?" When Bannister inquired about the prize, an official responded, "What's that to you?" "In an instant my blood was up. The looks that passed between that official and the others were unmistakable in their meaning. To them I was not an artist; simply an inquisitive colored man. Controlling myself I said with deliberation . . . 'I painted that picture.' The explosion of a bomb could not have created more of a sensation in that room."[44]

Bannister appears to have been the only black painter represented at the centennial and the only New Englander to receive an award, and it might have been expected that such a distinction would bring him lasting recognition. But Bannister received one of the supplemental awards, and he did not fit the traditional mold of the white male artist; it seems that the tainted medal could not help him overcome the obstacles faced by an artist of African descent. Unlike African American–Chippewa sculptor Edmonia Lewis (discussed in chapter 2), he had no sensational past, and he did not employ the unconventional promotional methods that Lewis used to draw attention to her work. Bannister's award brought him esteem and a modestly successful career in his community of

Providence, Rhode Island, but it did not advance him to national prominence. He was quickly forgotten after his death in 1901, and his reputation was only resurrected in the late twentieth century.

In a year when the nation was reeling from a succession of political scandals, the perceived corruption of the awards process (even, ironically, in the service of nationalistic pride) suggested that nothing was sacred, not even the lofty and elevated concourse of the fine arts. The awards' lost credibility placed the burden of judgment on the official report that was expected to summarize the Fine Arts Department as a whole.[45] The summary was included with the reports of the Centennial Commission and as such constituted a government-sanctioned appraisal of the American art exhibition and its official legacy. According to American judge George Ward Nichols, asking the jury to write a general report was just as inappropriate as the written reports requested for individual works, since "the judges of the Group would never have consented to adopt as their collective judgment the individual opinions of any one of their members." Instead, Nichols submitted a list of the awards and the group's reasons for not following the guidelines set out by the Awards Bureau. Awards Bureau chief Walker then turned to the distinguished American artist John F. Weir, one of the three judges who added the controversial supplementary awards. Nichols was outraged and protested that Weir's "official report" was not their report at all.[46]

Nichols's response echoed the protests that Sartain encountered when he admitted works, including Moore's *Almeh*, to the exhibition outside the Selection Committee's authority: creating and assessing the fine arts canon at the Centennial Exhibition

required judgments by an authoritative group, and those evaluations were too important to be made by one individual, no matter how well qualified. The Centennial Exhibition not only called for a history and assessment of American art, but it also raised the crucially important question of *who* would write it. Of the many constituencies involved, which had the expertise and moral authority? These questions resonated in Memorial Hall from the beginning of the planning process and continued to echo through its galleries years later.

The Centennial Commission reports were not published until 1880. However, a copy of Weir's report was released to the press in 1877 and excerpted in the New York *Evening Post*.[47] The following year, Weir's statement was reprinted in the *Nation* in four installments.[48] It is remarkable that even a year later the report was newsworthy; the country was still thinking about the great fair's message and seeking the final word on its art displays. Weir addressed the foreign art displays, but his focus was on the American Art Department, and he took the opportunity to survey the entire history of American art, as did many critics when summing up the exhibition. He also evaluated the state of American art and many of the issues under discussion in the centennial year. Like his contemporaries, he addressed issues of both the past and the present, nationalism versus foreign influences on the American School, the complexity of fine arts' relationship to commerce, and the country's nascent museum culture. His concerns aligned closely with those expressed and enacted by other artists, with their passionate efforts to form an American canon; critics, in their vociferous debates about the growing interest in international styles; collectors, who took an

increasingly active role in shaping artistic tastes; and the general public, many of whom entered Memorial Hall as neophytes and exited with a budding interest in art and a new understanding of the art encounter.

Weir unconsciously acknowledged the complex relationship between art and commerce when he began his report by calling the exhibition a landmark moment in the history of private collecting and museum culture. He pointed out that Americans were well prepared for the exhibition of the world's art in Philadelphia because of the high caliber of their private collections, as evidenced at the New York Centennial Loan Exhibition. Weir declared that the Centennial Exhibition's Fine Arts Department attracted more visitors and more press commentary than any other aspect of the fair and that the rise of museums and academies in major American cities made it possible to gratify this new interest.[49]

Weir agreed with the popular opinion that the American art display was good overall, but marred by the indiscriminate admission of subpar works. Then, like many of his colleagues, he departed from the exhibition to include other paintings he considered to be important to the country's cultural history from its beginning to the present day. He considered John Singleton Copley and Gilbert Stuart to be unsurpassed in the United States and praised Washington Allston, Samuel F. B. Morse, Gilbert Stuart Newton, John Trumbull, and Benjamin West. All were represented in Fairmount Park, but rather than discussing their works exhibited there, he carefully built the artists themselves into the international canon by emphasizing that they were as well known abroad as they were in their native country in their day, and he was sure to add that they were as good as any of

their contemporaries in Europe.[50] John Wesley Jarvis, Henry Inman, and Thomas Sully were lauded as well. Weir also elaborated on mid- and late-century artists. He gave Thomas Cole and Asher B. Durand accolades as the fathers of the Hudson River School, and he wrote expansively on its great names, as well as Eastman Johnson.[51] He addressed the omnipresent notions of progress and nationality by warning that the development of art is not always a steady forward march; however, he quickly went on to say that American art was making rapid progress, since it was built not from the slow advance of barbarism, but on a foundation of earlier civilizations.

Like many of his contemporaries, Weir connected his history of art with the much-discussed question of a national school. He noted the growth of transportation, the dissemination of mass-produced images, and the blurring of cultural boundaries, and he questioned "if, indeed, the term 'school' has any proper application in modern art, where such classifications are being fast obliterated."[52] Some people would think, to the contrary, that the growing distribution of common ideas and images would contribute to the formation of a national school, but Weir did not agree. Since he had a year after the fair's close to write his report, he may have been thinking of new developments in the New York art world in the months after the centennial: greater numbers of artists returning from abroad and the beginnings of the secessionist Society of American Artists. Such changes would facilitate not a national school, but an international style.

Weir's thoughtful and sweeping report reflected the unprecedented encyclopedic character of the Centennial Exhibition's fine arts display; a dawning

consciousness of the event's lasting importance as a reckoning with American art and its place on the international stage; and the possibility that such a broad vision might manifest in a permanent physical form. Weir's comprehensive view indicated a growing desire for what was hinted at in the art exhibition at Fairmount Park: a permanent museum displaying high-caliber original works that represented the history of Western art. Such a museum seemed all but impossible at that time, but Philadelphians hoped that Memorial Hall in its postcentennial form would eventually embody Weir's ideal.

The Afterlives of the Fair

The Centennial Exhibition ended on November 10. Its abiding fascination was such that more than 115,000 people braved heavy rains to attend the closing ceremonies—more than were present at the opening.[53] It was recognized, however, that the exhibition's magic was waning and it was time for the fair to end. The *Atlantic Monthly* observed the grounds' "dust and dinginess," the "grass trodden bare," and the "flower-beds filled with litter."[54] Many closing-day speakers tried to articulate the meaning of the great spectacle they had witnessed. John Walsh, president of the Centennial Board of Finance, realized that the exhibition's effects would be felt for many years to come: "With the close of this day another International Exhibition will be concluded and added to the records of the past. But it will not be ended,— it will rather have only begun. The real exhibition we have striven for is not limited to the display of material products. . . . The teachings, the social and moral influences, the improvements in the productive powers of genius and inventive knowledge, constitute in part the object and aim. May these be fully realized as the legitimate results of the Exhibition!"[55]

At 4:00 P.M. that day, President Ulysses S. Grant gave the signal for the machinery of the exhibition to cease. The *New-York Tribune* recorded the strangeness of the moment, as the centennial spell was broken: "A few minutes after the engine had rested from its labors . . . an English road locomotive steamed along the main thoroughfare of the grounds to the Main Building, drawing two wagons heaped with packing boxes. This little incident was more significant than the speeches, the screaming whistles, and the chimes. It told that the end had come, and the work of pulling the Exhibition to pieces was already beginning."[56] The paintings and sculptures in the American art display were returned to their owners, whether artists, collectors, institutions, or those who had purchased works there.[57] However, for American artists and critics, the work of "pulling the Exhibition to pieces," of assessing its impact and absorbing its lessons, would last for decades.

There were attempts to resuscitate the fair in a corporeal form, but they only highlighted the irreproducible character of the Centennial Exhibition's fine arts display and affirmed the importance of written accounts to its legacy. On May 10, 1877, one year after the original opening, a group of investors called the Permanent International Exhibition Company reopened the Main Building, full of exhibitors, in a hopeful attempt to continue the Centennial Exhibition as a profit-making enterprise.[58] The adjacent Memorial Hall reopened in a more modest form as the Pennsylvania Museum (fig. 82).

Plans to create a national museum seem to have fallen by the wayside. As modern scholar Alan Wallach has pointed out, and as the inactivity of the early Fine Arts Committee of collectors made clear, elites were accustomed to and quite successful at organizing art exhibitions and institutions within their own communities, but they were too divided to be able to create a national museum; traditionally such institutions have required strong government support.[59] In the absence of government or private leadership, the fate of Memorial Hall and the cultural authority vested therein were up for grabs. Centennial Exhibition officials made an agreement with the Permanent International Exhibition Company to place pictures and statues in certain galleries of Memorial Hall and give the company all the admission fees; in return, the company would pay the Pennsylvania Museum $6,000 per year.[60]

The new institution emphasized the decorative arts in the tradition of London's South Kensington Museum (now called the Victoria and Albert Museum), which was inspired by the 1851 Great Exhibition of the Works of Industry of All Nations at the Crystal Palace. A Committee of Selection for the Pennsylvania Museum was given $25,000 to purchase works from the Centennial Exhibition, and it also received gifts from foreign commissioners and from the South Kensington Museum itself.[61] True to its purpose, the museum's accession books for its early years show that all of its acquisitions were decorative art objects, most of them foreign, and they included no American paintings or sculptures.[62]

The International Exhibition Company proved to be a poor business partner for the Pennsylvania Museum. As of 1878, the company had paid only

FIGURE 82 "Exhibition of the Pennsylvania Museum." From *Harper's Weekly*, January 25, 1879, 64.

a fraction of its obligation, and museum trustees were bringing legal action.[63] After several changes in management and the withdrawal of many foreign exhibitors, the Main Building was closed in 1881 and torn down, but the Pennsylvania Museum continued.[64] In 1893, it was transformed by a bequest from W. P. Wilstach, a Philadelphia leather manufacturer, who left a collection of paintings and a $500,000 endowment to the city of Philadelphia. His gift began the institution's development into the temple of masterworks now called the Philadelphia Museum of Art. Its current building on Benjamin Franklin Parkway opened in 1928, a delayed but most fitting manifestation of the encyclopedic, national-caliber art museum that the Centennial Exhibition organizers hoped would be the final fruit of their labors.

The Philadelphia Museum of Art took decades to evolve, but the Centennial Exhibition had a more immediate impact farther afield, as it spread the seeds of art museum ideals all over the nation. In 1870, George Fisk Comfort's tract *Art Museums in America* had called for the establishment of museums in all major cities, including St. Louis, Baltimore, Cincinnati, Chicago, and San Francisco. He boldly envisioned these museums as encyclopedic, covering all periods and all countries, though "at first glance it may seem impossible."[65] The art exhibition in Fairmount Park six years later opened Americans' eyes to new possibilities. Though the exact geographic origins of the Centennial Exhibition's visitors cannot be known, it seems likely that most arriving from beyond the East Coast hailed from the Midwest, since travel from the far West could be prohibitive, and southern attendance was notably low. Among the buildings on the fairgrounds sponsored by individual

states were those of Kansas, Ohio, Indiana, Illinois, Michigan, Wisconsin, Arkansas, Mississippi, and Missouri, suggesting that the citizens of those states had a particular interest in the fair.

Many visitors from the midwestern states had their first experience of fine art, not just by their fellow citizens but from all over the world, accompanied by instruction from the press and other visitors on how to interact with the works and how to conduct themselves in a museum setting. The Centennial Exhibition has long been acknowledged for launching the "era of museum expansion," since it likely spurred the opening of Boston's Museum of Fine Arts and the Metropolitan Museum of Art's move to a larger building a few years later.[66] However, its impact reached far beyond the East Coast. During the decade after the Centennial Exhibition, a remarkable number of art institutions were founded in the Midwest, including the organizations that are now known as the Art Institute of Chicago (1879), the Cincinnati Art Museum (1881), the Columbus Museum of Art (1878), the Detroit Institute of Arts (1885), the Indianapolis Museum of Art (1883), the Milwaukee Art Museum (1880s), the Minneapolis Institute of Art (1883), and the Saint Louis Art Museum (1879). In some instances, their beginnings were directly linked to the Centennial Exhibition. For example, the women who led the way in establishing the Cincinnati Art Museum were the same group who worked successfully to raise funds and organize the city's contribution to the Women's Pavilion at the world's fair. The museum's first director was Alfred T. Goshorn, director general of the Centennial Exhibition.[67] The establishment of the Detroit Institute of Arts was inspired by the excitement

generated from a successful loan exhibition in 1883, and the hall for the loan show was modeled after the Art Annex in Fairmount Park.[68] The sudden and swift dissemination of museum ideals into the nation's interior was a crucial step forward in the country's cultural progress, one that could have only been inspired by a collective event of national significance.

As important as the physical manifestations of the Centennial Exhibition's legacy were, they were rivaled by its impact on the relationships that underlaid the entire art world, beginning with the way that Americans perceived themselves. Writer Edward C. Bruce reflected that "any movement which assembles from distant quarters seven or eight millions of people must have other results than those perceptible at the time or on the spot—results slow to shape and to declare themselves. . . . We have, as it were, to stand outside of ourselves—a process not to be gone through with in a stroll of a few hours through acres of novelties."[69] The many assessments of the great fair showed a new consciousness of the nation's place in the world and a new vision of a progressive, internationalized future. John Walsh, president of the Centennial Board of Finance, observed, "It has taught *us* what *others* excel, and excited our ambition to try and equal them."[70] The *New-York Tribune* believed that the centennial "has shown us ourselves as other[s] see us. . . . It has taken us for a season outside of ourselves."[71] It was expected that other nations would closely scrutinize the United States in every aspect of its production, both commercial and cultural. At the same time, American citizens were watching themselves, contemplating the progress of the nation over the previous century, and watching each other, as people from all parts of a country that had recently been bitterly divided came together in unprecedented numbers.

The great fair was instantly acclaimed as a turning point in American art. *Scribner's Monthly* reflected at the exhibition's closing that "we look forward upon the next quarter of a century to the only general movement in art that our young country has ever known. We are ready for it, and stimulus and direction have come just when we needed it."[72] A *New-York Times* writer voiced concern about the art market for the fall of 1876, given the difficult economy. However, he noted the popularity of the art exhibition in Philadelphia and predicted that the people who had attended "will surely carry to every corner of the country broader ideas of the value of art and juster notions of the relative position of American painters," adding that the nation's art "has every appearance of vitality and promise."[73]

As the years passed, critics continued to affirm the centennial's significance. In 1879, *Harper's Monthly* marked the world's fair as a catalyst for the developments that followed, calling it "the occasion which set in motion or accelerated certain influences which had been gradually gathering in momentum for over twenty years."[74] In 1880, *Scribner's Monthly* acknowledged that "the Centennial year had in many ways awakened a popular interest in art," citing loan exhibitions springing up all over the country.[75] The following year, Dalton Dorr declared in the *Penn Monthly* that "with the opening of the Centennial Exhibition were unfolded possibilities of culture and refinement for the people never before thought of," and he further asserted that "the era of national culture in the United States may be dated from the Centennial."[76]

The fair's impact unfolded over decades; however, like the museums that sprang up in the wake of Memorial Hall's example, one of its most important consequences was the formation of a new organization, the Society of American Artists. The society's early years can be taken as a case study of the Centennial Exhibition's impact on the American art world. Its founders put the fair's lessons to use, rallying the transformed art world's constituencies to amazingly quick and far-reaching effect.

The Society of American Artists and the New Art World

The society epitomized the new realities of the art world that the Centennial Exhibition brought into being. The tensions between the National Academy of Design and the expatriate "new men" that began during preparations for the Centennial Exhibition were noted at the fair. S. S. Conant apologized for the academy in his souvenir book *The First Century of the Republic* for being subject to "sharp animadversion, sometimes not undeserved, from those who deem it too conservative."[77] The Centennial Exhibition brought the conflict into sharp focus, as the American art display in Fairmount Park, combined with the New York Centennial Loan Exhibition in the National Academy's own galleries, caused a widespread debate on the merits of foreign training versus the value of American character and subjects—the very issues at stake between the academy's old guard and the younger men. The Centennial Exhibition fueled the conflict by calling for an assessment of American art at a moment when its future hung in the balance.

In 1877, the academy attempted to reconcile its squabbles with younger artists by appointing two European-trained academicians, Charles Henry Miller and A. Wordsworth Thompson, to the hanging committee for its annual exhibition. Through their agency, large works by Will Low, Walter Shirlaw, and Abbott Thayer, as well as Frank Duveneck's *The Turkish Page* (fig. 83), were hung on the line—that is, in the coveted position at eye level—to the shock of some members. President Daniel Huntington demanded that the exhibition be rehung, but the committee refused. The academy then instituted an "eight-foot rule" whereby academicians were entitled to two works on the line measuring up to eight feet. They also changed the membership of the hanging committee and blackballed European-trained artists being considered for associate membership.[78]

Huntington was adamant that "this battle must be maintained, there will be no truce. . . . Foreign art will continue to pour in its forces and we shall triumph . . . by surpassing it."[79] The New York *Evening Post* was indignant, asking, "What becomes of the national character of our 'National Academy'?"[80] The question was particularly relevant, coming mere months after the close of the exhibition in Philadelphia, which had attempted to define the character of the country's art. Huntington thought that he was helping to preserve that character by resisting foreign styles, but they were fast becoming intertwined with American art, and after seeing the work of other countries at the Centennial Exhibition and the New York Centennial Loan Exhibition, many collectors and artists were ready to embrace them. In the 1880s, Americans continued to collect European art with enthusiasm. European dealers

FIGURE 83 Frank Duveneck (American, 1848–1919), *The Turkish Page*, 1876. Oil on canvas, 42 × 58 ¼ in. (106.7 × 148 cm). Courtesy of the Pennsylvania Academy of the Fine Arts, Philadelphia, Joseph E. Temple Fund, 1894.1.

such as Duveen Brothers and Durand-Ruel opened offices in New York, and European writers even showed interest in American collections. For example, in 1887 the *Gazette des Beaux-Arts* published a two-part article by E. Durand-Gréville titled "La peinture aux Etats-Unis: Les galleries privées." Late in that decade, Émile Zola worried that all the best paintings in Europe were liable to be sent to the United States.[81]

In the end, the academy's 1877 exhibition included some paintings by younger men, but broadly rendered works by William Merritt Chase and J. Alden Weir were hung unfavorably near the ceiling, and paintings by foreign-trained artists that were

FIGURE 84 Augustus Saint-Gaudens (Irish-born American, 1848–1907), *William Maxwell Evarts*, 1872–73, carved 1874. Marble, 22 ⅞ × 12 ¾ × 9 ¼ in. (58.1 × 32.4 × 23.5 cm). The Metropolitan Museum of Art, Gift of Erving and Joyce Wolf, in memory of Diane R. Wolf, 1987 (1987.405).

hung on the line were more in keeping with the academy's emphasis on finish and detail. Among the works that were rejected outright was a plaster sketch (destroyed) by Augustus Saint-Gaudens, which had provoked particular indignation.[82] The acceptance of Saint-Gaudens's bust of William Evarts (fig. 84) at the Centennial Exhibition, though it was probably more conservative in technique, must have made the

academy's rejection seem all the more preposterous. These slights spurred younger artists to action, and the Society of American Artists was founded on June 1, 1877, by painter Wyatt Eaton, critic Helena de Kay Gilder, Saint-Gaudens, and Shirlaw.

A *Scribner's* article of 1880 observed, "The annals of art in America have not been eventful, but the year 1876–7 may be said to mark the beginning of an epoch in them."[83] By eliding the years 1876 and 1877, the writer conveniently combined two signal events, rather than attempting to unravel the tangled relations of cause and effect. The Centennial Exhibition was the crucial art event of 1876, and the following year saw the formation of the Society of American Artists. When Clarence Cook assessed the Centennial Exhibition's impact, he singled out 1878 as "the year of grace," because it marked the society's first exhibition and the return home of several painters from France and Germany, such as Chase, Duveneck, Saint-Gaudens, Shirlaw, and Weir. He considered those events "the first answer American artists had made to the strivings of heart excited by the Centennial Exhibition."[84] The Society of American Artists exploded onto the national art scene. In a few short years, the group fostered an American style that incorporated international influences and became a serious rival to the academy. Many of its founding members were young, lesser-known artists, and the society helped launch them into long and successful careers.[85] How was this modest group able to achieve such quick and lasting success and make a respected place for themselves in the history of American art?

The Society of American Artists embodied the changes that the fair foretold and the challenge that

it represented to traditional forms of cultural authority. Its founders made a studied effort to form an art world of their own by recruiting all of its players to their cause, creating links among artists, critics, the market, and the public. By its nature, the new group was international in scope; it created a welcoming atmosphere for foreign-trained artists and encouraged their return to the United States. At the same time, it was also broadly national. In contradistinction to the academy, the society called for participation from across the country and actively solicited work from Boston and Philadelphia. The society's expansive reach echoed Sartain's ambitions for the Centennial Exhibition. The participating artists persuaded several progressive young members of the academy to join them, including Edwin Howland Blashfield, Frederic A. Bridgman, Homer Dodge Martin, Frank D. Millet, Charles Sprague Pearce, and Louis Comfort Tiffany. All had been represented the previous year at Fairmount Park.[86]

The new organization was immediately involved in the art market but made careful choices about the nature of its relationships. Its first several exhibitions took place at Kurtz Gallery and at the American Art Gallery; however, the society professed not to be concerned with selling. It wished to distinguish itself from what it considered to be the National Academy's preoccupation with sales at the expense of loftier ideals—and indeed, the society's early exhibitions generated few sales.[87] It worked to distance itself from the grubby machinations of the market, insisting that the act of painting itself was its highest aim. The society's stance would have resonated strongly with the many Fairmount Park visitors who were disappointed by the European art contributions, which

were considered to be of abysmal quality because they were chosen with sales in mind. Like the American art exhibition in 1876, the society's exhibitions served as a platform for articulating an ideological position, rather than as a marketplace. But its idealism was no doubt underpinned by a clear-eyed understanding of the art market's new direction. As American collectors began to favor contemporary European artists, the society's very public embrace of European subjects and techniques provided excellent promotional value to its artist members.

The Centennial Exhibition had just introduced the nation to the fine arts of the United States and other countries in a museum setting, and the society fed the new public interest, both locally and farther afield. Unlike the Centennial Exhibition, its very first show in 1878 was open on Sundays so that working people could attend. The society sent works to the Pennsylvania Academy of the Fine Arts in 1879, to the International Art Exhibition in Munich in 1883, and to the Chicago Inter-State Industrial Exposition in 1884. Perhaps its greatest early success was an exhibition at the Metropolitan Museum of Art in 1886, a remarkable endorsement of the society in particular and American art in general.[88]

The society's founding members were well aware of critics' growing influence on the shape of American art, and from the beginning they sought out writers to support their cause. Richard Watson Gilder, the husband of founding member and critic Helena de Kay Gilder, convinced Clarence Cook to support the new contingent in the *New-York Tribune.* Helena Gilder's brother, the critic Charles de Kay, had recently been hired by the *New-York Times,* and he too proved to be an important advocate.[89] Critics

were fresh from assessing the state of American art at the Centennial Exhibition and declaring that a new epoch had begun. As an embodiment of the new era, the society's media campaign was a great success. Its exhibitions were widely noticed and well received, and the issues under discussion paralleled those raised by the American art display in Fairmount Park. The Society of American Artists was particularly praised for limiting the number of works in its annuals, in contrast to the much-criticized overabundance of the American art display in Memorial Hall. The group was also lauded for its high standards of selection and hanging, in contrast to the controversies of the centennial year, and the society was quickly reproved for any deviation as the years progressed.[90]

By 1880, a writer for *Scribner's Monthly* noted a new emphasis on technique, an attribute closely associated with foreign training. He cited artists Chase, Duveneck, Eakins, Eaton, Ryder, and Shirlaw and connected the change with the "Renaissance, so to speak, of 1877" at the controversial National Academy exhibition. In three short years, the writer asserted, "the new men have, indeed, not only ceased to be a sensation, but they have come to be accepted, in many quarters . . . with cordial unquestioningness."[91] The Centennial Exhibition's surprisingly strong representation of expatriates had provided an encouraging example. National Academy of Design president Daniel Huntington had realized his error and urged the election to the academy of some of the "younger men" to "send some new and hot blood through our old veins."[92]

The triumph of the new men at the Centennial Exhibition, reified by the Society of American Artists, was also the death knell of the Hudson River School. In 1883, Cook reflected on those halcyon days of the "new men" whose "dash and unexpectedness made the Academy seem tame, and we heard all this tameness summed up in the newly invented stigma, 'the Hudson River School' . . . and in truth, it was time for the Hudson River School to at least begin to die." He may have been remembering the landscapes in Memorial Hall's retrospective Central Gallery West when he conceded that at least the movement "has a historical value, and specimens of it deserve to be collected in the museum of the future."[93]

John F. Weir, who wrote the official report on the fine arts at the Centennial Exhibition, devoted several pages to the impact of the Society of American Artists in an assessment titled "American Art: Its Progress and Prospects." He acknowledged that in Fairmount Park, Americans "learned the deficiencies of our own art; we have learned to discriminate between that which is really excellent, and that which is meretricious and false, in foreign art." He described the "new generation who have unfurled their banner most auspiciously" in the 1877 Society of American Artists exhibition and praised their vigor, but he asked the troubling, lingering question: Was it "advancing, with distinctive individuality, American art as such? This is the problem, not yet completely solved by either the old or the new generation of artists."[94] Discussions about the cross-currents of influence continued through the rest of the century, as critics debated what part they played in the country's history and how they affected the elusive idea of an American School.

After the country's enthusiastic embrace of all things centennial, even the anniversary's end had

to be memorialized in song. Will Gaylord's *The Centennial Is Over* from 1877 nostalgically described the quotidian travails of crowded trains and sleeping three to a bed, as well as the lofty ideals of national and international harmony. The centennial year was the defining moment of the postwar generation: Did you go? Did you bear witness to the entire world and, more important, did you see your country as it was displayed there? In the same manner as Professor D. S. Wright of Iowa State Normal School, quoted in the epigraph of this book, Gaylord divided the nation into two groups, those who had witnessed the wonders of Fairmount Park and those who had not:

> The Centennial is over, I'm home again you see
> I'm happy as an Emperor, I've "done" the Jubilee
>
>
>
> The Centennial is over, I'm home again you see
> Now ain't you sorry that you didn't go to the
> Centennial with me.[95]

For an event as important as this, one's own experience was not enough, and tedious lists of objects seen were inadequate to convey the fair's significance. It could only be fully captured in the imagination. The finest works of art in Fairmount Park were not merely transcriptions of scenes encountered; rather, they were freighted with ideas that were too large and too complex for straightforward description. So too, accounts of the Centennial Exhibition ranged from simple descriptions and recollections of events, to richly layered narratives that appropriated, selected, rejected, and even created fictions in order to capture the event's meaning and convey its story to those who could not experience it firsthand, both during the exhibition and long afterward.

The richness and variety of the descriptions and evaluations paralleled the struggles of various groups to create and assert their vision of American art at the Centennial Exhibition. James Smillie's and John Sartain's accounts narrated their personal struggles while artists clashed over their respective visions for American art on a public stage, and Xanthus Smith's surprisingly evenhanded observations offered a window for viewing the exhibition that resulted, along with the subtle ways that the organizers projected their ideals. Marietta Holley wove many points of view into a comic narrative meant to appeal to everyday Americans, whose presence numbered in the millions. Earl Shinn faced the dilemma of foreseeing the exhibition, and he presaged the crucial role of critics, who affirmed the importance of the event and their role in it by making their reviews a referendum on American art's past and future. Nathan Appleton's play *The Centennial Movement* gently lampooned the serious international tensions that underlaid the expectations of foreign exhibitors. His story ended on an ambivalent note, in keeping with fairgoers' intense disappointment that most other countries' art contributions were commercial, intended to sell rather than to educate. Gore Vidal's novel one hundred years later shifted the focus of the centennial moment from Philadelphia to New York and meditated on the power of wealthy, influential, and sometimes corrupt individuals; that power was displayed in one cultural form at the New York Centennial Loan Exhibition. The art exhibition at Fairmount Park ended under a cloud after its leaders attempted to shape events to their will, and even Sartain tried to erase the

American art exhibition from memory and rewrite the centennial story to build his own legacy and memorialize his part in it.

According to Howard Becker, the history of art is about innovators who won organizational victories; that is, they were able to create the apparatus of an art world, recruiting people to their cause who represented all of its constituencies: artists, collectors, critics, the public, and museums. This cooperative network then created a heroizing narrative that shows how the artists involved produced meritorious work from their beginnings and then progressed inevitably to high-art status.[96] Pierre Bourdieu added, "It is not sufficient to say that the history of the field is the history of the struggle for the monopolistic power to impose the legitimate categories of perception and appreciation. The *struggle itself* creates the history of the field."[97]

Memorial Hall was the site of a power struggle, a struggle to create history. As preparations progressed, the art world came to understand that the Centennial Exhibition's legacy was just as important as the event itself, perhaps even more so. It was not simply a mirror that reflected the current state of American commerce and culture, but it was also a crystal ball that Americans could peer into for answers to their questions about the past and the future. As the exhibition's import gradually became clear, every conceivable constituency rushed in to make its claim on the event and play a role in writing history. Artists planned the exhibition and established a new accommodation of internationalism that was conveyed by the works chosen and how they were displayed. Visitors experienced the exhibition and brought home a new familiarity with art that

sparked the founding of numerous museums. Critics and commentators used the display as a platform for larger concerns and an occasion to disseminate more nuanced views of the nation's art. Foreign exhibitors tried to define a market for their work. American collectors asserted a newfound confidence that would dominate the international art market and eventually catapult American museums to prominence. And finally, the artist-organizers completed the cycle, trying to create an official American triumph through the awards and the final report. The history of the art displays at the Centennial Exhibition is the history of power structures, and each constituency's involvement set into motion new relations and ideas that vaulted American art onto the international stage, poised for the key role it would play in the coming decades and the next century.

My own experience of the Centennial Exhibition has been transformed as well. I made another visit to Memorial Hall in 2012, eight years after my first journey there. The building had been converted from the offices of the Fairmount Park Commission to another civic use, an interactive children's museum called the Please Touch Museum that opened there in 2008. During my visit, the building was populated with laughing children and their parents, moving among brightly colored displays while music from loudspeakers filled the air. Memorial Hall has undergone extensive restoration, and the staff and volunteers are dedicated to researching, preserving, and informing visitors of its original purpose. John Baird's 1889 scale model of the fairgrounds has a place of honor, surrounded by a display of related objects and elucidated by audio commentary. The entrance and the rotunda

have been restored to their original glory, from the crisp architectural details in the moldings near the ceiling to the fine mosaics of the marble floor.

In 1876, when the Centennial Exhibition opened a gateway to the nation's next century, that floor was trod by millions of Americans who used the great fair as an occasion to create their own understanding of the country's past and chart their way toward its future. The fine arts exhibition laid the groundwork for today's art world, where the status of its players is regularly evaluated and eagerly discussed. The modern preoccupation with power is frankly acknowledged in *Art + Auction* magazine's closely watched annual "Power 100" issue, which includes artists, critics, collectors, art schools, and curators. *ArtNews* publishes a yearly list of the top two hundred collectors. The *Art Newspaper* offers an annual list of the best-attended museum exhibitions. The appointment of curators for biennials and the comings and goings of key museum staff are big news, as are the huge sums realized at auction for artworks. Museum acquisitions and, more controversial, deaccessions are the subjects of intense discussion. Museum expansions, renovations, and even reinstallations inflame passions.

All this jockeying and keen spectatorship signify the never-ending rush to lay claim to relevance and meaning, to assert one's own view of the art world as the version that will endure. Creating history makes us human and feeds the universal hunger to give meaning to our own stories and our larger collective life. Modern philosopher Paul Ricoeur reminds us that we grasp at the opportunity to write history, though our "revisions" all fall short and our attempts at objectivity are doomed to failure to a greater or lesser degree.[98] But we keep trying—for money, for prestige, for influence, and for our own understanding of the bewildering world that seems to grow larger and more complicated every day, just as it must have seemed in 1876.

APPENDIX:

COMMITTEES AND AWARDS

Centennial Exhibition

U.S. Fine Arts Committees

FINE ARTS ADVISORY COMMITTEE
William Tilden Blodgett
James L. Claghorn
Henry C. Gibson
William J. Hoppin
John Taylor Johnston
Peter F. Rothermel
Worthington Whittredge

SELECTION COMMITTEE
Henry Kirke Brown
Thomas Hicks
Daniel Huntington
Jervis McEntee
Howard Roberts
Thomas Robinson
Richard Staigg
John Quincy Adams Ward
Samuel B. Waugh
William H. Willcox

HANGING COMMITTEE
Charles C. Perkins
Howard Roberts
Christian Schussele

James D. Smillie
Thomas U. Walter
Worthington Whittredge
Isaac L. Williams

New York Centennial Loan Exhibition

Executive Committee

John Taylor Johnston, chairman
Thatcher Adams
W. Loring Andrews
Samuel Avery
S. L. M. Barlow
Clark Bell
August Belmont
Albert Bierstadt
William H. Bridgman
J. G. Brown
William Cullen Bryant
J. M. Bundy
G. W. Burnham
Charles Butler
T. R. Butler
Legrand B. Cannon
Samuel Colman
William E. Dodge Jr.
Benjamin H. Field
Josiah M. Fiske
Parke Godwin
Robert Gordon
Henry Peters Gray
Seymour Joseph Guy
J. H. Hall
T. A. Havemeyer
Samuel Hawk
Aaron Healy
Thomas Hicks
John Hoey
William J. Hoppin
Henry E. Howland
Daniel Huntington
J. B. Irving
Eastman Johnson
George Jones
W. W. Kenyon

Manton Marble
H. G. Marquand
D. H. McAlpine
J. Milbank
Edwin D. Morgan
L. P. Morton
T. B. Musgrave
William Niblo
Jules Oehme
Charles O'Hara
R. M. Olyphant
William Henry Osborn
F. N. Otis
William Page
Royal Phelps
J. W. Pinchot
Whitelaw Reid
T. Addison Richards
H. W. Robbins
Theodore Roosevelt
William Schaus
John H. Sherwood
Bryan H. Smith
C. S. Smith
Henry N. Smith
Henry G. Stebbins
Lucius Tuckerman
J. H. Van Alen
P. Van Volkenburgh
F. Waller
John A. Weeks
Worthington Whittredge
John Wolfe

Committee on Application and Selection of Pictures

Edwin D. Morgan, chairman
Clark Bell
Parke Godwin
Robert Hoe Jr.
William J. Hoppin
John Taylor Johnston
J. W. Pinchot
Lucius Tuckerman

Committee on Finance and Insurance

John H. Sherwood, chairman
William H. Bridgman
Robert Gordon
Samuel Hawk
T. B. Musgrave
William H. Osborn
Philip Van Volkenburgh

Committee on Press and Printing

T. Addison Richards, chairman
John G. Brown
Jules Oehme

Committee on Transportation and Hanging

Daniel Huntington, chairman
Thomas Hicks
Worthington Whittredge

Committee of Management

John Taylor Johnston, chairman
Parke Godwin
Thomas Hicks
Edwin D. Morgan
J. W. Pinchot
Theodore Roosevelt
Worthington Whittredge

Treasurer

John H. Sherwood

Centennial Exhibition Awards

Department of Art: American Artists

SCULPTURE (ALL ORIGINAL AWARDS, NO SUPPLEMEN-
TARY AWARDS GIVEN)
Isabella Gifford, for artistic excellence in sculpture of the
 bust
F. Montague Handley, for artistic excellence in the fine art
 of sculpture
E. D. Palmer, for artistic excellence in the fine art of
 sculpture

Howard Roberts, for artistic excellence in the fine art of sculpture

John Rogers, for artistic excellence in the fine art of sculpture

PAINTING

Original Awards

F. A. Bridgman, for artistic excellence in genre, *Flower of the Harem, Nubian Story-Teller*

F. M. H. De Haas, for artistic excellence in landscape, *Drifted Ashore*

James M. Hart, for artistic excellence in landscape, *A Summer Memory of Berkshire*

Thomas Hill, for artistic excellence in landscape, *Yosemite Valley*

W. M. Hunt, for artistic excellence in portrait, *Portrait*

Eastman Johnson, for artistic excellence in genre, *What the Sea Says, The Prisoner of State, The Old Stagecoach*

J. R. Key, for artistic excellence in landscape, *The Golden Gate—San Francisco*

Anna M. Lea (Merritt), for artistic excellence in portrait, *Portrait, Genevieve de Brabant*

Jervis McEntee, for artistic excellence in landscape, *The Woods of Ashokan, November, October Afternoon*

T. E. Rosenthal, for artistic excellence in genre, *Remind Me Not That I Alone / Am Cast Out from the Spring*

W. A. Shade, for artistic excellence in genre, *Tantalizing*

W. Whittredge, for artistic excellence in landscape, *Twilight on the Shawangunk, Rocky Mountains from the Platte River*

Supplementary Awards

E. M. Bannister, for merit in landscape painting, *Under the Oaks*

James H. Beard, for excellence in genre painting, *The Attorney and His Clients*

Albert Bierstadt, for eminence in landscape painting

George H. Boughton, for artistic excellence in genre painting, *God Speed*

J. B. Bristol, for excellence in landscape painting, *Lake Memphremagog*

G. Brüerke, for excellence in genre painting of the historical class, *Columbus Discovering America*

W. M. Chase, for great merit in genre painting, *"Keying Up"—The Court Jester*

F. E. Church, for eminence in landscape painting, *Chimborazo*

E. J. Gardner, for excellence in genre painting, *Corinne*

R. Swain Gifford, for excellence in landscape painting, *Mosque of Mohammed Ali, Cairo*

S. R. Gifford, for eminence in landscape painting, *Pallanza, Lago Maggiore; Fishing-Boats of the Adriatic; Lake Geneva; The Golden Horn; San Giorgio, Venice; Tivoli; Sunrise on the Sea-Shore*

H. Peters Gray, for eminence in genre painting, *The Apple of Discord*

H. Herzog, for excellence in landscape painting, *Sentinel Rock, Yosemite*

D. Huntington, for eminence in historical painting, *Titian and Charles V*

J. B. Irving, for excellence in genre painting, *The End of the Game*

David Johnson, for excellence in landscape painting, *Scenery on the Housatonic*

Francis B. Mayer, for excellence in genre painting, *Attic Philosopher, Continentals*

H. H. Moore, for excellence in genre painting

Edward Moran, for excellence in landscape painting, *Minot Ledge Light*

Peter Moran, for merit in genre painting, *Return of the Herd*

Thomas Moran, for excellence in landscape painting, *The Mountain of the Holy Cross*

W. T. Richards, for excellence in landscape painting, *The Wissahickon*

P. F. Rothermel, for excellence in historical painting, *The Battle of Gettysburg, The Defence of Sir Harry Vane*

Emily Sartain, for merit in genre painting

Walter Shirlaw, for excellence in genre painting, *Toning the Bell, Feeding Poultry*

Clementina Tompkins, for merit in genre painting, *An Artistic Debut*

Charles Volkmar, for great merit in landscape painting, *The Passing Shower, near Vichy, France*

A. J. H. Way, for remarkable excellence in still-life painting, *Grapes* (two panels)

P. F. Wharton, for merit in genre painting, *Perdita*

NOTES

The epigraph to this book, from Professor D. S. Wright, is quoted in Bailey 1877.

Introduction

1. U.S. Centennial Commission (hereafter USCC) 1880c, 27–30. Also see Rydell, Findling, and Pelle 2000, 25; Maass 1973, 13–15, 36. According to Rydell, Findling, and Pelle 2000, total attendance on opening day was 186,672.
2. *Philadelphia Evening Bulletin* (hereafter *PEB*) 1876b, 2.
3. Foner 1976, 533–34.
4. *New-York Times* (hereafter *NY Times*) 1876f, 1; *PEB* 1876b, 2.
5. USCC 1880c, 31.
6. *NY Times* 1876e, 1.
7. *PEB* 1876b, 3; *New-York Tribune* (hereafter *NYT*) 1876d, 6.
8. Just across from the Main Building, outside the Centennial Exhibition grounds, was Centennial City, an unofficial midway filled with restaurants, small hotels, beer gardens, ice cream shops, displays, and other attractions. Rydell 1984, 33–34.
9. *Philadelphia Inquirer* 1876, 2.
10. For the purposes of this book, "nativist" Hudson River School artists were New York–based landscape paint-ers with a self-identified American sensibility and no interest in seeking out contemporary foreign styles to emulate.
11. *Arthur's* 1876a, 121.
12. Saunders 1877, preface, n.p.
13. Pattee 1915, 9; Bellows 1876, 44.
14. Quoted in Brown 1966, 295.
15. *New York Herald* (hereafter NY Herald), May 1, 1876, 6, quoted in Donaldson 1948, 67.
16. *Atlantic Monthly* 1876b, 88.
17. Randel 1927, 240.
18. Wiebe 1967, 15.
19. Brown 1966, 168, 107.
20. Ibid., 194.
21. Nugent 1973, 40.
22. Twain and Warner 1883, ix.
23. Ibid., 250–56.
24. Gregg Camfield, "Afterword," in ibid., 13–14.
25. McKeever 1876, 57.
26. Higham 1970, 109.
27. Parkman 1865, 13.
28. Quoted in Kraus and Joyce 1985, 83–84.
29. Higham 1970, 111.
30. Kraus and Joyce 1985, 92.
31. Goodheart 1992, 6. Ironically, by the 1870s this approach had fallen out of favor with increasingly professionalized, university-trained historians, who turned to the more restrained and scientific approach that is familiar to modern readers. See Kraus and Joyce 1985, 136.
32. *NYT* 1876k, 1.
33. Lossing 1876.
34. Burley 1876.
35. Cohen 1876, 9–10.
36. Lowenthal 1985, 208. See also Halbwachs 1992, 183.
37. Ricoeur 2004, 448.
38. Lowenthal 1985, 216.
39. Ricoeur 2004, xvi.
40. See Halbwachs 1992.
41. Ricoeur 2004, 121, 333.
42. Kammen 1991, 4.
43. Ibid., 80.
44. For a study of the roles of memory and history in understanding an American world's fair, see Gilbert 2009.
45. Quoted in Kammen 1991, 17.
46. *Art Journal* 1876d, 161.
47. Giberti 1994, 99.
48. Hicks 1972, 7.

49. *Art Journal* 1876d, 161.

50. Quilibet 1876b, 696.

51. Cook 1875, 7.

52. A handful of Hudson River School artists trained abroad, including Albert Bierstadt, John F. Kensett, and Worthington Whittredge. Many others traveled in Europe, but not as students. When Frederic E. Church, Thomas Cole, Asher B. Durand, Sanford Gifford, and Jervis McEntee journeyed to Europe, they did so as mature artists whose painting styles were firmly established, and while there they sought out landscapes, just as they did in the United States.

53. The league remains an important source of affordable, egalitarian art education and boasts many distinguished alumni. See http://theartstudentsleague.org/.

54. Trachtenberg 1970, 1–2, 15; Nugent 1973, 38–39; Wiebe 1967, xiii.

55. Donaldson 1948, 119.

56. *Atlantic Monthly* 1876b, 87.

57. Troyen 1980, 27.

58. Donaldson 1948, 118.

59. *Scribner's Monthly* 1876a, 432.

60. Van Ginkel 1999, 22; Talcott Parsons, "Power and the Social System," in Lukes 1986, 94, 102.

61. John Kenneth Galbraith, "Power and Organization," in Lukes 1986, 212–14.

62. Examples from Michel Foucault and Steven Lukes, respectively.

63. Robert Dahl, "Power as the Control of Behavior," in Lukes 1986, 40; Hannah Arendt, "Communicative Power," in Lukes 1986, 64.

64. There are a few studies focusing on English art in the mid-nineteenth century; see, for example, Fyfe 2000; Wolff and Seed 1988.

65. See Dahl in Lukes 1986, 41–51; Lukes, "Introduction," in Lukes 1986, 9–15; Lukes 2005, 70–73; Morriss 2002, 32, 45, 146–49; van Ginkel 1999, 3; Galbraith in Lukes 1986, 212–15.

66. Bourdieu 1993, 6, 9, 14.

67. Ibid., 19. While a number of Bourdieu's ideas apply universally, others are informed by his own time and place: France in the later twentieth century. For instance, his studies of French museum visitors were shaped by a long-standing state-run museum system and keenly class-conscious visitors. In another example, his concept of the art field as "the economic world reversed" was based on the mid-twentieth-century artist's posture of disdain for sales and awards, a stance that most nineteenth-century artists did not share.

68. Becker 1982, xxiv, 25, 35.

69. See, for example, Rydell 1984; Böger 2010.

70. Photography would be of particular interest as a topic in its own right, since an entire building was devoted to the photography exhibition, and Philadelphians were pioneers in popularizing and legitimizing the medium.

71. USCC 1880a, 85.

72. The sparsely furnished "New England Farmer's Home of 100 Years Ago" display has been offered as an exception to this rule, but its focus was not on historical decorative arts, as I discuss in chapter 3.

73. See McCabe 1876, 350–60; Sandhurst 1876, 153–58; Ferris 1877; and a series of articles in the *Art Journal* on the decorative arts, all titled "The Centennial Exhibition," 2 (1876):161–68, 193–201, 225–32, 257–63, 301–9, 334–41, 348–49, and 366–71; and 3 (1877):9–12, 41–43, 81–82, 182.

74. Valenti 2013, n.p.

75. Baird 1889, 6.

76. See Troyen 1984; Blaugrund 1989; Fischer and Docherty 1999; Carr and Gurney 1993; Ganz 2015.

77. The few exceptions include Gold 2008; Robey 2000a; Hobbs 1976; Sellin 1975. For a full historiography, see Orcutt 2005, 12–16.

Chapter 1

1. James D. Smillie Diary (hereafter Smillie Diary), May 5, 1876, reel 5; "Jervis McEntee's Diary" 1991, 15.

2. Robey 2000b, 25, 68.

3. For summary accounts of the 1853 Exhibition of the Industry of All Nations in New York, see Böger 2010; Hirschfield 1957.

4. Norton 1974, 6.

5. Robey 2000b, 306–7.

6. Cummings 1865, 238.

7. Sacco 1991, 63; Steen 1963, 278–79; Mayer 2002, 21–26. Sculpture, on the other hand, was a major attraction; Hiram Powers garnered high praise for examples of his many versions of *Eve Tempted*, *The Fisher Boy*, *Proserpine*, and *The Greek Slave*. In March 1854, P. T. Barnum took over the exhibition, but even the great showman could not stimulate interest, and it closed just eight months later. The building was available for rent in the following years and finally burned down in 1858 during, ironically, a mechanics' fair of the American Institute. See Steen 1963, 282–87.

8. See Savidou-Terrono 2002 for a thorough study of these exhibitions.

9. "The Art Gallery," *Forney's War Press* 3 (June 11, 1864): 5, quoted in Savidou-Terrono 2002, 177. Ironically, most of the works in the Philadelphia exhibition were contributed by New York collectors, such as William Aspinwall, Marshall Roberts, Robert Olyphant, Michael Knoedler, William T. Blodgett, and John Taylor Johnston.

10. Nutty 2000, 59; 1993.

11. Just as important, the fairs' art exhibitions demonstrated the potential for great American museums; the Metropolitan Museum of Art was founded as a direct result of the sanitary fairs. See Tomkins 1989.

12. At the 1855 Exposition universelle in Paris, Napoleon III declared that the fine arts were equal in importance to industry and should be displayed in a separate building. Future world's fairs, including the Centennial Exhibition, would make every effort to separate art from the coarse and motley products of industry. American participation in the 1855 exhibition amounted to only thirty-nine paintings lent by ten artists living in France: the painters William Morris Hunt, G. P. A. Healy, Christopher Pearse Cranch, Regis Gignoux, Henry P. Hunt, G. Powers-Alanson, John Robertson, Thomas P. Rossiter, and David B. Walcutt and the sculptor Eugène Warburg. See *Exposition* 1855; Mainardi 1987.

13. *NYT* 1867, 2.

14. Leslie 1868, 8–9, 15.

15. Troyen 1984, 5, 6, 13, 20.

16. *NY Herald* 1873, 3.

17. For instance, the *Nation*'s articles on the opening in Philadelphia were full of comparisons to Vienna, contrasting the pomp of the ceremonies, the buildings, and the views afforded by their positioning on the grounds. See, for example, *Nation* 1876b, 318–20. Unfortunately, the Vienna exhibition was plagued by bad luck. A stock market crash near the time of the opening caused hotels and restaurants to double their rates, and tales of the greedy Viennese made their way across Europe and the United States. A cholera epidemic further suppressed attendance. See Maass 1973, 30; Norton 1974, 7.

18. *NYT* 1873a, 4.

19. Taylor 1873, 1.

20. *NYT* 1873b, 1; Massachusetts Commission 1875, 210.

21. Massachusetts Commission 1875, 210. Two paintings by Bierstadt were contributed, and it is unclear which was placed there. One was *"The Emerald Pool," White Mountains, New Hampshire*, and the other was recorded simply as "oil painting." See U.S. Commission to the Vienna Exposition (hereafter USCVE) 1876, 194.

22. *NY Herald* 1876c, 6.

23. Sartain 1880, 135.

24. Memorial Hall is discussed here only briefly and as it relates to the American art exhibition. Giberti 2002 focuses on the development of the design plans and the building.

25. Rydell, Findling, and Pelle 2000, 21.

26. Giberti 1994, 98.

27. Trumbull 1986, 2.

28. Sartain 1880, 148; Pennsylvania Museum 1878, 7.

29. Giberti 1994, 103.

30. *Art Journal* 1876d, 162, 164.

31. *Journal of the Franklin Institute* 1875, 18; Maass 1973, 46.

32. Memorial Hall's footprint measures approximately 76,650 square feet; the Corcoran Gallery's footprint was approximately 12,500 feet; and the Museum of Fine Arts covered approximately 58,000 square feet. See Wallach 1998, 34; Whitehill 1970, 23–25.

33. Cheryl Leibold, the Pennsylvania Academy's longtime archivist, attested to regular requests for information on the Centennial Exhibition that could

34. *NYT* 1875a, 2; 1875d, 5.

35. Boston was not represented at this stage, perhaps because the committee was a compromise between the city that had won the right to host the Centennial Exhibition and its fiercest competitor.

36. Claghorn's collection included work by Philadelphia history painters Peter F. Rothermel and Christian Schussele, landscapist Herman Herzog, figure painter Thomas Sully, and New York–based landscape painters Albert Bierstadt, Jasper F. Cropsey, Asher B. Durand, William Trost Richards, and Worthington Whittredge. See "Catalogue of Paintings Belonging to James L. Claghorn," reel 4131, frames 329–35, Claghorn Papers.

37. Fairmount Park Association 1922, 87–89.

38. Wright 2000, 27–28.

39. John Sartain (hereafter JS) to Emily Sartain, July 3, 1875, reel 4563, frame 738, Sartain Family Papers (hereafter Sartain Papers).

40. On August 26, both the New York *Evening Post* and the *Tribune* complained that nothing seemed to be happening. *Evening Post* 1875a, 2; *NYT* 1875b, 2.

41. *Daily Evening Transcript* 1875a, 6.

42. *Philadelphia Inquirer* 1875, 4.

43. *NYT* 1875d, 4.

44. JS to Thomas Moran, September 23, 1875, reel 4562, frame 1085, Sartain Papers.

45. Sellin 1975, 7.

46. Martinez 2000, 1–5, 12; Sellin 1975, 26; Martinez 1986, 147–49.

47. Martinez 2000, 1, 12. In 1899, Sartain would publish *The Reminiscences of a Very Old Man*, a series of self-congratulatory, name-dropping anecdotes from his life. He speculated on the insurance value of Gilbert Stuart's Landsdowne portrait of George Washington, which was shipped from England for the Centennial Exhibition, and he noted that Rothermel's *The Battle of Gettysburg* was insured for $30,000 in 1886 (Sartain 1899, 255).

48. JS to T. Addison Richards, November 20, 1875, reel 4562, frame 1230, Sartain Papers.

49. *NYT* 1875e, 3.

50. JS to W. Grut, September 27, 1875, reel 4562, frame 1088; JS to August Morand, October 16, 1875, reel 4562, frame 1128, both Sartain Papers.

51. JS to Col. Edward Perkins, October 5, 1875, frame 4562, frame 1100; JS to William P. Blake, October 4, 1875, reel 4562, frame 1099, both Sartain Papers.

52. JS to Albert Bierstadt, October 29, 1875, reel 4562, frame 1156, Sartain Papers.

53. JS to Benjamin Durham, December 9, 1875, reel 4562, frame 1266, Sartain Papers.

54. JS to John Taylor Johnston, January 4, 1876, reel 4563, frame 16, Sartain Papers; Sartain 1880, 135, 144.

55. JS to Worthington Whittredge, November 5, 1875, reel 4562, frame 1184, Sartain Papers.

56. JS to A. G. Heaton, October 6, 1875, reel 4562, frame 1109; JS to R. W. Moore, November 3, 1875, reel 4562, frame 1174; JS to Peter F. Rothermel, November 19, 1875, reel 4562, frame 1220, all Sartain Papers. For a full account, see Orcutt 2005, 85–89.

57. Sartain 1880, 142.

58. Spassky 1985, 180.

59. Falk 1999, 3484, 3573.

60. "American Art" 1875, 2. In May 1876, the *Galaxy* considered the opposite point of view, commenting that the Centennial Exhibition would show foreign visitors that American artists working in the United States were just as good as the Americans working overseas (Quilibet 1876b, 698).

61. Fink 1990, 114.

62. Carbone 2006, 553.

63. *Daily Evening Transcript* 1875b, 6; JS to Hon. Joseph R. Hawley, July 28, 1876, reel 4563, frame 233, Sartain Papers; Groce and Wallace 1966, 433–34.

64. *Daily Evening Transcript* 1876a, 6.

65. JS to Wickham Hoffman, February 21, 1876, reel 4563, frame 77, Sartain Papers.

66. *NY Herald* 1876b, 5.

67. As a result, the first major showing of Whistler's work in the United States was delayed until 1881, when his *Arrangement in Grey and Black: Portrait of the Painter's Mother* was displayed in Philadelphia. See Nicolai Cikovsky Jr. with Charles Brock, "Whistler and America," in Dorment and MacDonald 1995, 33.

68. Sartain 1880, 147, 150.

69. *NY Herald* 1875, 5.

70. *Appleton's* 1876b, 504.

71. JS to Daniel Huntington, March 17, 1876, reel 4563, frame 164, Sartain Papers; Hobbs 1976, 8. No evidence has been found, however, that this was the salon's policy, and Patricia Mainardi (pers. comm., 2005) suggested that the approach depended on the individual juror. Sartain may have misunderstood the salon's policy, or perhaps he simply invoked its name to support his own preferred method.

72. JS to John F. Weir, February 17, 1876, reel 4563, frame 69, Sartain Papers.

73. "Jervis McEntee's Diary" 1991, 12.

74. *NY Herald* 1876a, 10.

75. JS to James D. Smillie, December 28, 1875, reel 4562, frame 1311, Sartain Papers. His bitterness remained more than twenty years later, and he recalled the "jealousies and selfishness of those with whom one has to deal" (Sartain 1899, 265–66).

76. JS to W. J. Burton, September 27, 1876, reel 4563, frame 349, Sartain Papers.

77. JS to Mrs. A. E. Slocum, December 24, 1875, reel 4562, frame 1304; JS to Messrs. Myers and Hedian, January 19, 1876, reel 4563, frame 39; JS to A. and C. Kaufmann, March 3, 1876, reel 4563, frame 106; JS to Henry E. Alvord, March 8, 1876, reel 4563, frame 131; JS to Daniel Dougherty, March 14, 1876, reel 4563, frame 153, all Sartain Papers.

78. JS to W. H. Machen, February 4, 1876, reel 4563, frame 65; JS to Forbes Lithographic Mfg. Company, February 22, 1876, reel 4563, frame 83, both Sartain Papers.

79. JS to Thomas Moran, March 6, 1876, reel 4563, frame 118, Sartain Papers. Sartain had a long history of working relationships with the Moran family as a mentor in etching to Thomas Moran. JS to T. W. Noble, March 7, 1876, reel 4563, frame 128, Sartain Papers.

80. "Jervis McEntee's Diary" 1991, 14.

81. JS to John F. Weir, February 17, 1876, reel 4563, frame 69, Sartain Papers.

82. *NYT* 1876b, 8. The artists listed were Henry Bacon, E. M. Bannister, S. G. W. Benjamin, E. T. Billings, Elizabeth Boott, Walter Brackett, George L. Brown, W. Warren Brown, H. R. Burdick, Edward Burrill Jr., E. Carlsen, J. W. Champney, J. J. Enneking, Ellen Day Hale, Robert C. Hinkley, George Inness, Millicent Jarvis, Helen M. Knowlton, F. D. Millet, Imogene Robinson Morrell, Charles S. Pearce, B. C. Porter, Thomas Robinson (a member of the Committee on Selection), F. Hill Smith, T. L. Smith, R. M. Staigg (a member of the Committee on Selection), E. L. Weeks, and William Willard.

83. Henry Kirke Brown (hereafter HKB) to Mrs. Henry Kirke Brown, March 30, 1876, 2210, Henry Kirke Brown Papers (hereafter Brown Papers).

84. *NY Herald* 1876b, 5.

85. *Art Journal* 1876c, 157.

86. Janson 1989, 152. New York landscapists were not averse to exhibiting other genres of painting, but it is easy to imagine that, for an exhibition of representative art of the United States, they would want to ensure that American landscapes were present in force.

87. HKB to Mrs. HKB, New York, April 1, 1876, 2212–13, Brown Papers.

88. Anderson and Ferber 1990, 31.

89. "Jervis McEntee's Diary" 1991, 14–15.

90. Ibid., 14.

91. HKB to Mrs. HKB, April 4, 1876, 2213, Brown Papers.

92. "Jervis McEntee's Diary" 1991, 14, 15.

93. JS to T. Addison Richards, November 16, 1875, reel 4562, frame 1213, Sartain Papers.

94. JS to S. R. MacKnight, New York, March 21, 1876, reel 4563, frame 178, Sartain Papers. Only a few works appeared in both the Pennsylvania Academy's exhibition catalog and the Centennial Exhibition's catalog: sculptor J. W. Bailly's *Spring*; the bas-reliefs *Rose-bud* and *Inspiration* by Joseph C. Gordon; and the following paintings: H. Merle's *Charity*; Walter Shirlaw's *Feeding the Poultry* and *Toning the Bell*; W. H. Weisman's *Cape Ann Rocks*; and G. Wolf's *Portia*.

95. HKB to Mrs. HKB, April 5, 1876, 2213, Brown Papers. Among the works rejected were two unnamed portraits and *A Musical Party* by a young Mary Cassatt.

96. JS to Messrs. Bailey and Co., March 4, 1876, reel 4563, frame 113, Sartain Papers.

97. Sewell 2001, xiv; JS to Emily Sartain, December 20, 1874, reel 4563, frame 750, Sartain Papers.

98. Simpson 2001, 33.

99. William J. Clark, *Evening Telegraph*, June 16, 1876, n.p., quoted in Berkowitz 1999, 202–6.

100. Sellin 1975, 14; Berkowitz 1999, 202–3.

101. Braddock 1975, 85; Hajdel 1950, 7; Susan James-Gadzinski, "Harry Humphrey Moore," in Blaugrund 1989, 190–91.

102. *PEB* 1876j, 1.

103. Ackerman 1986, 214.

104. Sears 1876, 196; *Aldine* 1876b, 293–94.

105. *NY Times* 1876d, 2.

106. Fink 1990, 90.

107. *Evening Post* 1876a, 1.

108. *NY Times* 1876a, 10.

109. Sartain explained to Goshorn that the paintings he spirited into Fairmount Park had been approved by the Pennsylvania Academy's exhibition committee, which included half of the members of the centennial Selection Committee. This was an exaggeration, since the academy's exhibition committee included only two of the centennial committee's ten members. Sartain claimed that the rejections "had elicited earnest and indignant remonstrance from influential and impartial judges and lovers of art," including highly placed Centennial Exhibition officials. He further explained that the pictures he admitted represented only a fraction of the more than three hundred pictures that the committee had rejected and that he had hung them in Gallery 42 of the Art Annex, a less-visited location (JS to Director General A. T. Goshorn, July 29, 1876, reel 4563, frame 235, Sartain Papers).

110. *PEB* 1876n, 2; *NYT* 1876n, 2; Pennsylvania Academy of the Fine Arts 1876. In addition to Moore's *Almeh*, the following works from the Pennsylvania Academy's spring exhibition appeared in Gallery 42: F. T. L. Boyle's *The Prayer of Judith* (unlocated), G. L. Brown's *Niagara by Moonlight* (unlocated), Theodore Kaufmann's *Influence of Electricity on Human Culture* (unlocated), Clarence M. Johns's *"To Tubal-Cain Came Many a One"* (unlocated), Carl Raupp's *Approaching Storm* (unlocated), Henry Ulke's

Portrait—General Grant (Orange County Museum of Art), and Oregon Wilson's *Woman's Devotion* (unlocated). Six of these artists had their training abroad, and some were known for working in European styles. Sartain also installed two other works in the Art Annex's Gallery 42 that the Selection Committee had rejected: Bierstadt's *California Spring* and Thomas Satterwhite Noble's *The Tramp*. *The Tramp* may be the same painting as the Yale University Art Gallery's *Blind Man of Paris*, but the gallery's files do not confirm it.

111. Daniel Huntington and Thomas Hicks to A. T. Goshorn, June 21, 1876, Director-General Correspondence Received, 1876 (2), USCC Papers.

112. *Evening Post* 1876j, 2–3. They sent another indignant letter on November 2, even though the exhibition would close just a week later, declaring that "we disclaim all responsibility for the mass of crude and ill-arranged works which lower the tone of the American art exhibit." Apparently the two conservative New York painters wanted to make their protest seem more universal and less partisan, since this letter was sent over the names of other members of the New York contingent and Thomas Robinson of Boston, but Robinson vehemently denied that he had authorized his signature. See *PEB* 1876n, 2.

113. JS to F. Boyle, August 11, 1876, reel 4563, frame 257, Sartain Papers.

114. JS to Theodore A. Kaufmann, August 21, 1876, reel 4563, frame 279, Sartain Papers.

115. JS to Director General A. T. Goshorn, July 29, 1876, reel 4563, frame 237, Sartain Papers.

116. *NYT* 1876m, 4.

117. JS to W. J. Burton, September 27, 1876, reel 4563, frame 349, Sartain Papers.

118. *New-York Tribune Guide* (hereafter *NYT Guide*) 1876, 60.

119. Fink 1990, 115, 121.

120. JS to James D. Smillie, New York, November 1, 1875, reel 4562, frame 1163; JS to James D. Smillie, November 4, 1875, reel 4562, frame 1178, both Sartain Papers. He also remarked, "As allotter of space in *large* and in *detail* I am the hanging committee," and "the arrangement of the pictures on the walls rests with

me" (JS to Charles C. Perkins, March 24, 1876, reel 4563, frame 192; JS to R. W. Moore, November 3, 1875, reel 4562, frame 1174, both Sartain Papers).

121. JS to Charles C. Perkins, March 24, 1876, reel 4563, frame 192; JS to Charles C. Perkins, March 25, 1876, reel 4563, frame 191, both Sartain Papers.

122. Sartain 1880, 142–43.

123. Eliot 1887, 223–26, 234, 236; Falk 1999, 574.

124. Smillie Diary, April 27, 1876.

125. Sartain 1880, 143.

126. JS to Charles C. Perkins, March 24, 1876, reel 4563, frame 193; JS to Thomas Moran, March 4, 1876, reel 4563, frame 115; JS to Worthington Whittredge, December 14, 1875, reel 4562, frame 1277, all Sartain Papers.

127. Sartain 1880, 143. Sartain's qualification was a polite recognition that other cities had contributed, but the vast majority of works came from the three metropolitan centers.

128. JS to Leverett Saltonstall, November 9, 1875, reel 4562, frame 1192; JS, "Report of the Art Department," handwritten draft, reel 4564, frame 796, both Sartain Papers; Janson 1989, 153; Sartain 1880, 143. A story in the *New York Herald* even reported acrimony between the Selection and Arrangement Committees, with members accusing each other of throwing out works that were better than their own or admitting works that had been rejected (*NY Herald* 1876f, 8).

129. "Jervis McEntee's Diary" 1991, 15. For Whittredge's part, he recalled the entire year of 1876 as one of "unremitting labor" for the Centennial Exhibition and was probably quite fatigued at this point. See Janson 1989, 44.

130. Janson 1989, 153. Janson referred to "European" artists, but since Sartain was not responsible for the arrangement of works from other countries, this was probably a reference to Sartain's partiality for American artists working in European styles.

131. Smillie Diary, May 5, 1876.

132. Sartain 1880, 143. It is unclear whether this statement was in reference to paintings in Memorial Hall or the annex, but it seems more likely to be the Art Annex, where most galleries were arranged by city, according to Sartain's plan.

133. *PEB* 1876c, 2.

134. *NY Herald* 1876e, 11.

135. Cook 1876c, 8.

Chapter 2

1. Nearly nine hundred works of art were displayed in the American galleries at the Centennial Exhibition. For a searchable version of the 1876 official catalog of the Art Department, see https://babel.hathitrust.org/cgi/pt?id=njp.32101076367885;view=1up;seq=5.

2. Bourdieu 1993, 14.

3. Lukes 2005, 19–25, 29.

4. Smith manuscript, reel 2040, frame 67.

5. Ibid., frame 80.

6. Hobbs 1976, 7.

7. Sandhurst 1876, 25.

8. Several versions of Willard's *The Spirit of '76* exist; the one probably displayed at the Centennial Exhibition is at Abbot Hall in Marblehead, Massachusetts. McDonald's *Bust of Washington* may be the New-York Historical Society's *George Washington* by James Wilson Alexander MacDonald, but the society's records include no information on its presence at the Centennial Exhibition.

9. Kenneth L. Ames, "Introduction," in Axelrod 1985, 3. Edward Teitelman's essay in Axelrod 1985, "Wilson Eyre and the Colonial Revival in Philadelphia," 71–90, identified the centennial moment's impact on interest in colonial architectural forms. See also Richard Guy Wilson, "What Is the Colonial Revival?," in Wilson, Eyring, and Marotta 2006, 3.

10. Kammen 1991, 135.

11. The New England kitchen exhibits at both the Centennial Exhibition and the World's Columbian Exposition were commercial enterprises on the part of Emma Southwick, who by 1893 had married to become Emma S. Brinton; she still billed herself as "Mother Southwick." See Roth 1985.

12. Schoelwer 1985. Michael Kammen also argued for the 1890s as the beginning of Americans' "absorbing passion" for the period (Kammen 1991, 147–48).

13. *NY Times* 1876b, 5; 1876c, 8.

14. *Art Journal* 1876g, 283–84.

15. Cooper 2001, 30; also see Pergam 2001.
16. Greenhalgh 1988, 200, 208.
17. Nearpass 1983, 21–22.
18. The American Art-Union also issued a medal of John Trumbull, who was represented at the Centennial Exhibition by only two paintings, perhaps because the organizers could not secure any other loans of his work.
19. Smith manuscript, reel 2040, frame 75.
20. Cook 1875, 7.
21. Burke and Voorsanger 1987, 71.
22. Janson 1989, 153, 176–77. Though the Hudson River School is heavily emphasized in modern narratives of American art from the 1820s to the 1870s, it was concentrated in the New York area. It had fewer adherents in Philadelphia and Boston, where collectors and artists were more interested in the European manner, notably the Barbizon style popularized in Boston by William Morris Hunt and the figural subjects embraced by Philadelphians. See Webster 1991; Sellin 1975.
23. Worthington Whittredge to James Pinchot, September 21, 1871, quoted in Janson 1989, 153–56.
24. Bienenstock 1983, 15.
25. Conrads 2001, 65, 73.
26. Bienenstock 1983, 19.
27. Ibid., 18–23.
28. "Art Matters" 1876, 3.
29. Randel 1927, 385.
30. Though the opposite gallery on the right side of the ground plan was also designated "U.S.," it was installed with works from France, which occupied Gallery E adjoining it above, and works from Germany, which occupied Gallery F below.
31. Smith manuscript, reel 2040, frames 67–68.
32. Anderson and Ferber 1990, 41–45, 52.
33. Smith manuscript, reel 2040, frame 80.
34. Ibid., frame 121.
35. Kensett died in 1872, Leutze in 1868, Sully in 1872, and Suydam in 1865.
36. *The American Type* was said to depict "a rustic youth and a maiden in a cornfield. Before them lie[s] a pile of ripe and ruddy ears, and the maiden has turned her pouting, coquettish face away from the earnest gaze of her admirer" (*National Republican* 1876b, 1).
37. Smith manuscript, reel 2040, frame 73.
38. Fort 1990, 136, 139.
39. Ibid., 218, 235.
40. Smith manuscript, reel 2040, frame 72.
41. Sellin 1975, 48.
42. May 1995, 7, 9.
43. *NYT* 1876j, 2.
44. *NY Herald* 1876f, 8.
45. Ingram 1876, 372; Dale 1876, 188; Hartigan 1985, 91.
46. The overall representation of women in the American art display seems low by today's standards, at approximately 43 out of 436 artists, or 10 percent. It was significantly less than the 19 percent at the National Academy of Design's 1876 annual exhibition, with approximately 54 women artists out of a total of 285. However, it slightly exceeded the proportion in the Pennsylvania Academy of the Fine Arts's 1876 exhibition, which was 8 percent, or approximately 26 of 314 artists. See Pennsylvania Academy of the Fine Arts 1876; National Academy of Design 1876. The artist's gender was determined by honorific or first name when provided.
47. However, these galleries also included three works by the more progressive John La Farge.
48. Smith manuscript, reel 2040, frame 80.
49. There was also a display of sculptures by John Rogers in the Main Building.
50. Barter 1998, 208–10.
51. Matthews 1946 is often cited as the basis for this conclusion. She conducted a statistical analysis of the Hudson River School's contributions that seemed to be a model of the scientific method. However, the subjective nature of Matthews's assumptions clouded her seemingly objective formulas, and mathematical errors weakened her conclusions. See Orcutt 2005, 158–60.
52. Fink 1990, 315–409.
53. As expected, expatriate sculptors made a strong showing with 71 works out of 154. However, if anything, this reflected the opposite trend of that in painting. Whereas painters were going abroad in increasing numbers, sculptors, who had long been expected to

study in Rome or Florence, were just beginning to find training options in the United States.

54. Miller 1973, 7, 9.
55. Quoted in Angell 1881, 88.
56. Webster 1991, 125.
57. Hunt's portrait of Barthold Schlesinger was contributed by the sitter and hung in Memorial Hall's Gallery C along with other foreign-influenced works. Hunt's genre painting *The Boot Black* was lent by J. H. Wright and appeared in the annex in Gallery 28, which showcased Boston artists.
58. Smith manuscript, reel 2040, frame 67.

Chapter 3

1. Paul 1875, n.p.
2. Curry 1996, 12–14, 18.
3. Quoted in ibid., 87.
4. Ibid., 7.
5. Hicks 1972, 127; Maass 1973, 117–18.
6. "Sabbath" 1876, 343; Holley 1877, 408–10.
7. Bellows 1876, 52.
8. USCC 1880c, 27.
9. Sears 1876, 196.
10. "Centennial Art" 1876, 5.
11. *NYT* 1876e, 1.
12. Duncan and Wallach 2004, 65.
13. Bennett 1988, 100–101.
14. Trout 1929, 90–91.
15. JS to Thomas Cochran, March 25, 1876, reel 4563, frame 196, Sartain Papers.
16. *Scribner's Monthly* 1876c, 120.
17. *Evening Post* 1876b, 1.
18. Wager 1876, 650; *Atlantic Monthly* 1876d, 734. Attendance slumped during the unusually hot summer months and increased significantly when the fall brought cooler temperatures. See Hicks 1972, 114–16.
19. *NYT Guide* 1876, 60.
20. *New York Evening Mail* (hereafter *NYEM*) 1876d, 2.
21. Many editions of the catalog were produced, and none was complete; further, works were added throughout the course of the exhibition, making it

impossible to tally a definitive number of works present. By way of comparison, present-day exhibitions rarely exceed two hundred artworks.

22. Sartain 1880, 137.
23. Sandhurst 1876, 25; Sears 1876, 196; Sartain 1880, 137; Randel 1927, 383.
24. Simonin 1877a, 16.
25. *American Architect and Building News* (hereafter *AABN*) 1876g, 269.
26. *NYT Guide* 1876, 58; Briggs 1876, 4.
27. Bailey 1877, 45; *Centennial Eagle*, July 25, 1876, quoted in Goodheart 1992, 90; Holley 1877, 414; Coan 1876, 763; Clemmer, "A Woman's Letter from Philadelphia," *Independent* 28 (October 26, 1876), quoted in Goodheart 1992, 91.
28. Walker 1877b, 51; *Atlantic Monthly* 1877a, 96; Cook 1876c, 8; Cook 1876d, 2; *AABN* 1876g, 269; Walker 1877a, 509. Cook was aware, though, that the "inertia of the American Commission" had led to Sartain's rushed preparations.
29. Holley 1877, 434.
30. Crary 1992, 20, 24.
31. Goodheart 1992, 90.
32. For examples, see *NYT Guide* 1876; *What Is the Centennial?* 1876; *Hand-Book* 1876.
33. The job of producing the catalog was originally given to the Philadelphia publisher Nagle and Co., which proved unable to accomplish the task. The Centennial Commission took over, contracting out various aspects of the work to different firms. See Giberti 2002, 30.
34. *Nation* 1876c, 310; Cook 1876c, 8.
35. "Centennial Art" 1876, 5. Except where noted, in this book references to works in the exhibition and their gallery locations are drawn from the fourteenth edition of the exhibition catalog (USCC 1876).
36. Hicks 1972, 19.
37. USCC 1880c, quoting from Sidney Lanier's "Cantata," 35; from Oliver Wendell Holmes's "Welcome to All Nations," 46; and from Dexter Smith's "Our National Banner," 55.
38. Giberti 1994, 41; *NYT* 1876o, 4.
39. *Scribner's Monthly* 1876a, 432.

40. Burley 1876, 5.
41. *International Exhibition Guide* 1876, 6.
42. Goodheart 1992, 77; Randel 1927, 69; *Atlantic Monthly* 1876d, 737.
43. Simonin 1877a, 67; "Address of Joseph Hawley," in McCabe 1876, 895, quoted in Goodheart 1992, 77. One exception to the Southern absence was a traditional "Southern tournament" on the fairgrounds, which was organized by Marylanders and West Virginians. Riders styled as knights navigated a course that included catching rings with their spears. The tournament was followed by an elaborate ceremony that culminated in crowning a "Queen of Love and Beauty." See McCabe 1876, 766–73.
44. Foner 1976, 533–35.
45. See chapter 2. Examples include Henry Kirke Brown, James L. Claghorn, Thomas Hicks, Thomas F. Hoppin, Daniel Huntington, John Taylor Johnston, Jervis McEntee, Rothermel, Sartain, J. Q. A. Ward, and Worthington Whittredge.
46. JS to Director General A. T. Goshorn, July 21, 1876, reel 4563, frame 222, Sartain Papers.
47. Ricoeur 2004, 453, 456.
48. Savage 1997, 5.
49. The scene was assumed to take place in the South, but the painting actually depicted a location in Washington, D.C. For a synopsis, see Gallati 2011, 234–35.
50. *NY Herald* 1876g, 9. The Fairmount Park Art Association had been raising funds for a statue of General Meade since his death in 1872, and its annual report for 1877 appealed to citizens *not* to put the war behind them: "It is becoming popular, and perhaps it is proper, to forget the acrimonious issues and to cover up the wounds of civil strife, but there is no patriot who can wish to extend this oblivion to the memories of the heroism displayed in that fearful contest" (quoted in Fairmount Park Association 1922, 44).
51. *NY Herald* 1876f, 8.
52. Gold 2008, 277–89.
53. Thistlethwaite 1995, 21–22.
54. Quilibet 1875, 120; Maass 1973, 21; Winer 1975, 9. The minutes of the Fairmount Park commissioners noted parenthetically that the group planned to display other history paintings there too: works from the collection of Philadelphian Joseph Harrison, such as Benjamin West's *Christ Rejected* (Pennsylvania Academy of the Fine Arts) and William-Adolphe Bouguereau's *Orestes Pursued by the Furies* (unlocated); Ferdinand Pauwel's *New Republic* (unlocated), which depicted the past and future progress of the United States; and Rothermel's *Christian Martyrs at the Coliseum* (unlocated). Minutes of Meeting of the Commissioners of Fairmount Park, May 10, 1873, Fairmount Park Commission Archives, n.p.; Winer 1975, 9; *Hand-Book* 1876, 18; John C. McIlhenny and Martha Halpern, Philadelphia, to Donald Winer, Harrisburg, Pa., June 25, 1984, Fairmount Park Commission Archives, 1; Nutty 1993, 283–86.
55. Centennial regulations prohibited "articles that are in any way dangerous or offensive" (USCC 1875, 26). In JS to Director General A. T. Goshorn, July 21, 1876, reel 4563, frame 221, Sartain Papers, Sartain mentioned Goshorn's "decided objection to all that class of pictures that were calculated to awaken ill feeling in our Southern visitors, such as the Battle of Gettysburg." Such a frank acknowledgment that the picture went against Goshorn's regulations suggests that Sartain was not responsible for its inclusion.
56. Thistlethwaite 2000, 39–43.
57. Rothermel Papers, MG-108, n.p., Pennsylvania State Archive, Harrisburg, quoted in Thistlethwaite 2000, 41.
58. Carter 1876b, 284.
59. Cook 1876b, 2. See also *Daily Evening Transcript* 1876c, 6.
60. "Short Sermon to Sightseers at the 1901 Pan-American Exposition," quoted in Bennett 1988, 81.
61. Donaldson 1948, 103.
62. *NYT* 1876n, 2.
63. Donaldson 1948, 88.
64. Harris 1990, 18, 22. See also Shapiro 1990, 234–35.
65. Bennett 1988, 100.
66. Jarves 1870a, 292.
67. There were some notable exceptions in the 1850s and 1860s in larger cities like Chicago, St. Louis, and

Detroit in the form of local art unions, mechanics' association fairs, and sanitary fairs.

68. Carson 1967, 166.
69. Schlesinger 1946, 31, 33–34; Mott 1938, 308.
70. *Nation* 1865, 113–14.
71. For a full account, see Sellers 1980.
72. See Foshay 1990; Stillwell 1918; Savidou-Terrono 2002, 335; Zalewski 2009, 72; Ferber 1982, 21.
73. *Appleton's* 1876a, 214.
74. Hartley 1873, 14–15, 296–97.
75. Wells 1872, 106.
76. Quoted in *Harper's Weekly* 1876a, 579.
77. Coan 1876, 762. The responses of middle-class patrons in museum environments had been of interest to British periodicals for decades. See Johnson 2003; Fyfe 2000, 140.
78. Ingram 1876, 731–32.
79. Howells 1876, 93; Coan 1876, 762; Maass 1973, 76. See also *NYT Guide* 1876, 58; *Atlantic Monthly* 1876b, 89.
80. Quoted in Brown 1966, 135.
81. *Atlantic Monthly* 1876c, 234.
82. Coan 1876, 761–62.
83. Johns 1991, 12–15.
84. Authors immortalized the Pike in works such as John Hay's *Pike County Ballads* (1871) and numerous stories by Bret Harte, including "The Luck of Roaring Camp" (1868). See Pattee 1915, 83–98.
85. Holley 1877, 473. Holley did not satirize only naïve provincials. She also struck at oversophisticated eastern critics: Samantha's husband, Josiah, explains that "runnin' things down is always safe; *that* never hurts anybody's reputation. The pint is, they say, in not bein' pleased with anything, or if you be, to conceal it; look perfectly wooden, and not show your feelins a mite; that is the pint they say" (482).
86. Bellows 1876, 45.
87. Bourdieu and Darbel 1991, 51.
88. Twain 1869, 192.
89. Ibid., 242.
90. *Art Journal* 1875, 383; *NY Herald* 1876d, 7; Sears 1876, 196; JS to A. T. Goshorn, August 28, 1876, reel 4563, frame 288, Sartain Papers; *NY Times* 1876L, 4; Lancaster 1950, 295; *PEB* 1876e, 1.
91. The cartoonists might have taken a cue from British magazines like *Punch*, which published numerous views of visitors in galleries in the mid-nineteenth century. Many were lampoons of inappropriate behavior, whether by the pretentious upper classes or the uncouth lower classes. See Johnson 2003, 124–25, 128–29, 192–94.
92. *NY Times* 1876L, 4; Bricktop 1876, 47; *PEB* 1876f, 4.
93. *NY Times* 1876L, 4.
94. Coan 1876, 764.
95. Holley 1877, 411–13.
96. See Gerdts 1974.
97. Trollope 1832, 85.
98. Holley 1877, 436.
99. *Aldine* 1878, n.p.

Chapter 4

1. Shinn 1875a, 271. Shinn followed the example of Henry Wadsworth Longfellow's 1839 novel, *Hyperion*.
2. Earl Shinn to Rich Cadbury, August 5, 1874, Shinn Letters.
3. Shinn 1875b, 350–51.
4. Earl Shinn letter, n.d., Earl Shinn Letters (hereafter Shinn Letters).
5. Ricoeur 2004, xvi.
6. Becker 1982, 131.
7. Bourdieu 1993, 19–20.
8. Cranch 1867, 77.
9. *Aldine* 1873, 15.
10. *AABN* 1876a, 130.
11. Benjamin 1879, 29–31.
12. Docherty 1985, 43–44; "Art and Teach" 1876, 28.
13. Conrads 2000, 93. See also Simoni 1952.
14. Dearinger 2000a, 21, 23; 2000b, 69–70.
15. Mott 1950, 415–25.
16. Dearinger 2000c, 274.
17. Mott 1950, 32, 184, 339, 361, 378, 420, 459, 467.
18. Conrads 2001, 3–5; Dearinger 2000a, 21–22; Donaldson 1948, 114, 116; Mott 1950, 187, 190 (includes the *North American Review* citation).
19. Norton 1974; *NYT Guide* 1876.
20. *What Is the Centennial?* 1876; *Hand-Book* 1876.
21. Bricktop 1876; Bailey 1877; Dale 1876; Holley 1877.

22. *Something for the Children* 1876; *International Exhibition Guide* 1876; Bruce 1877.

23. Burley 1876, 17.

24. *Scribner's Monthly* 1876d, 126.

25. One installment focusing on American art was *Evening Telegraph* 1876a, 8.

26. Articles appeared on page 1 or 2 almost daily from June 17 to June 29 and from July 5 to July 13. A sculpture review appeared on July 19.

27. Docherty 1985, 39.

28. Leslie 1868, 15.

29. Jarves 1870a, 316.

30. *PEB* 1876i, 1.

31. Conrads 2000, 93; 2001, 4.

32. Weir 1880, 4; Anderson 1876. Anderson concluded that a national character did not at that time exist, but it would soon: "All we want is time for our national stream to settle . . . and our national character will become apparent" (737).

33. *Press* 1876a, 1.

34. JS to Smillie, August 5, 1876, reel 4563, frame 250, Sartain Papers.

35. *PEB* 1876n, 2.

36. *AABN* 1876g, 269.

37. *Atlantic Monthly* 1877b, 617–18.

38. One exception to the landscapists' dominance was John La Farge, who had been praised by progressive critics for more than a decade and whose style had become familiar to them by the centennial year.

39. Wager 1876, 650.

40. Miller 1876, 1.

41. Burns 1999, 210.

42. Carter 1876b, 284; *PEB* 1876L, 2; *Atlantic Monthly* 1877a, 96; *PEB* 1876d, 1; *PEB* 1876k, 2; *NY Herald* 1876c, 6; "American Art" 1876, 2.

43. Shinn 1876f, 72; "Life at the Exhibition" 1876, 613; *NY Times* 1876r, 1–2; Bruce 1877, 183; *NYT Guide* 1876, 62; *PEB* 1876m, 2; *NY Times* 1876r, 2.

44. *AABN* 1876g, 269–70; Bruce 1877, 182.

45. Cook 1876c, 8.

46. *AABN* 1876g, 270; *PEB* 1876h, 1; *PEB* 1876i, 2; Norton 1974, 204; *NY Times* 1876p, 1; *National Republican* 1876b, 1; Fletcher 1876, 8; Shinn 1876f, 72.

47. *PEB* 1876i, 1; 1876g, 5.

48. William J. Clark, *Daily Telegraph*, April 28, 1876, quoted in Berkowitz 1999, 200–205.

49. Simpson 2001, 33.

50. *AABN* 1876g, 269; Burley 1876, 638; *NYEM* 1876d, 1; Shinn 1876f, 72; Shinn 1877, 38.

51. See Blaugrund 1989; Carr and Gurney 1993; Fischer and Docherty 1999.

52. Dunlap 1834, 9, 33, 167. For an analysis of Dunlap's *History*, see Lyons 2005.

53. Dodge 1850, 331–36.

54. Tuckerman 1867, vii, ix.

55. Ibid., 16–24, 32–35.

56. See also Dearinger 2000a, 23; Johns 1984, 339.

57. Tuckerman 1867, 36.

58. Johns 1984, 339.

59. Shinn 1876f, 71.

60. Tuckerman 1867, 71–72; Dunlap 1834, 1:103.

61. Dunlap 1834, vol. 3; Tuckerman 1867, 112.

62. Tuckerman 1867, 137; Dunlap 1834, 2:152.

63. Shinn 1876e, 7; *AABN* 1876g, 270; *PEB* 1876j, 1; Shinn 1876f, 72; Carter 1876a, 724; Weir 1880, 25.

64. Malraux 1952–54.

65. Shinn 1876e, 7.

66. Shinn 1876f, 72.

67. Cook 1876e, 1.

68. Cook 1876c, 8; 1876d, 2; 1876e, 1; 1876f, 1; 1876g, 2.

69. Shinn 1878, 1879–80.

70. Shinn 1875c.

71. Shinn 1878, 1881a, 1881b, 1882.

Chapter 5

1. Appleton's play was not the only one inspired by the occasion of the centennial. In 1875, M. Theodore Michaelis offered a series of prizes to French playwrights for dramas on the subject of American independence and France's role in the Revolutionary War. Unfortunately, an international jury of writers and critics was not able to find one play among the sixty-nine submitted that was worthy of a prize. See *PEB* 1876a, 1.

2. Appleton 1877, 7, 9.

3. Nathan Appleton Papers Finding Aid, Library of Congress, http://hdl.loc.gov/loc.mss/eadmss.ms010048.

4. Appleton 1877, 12.

5. Becker 1982, 93.

6. Goldstein 2000, 47–57.

7. Sellin 1975, 38.

8. *NYT* 1875e, 3. See also Quilibet 1876a, 271.

9. Dulles 1964, 102.

10. Twain 1869, 12.

11. Goldstein 2000, 35–50.

12. Zalewski 2009, 61, 65.

13. Jarves 1876, 5.

14. Sartain 1880, 134, 160.

15. *Art Journal* 1876d, 161; Weir 1880, 3. Much of the rhetoric surrounding the American art display was based on the expectation that the nation's art would come under the eyes of Europeans. However, attendance at the exhibition was overwhelmingly American. One writer reported seeing few foreign faces after "the curious strangers of May and June" in the opening weeks of the exhibition and expressed disappointment at the low foreign attendance (Coan 1876, 761).

16. *Art Journal* 1876e, 218.

17. "Address to the Artists of the United States," 1875, box 2, folder 3, Centennial Exhibition Miscellaneous Papers.

18. Maass 1973, 94.

19. *NY Times* 1875a, 6.

20. Verdier 1994, 64; "Centennial Notes" 1876, 157; Simonin 1877b, 440; De Marchi and Goodwin 1999, 210–13.

21. De Marchi and Goodwin 1999, 210. After the centennial year, the tariff on art fluctuated, then differentiated between older and newer works, and was finally eliminated altogether in 1913. Ibid., 223–30.

22. Some artists strenuously objected. See Orcutt 2002.

23. Giberti 2002, 173.

24. Robey 2000b, 205, 289–91.

25. Cummings 1865, 238.

26. JS to William E. Marshall, December 12, 1875, reel 4562, frame 1289; JS to Oscar Marshall, March 3, 1876, reel 4563, frame 104; JS to L. Prang and Co., March 10, 1876, reel 4563, frame 144, all Sartain Papers.

27. *NY Herald* 1873, 3; "Suspension" 1873, 1; Stillman 1873, 7; "Vienna" 1875, 11, 20–21.

28. Howells 1876, 98.

29. Ibid.

30. *NY Times* 1876u, 8; Robey 2000a, 89; *NYT* 1876i, 2; Donaldson 1948, 55.

31. JS to Messrs. Weiner and Co., August 31, 1876, reel 4563, frame 298; JS to A. T. Goshorn, September 27, 1876, reel 4563, frame 348; JS to William E. Marshall, December 21, 1875, reel 4562, frame 1289; JS to Signor Giuseppe Dass, July 22, 1876, reel 4563, frame 224; JS to Committee on Concessions, August 17, 1876, reel 4563, frame 271, all Sartain Papers.

32. JS to R. W. Moore, November 3, 1875, reel 4562, frame 1173; JS to Hon. George P. Marsh, January 25, 1876, reel 4563, frame 57; JS to J. S. Dumaresq, December 22, 1875, reel 4562, frames 1295–96, all Sartain Papers.

33. JS to James Smillie, August 5, 1876, reel 4563, frame 250; JS to Mrs. J. Francis Fisher, August 15, 1876, reel 4563, frame 265, both Sartain Papers.

34. J. V. P. Turner, Secretary of Art Department, to Thomas Cochran, October 20, 1876, reel 4563, frame 379, Sartain Papers.

35. JS to John Carbutt, February 24, 1876, reel 4563, frame 90; JS to George A. Leavitt and Co., July 31, 1876, reel 4563, frame 241, both Sartain Papers. It is not clear how many works were sold, since the records are spotty at best. Sartain reported that more works had been sold than was expected, and many of them were American. See *NYT* 1876n, 2.

36. *Art Journal* 1875, 383.

37. "Jervis McEntee's Diary" 1991, 16.

38. *AABN* 1876c, 213.

39. Walker 1877a, 508. While most critics expressed bitter disappointment, some realized that other contingencies had affected the European organizers' choices, and they could not be entirely condemned. A commissioner to the 1873 Vienna exhibition warned that lenders to that display might not be able to spare their masterpieces for a long absence again so soon for another world's fair, and Sartain cited the grave risk of sending the most valued works of art across the ocean, in light of recent disasters at sea. See USCVE 1875, 12.

40. Shinn 1876d, 409.
41. Howells 1876, 95; *NY Times* 1876n, 1.
42. *NYT Guide* 1876, 60; Auer 2011; Shinn 1876d, 408–9; *Scribner's Monthly* 1876c, 123–24; Carter 1876b, 285; *NYT* 1876j, 2.
43. Bruce 1877, 191.
44. Appleton 1877, 17.
45. Jarves 1870a, 191.
46. Walker 1877a, 506–7; *AABN* 1876d, 221; Howells 1876, 94; National Academy of Design Minutes (1825–2012), subseries 1: Official Council Minutes, October 9 and October 16, 1876, National Academy of Design (hereafter NAD) Archives.
47. Cook 1876h, 3; Shinn 1876a, 347–48.
48. On Constable: *NYT Guide* 1876, 59, 63; Cook 1876i, 2; Shinn 1876a, 348; Bruce 1877, 177; on Gainsborough: *NYT Guide* 1876, 1; Cook 1876h, 3; Shinn 1876a, 348; Carter 1876a, 725; on Turner: *NYT Guide* 1876, 63; Cook 1876i, 2; Shinn 1876a, 348; *NY Herald* 1876c, 6; on Reynolds: Cook 1876h, 3; *NYT Guide* 1876, 59; Shinn 1876a, 348; *NYEM* 1876d, 1; F. D. M. 1876, 4; on Alma-Tadema: Cook 1876j, 3; Shinn 1876b, 362; on Leighton: Cook 1876j, 3; Shinn 1876b, 363. The location information for *Summer Moon* and *Eastern Slinger* is from Barringer and Prettejohn 1999, 32 and 147, respectively.
49. F. D. M. 1876, 4; *Press* 1876c, 1; *NY Times* 1876k, 1; Bruce 1877, 177.
50. Cook 1876i, 2; Shinn 1876b, 363; *NY Herald* 1876c, 6; *Press* 1876c, 1; *NY Times* 1876k, 1; *NYEM* 1876d, 1; *Arthur's* 1876b, 565.
51. Wood 2006, 73–83; *NYT Guide* 1876, 64; *Press* 1876c, 1. The painting was sold in the early 1880s to the Englishman Thomas Holloway, who made his fortune in patent medicines. He later gave this painting, along with his entire collection, to the University of London.
52. Howells 1876, 94; *AABN* 1876d, 221; Cook 1876j, 3; *NY Times* 1876k, 1.
53. Bruce 1877, 176. However, Hogarth was not represented in the British display.
54. Shinn 1876a, 348.
55. *NY Herald* 1876c, 6.
56. Appleton 1877, 16.
57. Shinn 1876h, 193; Simonin 1877b, 417; Saintin 1877, 6; Bruce 1877, 188; *Press* 1876b, 3; *NYT Guide* 1876, 60; Walker 1877a, 508; *NYEM* 1876c, 2; *NY Times* 1876i, 1.
58. Fink 1990, 115, 121.
59. Some also included a few lines on their qualifications, such as their teachers or medals they had won. "Beaux-arts, 1876, exposition international, à Philadelphie," Expositions universelles. I am grateful to Hadrien Viraben for his research and his thoughtful insights on these materials.
60. Exposition universelle 1867.
61. On Clement: Shinn 1876i, 225; *NY Herald* 1876c, 6; F. D. M. 1876, 4; *NY Times* 1876j, 1; Bruce 1877, 187; on Dumaresq: *NYT Guide* 1876, 60; Shinn 1876i, 225; Carter 1876b, 285; *National Republican* 1876a, 1; on Priou: *NYT Guide* 1876, 69; Shinn 1876i, 225; *NY Times* 1876j, 1; Bruce 1877, 187; on Carolus-Duran: *Carolus-Duran* 2003, 120; *NYT Guide* 1876, 69; Shinn 1876h, 193; Bruce 1877, 187.
62. *NYT Guide* 1876, 60; Shinn 1876h, 194; *NY Times* 1876i, 1.
63. *Harper's Weekly* 1876b, 838.
64. Walker 1877b, 50.
65. *NYT Guide* 1876, 59.
66. Shinn 1876h, 194; Coan 1876, 766–67; Saintin 1877, 6.
67. Weir 1880, 5; *NY Times* 1876g, 1; *NY Times* 1876i, 1; Saintin 1877, 8.
68. Appleton 1877, 15.
69. Howells 1876, 93; *NY Herald* 1876c, 6; Walker 1877a, 508; *AABN* 1876e, 229.
70. See Gerdts 1999.
71. *AABN* 1876e, 229; *NY Times* 1876m, 4. However, Gar. noticed a "fresh impulse" and increasing internationalism in the form of a few "vigorous heads" and Fortuny-influenced landscapes, which showed an "upspringing of young grass under the old withered and juiceless tufts."
72. *NYT Guide* 1876, 59–60; Shinn 1876j, 268; *NY Times* 1876m, 4; *Arthur's* 1876b, 565.
73. *NYT Guide* 1876, 60; *NY Herald* 1876c, 6.
74. Walker 1877a, 508; Howells 1876, 93–94.
75. *NYT Guide* 1876, 60.
76. In an exception among the foreign countries, the catalog included the owners of the works on display.

77. Walker 1877a, 507; Shinn 1876j, 267–68; *NY Times* 1876g, 1.
78. Bruce 1877, 191; *NYT Guide* 1876, 60.
79. *NYT Guide* 1876, 60; *NY Herald* 1876c, 6.
80. Bruce 1877, 190; Weir 1880, 20; *NY Times* 1876g, 1; Norton 1974, 189; McCabe 1876, 601.
81. Boone 2007, 1.
82. *Scribner's Monthly* 1876c, 122.
83. Shinn 1876j, 268. The attribution to Velázquez was probably changed at a later date, since there are no portraits currently credited to him that are connected with the 1876 owner of the painting, listed in the catalog as Countess Antonia du Mazuel.
84. *NY Times* 1876h, 4; Shinn 1876j, 268; Norton 1974, 189; Weir 1880, 20.
85. Appleton 1877, 18.
86. *NY Times* 18760, 5; *NYT* 1876c, 2. See also *NYT Guide* 1876, 61; *NYEM* 1876d, 1. The much smaller group of 125 Italian paintings was barely noted in contemporary periodicals.
87. Sicca and Yarrington 2000, 8–13.
88. Shinn 1876g, 104; *NYEM* 1876d, 1; Gerdts 1974, 103; Jarves 1870a, 261, 144. The nude in art had become increasingly accepted in the United States during the nineteenth century, particularly in sculpture, but it remained an unusual subject in the late century.
89. Pasquale Romanelli, Emilio Zocchi, and Pietro Bazzanti.
90. Dale 1876, 171–72.
91. "The Exhibition" 1876, 1.
92. *NY Times* 18760, 5.
93. *Popular History* 1878, xliii; *NYEM* 1876d, 2; Miller 1876, 1; JS to Signor Giuseppe Dass, July 22, 1876, reel 4563, frame 224, Sartain Papers. The success of the venture can be judged by the images of Italian sculptures by the Centennial Photographic Company that are ubiquitous in collections of Centennial Exhibition ephemera.
94. *Harper's Weekly* 1876c, 870. In an example of critical dismay, a writer for the *Boston Daily Advertiser* admitted to being discouraged by public enthusiasm for these "imbecile expressions of false and venal sentiment" (F. D. M. 1876, 4).
95. Ingram 1876, 526.
96. Jarves 1876, 5.
97. Round 1876, 12.
98. *NY Times* 18760, 5.
99. USCC 1876, 244–49.
100. *Atlantic Monthly* 1876b, 89–90.
101. *NYT* 1876g, 3.
102. See Hosley 1990, 32–42; *Japan Goes to the World's Fairs* 2005.
103. Meech and Weisberg 1990, 15–18.
104. *NYT* 1876n, 2.
105. "Relevé des objets d'art qui ont été vendus à l'exposition de Philadelphie," *Expositions universelles.*
106. *NYT* 1876a; 1876n, 2.
107. *AABN* 1876f, 261.
108. Archer 1877, 8.
109. "Be happy, my children, be happy" (Appleton 1877, 65).
110. Carter 1876a, 725.

Chapter 6

1. Hobbs 1976.
2. Vidal 1976, 30, 34–35.
3. Ibid., 69, 80.
4. *Scribner's Monthly* 1876b, 430.
5. Whitman 1871, 12. Many thanks to John Davis for pointing out this quotation.
6. Hon. Thomas G. Alvord, "The Nation's Jubilee," Syracuse, New York, and Rev. Jeremiah Taylor, "Our Republic," Providence, Rhode Island, both quoted in Saunders 1877, 405, 474.
7. Lowenthal 1985, 225–27.
8. Vidal 1976, 208.
9. Ibid., 224–25. Contemporary accounts of opening day conflict. One writer reported that the president was greeted with prolonged applause and enthusiastic acclaim (*PEB* 1876b, 2). Another observed, to the contrary, "a few scattering cheers made more apparent the silent indifference with which he was received" (*Atlantic Monthly* 1876b, 89).
10. Lossing 1884, 842.
11. Fyfe 2000, 169.

12. The National Academy of Design also noted that the exhibition commemorated the fiftieth anniversary of its first exhibition in 1826 (Clark 1954, 89).

13. Hicks 1972, 31.

14. *NY Times* 1874a, 3.

15. Hicks 1972, 114.

16. *NYT* 1876f, 1.

17. Even the name of the New York exhibition was similar to the Centennial Exhibition's Loan Collection, and it was likely intended to draw comparisons between the two displays.

18. Sartain 1880, 152–53.

19. JS to John Taylor Johnston, November 20, 1875, reel 4562, frame 1227, Sartain Papers.

20. Jarves 1870b, 540.

21. *NY Times* 1875d, 6.

22. *Appleton's* 1876a, 215. See also *Art Journal* 1876f, 256; *Evening Post* 1876b, 2.

23. *NYT* 1876a, 4.

24. Samuel Willard Crompton, "John Taylor Johnston," in Garraty and Carnes 1999, 155.

25. Baetjer 2004. Blodgett died in 1875, but would no doubt have been deeply involved in the New York Centennial Loan Exhibition. He built his fortune in varnish manufacturing and real estate and formed an enviable collection of contemporary American and European works that included Frederic E. Church's *Heart of the Andes* (Metropolitan Museum of Art). See *NY Times* 1875c; Tyng 1875, 61–65.

26. New York Centennial Loan Exhibition (hereafter NYCL) 1876c, 4; *Art Journal* 1877, 32. See the appendix for a full list of committee members.

27. See Foshay 1990.

28. Beaufort 1982, 51; Baetjer 2004.

29. See Gallati 2013 for a thorough study of this phenomenon and numerous other examples.

30. Whittredge 1942, 44.

31. Robey 2000b, 71.

32. See Wallach 1998, 25; Harris 1962, 565.

33. Whitehill 1970, 27, 30.

34. *Aldine* 1876a, 241.

35. Zalewski 2009, 64–65, 168.

36. Metropolitan Museum of Art 1902 includes the 1881 report. The importance of the loan collection began to decline in the 1880s: in 1882 it was reported that the museum had to curtail loans due to the increasing number of gifts, and in 1883 the concern was raised that without more space the institution would have to abandon loan exhibitions altogether.

37. Duncan 1994, 60, 63.

38. See the appendix for a full list.

39. *NYT* 1876h, 3.

40. *Evening Post* 1876k, 2.

41. *NY Times* 1876c, 8.

42. NYCL 1876a, 6.

43. *NYT* 1876h, 3.

44. Vidal 1976, 59–60.

45. *Evening Post* 1876c, 4; 1876d, 4.

46. *Evening Post* 1876e, 4; NYCL 1876a, 4, 8; Randel 1927, 384; *NYT* 1876h, 3.

47. *NY Times* 1876y, 8; *Evening Post* 1876h, 3.

48. *Evening Post* 1876d, 4.

49. Ackerman 1986, 94, 232.

50. *Evening Post* 1876c, 4; *NY Times* 1876s, 4.

51. *Evening Post* 1876e, 4.

52. Bartoli 2010, 60.

53. *Evening Post* 1876e, 4.

54. NYCL 1876c, 1876b, 1876d.

55. *Newark Daily Advertiser* (hereafter *NDA*) 1876c, 1.

56. *NDA* 1876c, 1.

57. Thorpe, 1876, 1. I appreciate David Dearinger's generosity in sharing this citation.

58. Cash 2011, 112–15.

59. *NYT* 1876h, 3.

60. *NYEM* 1876b, 1; *Atlantic Monthly* 1876a, 760.

61. *NYEM* 1876a, 1; Cook 1876a, 7.

62. *Atlantic Monthly* 1876a, 758.

63. *NYEM* 1876a, 1; *Art Journal* 1876c, 158.

64. Vidal 1976, 14, 94, 283. However, I am not aware of any evidence that Bryant was actually corrupt.

65. See Metropolitan Museum of Art 1889.

66. *NY Times* 1876y, 8; *Evening Post* 1876d, 4; *NDA* 1876b, 1; *Evening Post* 1876g, 2; *NDA* 1876c, 1; NYCL 1876a, 7–8; *NY Times* 1876t, 7.

67. *NDA* 1876d, 1. D. H. McAlpine, the 1876 owner of the Bouguereau, is not listed in the provenance for the Dali Museum painting. However, it is the only known work by that title that Bouguereau had painted by 1876. See Bartoli 2010, 162.
68. *Evening Post* 1876c, 4; *NDA* 1876c, 1; *NY Times* 1876t, 7.
69. *NDA* 1876b, 1; *NDA* 1876d, 1; *Evening Post* 1876c, 4.
70. *Aldine* 1876a, 241.
71. *Evening Post* 1876c, 4.
72. Shinn 1876c, 378; 1876i, 225.
73. *NYT* 1876i, 2; Cook 1876j, 3.
74. *AABN* 1876h, 377.
75. *NY Times* 1876t, 7.
76. *NY Times* 1876v, 5.
77. *Art Journal* 1877, 32. The Metropolitan Museum of Art's annual report for the year ending May 1, 1876, recorded total attendance of 66,663.
78. *NY Times* 1876t, 7.
79. *Evening Post* 1876g, 2; see also *Evening Post* 1876h, 3.
80. *Evening Post* 1876g, 2.
81. *Aldine* 1876a, 241.
82. Thorpe 1876, 1. However, like the Centennial Exhibition, the New York exhibition was not open on Sundays, making it difficult for working people to attend. See New York Centennial Loan Exhibition Receipts, NAD Archives; *Evening Post* 1876e, 4; NYCL 1876a, 4.
83. NYCL 1876a, 9.
84. *Evening Post* 1876k, 2. For instance, the Metropolitan, operating on a razor-thin margin, ended its 1875 season with a cash balance of only $79.06. Even with the proceeds of the Loan Exhibition in hand, its balance was only $1,540.68 at the end of the 1876–77 season. See Metropolitan Museum of Art 1902, 62, 95–96.
85. Lossing 1884, 841; Skalet 1980, 224–25; Beaufort 1982, 51–52.
86. See Ditter 1947, 153, 166.
87. *NY Times* 1876s, 4.
88. Young 1864.
89. Shinn 1883–84, vi; see also Shinn 1879–80.
90. The National Academy of Design's collection was built for the most part through its requirement that artists submit a portrait of themselves when they were elected associate members and a typical example of their work when they became full academicians.
91. Zalewski 2009, 173, 188.

Conclusion

1. Martinez 1986, 5. Sartain emerged from retirement to organize an exhibition of American art in London in 1887, collecting works from Philadelphia, Boston, New York, Paris, London, Rome, and Florence.
2. Sartain 1899, 263–67. See also McCabe 1876, 865–86.
3. Sartain 1880, 145.
4. Eco 1983, 292. See also Giberti 2002, 1.
5. Giberti 1994 discusses the importance of classification schemes.
6. Ibid., 150.
7. USCVE 1876, 93, 147, 199.
8. Bruce 1877, 56; Massachusetts Commission 1875, 185.
9. Maass 1973, 37.
10. USCC 1880b, 565–67.
11. *Journal of the Franklin Institute* 1877, 2; Simonin 1877a, 18.
12. Giberti 1994, 153–54. Overall, the jury was composed of 118 foreign judges and 115 American judges, with the largest foreign representations from Great Britain, France, and Germany. See USCC 1880b, 567.
13. Nichols 1876, 227. Sartain asserted that he was not involved with the jurying in any way and that he studiously kept away from the jury and its activities. See JS to Max Mittermaier, August 1, 1876, reel 4563, frame 243; JS to Messrs. Hollenbach and Diffenbach, September 27, 1876, reel 4563, frame 353, both Sartain Papers.
14. Giberti 1994, 153–54.
15. *Evening Post* 1875b, 2.
16. USCC 1880b, 576.
17. Quoted in *Evening Telegraph* 1876b, 1.
18. Smith 1876, 340.
19. Ibid.
20. Nichols 1876, 227.
21. *NY Times* 1876w, 6.
22. USCC 1880b, 576.
23. *Nation* 1876c, 310.

24. Smith 1876, 340.
25. Ibid.
26. USCC 1880b, 570.
27. Giberti 1994, 166.
28. USCC 1880a, 63, 86–103, 715–16.
29. USCC 1880b, 571.
30. Mayer and van Beest were appointed to the original jury, but reportedly did not appear until the last day of the original group's work. See *Evening Telegraph* 1876b, 1.
31. "Brantz Mayer," in Wilson and Fiske 1888, 273–74.
32. Thieme and Becker 1923, 226.
33. Nichols 1876, 227–28; *Daily Evening Transcript* 1876d, 8.
34. Leslie 1868, 41–42.
35. Thurston 1876, 198.
36. *Nation* 1876c, 310; *NYT* 1876L, 1.
37. *NY Herald* 1877, 7; *Evening Post* 1876i, 1; "Jervis McEntee's Diary" 1991, 17; Smith manuscript, reel 2040, frame 82; *Daily Evening Transcript* 1876c, 6; *Aldine* 1876b, 294. *Daily Evening Transcript* 1876d, 8, listed thirteen original awards, but the newspaper mistakenly counted Toby Rosenthal as two people.
38. See the appendix for a full list of American award winners in painting and sculpture.
39. USCC 1880a, 87–92. They were Edward Mitchell Bannister, Albert Bierstadt, J. B. Bristol, Frederic E.Church, F. M. H. De Haas, Sanford Gifford, James Hart, Herman Herzog, David Johnson, Jervis McEntee, Edward Moran, Peter Moran, Thomas Moran, William Trost Richards, and Worthington Whittredge.
40. They were George Henry Boughton, Frederic A. Bridgman, William Merritt Chase, Elizabeth Jane Gardner, R. Swain Gifford, William Morris Hunt, J. B. Irving, Anna M. Lea, H. H. Moore, Toby Rosenthal, Emily Sartain, Walter Shirlaw, Clementina Tompkins, Charles Volkmar, and P. F. Wharton.
41. The landscapists were De Haas, Hart, McEntee, and Whittredge, and the foreign-trained painters were Bridgman, Hunt, Lea (Merritt), and Rosenthal.
42. Fielding 1986, 370.
43. *Daily Evening Transcript* 1876b, 6; Norton 1974, 204.

44. George W. Whitaker, "Reminiscences of Providence Artists," *Providence Magazine: The Board of Trade Journal* (March 1914), 207, quoted in Hartigan 1985, 69–70, which also includes an account of Bannister's life and work.
45. The general report is distinct from Sartain 1880, which is a straightforward account of the Fine Arts Department's procedures and regulations.
46. Nichols in *Nation* 1877, 393–94.
47. *Evening Post* 1877b, 3.
48. Weir's report was published in the *Nation* in volume 3: January 26, 1878, 28–30; February 2, 1878, 40–41; February 23, 1878, 69–70; and March 30, 1878, 111–12.
49. Weir 1880, 608, 610, 616–17, 627.
50. Ibid., 23–24, 635.
51. *Evening Post* 1877b, 3.
52. Weir 1880, 617.
53. *Journal of the Franklin Institute* 1876, 361.
54. *Atlantic Monthly* 1877a, 100.
55. USCC 1880c, 101.
56. *NYT* 1876n, 2.
57. Rothermel's infamous *Battle of Gettysburg* remained in Memorial Hall until 1894, when it was sent to the state capitol at Harrisburg. It is now displayed at the State Museum of Pennsylvania. See Winer 1975, 9.
58. Nicolai 1976, 90.
59. Wallach 1998, 9–10, 22.
60. Pennsylvania Museum 1878, 11.
61. Ibid., 8, 15.
62. Pennsylvania Museum of Art, Accession Records, vol. 1: 1876 and vol. 2: 1877–82. The museum's early history is traced in Hiesinger 2011.
63. Pennsylvania Museum 1878, 11.
64. Nicolai 1976, 90–91.
65. Comfort 1870, 5–6.
66. Coleman 1939, 16–17.
67. Macht 1976, 7–8.
68. Peck 1991, 19–28.
69. Bruce 1877, 235–36.
70. USCC 1880c, 97–98.
71. *NYT* 1876o, 4.
72. *Scribner's Monthly* 1876d, 127. See also Benjamin 1887, 18–19.
73. *NY Times* 1876x, 6.

74. "Present Tendencies" 1879, 483.
75. *Scribner's Monthly* 1880, 1–2.
76. Dorr 1881, 562–63. See also Editor 1877, 451.
77. Conant 1876, 403.
78. Bienenstock 1983, 25, 28.
79. Quoted in ibid., 29.
80. *Evening Post* 1877a, 2.
81. Ayres 1993, 47, 57.
82. Bienenstock 1983, 25–27. Saint-Gaudens's sketch, destroyed in a 1904 studio fire, was described as a "young girl lying on her face on a low couch, dandling an infant in her arms."
83. *Scribner's Monthly* 1880, 1.
84. Cook 1883, 311–12.
85. The most thorough accounts of the Society of American Artists currently available are Bienenstock 1983; Grace 2000.
86. Bienenstock 1983, 30–35, 43, 44.
87. Ibid., 85–86.
88. Ibid., 47, 87, 159, 173, 176.
89. Ibid., 22, 36.
90. Grace 2000, 107–10.
91. *Scribner's Monthly* 1880, 2–7.
92. Clark 1954, 99.
93. Cook 1883, 311–12.
94. Weir 1878, 816, 822, 825.
95. Gaylord 1877, n.p.
96. Becker 1982, 301, 346.
97. Bourdieu 1993, 106.
98. Ricoeur 2004, 449.

BIBLIOGRAPHY

Archives

Henry Kirke Brown Papers, ca. 1834–86. Vol. 8. Yale
 University Library.
Centennial Digital Collection. Prints and Picture
 Department, Free Library of Philadelphia.
Centennial Exhibit 1876 Philadelphia Scrapbook. Free Library
 of Philadelphia.
Centennial Exhibition Miscellaneous Papers, 1873–76.
 Historical Society of Pennsylvania.
James Lawrence Claghorn Papers, 1849–82. Archives of
 American Art, Smithsonian Institution.
Expositions universelles, internationales et nationales,
 1844–1921. Archives nationales, Paris.
Fairmount Park Commission Archives, Philadelphia.
National Academy of Design Archives, New York.
Pennsylvania Museum of Art, Accession Records.
 Philadelphia Museum of Art.
Sartain Family Papers (collection no. 1650), Historical
 Society of Pennsylvania. Reel and frame numbers
 from microfilm at the Archives of American Art,
 Smithsonian Institution.
Earl Shinn Letters and Diary, 1852–89. From the collection
 at Swarthmore College. Archives of American Art,
 Smithsonian Institution.
James D. Smillie Diary. Smillie Family Papers, 1825–1957.
 Archives of American Art, Smithsonian
 Institution.
Xanthus Smith, untitled manuscript on the Centennial
 Exhibition. Mary, Russell, and Xanthus Smith
 Family Papers, 1793–1977. Archives of American
 Art, Smithsonian Institution.

U.S. Centennial Commission Correspondence and Papers.
 Philadelphia City Archives.

Primary Sources

Aldine. 1873. "Critics." 6 (January): 15.
———. 1876a. "The Loan Exhibition." 8 (August): 241.
———. 1876b. "An Opinion." 8 (September): 293–94.
———. 1878. "Preface." 9: n.p.
American Architect and Building News. 1876a. "Artistic
 Criticism." 1 (April 22): 130.
———. 1876b. Untitled article. 1 (May 27): 169.
———. 1876c. "The Fine Arts at the Centennial I." 1
 (July 1): 213–14.
———. 1876d. "The Fine Arts at the Centennial II." 1
 (July 8): 221.
———. 1876e. "The Fine Arts at the Centennial III. The
 German Pictures." 1 (July 15): 229.
———. 1876f. "The Fine Arts at the Centennial VII." 1
 (August 12): 261–62.
———. 1876g. "The Fine Arts at the Centennial VIII." 1
 (August 19): 269–70.
———. 1876h. Untitled article. 1 (November 18): 377.
"American Art and the Centennial." 1875. *New York
 Commercial Advertiser*, July 28, 2.
"American Art at the Centennial." 1876. *New York World*, July
 24, 2.
Anderson, Thomas M. 1876. "Have We a National
 Character?" *Galaxy* 21 (June): 733–37.
Angell, Henry C. 1881. *Records of William M. Hunt*. Boston:
 James R. Osgood.
Appleton, Nathan. 1877. *The Centennial Movement*. Boston:
 Lockwood, Brooks.
Appleton's Journal. 1876a. "Editor's Table." 15 (February 12):
 213–15.
———. 1876b. "Editor's Table." 15 (April 15): 503–4.
Archer, T. C. 1877. "On the Probable Influence Which the
 Centennial Exhibition Will Have on the Progress
 of Art in America." *Art Journal* (London) 16
 (January): 7–8.
"Art and What It May Teach." 1876. *Centennial Eagle* 1.2
 (July 11): 28–29.
Arthur's Illustrated Home Magazine. 1876a. "Centennial
 Notes." 44 (February): 121.
———. 1876b. "The Great Centennial Exhibition: The
 Art Exhibition" (by E. B. D.). 44 (September):
 563–66.

Art Journal (New York). 1875. "In the Studios: The Centennial Exhibition." 1:383.

———. 1876a. "Centennial Fine-Arts Gallery." 1:86.

———. 1876b. "Notes: From Rome." 2:127–28.

———. 1876c. "The National Academy of Design: First Notice." 2:157–59.

———. 1876d. "The Centennial Exhibition." 2:161–68.

———. 1876e. "Paintings at the Centennial Exhibition: The English Pictures." 2:218–20.

———. 1876f. "Notes: The Centennial Loan Exhibition, New York." 2:256.

———. 1876g. "Paintings at the Centennial Exhibition." 2:283–85.

———. 1877. "Notes: The New York Centennial Loan Exhibition." 3:32.

"Art Matters: The American Society of Painters in Water Colors." 1876. *Evening Telegram* (New York), February 3, 3.

Atlantic Monthly. 1876a. "Art." 37 (June): 760.

———. 1876b. "Characteristics of the International Fair." 38 (July): 85–91.

———. 1876c. "Characteristics of the International Fair: II." 38 (August): 233–39.

———. 1876d. "Characteristics of the International Fair: V." 38 (December): 732–40.

———. 1877a. "Characteristics of the International Fair: Closing Days." 39 (January): 94–100.

———. 1877b. "The Contributor's Club." 39 (May): 617–18.

Bailey, David. 1877. *"Eastward Ho!" or, Leaves from the Diary of a Centennial Pilgrim*. Highland, Ohio: David Bailey.

Baird, John. 1889. *Model of the Centennial Exhibition of 1876*. N.p.: n.p.

Bellows, Henry W. 1876. "The Century Gone and the Century to Come in Our National Life." *Unitarian Review and Religious Magazine* 6.1 (July 1): 40–55.

Benjamin, S. G. W. 1879. "Art-Criticism." *Art Journal* 5:29–31.

———. 1887. "American Art Since the Centennial." *Princeton Review* 4 (July): 14–30.

Bricktop [George C. Small]. 1876. *Going to the Centennial and a Guy to the Great Exhibition*. New York: Collin and Small.

Briggs, Charles F. 1876. "Centennial Paintings: The American Department." *Independent*, July 13, 4–5.

Bruce, Edward C. 1877. *The Century: Its Fruits and Its Festival: Being a History and Description of the Centennial Exhibition, with a Preliminary Outline of Modern Progress*. Philadelphia: Lippincott.

Burley, Sylvester W. 1876. *American Enterprise: Burley's United States Centennial Gazetteer and Guide, 1876*. Philadelphia: S. W. Burley.

[Carter, Susan Nichols]. 1876a. "Art at the Exhibition." *Appleton's Journal* 15 (June 3): 724–26.

———. 1876b. "Paintings at the Centennial Exhibition." *Art Journal* 2:283–85.

"Centennial Art: Glimpses at the Philadelphia Art Collections." 1876. *Boston Globe*, May 16, 5.

"Centennial Notes." 1876. *American Builder*, July 1, 157.

Coan, Titus Munson. 1876. "People and Pictures at the Fair." *Galaxy* 22 (December): 761–69.

Cohen, David Solis. 1876. *One Hundred Years a Republic: Our Show*. Philadelphia: Claxton, Remsen and Haffelfinger.

Comfort, George Fisk. 1870. *Art Museums in America*. Boston: H. O. Houghton.

Conant, S. S. 1876. "Progress of the Fine Arts." In his *The First Century of the Republic: A Review of American Progress*. New York: Harper.

Cook, Clarence. 1875. "Fine Arts: The National Academy of Design." *New-York Tribune*, April 29, 7.

——— [C. C.]. 1876a. "Fine Arts." *New-York Tribune*, April 1, 7.

———. 1876b. "A Centennial Blunder." *New-York Tribune*, May 4, 2.

——— [anonymous but attributed]. 1876c. "The Fine Art Department: American Pictures: First Notice." *New-York Tribune*, June 1, 8.

——— [C. C.]. 1876d. "The Fine Art Department: American Pictures: Second Notice." *New-York Tribune*, June 3, 2.

——— [C. C.]. 1876e. "The Fine Art Department: American Pictures: Third Notice." *New-York Tribune*, June 7, 1.

——— [C. C.]. 1876f. "The Fine Art Department: American Pictures: Fourth Notice." *New-York Tribune*, June 9, 1.

——— [C. C.]. 1876g. "The Fine Art Department: American Pictures: Fifth Notice." *New-York Tribune*, June 17, 2.

———. 1876h. "Features of the Fair: Department of Fine Arts, Great Britain." *New-York Tribune*, October 21, 3.

———. 1876i. "British Pictures: Modern Painters." *New-York Tribune*, October 28, 2.

———. 1876j. "Art at the Exhibition: Modern British Pictures." *New-York Tribune*, November 7, 3.

———. 1883. "Art in America in 1883." *Princeton Review* 59 (May): 311–20.

Cranch, C. P. 1867. "Art-Criticism Reviewed." *Galaxy*, May 1, 77.

Cummings, Thomas Seir. 1865. *Historic Annals of the National Academy of Design.* Philadelphia: G. W. Childs; rpt., New York: Kennedy Galleries, 1969.

Daily Evening Transcript (Boston). 1875a. "Art and Artists." August 31, 6.

———. 1875b. "Art and Artists." December 14, 6.

———. 1876a. "Paris Echoes." March 2, 6.

———. 1876b. "Art and Artists." April 4, 6.

———. 1876c. "Centennial Echoes" (by A. P.). September 29, 6.

———. 1876d. "Art at the Centennial Exhibition." October 14, 8.

Dale, John Thomas. 1876. *What Ben Beverly Saw at the Great Exposition.* Chicago: Centennial Publishing.

Dodge, Pickering. 1850. *Sculpture and the Plastic Art.* Boston: John P. Jewett.

Dorr, Dalton. 1881. "Art Museums and Their Uses." *Penn Monthly* 12 (August): 561–73.

Dunlap, William. 1834. *History of the Rise and Progress of the Arts of Design in the United States.* New York: George P. Scott; rpt., New York: Dover, 1969.

The Editor. 1877. "The Progress of Painting in America." *North American Review* 124 (May): 451–64.

Evening Post (New York). 1875a. "American Paintings at the Centennial Exhibition." August 26, 24.

———. 1875b. "American Art at the Centennial Exhibition." September 24, 2.

———. 1876a. "Fine Arts." January 17, 1.

———. 1876b. "Fine Arts." March 15, 1.

———. 1876c. "The National Academy of Design: The New York Centennial Loan Exhibition." June 19, 4.

———. 1876d. "Metropolitan Museum of Art: The New York Centennial Loan Exhibition." June 20, 4.

———. 1876e. "The Belmont Gallery." June 21, 4.

———. 1876f. "Another English View of American Art." August 30, 2.

———. 1876g. Verb. Sat. Sap. "The Centennial Loan Exhibition." September 11, 2.

———. 1876h. "The Centennial Loan Exhibition." October 17, 3.

———. 1876i. American Artist. "The Centennial Exhibition: An American Artist on the Art Awards." October 20, 1.

———. 1876j. "The Centennial Art Exhibition." November 4, 3.

———. 1876k. "The Success of the Loan Exhibition." November 25, 2.

———. 1877a. "The Mistake of the Academicians." April 23, 2.

———. 1877b. "American Artists." November 30, 3.

Evening Telegraph (Philadelphia). 1876a. "The Art Department: Forty-Sixth Notice: American Sculpture." October 12, 8.

———. 1876b. "Centennial Awards. The Art Department List." October 20, 1.

"The Exhibition. A Ghost of Leutze's Washington—How the Memory of the Father of His Country Is Treated—Classic American Paintings." 1876. *New York Commercial Advertiser*, August 24, 1.

Exposition des Beaux-Arts de 1855: Liste par ordre alphabétique des artistes étrangers et francais dont les ouvrages sont exposés au Palais des Beaux-Arts. 1855. Paris: Vinchon.

Exposition universelle de 1867 à Paris. 1867. *Complete Official Catalogue, English version.* London: J. M. Johnson and Sons.

F. D. M. 1876. "The Exhibition: Appearance of the Display in Memorial Hall." *Boston Daily Advertiser*, May 24, 4.

Ferris, George T. 1877. *Gems of the Centennial Exhibition.* New York: Appleton.

"Fine Arts." 1876. *Independent*, May 18, 5.

Fletcher, Robert Schenck. 1876. *The Centennial Exhibition of 1876: What We Saw and How We Saw It*, pt. 1: *Art Glances.* Philadelphia: S. T. Souder.

Gaylord, Will. 1877. *The Centennial Is Over.* Cleveland, Ohio: A. J. Peck.

Hand-Book to the Centennial Grounds and Fairmount Park: Where to Go and What to See. 1876. Philadelphia: John E. Potter.

Harper's Weekly. 1876a. "Home and Foreign Gossip." July 15, 579.

———. 1876b. "Home and Foreign Gossip." October 14, 838.

———. 1876c. "The Centennial." October 28, 870.

Hartley, Cecil B. 1873. *Gentlemen's Book of Etiquette.* Boston: De Wolfe, Fiske.

Holley, Marietta. 1877. *Josiah Allen's Wife as a P.A. and P.I.: Samantha at the Centennial.* Hartford, Conn.: American Publishing.

Howells, William Dean. 1876. "A Sennight of the Centennial." *Atlantic Monthly* 38 (July): 92–107.

Ingram, J. S. 1876. *The Centennial Exposition.* Philadelphia: Hubbard.

The International Exhibition Guide for the Southern States. 1876. Raleigh, N.C.: R. T. Fulghum.

Jarves, James Jackson. 1870a. *Art Thoughts: The Experiences and Observations of an American Amateur in Europe.* New York: Hurd and Hudson.

———. 1870b. "Pictures in the Private Galleries of New York: Part I." *Putnam's Magazine* 5.29 (May): 534–40.

———. 1876. "Italian Art-Frauds vs. American Art-Imposture." *Independent,* June 8, 5.

Journal of the Franklin Institute. 1875. "Centennial Exhibition" (by K.). 70 (July): 16–19.

———. 1876. "The United States International Exhibition of 1876." 102 (December): 361–64.

———. 1877. "Motive Power of the International Exhibition." 103 (January): 1–7.

Leslie, Frank. 1868. *Report on the Fine Arts.* Washington, D.C.: U.S. Government Printing Office.

Lester, C. Edwards. 1846. *The Artists of America: A Series of Biographical Sketches of American Artists.* New York: Baker and Scribner.

"Life at the Exhibition." 1876. *Daily Graphic* (New York), May 13, 613.

Lossing, Benson John. 1876. *The American Centenary.* Philadelphia: Porter.

———. 1884. *History of New York City,* vol. 1. New York: Perine Engraving and Publishing.

Massachusetts Commission to the Vienna Exposition. 1875. *Reports of the Massachusetts Commissioners to the Exposition at Vienna, 1873.* Boston: Wright and Potter.

McCabe, James D. 1876. *The Illustrated History of the Centennial Exhibition.* Philadelphia: National Publishing.

McKeever, Harriet B. 1876. *Young America at the Centennial.* Philadelphia: Porter and Coates.

Metropolitan Museum of Art. 1889. *Catalogue of the Loan Exhibition at the Metropolitan Museum of Art,* vols. 1873–89. Thomas J. Watson Library, Metropolitan Museum of Art.

———. 1902. *The Metropolitan Museum of Art Annual Reports of the Trustees of the Organization, from 1871 to 1902.* New York: Metropolitan Museum of Art.

Miller, Joaquin. 1876. "The Great Centennial Fair and Its Future." *Independent,* July 13, 1.

Nation. 1865. "A Word About Museums." 1 (July 27): 113–14.

———. 1876a. "The Progress of the Exhibition." 22 (March 16): 174–75.

———. 1876b. "The Exhibition." 22 (May 18): 318–20.

———. 1876c. "The Awards at the Centennial Exhibition." 23 (November 23): 310.

———. 1877. "'Correspondence: The Fine Arts Group at the Centennial Exhibition,' letter from Geo. Ward Nichols, Cincinnati, December 17, 1877, and Francis A. Walker, New Haven, December 24, 1877." 25 (December 27): 393–94.

National Academy of Design. 1876. *Catalogue of the Fifty-First Exhibition of the National Academy of Design.* New York: E. Wells Sackett.

National Republican. 1876a. "An Hour's Sojourn in the Gallery of Art" (by Ruhamah). June 13, 1.

———. 1876b. "Art at the Centennial" (by Ruhamah). June 15, 1.

Newark Daily Advertiser. 1876a. "The Art Exhibition." July 13, 1.

———. 1876b. "Fine Art. The Great Double Exhibition of Paintings in New York" (by A. I. G.). July 29, 1.

———. 1876c. "Fine Arts: Pictures of the 'Centennial Loan' at the National Academy of Design" (by A. I. G.). August 7, 1.

———. 1876d. "Centennial Loan Exhibition." September 19, 1.

———. 1876e. "The Centennial Loan Collection." November 25, 2.

New York Centennial Loan Exhibition. 1876a. *Report of the Committee of Management.* Thomas J. Watson Library, Metropolitan Museum of Art.

———. 1876b. *Catalogue of the New York Centennial Loan Exhibition of Paintings, Selected from Private Art Galleries.* Thomas J. Watson Library, Metropolitan Museum of Art.

———. 1876c. *New York Centennial Loan Exhibition.* New York: Metropolitan Museum of Art.

———. 1876d. *New York Centennial Loan Exhibition, 1876: The Belmont Gallery.* Thomas J. Watson Library, Metropolitan Museum of Art.

*New York Evening Mail.*1876a. "Fine Arts: The Fifty-First Academy Exhibition." March 30, 1.

———. 1876b. "Fine Arts: Academy Exhibition Notes." April 18, 1.

———.1876c. "Fine Arts at the Centennial." May 18, 2.

———. 1876d. "Fine Arts at the Centennial" (by E. A. C.). August 10, 1–2.

*New York Herald.*1873. "The Vienna Exhibition." August 4, 3.

———.1875. "Art at the Centennial." October 23, 5.

———.1876a. "Fine Arts." February 21, 10.

———.1876b. "American Artists in London." April 10, 5.

———.1876c. "The World's Display of Art." May 11, 6–7.

———. 1876d. "Vandalism at the Exhibition." May 20, 7.

———. 1876e. "The Exhibition." May 29, 11.

———. 1876f. "Condition of the Art Department at the Centennial." June 5, 8.

———. 1876g. "The Changes Made in the Art Department of the Exhibition During the Past Week." June 19, 9.

———. 1877. "After the Centennial." February 20, 7.

New-York Times. 1874a. "New-York's Centennial Appeal." December 25, 3.

———.1874b. "A Book for the Centennial." December 26, 4.

———. 1875a. "Revising History." May 4, 6.

———. 1875b. "American Interest in the Exposition." June 2, 6.

———. 1875c. "Obituary: William Tilden Blodgett." November 6.

———. 1875d. "American Art." December 12, 6.

———.1876a. "The Fine Arts: Some New and Striking Pictures." January 2, 10.

———. 1876b. "Art and the Centennial." February 5, 5.

———. 1876c. "The New-York Centennial Board." March 16, 8.

———. 1876d. "Something About Memorial Hall" (by Gar.). May 7, 2.

———. 1876e. "The Exhibition Declared Open." May 11, 1.

———. 1876f. "The Nation's Centennial." May 12, 1.

———. 1876g. "Views at the Centennial: The Fine Arts of Spain" (by Gar.). May 15, 1.

———. 1876h. "The Great Exhibition: Other Spanish Pictures." May 19, 4.

———. 1876i. "The Great Exhibition: The French Department." May 21, 1.

———. 1876j. "The Great Exhibition: More About the French Pictures." May 22, 1.

———. 1876k. "The English Art Display: Chief Features of the Pictures." May 25, 1.

———. 1876L. "The Centennial Problem." May 26, 4.

———. 1876m. "The German Paintings" (by Gar.). May 26, 4.

———. 1876n. "Austria's Art Gallery: Signs of Italian Inspiration." May 28, 1.

———. 1876o. "The Great Exhibition. Italian and Scandinavian Art." June 3, 5.

———. 1876p. "The Art of America." June 9, 1.

———. 1876q. "The Art of America." June 11, 1–2.

———. 1876r. "The Art of America." June 13, 1–2.

———. 1876s. "The Loan Collection." June 23, 4.

———. 1876t. "The Fine Arts: The Loan Collection." June 25, 7.

———. 1876u. "An Exhibition Swindle" (by Art.). June 25, 8.

———. 1876v. "The Fine Arts: The Loan Collection" (by Gar.). July 2, 5.

———. 1876w. "The Medal Muddle." September 30, 6.

———. 1876x. "Painters and Buyers." September 30, 6.

———. 1876y. "The Centennial Loan Exhibition." October 27, 8.

———. 1891. "Victory Is Won at Last." May 19, 1.

New-York Tribune. 1867. "Our Artists at the Paris Exposition." January 23, 2.

———. 1873a. "American Art at Vienna." March 4, 4.

———. 1873b. "The Universal Exhibition." June 10, 1.

———. 1875a. "Centennial Monuments." April 30, 2.

———.1875b. "The Centennial Exhibition." August 26, 2.

———. 1875c. "American Art at the Centennial." September 6, 4.

———. 1875d. "Art at the Centennial" (by An American Artist). September 16, 5.

———. 1875e. "The Great Exhibition: Department of Art." November 22, 3.

———. 1876a. "A Suggestion for the Centennial Summer." March 2, 4.

———. 1876b. "Boston Artists at the Centennial." March 20, 8.

———. 1876c. "Department of Fine Arts." May 10, 2.

———. 1876d. "International Exhibitions." May 10, 6.

———. 1876e. "The Centennial Fair: Novelties Added Daily." May 17, 1.

———. 1876f. "The American System of Award." May 26, 1.

———. 1876g. "Art at the Exhibition: The Japanese Section." May 27, 3.

———. 1876h. "Art Treasures at Home." June 17, 3.

———. 1876i. "Art Notes." August 19, 2.

———. 1876j. "Art Notes." September 2, 2.

———. 1876k. "Centennial Exhibition: Its Value to America." September 30, 1.

———. 1876L. "Botching the Awards" (by E. V. S.). October 27, 1.

———. 1876m. "The American Department Debased." November 4, 4.

———. 1876n. "The Great Fair Closed." November 11, 1–2.

———. 1876o. "The Past Exhibition." November 16, 4.

New-York Tribune Guide to the Exhibition. 1876. New York: New-York Tribune.

[Nichols, George Ward]. 1876. "Correspondence: The Centennial Painting Awards." *Nation* 23 (October 12): 227–28.

Norton, Frank H., ed. 1974. *Frank Leslie's Illustrated Historical Register of the Centennial Exposition 1876*. New York: Paddington.

Parkman, Francis. 1865. *France and England in North America*, vol. 1. Boston: Little, Brown; rpt., New York: Viking, 1983.

Paul, Howard. 1875. *The Great Centennial: A New View of the Matter*. Philadelphia: Lee and Walker.

Pennsylvania Academy of the Fine Arts. 1876. *Catalogue of the Forty-Seventh Annual Exhibition of the Pennsylvania Academy of the Fine Arts, 1876*. Philadelphia: Collins.

Pennsylvania Museum. 1878. *First and Second Reports of the Board of Trustees of the Pennsylvania Museum and School of Industrial Art, 1876–77*. Philadelphia: Review Printing House.

Philadelphia Evening Bulletin. 1876a. "Centennial Plays." February 11, 1.

———. 1876b. "1776–1876. The Nation's Festival." May 10, 1–3.

———. 1876c. "Art Arrivals." May 13, 2.

———. 1876d. "Our Great Show." May 17, 1–8.

———. 1876e. "The Fine Arts: Department of Sculpture." May 20, 1–2.

———. 1876f. "The Centennial Pawnees." May 20, 4.

———. 1876g. "Medical Department U.S.A." May 30, 5.

———. 1876h. "The Fine Arts: United States Section: Paintings in Oil." June 19, 1.

———. 1876i. "The Fine Arts: United States Section: Paintings in Oil." June 21, 1–2.

———. 1876j. "The Fine Arts: United States Section: Paintings in Oil." June 23, 1.

———. 1876k. "The Fine Arts: United States Section—Paintings in Oil." June 26, 1–2.

———. 1876L. "The Fine Arts: United States Section: Paintings in Oil." June 29, 1–2.

———. 1876m. "The Fine Arts: United States Section: Paintings in Oil." July 10, 1–2.

———. 1876n. "The Centennial Art Show." November 14, 2.

Philadelphia Inquirer. 1875. "American Art at the Centennial." August 31, 4.

———. 1876. "The Great World's Fair: Art and Industry." May 17, 2.

A Popular History of Our Country: One Hundred Years of American Independence. 1878. Springfield, Mass.: Gay Brothers.

"Present Tendencies of American Art." 1879. *Harper's New Monthly Magazine* 43 (March): 481–96.

The Press (Philadelphia). 1876a. "Visitors Inside and Their Comments." May 11, 1.

———. 1876b. "After the Ceremonies." May 11, 3.

———. 1876c. "Memorial Hall Notes: A Walk in the Art Gallery." November 3, 1–2.

Quilibet, Philip. 1875. "Drift-Wood: The Centenary." *Galaxy* 20 (July): 118–21.

———. 1876a. "Drift-Wood: Come Over and Help Us." *Galaxy* 21 (February): 269–72.

———. 1876b. "Drift-Wood." *Galaxy* 21 (May): 696–99.

Round, W[illia]m M. F. 1876. "Art at the Exposition." *Independent*, June 8, 12.

"The Sabbath and the Centennial." 1876. *Christian Union* 13.18 (May 3): 343.

Saintin, Jules-Émile. 1877. *Exposition internationale de Philadelphie en 1876: Section française: Rapport sur les Beaux-Arts*. Paris: Imprimerie Nationale.

Sandhurst, Phillip T. 1876. *The Great Centennial Exhibition*. Philadelphia: P. W. Ziegler.

Sartain, John. 1880. "Report of the Chief of the Bureau of Art." In U.S. Centennial Commission, *International Exhibition, 1876*, vol. 1: *Report of the Director-General, Including the Reports of Bureaus of Administration*, 134–60. Washington, D.C.: U.S. Government Printing Office.

———. 1899. *The Reminiscences of a Very Old Man*. New York: Appleton.

Saunders, Frederick, ed. 1877. *Our National Centennial Jubilee: Orations, Addresses, and Poems Delivered on the Fourth of July, 1876*. New York: E. B. Treat.

Scribner's Monthly. 1876a. "The Centennial." 11 (January): 432.

———. 1876b. "From Humility to Excellence." 12 (July): 430–31.

———. 1876c. "In and About the Fair: Dinners, Plants and Pictures." 13 (November): 115–24.

———. 1876d. "American Art." 13 (November): 126–27.

———. 1880. "The Younger Painters of America." 20 (May): 1–15.

Sears, John. 1876. "Art in Philadelphia." *Aldine* 8 (June): 196.

Shinn, Earl. 1875a. *The New Hyperion: From Paris to Marly by Way of the Rhine.* Philadelphia: Lippincott.

——— [Strahan, Edward]. 1875b. *A Century After: Picturesque Glimpses of Philadelphia and Pennsylvania.* Philadelphia: Allen, Lane and Scott.

——— [Strahan, Edward]. 1875c. *The Masterpieces of the Centennial Exhibition,* vol. 1: *Fine Art.* Philadelphia: Gebbie and Barrie.

——— [E. S.]. 1876a. "The International Exhibition—II. British Paintings." *Nation* 22 (June 1): 347–48.

——— [E. S.]. 1876b. "The International Exhibition—III. British Paintings II." *Nation* 22 (June 8): 362–63.

——— [E. S.]. 1876c. "The International Exhibition—IV. British Paintings: The Realists III." *Nation* 22 (June 15): 378–79.

——— [E. S.]. 1876d. "The International Exhibition—V. Austrian Art." *Nation* 22 (June 29): 408–9.

——— [E. S.]. 1876e. "The International Exhibition—VI. American Art." *Nation* 23 (July 6): 6–7.

——— [E. S.]. 1876f. "The International Exhibition—XI. American Art II." *Nation* 23 (August 3): 71–73.

——— [E. S.]. 1876g. "The International Exhibition—XIII. Italian Sculpture." *Nation* 23 (August 17): 104–5.

——— [E. S.]. 1876h. "The International Exhibition—No. XVI. French Art." *Nation* 23 (September 28): 193–94.

——— [E. S.]. 1876i. "The International Exhibition—No. XVII. French Art II." *Nation* 23 (October 12): 224–26.

———. 1876j. "The International Exhibition—No. XX. Spanish and Other Continental Art." *Nation* 23 (November 2): 267–68.

——— [Strahan, Edward]. 1877. *The Art Gallery of the Exhibition: A Selection from the Paintings and Sculpture Exhibition by Alma-Tadema, Bierstadt, Huntington, Moran, with Introduction and Descriptive Text by Edward Strahan.* Philadelphia: Gebbie.

———. 1878. *The Chefs-d'oeuvre d'art of the International Exhibition, 1878.* Philadelphia: Gebbie and Barrie.

——— [Edward Strahan]. 1879–80. *The Art Treasures of America: Being the Choicest Works of Art in the Public and Private Collections of North America.* Philadelphia: George Barrie.

———. 1881a. *Gérôme: A Collection of the Works of J. L. Gérôme.* New York: Hall.

———. 1881b. *Modern French Art.* New York: Lovering.

———. 1882. *Études in Modern French Art.* New York: R. Worthington.

———. 1883–84. *Mr. Vanderbilt's House and Collection.* Boston: G. Barrie.

Simonin, L. 1877a. *A French View of the Grand International Exposition of 1876.* Philadelphia: Claxton, Remsen and Haffelfinger.

———. 1877b. *Le monde américain.* Paris: Librarie Hachette.

Smith, Frank Hill. 1876. "Correspondence: The Centennial Art Awards." *Nation* 23 (December 7): 340.

Something for the Children; or, Uncle John's Story of His First Visit to the Centennial. 1876. Philadelphia: Campbell Press.

Stillman, W. J. 1873. "The Irregularities in the American Department." *New-York Tribune,* June 14, 1, 7.

"Suspension of Vienna Commissioners." 1873. *Evening Star* (Washington, D.C.), April 26, 1.

[Taylor, Bayard]. 1873. "The Universal Exhibition." *New-York Tribune,* May 28, 1.

Thorpe, T. B. 1876. "The Centennial Loan Exhibition." *Baldwin's Monthly* 13 (November): 1.

Thurston, Robert H., ed. 1876. *Reports of the Commissioners of the United States to the International Exhibition Held at Vienna, 1873.* Washington, D.C.: U.S. Government Printing Office.

Trollope, Frances Milton. 1832. *Domestic Manners of the Americans,* vol. 2. London: Whittaker, Treacher.

Tuckerman, Henry T. 1867. *Book of the Artists.* New York: Putnam.

Twain, Mark. 1869. *The Innocents Abroad.* Hartford, Conn.: American Publishing; rpt., New York: Book-of-the-Month Club, 1992.

Twain, Mark, and Charles Dudley Warner. 1873. *The Gilded Age: A Tale of Today.* Hartford, Conn.: American Publishing; rpt., Oxford: Oxford University Press, 1996.

———. 1883. *The Gilded Age: A Novel.* London: Routledge.

Tyng, Stephen H. 1875. *Address on the Occasion of the Funeral of William T. Blodgett.* New York: n.p.

U.S. Centennial Commission. 1875. *International Exhibition, Fairmount Park, 1876: Acts of Congress, Rules and Regulations, Description of the Buildings.* Philadelphia: U.S. Centennial Commission.

———. 1876. *International Exhibition, 1876: Official Catalogue, Art Gallery and Annexes. Department IV: Art.* 14th and rev. ed. Philadelphia: John R. Nagle.

———. 1880a. *International Exhibition, 1876: Reports and Awards,* vol. 7, *Groups XXI–XXVII.* Washington, D.C.: U.S. Government Printing Office.

———. 1880b. *International Exhibition, 1876: Report of the Director-General, Including the Reports of Bureaus of Administration,* vol. 1. Washington, D.C.: U.S. Government Printing Office.

———. 1880c . *International Exhibition, 1876: Reports of the President, Secretary, and Executive Committee, Together with the Journal of the Final Session of the Commission,* vol. 2. Washington, D.C.: U.S. Government Printing Office.

U.S. Commission to the Vienna Exposition. 1875. *Report of the Hon. H. Garretson, Chief Executive Commissioner of the United States.* Washington, D.C.: U.S. Government Office.

———. 1876. *Reports of the Commissioners of the United States to the International Exhibition Held at Vienna, 1873,* vol. 1. Washington, D.C.: U.S. Government Printing Office.

"Vienna and the Centennial." 1875. *International Review* 2 (January): 1–24.

Wager, Mary A. K. 1876. "Paintings and Statuary: The Annex to Memorial Hall." *Daily Graphic* (New York), May 18, 650.

Walker, Francis A. 1877a. "The Late World's Fair. Part II—The Display." *International Review* 4 (July): 497–513.

———. 1877b. *World's Fair, Philadelphia, 1876: A Critical Account.* New York: A. S. Barnes.

Weir, John F. 1878. "American Art: Its Progress and Prospects." *Princeton Review* 54 (May): 815–29.

———. 1880. "Group XXVII. Plastic and Graphic Art." In U.S. Centennial Commission, *International Exhibition, 1876: Reports and Awards,* vol. 7, *Groups XXI–XXVII,* 2–41. Washington, D.C.: U.S. Government Printing Office.

Wells, Samuel Roberts. 1872. *How to Behave.* New York: Samuel R. Wells.

What Is the Centennial? And How to See It. 1876. Philadelphia: Dando.

Whittredge, Worthington. 1942. *The Autobiography of Worthington Whittredge, 1820–1910.* Edited by John I. H. Baur. *Brooklyn Museum Journal* 1942:3-66.

Young, William. 1864. *Lights and Shadows of New York Picture Galleries.* New York: Appleton.

Secondary Sources

Ackerman, Gerald M. 1986. *The Life and Work of Jean-Léon Gérôme.* New York: Sotheby's Publications.

Anderson, Nancy K., and Linda S. Ferber. 1990. *Albert Bierstadt: Art and Enterprise.* Brooklyn, N.Y.: Brooklyn Museum.

Auer, Stephanie. 2011. "Caterina Cornaro: 'The Dearest Painted Queen.'" In *Makart: Painter of the Senses,* edited by Agnes Husslein-Arco and Alexander Klee, 47–56. New York: Prestel.

Axelrod, Alan, ed. 1985. *The Colonial Revival in America.* New York: Norton.

Ayres, William Smallwood. 1993. "The Domestic Museum in Manhattan: Major Private Art Installations in New York City, 1870–1920." Ph.D. diss., University of Delaware.

Baetjer, Katharine. 2004. "Buying Pictures for New York: The Founding Purchase of 1871." *Metropolitan Museum Journal* 39:13, 161–245.

Barringer, Tim, and Elizabeth Prettejohn, eds. 1999. *Frederic Leighton: Antiquity, Renaissance, Modernity.* New Haven: Yale University Press.

Barter, Judith A. 1998. *American Arts at the Art Institute of Chicago.* New York: Hudson Hills.

Bartoli, Damien, with Frederick Ross. 2010. *William Bouguereau: Catalogue Raisonné of His Painted Work.* New York: Antique Collectors' Club in cooperation with the Art Renewal Center.

Beaufort, Madeleine Fidell. 1982. "Some Views of Art Buying in New York in the 1870s and 1880s." *Oxford Art Journal* 5.1:48–55.

Becker, Howard S. 1982. *Art Worlds.* Berkeley: University of California Press, 2008.

Bennett, Tony. 1988. "The Exhibitionary Complex." *New Formations* 4 (Spring): 73–102.

Berkowitz, Julie S. 1999. *"Adorn the Halls": History of the Art Collection at Thomas Jefferson University.* Philadelphia: Thomas Jefferson University.

Bienenstock, Jennifer A. 1983. "The Formation and Early Years of the Society of American Artists: 1877–1884." Ph.D. diss., City University of New York.

Blaugrund, Annette. 1989. *Paris 1889: American Artists at the Universal Exposition.* Philadelphia: Pennsylvania Academy of the Fine Arts.

Böger, Astrid. 2010. *Envisioning the Nation: The Early American World's Fairs and the Formation of Culture.* Frankfurt: Campus.

Boone, M. Elizabeth. 2007. *Vistas de España: American Views of Art and Life in Spain, 1860–1914.* New Haven: Yale University Press.

Bourdieu, Pierre. 1993. *The Field of Cultural Production.* New York: Columbia University Press.

Bourdieu, Pierre, and Alain Darbel. 1991. *The Love of Art: European Art Museums and Their Public.* Cambridge: Polity.

Braddock, Guilbert C. 1975. *Notable Deaf Persons.* Washington, D.C.: Gallaudet College Alumni Association.

Brown, Dee. 1966. *The Year of the Century: 1876.* New York: Scribner's.

Burke, Doreen Bolger, and Catherine Hoover Voorsanger. 1987. "The Hudson River School in Eclipse." In *American Paradise: The World of the Hudson River School*, edited by John K. Howat, 71–90. New York: Metropolitan Museum of Art.

Burns, Sarah. 1999. "In Whose Shadow? Eastman Johnson and Winslow Homer in the Postwar Decades." In *Eastman Johnson: Painting America*, edited by Teresa A. Carbone and Patricia Hills, 185–213. Brooklyn, N.Y.: Brooklyn Museum of Art.

Carbone, Teresa A. 2006. *American Paintings in the Brooklyn Museum: Artists Born by 1876*, vol. 1. New York: Brooklyn Museum in association with D. Giles.

Carolus-Duran, 1837–1917. 2003. Paris: Réunion des Musées Nationaux.

Carr, Carolyn Kinder, and George Gurney. 1993. *Revisiting the White City: American Art at the 1893 World's Fair.* Washington, D.C.: National Museum of American Art and National Portrait Gallery.

Carson, Gerald. 1967. *The Polite Americans.* London: Macmillan.

Cash, Sarah, ed. 2011. *Corcoran Gallery of Art: American Paintings to 1945.* Washington, D.C.: Corcoran Gallery of Art, in association with Hudson Hills Press.

Clark, Eliot Candee. 1954. *History of the National Academy of Design, 1825–1953.* New York: Columbia University Press.

Coleman, L. V. 1939. *The Museum in America*, vol. 1. New York: American Association of Museums.

Conrads, Margaret C. 2000. "'In the Midst of an Era of Revolution': The New York Art Press and the Annual Exhibitions of the National Academy of Design in the 1870s." In *Rave Reviews: American Art and Its Critics, 1826–1925*, edited by David B. Dearinger, 93–105. New York: National Academy of Design.

———. 2001. *Winslow Homer and the Critics: Forging a National Art in the 1870s.* Kansas City, Mo.: Nelson-Atkins Museum of Art.

Cooper, Suzanne Fagence. 2001. "The British School at the Manchester Art Treasures Exhibition of 1857." *Apollo* 153 (June): 30–38.

Crary, Jonathan. 1992. *Techniques of the Observer.* Cambridge: MIT Press.

Curry, Jane. 1996. *Marietta Holley.* New York: Twayne.

Dearinger, David B. 2000a. "An Introduction to the History of American Art Criticism to 1925." In *Rave Reviews: American Art and Its Critics, 1826–1925*, edited by David B. Dearinger, 17–29. New York: National Academy of Design.

———. 2000b. "Annual Exhibitions and the Birth of American Art Criticism to 1865." In *Rave Reviews: American Art and Its Critics, 1826–1925*, edited by David B. Dearinger, 53–91. New York: National Academy of Design.

———. 2000c. "Appendix A: The Critics." In *Rave Reviews: American Art and Its Critics, 1826–1925*, edited by David B. Dearinger, 273–75. New York: National Academy of Design.

De Marchi, Neil, and Craufurd D. W. Goodwin, eds. 1999. *Economic Engagements with Art.* Durham: Duke University Press.

Ditter, Dorothy E. C. 1947. "The Cultural Climate of the Centennial City: Philadelphia, 1875–1876." Ph.D. diss., University of Pennsylvania.

Docherty, Linda Jones. 1985. "A Search for Identity: American Art Criticism and the Concept of the

'Native School.'" Ph.D. diss., University of North Carolina, Chapel Hill.

Donaldson, Christine Hunter. 1948. "The Centennial of 1876: The Exposition, and Culture for America." Ph.D. diss., Yale University.

Dorment, Richard, and Margaret F. MacDonald. 1995. *James McNeill Whistler.* London: Tate Gallery.

Dulles, Foster Rhea. 1964. *Americans Abroad: Two Centuries of European Travel.* Ann Arbor: University of Michigan Press.

Duncan, Carol. 1994. *Civilizing Rituals: Inside Public Art Museums.* London: Routledge.

Duncan, Carol, and Alan Wallach. 2004. "The Universal Survey Museum." In *Museum Studies: An Anthology of Contexts*, edited by Bettina Messias Carbonell, 51–70. Malden, Mass.: Blackwell.

Eco, Umberto. 1983. "A Theory of Expositions." In his *Travels in Hyper Reality.* San Diego: Harcourt Brace.

Eliot, Samuel. 1887. *Memoir of Charles Callahan Perkins.* Cambridge: J. Wilson and Son.

Fairmount Park Art Association: An Account of Its Origin and Activities. 1922. Philadelphia: Fairmount Park Art Association.

Falk, Peter Hastings, ed. 1999. *Who Was Who in American Art, 1564–1975*, vol. 3: *P–Z.* Madison, Conn.: Soundview.

Ferber, Linda S. 1982. *Tokens of a Friendship: Miniature Watercolors by William T. Richards from the Richard and Gloria Manney Collection.* New York: Metropolitan Museum of Art.

Fielding, Mantle. 1986. *Mantle Fielding's Dictionary of Painters, Sculptors, and Engravers.* Poughkeepsie, N.Y.: Apollo.

Fink, Lois Marie. 1990. *American Art at the Nineteenth-Century Paris Salons.* Washington, D.C.: National Museum of American Art, Smithsonian Institution.

Fischer, Diane P., and Linda Jones Docherty, eds. 1999. *Paris 1900: The "American School" at the Universal Exposition.* Montclair, N.J.: Montclair Art Museum.

Foner, Philip S. 1976. "Black Participation in the Centennial of 1876." *Negro History Bulletin* 39:533–35.

Fort, Ilene. 1990. "Frederick Arthur Bridgman and the American Fascination with the Exotic Near East." Ph.D. diss., City University of New York.

Foshay, Ella M. 1990. *Mr. Luman Reed's Picture Gallery: A Pioneer Collection of American Art.* New York: Abrams in association with the New-York Historical Society.

Foucault, Michel. 1977. *Discipline and Punish: The Birth of the Prison.* New York: Pantheon.

Fyfe, Gordon. 2000. *Art, Power and Modernity: English Art Institutions, 1750–1950.* London: Leicester University Press.

Gallati, Barbara Dayer, ed. 2011. *Making American Taste: American Art for a New Democracy.* New York: New-York Historical Society in association with D. Giles.

———. 2013. *Beauty's Legacy: Gilded Age Portraits in America.* New York: New-York Historical Society in association with D. Giles.

Ganz, James A., ed. 2015. *Jewel City: Art from San Francisco's Panama-Pacific International Exposition.* San Francisco: Fine Arts Museums of San Francisco in association with University of California Press.

Garraty, John A., and Mark C. Carnes, eds. 1999. *American National Biography*, vol. 12. New York: Oxford University Press.

Gerdts, William H. 1974. *The Great American Nude: A History in Art.* New York: Praeger.

———. 1999. "'Good Tidings to the Lovers of the Beautiful': New York's Düsseldorf Gallery, 1849–1862." *American Art Journal* 30:50–81.

Giberti, Bruno. 1994. "The Classified Landscape: Consumption, Commodity Order, and the 1876 Centennial Exhibition at Philadelphia." Ph.D. diss., University of California, Berkeley.

———. 2002. *Designing the Centennial: A History of the 1876 International Exhibition in Philadelphia.* Lexington: University Press of Kentucky.

Gilbert, James. 2009. *Whose Fair? Experience, Memory, and the History of the Great St. Louis Exposition.* Chicago: University of Chicago Press.

Gold, Susanna W. 2008. "'Fighting It over Again': *The Battle of Gettysburg* at the 1876 Centennial Exhibition." *Civil War History* 54.3:277–310.

Goldstein, Malcolm. 2000. *Landscape with Figures: A History of Art Dealing in the United States.* New York: Oxford University Press.

Goodheart, Adam Kaufman. 1992. "Last Summer of the Republic: The Centennial Exhibition as Experiment and Experience." A.B. honors thesis, Harvard University.

Grace, Trudie A. 2000. "The National Academy of Design and the Society of American Artists: Rivals Viewed by Critics, 1878–1906." In *Rave Reviews: American Art and Its Critics, 1826–1925*, edited by David B. Dearinger, 107–22. New York: National Academy of Design.

Green, Caroline V. 1992. "Fabricating the Dream: American World's Fair Sculpture, 1876–1915." Ph.D. diss., Boston University.

Greenhalgh, Paul. 1988. *Ephemeral Vistas: The Expositions Universelles, Great Exhibitions and World's Fairs, 1851–1939.* Manchester: Manchester University Press.

Groce, George C., and David H. Wallace. 1966. *Dictionary of Artists in America, 1564–1860.* New Haven: Yale University Press.

Hajdel, Eugene A. 1950. *Harry H. Moore: American 19th Century.* Jersey City, N.J.: n.p.

Halbwachs, Maurice. 1992. *On Collective Memory.* Translated and edited by Lewis A. Coser. Chicago: University of Chicago Press.

Harding, Jonathan P. 1984. *The Boston Athenaeum Collection: Pre–Twentieth Century American and European Painting and Sculpture.* Boston: Boston Athenaeum.

Harris, Neil. 1962. "The Gilded Age Revisited: Boston and the Museum Movement." *American Quarterly* 14.4 (Winter): 545–66.

———. 1990. *Cultural Excursions: Marketing Appetites and Cultural Tastes in Modern America.* Chicago: University of Chicago Press.

Hartigan, Lynda Roscoe. 1985. *Sharing Traditions: Five Black Artists in Nineteenth-Century America.* Washington, D.C.: National Museum of American Art.

Hicks, John Henry. 1972. "The United States Centennial Exhibition of 1876." Ph.D. diss., University of Georgia.

Hiesinger, Kathryn Bloom. 2011. *Collecting Modern: Design at the Philadelphia Museum of Art Since 1876.* Philadelphia: Philadelphia Museum of Art.

Higham, John. 1970. "The Construction of American History." In his *Writing American History: Essays on Modern Scholarship.* Bloomington: Indiana University Press.

Hirschfield, Charles. 1957. "America on Exhibition: The New York Crystal Palace." *American Quarterly* 9.2:101–16.

Hobbs, Susan. 1976. *1876: American Art of the Centennial.* Washington, D.C.: National Museum of American Art, Smithsonian Institution.

Hosley, William. 1990. *The Japan Idea: Art and Life in Victorian America.* Hartford, Conn.: Wadsworth Athenaeum.

Janson, Anthony F. 1989. *Worthington Whittredge.* Cambridge: Cambridge University Press.

Japan Goes to the World's Fairs: Japanese Art at the Great Expositions in Europe and the United States, 1867–1904. 2005. Los Angeles: NHK and NHK Promotions.

"Jervis McEntee's Diary, 1874–1876." 1991. *Archives of American Art Journal* 31 (January): 2–19.

Johns, Elizabeth. 1984. "Histories of American Art: The Changing Quest." *Art Journal* 44 (Winter): 338–44.

———. 1991. *American Genre Painting: The Politics of Everyday Life.* New Haven: Yale University Press.

Johnson, Jamie W. 2003. "The Viewer Viewed: Art's Public in Victorian England." Ph.D. diss., Graduate Center, City University of New York.

Kammen, Michael. 1991. *Mystic Chords of Memory: The Transformation of Tradition in American Culture.* New York: Random House.

Kraus, Michael, and Davis D. Joyce. 1985. *The Writing of American History.* Norman: University of Oklahoma Press.

Lancaster, Clay. 1950. "Taste at the Philadelphia Centennial." *Magazine of Art* 43 (December): 293–97, 308.

Lowenthal, David. 1985. *The Past Is a Foreign Country.* Cambridge: Cambridge University Press.

Lukes, Steven, ed. 1986. *Power.* New York: New York University Press, 1986.

———. 2005. *Power: A Radical View.* 1974; rpt., London: Palgrave Macmillan.

Lyons, Maura. 2005. *William Dunlap and the Construction of an American Art History.* Boston: University of Massachusetts Press.

Maass, John. 1973. *The Glorious Enterprise: The Centennial Exhibition of 1876 and H. J. Schwartzmann, Architect-in-Chief.* Watkins Glen, N.Y.: American Life Foundation.

Macht, Carol. 1976. *The Ladies, God Bless 'Em: The Women's Art Movement in Cincinnati in the Nineteenth Century.* Cincinnati, Ohio: Cincinnati Art Museum.

Mainardi, Patricia. 1987. *Art and Politics of the Second Empire: The Universal Expositions of 1855 and 1867.* New Haven: Yale University Press.

Malraux, André. 1952-54. *Le musée imaginaire de la sculpture mondiale*, vols. 1–3. Paris: Gallimard.

Martinez, Ann Katharine. 1986. "The Life and Career of John Sartain (1808–1897): A Nineteenth-Century Philadelphia Printmaker." Ph.D. diss., George Washington University.

———. 2000. "A Portrait of the Sartain Family and Their Home." In *Philadelphia's Cultural Landscape: The Sartain Family Legacy*, edited by Katharine Martinez and Page Talbott, 1–24. Philadelphia: Temple University Press.

Matthews, Mildred Byars. 1946. "The Painters of the Hudson River School in the Philadelphia Centennial of 1876." *Art in America* 34 (July): 143–60.

May, Stephen. 1995. "Succeeding Against the Odds: Recognition at Last for Edmonia Lewis." *Sculpture Review* 44 (Fall): 6–11.

Mayer, Stephanie. 2002. "Reconsidering the 1853 Crystal Palace." Boston University. Unpublished paper in author's possession.

Meech, Julia, and Gabriel P. Weisberg. 1990. *Japonisme Comes to America.* New Brunswick, N.J.: Jane Voorhees Zimmerli Art Museum, Rutgers, State University of New Jersey.

Miller, Lillian B. 1973. "Engines, Marbles, and Canvases: The Centennial Exposition of 1876." In *1876: The Centennial Year*, edited by Lillian B. Miller, Walter T. K. Nugent, and H. Wayne Morgan, 2–28. Indianapolis: Indiana Historical Society.

Morriss, Peter. 2002. *Power: A Philosophical Analysis.* 1987. Manchester: Manchester University Press.

Mott, Frank Luther. 1950. *American Journalism: A History of Newspapers in the United States Through 260 Years: 1690 to 1950.* New York: Macmillan.

———. 1938. *A History of American Magazines*, vol. 3. Cambridge, Mass.: Belknap.

Nearpass, Kate. 1983. "The First Chronological Exhibition of American Art, 1872." *Archives of American Art Journal* 23:21–30.

Nicolai, Richard R. 1976. *Centennial Philadelphia.* Bryn Mawr, Pa.: Bryn Mawr Press.

Nugent, Walter T. K. 1973. "Seed Time of Modern Conflict: American Society at the Centennial." In *1876: The Centennial Year*, edited by Lillian B. Miller, Walter T. K. Nugent, and H. Wayne Morgan, 30–45. Indianapolis: Indiana Historical Society.

Nutty, Carolyn Sue Himelick. 1993. "Joseph Harrison, Jr. (1810–1874): Philadelphia Art Collector." Ph.D. diss., University of Delaware.

———. 2000. "John Sartain and Joseph Harrison, Jr." In *Philadelphia's Cultural Landscape: The Sartain Family Legacy*, edited by Katharine Martinez and Page Talbott, 51–61. Philadelphia: Temple University Press.

Orcutt, Kimberly. 2002. "Buy American? The Debate over the Art Tariff." *American Art* 16.3 (Fall): 82–91.

———. 2005. "'Revising History': Creating a Canon of American Art at the 1876 Centennial Exhibition." Ph.D. diss., Graduate Center, City University of New York.

Pattee, Fred Lewis. 1915. *A History of American Literature Since 1870.* New York: Century.

Peck, William H. 1991. *The Detroit Institute of Arts: A Brief History.* Detroit: Wayne State University Press.

Pergam, Elizabeth A. 2001. "'Waking the Soul': The Manchester Art Treasures Exhibition of 1857 and the State of the Arts in Mid-Victorian Britain." Ph.D. diss., New York University.

Randel, William Peirce. 1927. *Centennial: American Life in 1876.* Philadelphia: Chilton Book.

Ricoeur, Paul. 2004. *Memory, History, Forgetting.* Chicago: University of Chicago Press.

Robey, Ethan. 2000a. "John Sartain and the Contest of Taste at the Centennial." In *Philadelphia's Cultural Landscape: The Sartain Family Legacy*, edited by Katharine Martinez and Page Talbott, 87–99. Philadelphia: Temple University Press.

———. 2000b. "The Utility of Art: Mechanics' Institute Fairs in New York City, 1828–1876." Ph.D. diss., Columbia University.

Roth, Rodris. 1985. "The New England, or 'Olde Tyme,' Kitchen Exhibit at Nineteenth-Century Fairs." In

The Colonial Revival in America, edited by Alan Axelrod, 159–83. New York: Norton.

Rydell, Robert W. 1984. *All the World's a Fair.* Chicago: University of Chicago Press.

Rydell, Robert W., John E. Findling, and Kimberly D. Pelle. 2000. *Fair America: World's Fairs in the United States.* Washington, D.C.: Smithsonian Institution Press.

Sacco, Ellen. 1991. "Art for the Millions: The Rise of Barnum's American Museum and the New York Crystal Palace." M.A. thesis, Hunter College, City University of New York.

Savage, Kirk. 1997. *Standing Soldiers, Kneeling Slaves: Race, War, and Monument in Nineteenth-Century America.* Princeton: Princeton University Press.

Savidou-Terrono, Evdokia. 2002. "For the 'Boys in Blue': The Art Galleries of the Sanitary Fairs." Ph.D. diss., City University of New York.

Schlesinger, Arthur M. 1946. *Learning How to Behave: A Historical Study of American Etiquette Books.* New York: Macmillan.

Schoelwer, Susan Prendergast. 1985. "Curious Relics and Quaint Scenes: The Colonial Revival at Chicago's Great Fair." In *The Colonial Revival in America*, edited by Alan Axelrod, 184–216. New York: Norton.

Sellers, Charles Coleman. 1980. *Mr. Peale's Museum: Charles Willson Peale and the First Popular Museum of Natural Science and Art.* New York: Norton.

Sellin, David. 1975. *The First Pose: 1876: Turning Point in American Art.* New York: Norton.

Sewell, Darrel. 2001. "Thomas Eakins and American Art." In *Thomas Eakins*, edited by Darrel Sewell, xi–xxii. Philadelphia: Philadelphia Museum of Art.

Shapiro, Michael. 1990. *The Museum: A Reference Guide.* New York: Greenwood.

Sicca, Cinzia, and Alison Yarrington, eds. 2000. *The Lustrous Trade: Material Culture and the History of Sculpture in England and Italy, c. 1700–c. 1860.* London: Leicester University Press.

Simoni, John P. 1952. "Art Critics and Criticism in Nineteenth Century America." Ph.D. diss., Ohio State University.

Simpson, Marc. 2001. "The 1870s." In *Thomas Eakins*, edited by Darrel Sewell, 27–40. Philadelphia: Philadelphia Museum of Art.

Skalet, Linda Henefield. 1980. "The Market for American Painting in New York, 1870–1915." Ph.D. diss., Johns Hopkins University.

Spassky, Natalie. 1985. *American Paintings in the Metropolitan Museum of Art*, vol. 2. Princeton: Princeton University Press.

Steen, Ivan D. 1963. "America's First World's Fair: The Exhibition of the Industry of All Nations at New York's Crystal Palace, 1853–1854." *New-York Historical Society Quarterly* 47 (July): 257–87.

Stillwell, John E. 1918. "Thomas J. Bryan: The First Art Collector and Connoisseur in New York City." *New-York Historical Society Quarterly Bulletin* 1.4 (January): 103–5.

Thieme, Ulrich, and Felix Becker. 1923. *Allgmeines Lexikon der Bildenden Künstler, Hansen-Heubach.* Leipzig: E. A. Seeman.

Thistlethwaite, Mark Edward. 1995. *Painting in the Grand Manner: The Art of Peter Frederick Rothermel (1812–1895).* Chadds Ford, Pa.: Brandywine River Museum.

———. 2000. "John Sartain and Peter F. Rothermel." In *Philadelphia's Cultural Landscape: The Sartain Family Legacy*, edited by Katharine Martinez and Page Talbott, 39–50. Philadelphia: Temple University Press.

Tomkins, Calvin. 1989. *Merchants and Masterpieces.* New York: H. Holt.

Trachtenberg, Alan, ed. 1970. *Democratic Vistas, 1860–1880.* New York: George Braziller.

Trout, S. Edgar. 1929. *The Story of the Centennial of 1876: Golden Anniversary.* Lancaster, Pa.: n.p..

Troyen, Carol. 1980. *The Boston Tradition: American Paintings from the Museum of Fine Arts, Boston.* Boston: Museum of Fine Arts.

———. 1984. "Innocents Abroad: American Painters at the 1867 Exposition Universelle, Paris." *American Art Journal* 16 (Autumn): 2–29.

Trumbull, Rebecca. 1986. *Memorial Hall: A History.* Philadelphia: Fairmount Park Council for Historic Sites.

Valenti, Phil. 2013. "Honoring the Past: A Legacy for the Future: The Restoration and Preservation of Memorial Hall." Unpublished manuscript in author's possession, Please Touch Museum.

van Ginkel, A. 1999. *General Principles of Human Power.* Westport, Conn.: Praeger.

Verdier, Daniel. 1994. *Democracy and International Trade.* Princeton: Princeton University Press.

Vidal, Gore. 1976. *1876.* New York: Random House.

Wallach, Alan. 1998. *Exhibiting Contradiction: Essays on the Art Museum in the United States.* Amherst: University of Massachusetts Press.

Webster, Sally. 1991. *William Morris Hunt.* Cambridge: Cambridge University Press.

Whitehill, Walter Muir. 1970. *Museum of Fine Arts, Boston: A Centennial History.* Cambridge, Mass.: Belknap.

Whitman, Walt. 1871. *Democratic Vistas.* New York: Redfield.

Wiebe, Robert H. 1967. *The Search for Order, 1877–1920.* New York: Hill and Wang.

Wilson, James Grant, and John Fiske, eds. 1888. *Appleton's Cyclopaedia of American Biography*, vol. 4. New York: Appleton.

Wilson, Richard Guy, Shaun Eyring, and Kenny Marotta, eds. 2006. *Recreating the American Past: Essays on the Colonial Revival.* Charlottesville: University of Virginia Press.

Winer, Donald A. 1975. "Rothermel's Battle of Gettysburg: A Victorian's Heroic View of the Civil War." *Nineteenth Century* 1 (Winter): 6–10.

Wolff, Janet, and John Seed, eds. 1988. *The Culture of Capital: Art, Power, and the Nineteenth-Century Middle Class.* New York: St. Martin's.

Wood, Christopher. 2006. *William Powell Frith: A Painter and His World.* Stroud, England: Sutton.

Wright, Helena E. 2000. "Prints in the Sartains' Circle." In *Philadelphia's Cultural Landscape: The Sartain Family Legacy*, edited by Katharine Martinez and Page Talbott, 25–38. Philadelphia: Temple University Press.

Zalewski, Leanne. 2009. "The Golden Age of French Academic Painting in America, 1867–1893." Ph.D. diss., City University of New York.

CREDITS

INDEX

Page numbers in *italics* refer to illustrations.

postwar maturation of, 13
support for growth of arts in U.S., 18
American Builder, 141–42
The American Centenary (Lossing), 9, 130
American Enterprise (Burley), 9, 118, 130
American Genre Painting (Johns), 107
American Institute (New York), 30
American masters, Exhibition retrospective on
critics' response to, 125–33
decision to include, 61
galleries for, 62, 63, 71, 127
selection of works for, 62–63
Americans, stereotypes of, 107. *See also* public
American School of Art. *See also* international vs. national
styles, debate on
civic rivalries as obstacle to, 120
conflict between Hudson River School and
European-trained artists, 5, 13, 28, 41, 81
contextualization within larger history of American art, 57
critics' efforts to outline, 127–33
Exhibition as effort to define, 5, 13–14, 81
as issue in Exhibition, 120–25
public perception of fine arts exhibition as means of
defining, 52
Tuckerman on, 127
Weir on, 203
American Society of Painters in Water Colors, 19
The American Type (Homer), 71–72
Amy Robsart interceding for Leicester (Rothermel), *69*
Andrea del Sarto, 171
Andrews, E. F., 78
Annapolis (Thompson), 183
Apotheosis of Washington (Guarnerio), 60, 159, *160*
The Apple of Discord (Gray), *69*
Appleton, Nathan, 137–38, 148, 151, 155, 157, 158, 164, 168, 213
Appleton's Journal
art criticism on Exhibition in, 128
focus of, 117
on importance of fine arts exhibition, 43
on New York Centennial Loan Exhibition, 172
on public behavior, 103, 104
Applicants for Admission to a Casual Ward (Fildes), 149
Ariadne Asleep on the Island of Naxos (Vanderlyn), 32, *33*, 73
Armand-Dumaresq, Charles-Edouard, 60, 152
Arrangement Committee, 53–55
conflicts with Selection Committee, 226n128
conflict within, 54–55

creation of, 39–40, 53
members of, 53, 217
Arrangement in Grey and Black (Whistler), 223n67
Art Amateur, 113
Art Annex, *39*, 76
American works in, 127; locations of, 66, 75–77
color scheme in, 89
construction delays in, 54
decision to build, 39
destruction of after Exhibition, 39
extreme heat and humidity in, 89–90
floor plan of, 66, *75*
focus on civic identities in, 75–76
hanging of New York artists' works in, 54
hanging of works in, 54
as less-visited of fine art venues, 39
as location of fine arts exhibition, 15, 19
paintings by American masters in, 63
paintings by foreign-trained artists in, 80
Art + Auction (magazine), 215
Art Bureau
and design of fine arts exhibition, 38–41
Sartain as head of, 27, 38–40, 41
art collections, private
as avenue to acceptance in high society, 172, 174–76
collectors' power over important works and, 189
commemorative volumes on, after New York Centennial
Loan Exhibition, 190
European interest in, 209
loans for museum display, and increased value, 188–89
public's opportunities to view, 30, 32, 104
sales of, after Panic of 1873, 188
art collectors
artists' dependence on, 28, 191
and arts exhibitions before Centennial Exhibition, 29, 34
and design of fine arts exhibition, 35, 37
display of cultural acumen as goal of, 139
European art in Exhibition as test of taste for, 138, 140,
147, 163–64, 189–90
on Exposition universelle of 1867, 34
interest in European art, 139, 179, 183, 190, 208–9
and international art market: methods of purchasing art,
139–40; risk of fraud and, 140, 172–73
means of accessing artists' works, 139
motivations of, 170, 191
nineteenth-century art museums' dependence on loans
from, 174
popularity of European travel and, 139

unprecedented power given to artists designing fine arts
	exhibition, 29, 55, 81
Powers, Hiram, 126, 222n7
Powers-Alanson, G., 222n12
La Première Pose (*The First Pose*) (Roberts), *69*, 73, 200
press. *See also* magazines; *individual newspapers and periodicals*
	art criticism of fine arts exhibition works, 118–20
	and art critics, hiring of, 116–17
	on awards for fine arts exhibition, 195–96
	coverage of fine arts exhibition, 4, 5, *11*
	criticisms of expatriate artist recruitment, 41
	on delays in fine arts exhibition design, 37–38
	evaluation of public's behavior, 105
	on Exhibition construction, 11
	on Exhibition opening ceremonies, 3–4
	on importance of fine arts exhibition, 42–43
	interest in Edmonia Lewis, 74–75
	national expansion of, and art criticism, 115
	reports on visitors' bad behavior, 107–10
	second-hand accounts of Exhibition in, 114
	Society of American Artists' ties with, 211–12
Press (Philadelphia periodical), 189
Priou, Louis, 152
Prisoners from the Front (Homer), 181, *182*
"Progress of the Fine Arts" (Conant), 130
progress of U.S.
	Centennial Exhibition as celebration of, 8–9
	need for historical narrative affirming, 9–10
	parodic accounts of, 9
	public behavior at Exhibition as measure of, 87, 105, 111
Proserpine (Powers), 222n7
public, at Centennial Exhibition. *See also* attendance
	accounts of Exhibition by, 58, 85–86
	behavior of: commentators' interest in, 87; concerns about,
		15; damaging artworks, 109–10; as measure of American
		cultural progress, 87, 105, 111; reports of comical misbe-
		havior, 105, *105*, 107; rush through Exhibition, 105, *105*;
		stereotypes used to describe, 107; Twain's influence on, 107
	and European art in Exhibition as test of taste, 138, 160
	and Exhibition as: first fine art experience for many, 87,
		102, 206; first U.S. shared national experience, 85, *86*;
		national taste-making project, 87, 88, 102, 110–11, 212; for
		proper behavior, 87, 88, 102–5, 110–11, 206
	and knowledge of history as collective memory, 87
	misbehavior by, 107–10, *108*, *109*
	and perception of Exhibition as means of defining
		American School of Art, 52

and power struggles over Exhibition design, 11
response to Exhibition: art world's interest in, 81; effect
	of environment on, 88; increased interest in art as, 111;
	overwhelming size of Exhibition and, 88, 91, 92; uncrit-
	ical acceptance of Exhibition's message, 57–58
and selection of Exhibition artists, resentment of Sartain's
	interventions in, 52, 92
U.S. visitors from outside East Coast, 102
public, at New York Centennial Loan Exhibition, behavior
	of, 188
Puebla, Dióscoro Teófilo, 157
Pueblo—Indian Village (Colyer), 69
Putnam's magazine, on etiquette, 103

Quilibet, Philip, 13

The Race of the Charioteers (Gérôme), 185
The Railway Station (Frith), 149–50, *150*, 233n51
The Rainbow (Turini), 76, *76*
Raupp, Carl, 225n110
Ream, Vinnie, 74
rebellion of 1876, 64–65
Reconstruction, lingering remnants of in 1876, 7, 93
Reed, Luman, 104, 173
regional origin of Exhibition works, 80
Reitlinger, A. H., 171
The Reminiscences of a Very Old Man (Sartain), 223n47
Renwick, James, 170, *177*
reproductions of artworks, proliferation of, 117
retrospective exhibitions, late-nineteenth century popular-
	ity of, 61–62. *See also* American masters, Exhibition
	retrospective on
Reynolds, Joshua, 149
Ribera, Jusepe de, 157
Richards, T. Addison, 172
Richards, William Trost, *69*, 223n36
Ricoeur, Paul, 10, 95, 115, 215
Rizpah Protecting the Bodies of Her Sons (Becker), 153, *154*
Roberts, Howard
	and Arrangement Committee, 53
	and Exhibition awards, 200
	and fine arts Advisory Commission, 40
	location of works in Exhibition, 73
	La Première Pose (*The First Pose*), *69*, 73, 200, *200*
	and Selection Committee, 43
Roberts, Marshall, 222n9
Robertson, John, 222n12

K.

K.

K.

q

q.

S.

S.